The Masters of Past Time

The Masters of Past Time

DUTCH AND FLEMISH PAINTING
FROM VAN EYCK TO REMBRANDT

Eugène Fromentin

Edited by H. Gerson

A Phaidon Book

Cornell University Press
ITHACA, NEW YORK

First published by Phaidon Press Ltd. 1948
First published, Cornell Paperbacks, 1981

International Standard Book Number 0-8014-9219-X
Library of Congress Catalog Card Number 80-69738
Printed in the United States of America

PUBLISHER'S NOTE

This volume has been photographically reprinted from the 1960 reprint of
the first English edition, published by Phaidon Press in 1948. The subject
illustrated on the cover of this new edition is a detail from Plate 54: the title
given on the cover is that by which the picture is now known.

CONTENTS

BELGIUM

★ ★ ★

EDITOR'S INTRODUCTION

'MONSIEUR FROMENTIN has a distinction that no other person has, to my knowledge, in equal measure: he has two muses, being a painter with the pen as well as with the brush. And what is more, he is no dilettante in one medium or the other, but he is a conscientious, strict and fine artist in both.' Such praise, coming as it did, from so distinguished a critic as Sainte-Beuve, must have given great satisfaction to Fromentin, particularly as it was upon Sainte-Beuve's style that he was trying to model his own writings.

Apart from that remark, Fromentin found but little recognition in his lifetime. His paintings failed to obtain for him admission to the Académie des Beaux-Arts, and when the publication of his book *Les Maîtres d'autrefois* in 1876 led him to approach the Académie again, he had to see the highest literary honour of France awarded not to himself, but to his colleague Charles Blanc. The new member of the Académie hotly disputed Fromentin's competence to judge matters of art: 'in forming an estimate of a great artist, nothing is so much out of place as a subtle intellect; for a man of genius is the very opposite of subtle'. Posterity has disposed of Blanc's arrogant strictures, and while his *History of Painting* is now considered obsolete, Fromentin has become a classic and his book is still being read. He has been unable, however, to maintain his rank as a painter, and his works find no longer a prominent place in our galleries, and are therefore unknown to the art-loving public. But such neglect and condemnation seem to me equally unjustified.

Who, then, was this painter with the pen as well as with the brush? Samuel-Auguste-Eugène Fromentin was born at La Rochelle in 1820. He spent much of his childhood in the nearby village of S. Maurice, where his parents had an estate, and it was there that he died at the age of fifty-six. Fromentin's parents were of a practical turn; young Eugène, however, was dreamy and taciturn, and his sensitive mind, finding no happiness in a cheerless middle-class home, turned for consolation to poetry. In 1841 he went to Paris in order to study law in accordance with the parents' wishes; but during his years in the capital he also did a good deal of writing, which was more to his

taste, and after he had taken his degree in 1844, he decided to take up painting. He had some measure of success in the Salon of 1847, and when he was awarded a Second Medal two years later, relations with his parents became easier and more cordial. Accompanied by a friend, he had been to Algiers in 1846 and on that visit made up his mind to become the 'painter of Southern scenery'. More journeys followed and sometimes he remained in Africa for many months: there he could paint, whereas in Paris he felt paralysed. When he received the First Medal and the Legion of Honour in 1859, his 'African' fame was at its height, and both the public and the art dealers continued to demand new pictures from Africa. 'I seem condemned to go on with this sort of thing for ever', the conscientious artist sighed.

Fromentin did not paint spontaneously. His decision to become a painter sprang, indeed, from careful deliberation, but by no-means from an irresistible inner urge. His works took shape through the recollection of what he had seen, and into each picture he put great care and zeal. His technique is almost classically solid, his colour values pleasingly balanced and blended in elegant tones. Fromentin depicts contemporary themes with the same scrupulousness and with equally mellow hues as Wouwerman had done two centuries earlier, while his drawing has almost the classic style of an Ingres. Like Chassériau, who was one year his senior, Fromentin aims at combining the pure forms of the classic masters with the wealth of brilliant colours characteristic of the romantics, of whom Delacroix in particular left a strong impression on him. If we seek the sources of Fromentin's art, we shall not find them in the models of his teacher, Louis Cabat, but rather in such works as Delacroix's 'Jewish Wedding in Morocco' (1839) in the Louvre, which should be compared with Fromentin's 'Moorish Funeral at Algiers' (1853) in the same museum. Delacroix had been to Africa in 1832, Decamps had travelled in Asia Minor five years earlier, and Chassériau had visited Algiers in 1846. Moreover, Prosper Marilhat, whom Fromentin greatly admired, had lived in the East during the early 1830s, and it was under the influence of these four artists that the youngest of the romantic painters shaped his style.

The force of a genius such as Delacroix is lacking in Fromentin's art, nor do his elegant, almost eclectic paintings suggest that his

inspiration was kindled by contact with Nature. Neither can Fromentin compare with Courbet, one year his senior; indeed, he may have regarded the sonorous realism of that painter as crude and uncultured. But if he had little sympathy with artists like Courbet, he had none at all with the rising Impressionists and denied emphatically their claim that Impressionism too had its roots in the Old Masters. Yet it is hardly to be wondered at that he abhorred the doctrines of a school that denounced the grey as 'the enemy of all painting' and declared that 'three brush strokes from Nature are worth more than two days in front of the easel': Fromentin on his part not only worked nearly always in his studio, but also admired the tints of the Old Masters, adhered to tonal colouring, and in his latest works goes so far as to adopt the grey tones of Corot. But the Impressionists could already boast of their first triumphs: Manet's 'Bon Bock', of which a colleague said, alluding to Frans Hals: 'c'est de la bière de Haarlem tout pure', achieved great success in the Salon of 1873, and in the year of Fromentin's death Impressionism produced one of its masterpieces, the 'Moulin de la Galette' by Renoir, now in the Louvre.

After Fromentin had failed to obtain admission to the Académie des Beaux-Arts in 1867, he lived at S. Maurice, retired and bored. He must therefore have been well pleased with the invitation of Buloz to write articles on Dutch Painting for the *Revue des Deux-Mondes*. He made a journey to Belgium and Holland in July 1875, and his journals appeared in the following year, first in the early numbers of the *Revue*, and some months later as a book entitled *Les Maîtres d'autrefois*. Even before the publication of the work, a discerning critic had said: 'Literature of travel is one of the fashions of our time, and we owe to this fashion several masterpieces'. This is true also of Fromentin's book, which surpasses everything that Maxime du Camp, Montégut, Charles Blanc, and other writers of the time had written about the art of the Old Dutch Masters.

As Fromentin always allowed his immediate impressions to sink slowly into his mind, everything he put down was carefully weighed and analysed. 'You know it is not in contact with things that I am at my best,' he wrote once from Belgium; 'in passing through the memory, truth turns into a poem, landscape into a picture'. 'I have a quite peculiar memory,' he explained later to the brothers de Goncourt.

'I take no notes, and sometimes, wearied by travelling, I shut my eyes and doze off, saying to myself, with great ill-humour: "You are losing this". But no, after two or three years I recollect my impressions quite clearly.' His letters from Holland are therefore not made up of a traveller's usual impressions; they are rather the fruit of intensive studies of the Dutch Masters, with whom he had already acquainted himself in the Louvre and at the Paris Exhibition of 1874.

Temperament played no great part in Fromentin's life. He has been aptly described as the child of his intellect, and as he had a special gift of observing and writing, the pen proved for him a better means of expression than the brush. He depicted the African desert most beautifully not in his paintings, but in his two books, *Un été dans le Sahara* (1856) and *Une année dans le Sahel* (1858), which are also made up of letters, written this time, however, many months after his return to France and mirroring his later recollections. His novel *Dominique* is likewise based on old memories—memories of his first love, which are now psychologically analysed, spun out and idealized.

One may wonder why a painter of Oriental scenery felt attracted so strongly by Dutch art, and why, for instance, his visit to Venice in July, 1870, was left unrecorded in his writings. This is due to the fact that aesthetic considerations, historical research and iconographic studies, all of which were regarded as indispensable for an understanding of Italian art, did not appeal to Fromentin. He was a painter, and as such he sought a direct approach to art. The wholesome pursuit of realistic painting, which considered any subject equally rewarding, could not fail to attract an observer open to the beauties of everyday life and sensitive to colour values; and where was this pursuit nearer at hand than in the heritage of the Dutch Masters? Fromentin speaks, above all, as an *homme de métier* and already in his first essay on art he proclaims: 'Study the technique of the Masters'. His starting point was at once sound and new. He tries to remain free from prejudice and to judge even the greatest masters with critical eyes. Biographical anecdotes find no place in his book, but a painter's life, as far as it concerns the spectator, is read from the pictures Fromentin describes.

The method he employs is that of contrasting different ways of pictorial representation. This becomes clear already in the chapter on the teachers of Rubens: the Master's artistic personality emerges as

it were from the contrast between Otto van Veen, a thinker steeped in Italian tradition, and Adam van Noort, a man of the people, rooted in northern soil and of impulsive disposition. The character of Rubens himself is clear, great and engaging. 'Rubens's stature increases with every step one makes in this country, a country of which he is the most indisputable pride and where he reigns supreme,' Fromentin writes from Brussels. Six chapters are devoted to Rubens alone, and no painting has ever been described in more thrilling words than the 'Miraculous Draught of Fishes' at Malines, a panel that had been taken down from the wall for cleaning and now stood in a school-hall in front of the traveller 'in its crudity and natural harshness, as it was on the day of its inception'. The painter Fromentin here feels so close to Rubens as if he were watching the master at work. And as we read Fromentin's lines we cannot but share his joy at that meeting.

But the emphasis of the book is on Dutch painting, on its place in the world and on its value for the art of our time. Fromentin finds it hard to do justice to Rembrandt's genius. 'Rembrandt does not increase in stature,' he says in the same letter, 'he astounds, shocks me a little, attracts, but does not convince me.' Two natures, he finds, struggled in Rembrandt's soul, and hence the 'Night Watch' is an unbalanced work; only in the 'Staalmeesters' are those opposites resolved. Nowadays we find this interpretation hardly convincing, but for Fromentin it was the foundation upon which he built an abundance of striking observations. In his expressive words, the experience of visual art is translated into the sphere of narrative art. His keen sense of values, combined as it was with a discerning eye, revealed to him a great deal that escapes the notice of others less gifted, while his intelligence saved him from straying into the nebulous realms of fancy. And which art critic would claim higher praise?

Fromentin's work does not, of course, lack all philosophical premises: it rests on Taine's determinist theory of art, a theory that is no longer considered valid. But when Fromentin relates Dutch and Flemish art to the people, the country and the climate, he steers clear of surrendering to the dogmas and systems that make Taine's philosophy so pedantic and so inartistic. His walks round the tranquil Vijver in The Hague, or along the sunlit dunes, are not described in

order to assist the reader in appreciating the paintings discussed further on; the author wants to see Holland through the eyes of the Old Masters and to recapture their simplicity and sincerity in looking at Nature. Then his thoughts return to their pictures, which try to catch the essentials of Dutch life—and how 'miraculously well' they knew to paint!—and he compares them to the paintings of French Masters, who have shown a great deal of inventive genius, but little real faculty for painting.

It is strange that so keen and intelligent an observer had no eyes for some works that are now reckoned among the loveliest creations of Dutch art. Thus he devotes not one word to Vermeer's works in Holland. This artist was indeed discovered so late that even ninety years ago Du Camp called the 'View of Delft', in the Mauritshuis, 'an exaggerated Canaletto, the work of a crude painter'. W. Burger, too, failed at first to see the beauties of this work and dismissed the painter with the words, 'he has carried the impasto to the same excess met with in Decamps'. Shortly afterwards, however, Burger recanted and published an enthusiastic description of Vermeer's works. This critical study was, it seems, not known to Fromentin, neither were the well-informed publications of the English scholar Weale nor the English-Italian handbook by Crowe and Cavalcaselle, who drew attention to early Flemish painting. No one familiar with these writings could have stayed at Bruges without looking at the chief work of Hugo van der Goes, the 'Death of the Virgin', or visited the Antwerp Museum without seeing the early Flemish masters in the Ertborn collection. The small catalogue of Bruges upon which visitors had then to rely was indeed a poor guide: it knows no painters of the fifteenth and sixteenth centuries except Jan van Eyck and Memling!

Les Maîtres d'autrefois is not a text-book that requires constant correction in the light of recent research. We have refrained therefore from adding notes to this new edition wherever modern opinion differs from that of the author. Needless to say, the emphasis in the appreciation of paintings is now on other qualities than it was formerly, but is our taste invariably better than that of the romantics? We speak no longer of progress in the domain of art and have become wary of jumping to conclusions where problems of art criticism are concerned. Let me quote only one instance in which Fromentin's

estimate of an Old Master has not been surpassed: no artist surely has
pronounced a truer and finer judgement on Jacob Ruisdael than
Fromentin, where he appraises that earnest, manly landscape painter,
who 'bears the most noble resemblance to his country of all the
Dutch painters'.

In order not to spoil the reader's enjoyment of Fromentin's reflec-
tions, the notes regarded as necessary to supplement and clarify the
text were separated from it and joined to the remarks accompanying
the plates. In the choice of illustrations, the aim has been, first, to
reproduce all works on which the author dwells at some length and,
secondly, to assemble Netherlandish paintings in a survey that may
be enjoyed independently of the text.

The Hague, 1948 H. GERSON

ACKNOWLEDGEMENT

*The translation by Andrew Boyle is here used by arrangement with
Messrs. J. M. Dent Ltd., who published it first in 1913*

AUTHOR'S FOREWORD

I am here to see Rubens and Rembrandt in their own country and at the same time the Dutch School in its natural setting. It is a setting that never changes, with its life on the farms and the sea, its dunes, pasture-lands, huge clouds and fine-drawn horizons. You will find there two quite distinct arts, so remarkable in their completeness and independence of each other, their brilliance and fascination, as to make an equal demand upon the studies of the philosopher, the historian and the painter. Indeed, the only critic to do them justice would be one who combined the qualities of these three characters in himself, and with two of them I have nothing in common. As for the third, the painter, had he only the slightest sense of perspective, he would cease to have any significance in the presence of the very obscurest master of these well-favoured countries.

I am going to visit the art-galleries, but shall not describe them in detail. I shall pause before certain people, but without narrating their lives or making a catalogue of their works, even such works as have been preserved by their countrymen. I shall describe, exactly as they appear to my mind, so far as I can grasp them, certain physiognomic traits of their genius or talent. I shall not approach any far-reaching issues: I shall avoid the abstruse and obscure. The art of painting, when all is said, is but the art of expressing the invisible by means of the visible: its paths, great or small, are sown with problems which we may legitimately examine for ourselves as Truths, but which it is well to leave in their native darkness as Mysteries. I shall merely describe, in the presence of certain pictures, the effects of surprise, pleasure, astonishment, and no less exactly of disappointment, which they happened to cause me. In so doing, I shall be only describing truthfully the quite unimportant impressions of a pure dilettante.

I warn you then to expect no method of any sort or continuity in these pages. If you find in them many gaps, many preferences and

omissions, you must not think that this lack of balance reflects on the importance or worth of the works I may leave unmentioned. I shall, on occasions, refer to the Louvre, and shall not hesitate to recall your attention thither, to the end that my illustrations may be nearer at hand to you and more easily verified. Possibly some of my views may run counter to accepted opinions: whilst I am not inclined to the revision of such ideas as would naturally give rise to these differences, I shall not go out of my way to avoid it. I only ask you not to see in this the sign of the carping critic, who seeks to make his mark by sheer effrontery and who while traversing beaten tracks fears he will be charged with observing nothing, if his judgements are not at odds with all others.

In truth, these studies will be mere notes, and these notes the unconnected and disproportionate elements of a book that is yet to be written—a book of more special scope than those that have so far been written, and one in which less space will be given to philosophy, aesthetics, nomenclature and anecdote, and far more to matters of technique. This book would be a kind of informal discourse on Painting, in which painters would recognize their peculiarities, and the world at large would come to a better understanding of painters and painting. For the present, my method of work will be to forget all that has been said on this subject, my aim, to raise problems, to stimulate thought upon them, and to inspire those capable of rendering us a like service with the longing to find their solution.

I am giving the title of The Masters of Past Time *to these pages, in the exact sense in which I would speak of the 'Masters' in the Grand or Familiar styles of French Literature, if I were speaking of Pascal, Bossuet, de la Bruyère, Voltaire or Diderot—with this difference that in France there are schools where the respect for and study of these masters of style are still practised, whilst I am hardly aware of any school where the respectful study of the always admirable masters of Flanders and Holland is at the present moment encouraged.*

For the rest, I shall assume that my reader so far resembles myself as to follow me without undue weariness, and yet has just enough difference in outlook to give me some pleasure in contradicting him and some anxiety in trying to convince him.

THE MASTERS OF
PAST TIME

BELGIUM

CHAPTER I

THE GALLERY AT BRUSSELS

THE merit of the Gallery at Brussels has always been far greater than its reputation. What lowers it in the eyes of those critics whose thoughts instinctively turn to the farthest side of a subject is the fact that it is only a stride from our frontiers, and consequently the first halting-place of a pilgrimage that leads to places of hallowed memory. Van Eyck is at Ghent, Memling at Bruges, Rubens at Antwerp: on none of these great men can Brussels lay special claim. She did not witness their birth, she has scarcely seen them at work; they should be seen in their native cities (at least that is the general assumption) and they await you elsewhere. All this gives that lovely capital the air of a deserted house, and exposes it to chances of neglect which it certainly does not deserve. Men do not know, or they forget, that in no other part of Flanders are these three princes of Flemish painting attended by such an escort of painters and wits—an escort that surrounds them, follows them, goes before them, opens the door of History to them, disappears when they enter, but not until it has made them enter. Belgium in this sense is a glorious art-book, whose chapters, happily for the good fame of the provinces, are scattered broadcast here and there, but whose introduction is at Brussels, and at Brussels alone. To everyone tempted to skip the preface in his desire to get on to the book I would say that he makes a mistake, that he has opened the book too soon, and that he will not read it aright.

This preface in itself is singularly beautiful; it is, moreover, a document that nothing else could supply. It warns us what ought to be seen, prepares us for everything, enables us to make out and understand everything. It brings order into the mass of proper names and works jumbled together in the numerous chapels where the chances of Time have scattered them; they are here sorted out without fear of confusion,

thanks to the consummate touch which has collected and tabulated them. It is, after a fashion, the inventory of what Belgium has produced in painting right down to the modern school; a sort of 'first estimate' of what she possesses in rhe various depositories—galleries, churches, convents, hospitals, mansion-houses, and private collections. Perhaps she did not know exactly herself the extent of that enormous national treasury, which with Holland's is the richest in the world after Italy's, until she had two registers of it, both very well kept— the Gallery at Antwerp, and this one. In a word, the history of art in Flanders is capricious and reads pretty much like a romance; every moment the thread of the story is broken, then taken up again; we think the art of painting lost, scattered abroad on the highways of the world; but it is somehow like the Prodigal Son, who came back when no one was expecting him. If you would learn its adventures and know what happened to it during its absence, pay a visit to the Gallery at Brussels. It will supply the information you require with all the ease that a complete, truthful, and lucid epitome of two centuries can offer.

I shall not speak of the arrangement and keeping of the place, which is excellent. Beautiful rooms, splendid light, choice works selected for their beauty, rarity, or even for their historical interest alone. There is the most practised accuracy in the fixing of provenances; in everything a good taste, care, technical knowledge, and a true regard for what is artistic, which make today of this valuable collection an ideal gallery. Of course it is above all else a Flemish Gallery, which gives it for Flanders a family interest, and for Europe a priceless value. The Dutch School scarcely figures there: one would not look for it there at all. It would meet there with creeds and habits that are not its own—mystic, catholic, and pagan: with none of these would it be at home. There it would be cheek-by-jowl with legends, ancient history, with reminiscences direct or otherwise of the dukes of Burgundy, the archdukes of Austria and the Italian dukes, with the Pope, Charles V, Philip II—that is, with all sorts of men and affairs that it never

knew or that it has since abjured; against which it fought for one hundred years, and from which its genius, instincts, requirements, and consequently its destiny, brought it perforce to an abrupt and emphatic separation. From Moerdijk to Dordrecht is not far—there is only the Meuse to cross; but to pass the frontier is like passing into a new world. Antwerp is the opposite of Amsterdam: and Rubens, with his large goodnatured eclecticism and the jolly sociable side of his genius, is more in his place at the side of Veronese, Tintoretto, Titian, Correggio, nay, even Raphael, than at the side of Rembrandt —his contemporary indeed, but his hopeless antithesis.

As for Italian art, it is here a mere memory. It is an art which has been falsified in the attempt to acclimatize it, and which of itself has deteriorated in passing into Flanders. When we see, in that part of the Gallery that is least Flemish, two portraits by Tintoretto, not excellent, 'tis true, and retouched a great deal, but typical of him nevertheless, we cannot understand him at the side of Memling, Martin de Vos, Van Orley, Rubens, Van Dyck, even at the side of Antony Mor. It is the same with Veronese: he is out of his element, his colouring is dull and washed out, his style is a trifle cold, his display pedantic and almost stilted. Yet the piece is splendid and done in his beautiful manner. It is a fragment of triumphant mythology taken from one of the ceilings of the Ducal Palace—one of his best;[1] but Rubens is at hand, and that is enough to give the Venetian Rubens a tone, an accent that is not of this country. Which of the two is right? and, only listening of course to the language spoken so well by these two men, which is the better: the faultless and erudite eloquence at Venice, or the emphatic, grandiose and fiery inaccuracy of speech at Antwerp? When at Venice, one is inclined to favour Veronese; but in Flanders Rubens is better understood.

Italian art has this in common with all arts of strong components, that it is very cosmopolitan, for it has been everywhere, and at the same time haughty and proud of its self-sufficiency. It is at home anywhere in Europe save in two

[1] See p. 353.

countries—Belgium, on whose artistic genius it has had some noticeable effect without ever being able to overthrow it; and Holland, which long ago made some pretence of consulting it, but which at last passed away from it and left it to itself. So that, if it is on good neighbourly terms with Spain, if it reigns in France, where, in historical painting at least, our greatest painters have been Roman, it encounters in Flanders two or three very great men of high descent and native blood who hold sway there and know full well how to keep the field to themselves.

The history of the relations between these two countries, Italy and Flanders, is curious and interesting; it is also lengthy and diffuse, and elsewhere one would lose his way in it: here, as I told you, it can be read fluently. It begins with Van Eyck and ends on the day when Rubens left Genoa, bringing with his luggage the delicate beauty of his Italian lessons, or, to be more accurate, all of it that his country's art could reasonably support. This history of the fifteenth and sixteenth centuries in Flanders forms the central portion and the real basis of this collection.

We begin with the fourteenth century—we end with the first part of the seventeenth century. At the two extremities of this magnificent expanse of art the same phenomenon, rare enough in so small a country, attracts our attention: an art born on the spot, and of its own begetting; an art born again when it was thought dead. We recognize Van Eyck in a very beautiful 'Adoration of the Magi' (Pl. 15); we catch sight of Memling in some beautiful portraits, and right towards the end, after a lapse of one hundred and fifty years, we discover Rubens again. In every case, it is truly a sun rising and then setting, with the brightness and transitoriness of a beautiful day without a morrow.

While Van Eyck is on the horizon, there are some stars who shine as far as the boundaries of the modern world, and it is by the light of these stars that the modern world seems to awaken, that it understands itself and has become enlightened. Italy has been notified of this and comes to Bruges. Thus a

visit of students anxious to learn the best way of setting about to become good painters, painting brilliantly, consistently, easily, and with stability, is the beginning of those comings and goings between the two peoples, which may change in character and object, but never cease altogether. Van Eyck is not alone: works swarm around him, works rather than names. We cannot distinguish them from the German School, we cannot distinguish them from one another; it is a casket, a reliquary, a blaze of precious jewellery. Imagine a collection of painted gold and silver work, in which you can see the trace of the enameller, the glass-blower, the engraver, and the illuminator of psalters, works of which the expression is pensive, the inspiration monastic, the destination princely, the execution already dexterous, the effect ravishing, but in the midst of which Memling is always distinct, unique, straightforward, and delightful, like a flower whose root cannot be unearthed and which has no offshoots.

That beautiful sunrise past and the lovely evening over, the night came down on the North, and it was Italy that shone above the rest then. And very naturally the North hastened down to her. The people of Flanders just then were at that critical moment, which comes to peoples as to individuals, when youth has passed and they must mature, when scepticism has practically taken the place of faith and they must have some knowledge. Flanders did with Italy what Italy had just done with Antiquity: it turned its attention to Rome, Florence, Milan, Parma, and Venice, just as Rome and Milan, Florence and Parma, had turned their attention to Rome and Greece.

The first to set out was Mabuse in 1508, then Van Orley, not later than 1527, then Floris, then Coxie, and the others followed. For a whole century there was on that Classical ground a Flemish Academy, which turned out some good students and several good painters, came near to stifling the School at Antwerp, by dint of a spiritless culture, and of lessons well or badly learned, and finally served to sow the seeds of the *unknown*. Should we regard them as pioneers? Pioneers are

always the first of a definite stock, men who do the spade-work, men of study and goodwill, attracted by honour and glory, fascinated by novelty, tortured by what is better than their own. I will not say that everything in this hybrid school of art was intended by nature as a consolation for what was lost, an encouragement to hope for what was expected. At least they all are attractive, interesting, and instructive, if one only bears in mind one thing, hackneyed as it is well known to be—the revival of the modern by the ancient world, and the extra-ordinary force which drew the whole of Europe around the Italian Renaissance as the centre of gravity. The Renaissance took place in the North exactly as it had done in the South, but with this difference, that at the time we are dealing with now Italy led and Flanders followed—Italy had the school of fine art and culture, and Flemish students flocked to it.

These students, to call them by a name which does honour to their masters, these disciples as they might better be called by virtue of their enthusiasm and deserts, were various and variously affected by the spirit which at a distance appealed to them all and, close at hand, charmed them according to their temperament. There were some whom Italy attracted but could not convert, like Mabuse, who remained Gothic alike in thought and work, and only brought back from his visit a taste for beautiful architecture, and that in palaces rather than churches. There were some whom Italy detained and kept there, others whom she sent away, loosened, suppler, more nervous, too much inclined, in fact, to those mobile attitudes and postures, like Van Orley; others she sent to England, Germany, or France; and, finally, some came back unrecognizable—Floris especially, whose cold and disorderly manner, whose rough, uneven style and commonplace execution were hailed as a wonderful event in the School, and brought him the dangerous honour of having (they say) one hundred and fifty pupils.

It is easy to recognize among these exiles those rare obstinate men who in an extraordinary manner remained strongly and artlessly attached to their native soil, who dug in it and there

made new discoveries: as, for example, Quentin Matsys, the smith of Antwerp, who began with the railings of a well that can still be seen in front of the main entrance to Notre-Dame, and later, with the same unaffected hand so accurate and strong, with the same metal graving tool, painted the 'Banker and his Wife', which is at the Louvre, and the admirable 'Burial of Christ' at the Gallery in Antwerp (Pl. 16).

Before leaving that historical room of the Brussels Gallery, we should have a long examination to make and many curiosities to discover. The period from the end of the fifteenth century to the third part of the sixteenth, beginning after Memling with the pupils of Gerard David and Dirk Bouts, and ending with the last pupils of Floris, as, for example, Martin de Vos (Pl. 21), is indeed one of the phases of the Northern School which we should know very badly if we looked no farther than our French Galleries. We should find here names altogether unknown in France, such as Coxie and Coninxloo. We should know what opinion to form of the merit and transitory value of Floris; we should be able to determine at a glance his historical interest: as for his vogue, it would always be startling, but more easily understood. Bernard van Orley, in spite of all the corruptions of his style, his silly gestures when he is excited, his theatrical stiffness when he takes pains, his mistakes in design, his errors in taste— in spite of all this, I say, Van Orley will be revealed to us as a painter far out of the ordinary, first of all by his 'Trials of Job' (Pl. 17), and then, perhaps indeed more certainly, by his portraits. You will find in him something Gothic and Florentine, with a trace of Mabuse and poor imitations of Michelangelo, a dramatic style in his triptych of Job and an historical style in his triptych of 'Pietà'. Here you will find the canvas heavy and stiff, the colouring dull, and a general paleness which is tiresome when the method of work is foreign. There you will find the happy touches of his native genius and impetuosity, the glistening surfaces, the glassy splendour natural to the workmen from the studios at Bruges. And yet such is the power, the strength of imagination, and the skilful

touch of this changeable, eccentric painter, that despite these discrepancies we discover in him an originality that forces itself upon us. At Brussels there are some surprising pieces by him. Note that I don't speak of Francken—Ambrosius Francken —a pure Fleming of the same period. The Gallery at Brussels has nothing by him, but at Antwerp he makes a remarkable figure; if he is not in this series, at least he is represented by his counterparts. Note again that I omit pictures of unknown origin and catalogued as 'Unknown Masters'—triptychs, portraits of all periods, beginning with two large standing portraits of Philip the Fair and Jeanne la Folle, two works rare by reason of the value iconographists attach to them, charming for their excellent execution, and possibly instructive for their aptness.[1] This gallery has about fifty pictures by unknown painters. No one positively lays claim to them. They remind one of certain better-known pictures; very often they unite and confirm them; the connexion becomes more obvious and the genealogical table better filled. You are to consider, also, that the original Dutch School, the one at Haarlem, which was confused with the Flemish School until the confusion of Holland with Flanders ceased altogether, that first attempt of the Netherlands to produce paintings of their own School, can be seen here, so that I need not speak of it. I shall only mention Dirk Bouts, with his two impressive panels of the 'Justice of Otto' (Pls. 10–11), Heemskerck and Mostaert: the latter a zealot of his own country's art, a gentleman of the House of Margaret of Austria, who painted all the well-known people of his time—a painter of a manner singularly tinged with history and legend, who in two pictures of episodes in the life of St. Benedict painted the interior of a kitchen, and represents to us, as was done one hundred years later, the family life of his time;[1] and Heemskerck, a simple apostle of the linear school of perspective—dry, angular, glaring, blackish—who cuts out his figure as in hard steel, with a faint imitation of Michelangelo.

It would be wrong to make any distinction here between Dutch and Flemish. At that time it mattered little whether one

[1] See p. 353.

was born on that or this side of the Meuse. What is really of importance to note is whether the painter has tasted the troubled waters of the Arno and Tiber. Did he visit Italy or not? That is everything. Nothing is so strange as this mixture, to a greater or lesser extent as the case may be, of Italian culture and persistent Germanisms, of the foreign tongue and the ineffaceable local accent, which marks the whole of this mongrel Italo-Flemish School. In vain the visits and pilgrimages. There is some little change but the roots remain. The style is new: movement invades the backgrounds: a suspicion of chiaroscuro can just be seen on their palettes; nudities begin to appear where till then had been an over-dressing of figures and costumes according to the local fashions. The appearance of the portraits is more imposing, the groups become more numerous; the pictures are loaded with detail, imagination is helped out by mythology, picturesque liberties are taken with the historical subjects: it is the period of Last Judgements, Satanic Conceptions, Revelations, and pictures of Hell with grinning devils. The Northern imagination surrenders itself with the greatest joy to those extravagancies in which Italian taste was always safe, and revels in the ridiculous or the awful.

At first nothing can disturb the methodical, immovable basis of the Flemish genius. The handiwork is always exact, acute, detailed, and clear; the hand remembers that not long since it worked in smooth, polished, heavy substances, chased leather, enamelled gold, and moulded and coloured glasswork. Then gradually the method changes for the worse: the colouring no longer blends, the tone is divided into lights and shades, the colours separate as in a spectroscope, remaining solid in the folds of the drapery, fading away and turning paler at each rounding. The painting becomes less solid and the colour less consistent, according as it loses the force and brilliancy which arose from their unity. The Florentine manner is beginning-to disorganize the rich and uniform Flemish palette. Once this first inroad has taken place, the damage makes rapid progress. In spite of the docility with which it is prepared to follow the Italian teaching, the Flemish genius is

not pliable enough to conform entirely with those lessons. It takes whatever it can, not always the best, and something always escapes it: either the workmanship when it thinks it can master the style, or the style when it succeeds in approaching the methods. After Florence, it is Rome which dominates it, and at the same time it is Venice. The influences it undergoes at Venice are peculiar. One scarcely notices that the Flemish painters have studied Bellini, Giorgione, or Titian. Tintoretto, on the other hand, attracts their attention considerably. They find in him a grandeur, a vitality, a muscularity, which tempts them to imitate him, and a certain transitional colouring from which that of Veronese must be distinguished, and which seems to them the most useful to consult for the purpose of discovering the elements of their own. They borrowed two or three tones from him (notably his use of yellow) and his manner of accompanying them. It is worth noticing that in these unsystematic imitations there are not only a number of incoherences, but also some startling anachronisms. They adopt the Italian manner more and more, and yet they carry it badly. Some inconsistency, some detail badly selected, some strange combination of two manners which do not go well together, still reveal the refractory bent of these incorrigible students. When Italian art was degenerating, at the end of the sixteenth century, we find among the Italo-Flemings certain men of the past, who are evidently quite unaware that the Renaissance was past and gone. They lived in Italy, and only followed up the changes at a distance. Whether it be an absolute lack of acumen, or a natural stubbornness and obstinacy, there seemed to be a side in their character that rebelled and could not be cultivated. The Italo-Fleming invariably lingered in the age of Italian ascendancy, with the result that Rubens's teacher was scarcely abreast of the School of Raphael.

While in historical painting some are lingering behind, in the other branches there are some who have foreseen the future and are steadily going forward. I do not refer to Brueghel alone, the discoverer of *genre*, a genius of the soil, an

original master if ever there was one; father of a school not yet born, who died without seeing his sons—but whose sons nevertheless belong to him alone. The Gallery at Brussels brings to our notice a painter scarcely known, of undetermined name, represented by nicknames: in Flanders *Herri met de Bles*, or *de Blesse, the man with the tuft*; in Italy *Civetta*, as his pictures, now very rare, bore the mark of an owl instead of a signature. One picture of this Herri met de Bles, a 'Temptation of St. Anthony' (Pl. 18), is a very unexpected piece, with its dark and bottle-green landscape, its pitch-black ground, its horizon of high blue mountains, its light Prussian-blue sky, its daring ingenious touches, the awful blackness which serves to set off the two nude figures, his chiaroscuro, so boldly effected in that open sky. This mysterious painting, which bears the mark of Italy on it and shows what Brueghel and Rubens will be like later on in their landscapes, shows the hand of a skilful painter, and one impatient to outstrip his age.

Of all these painters more or less unacclimatized, of all these *Romanists*, as they were called on their return to society at Antwerp, Italy made not only skilful artists, with ease of manner, great experience, true knowledge, above all with great endowments for propagating, for becoming vulgarized— the word being taken, I ask their pardon for it, in both its senses. Italy gave them also the taste for a variety of arts. Following the example of their masters, they became architects, engineers, and poets. Today that rare enthusiasm makes us smile a little when we think of the sincere masters that had preceded them, and the inspired one that was to follow. They were good, honest folk who worked to increase the culture of their day, and unconsciously the progress of their school. They set out, became rich, and returned to their quarters again, like those emigrants who are sparing abroad that they may have plenty to spend at home. It is here a matter of quite secondary importance, and one which even local history could afford to overlook, that they all did not follow each other in the natural succession of father and son, and that the conditions of genealogy are not in such cases the only criterion of the

usefulness of those who sought or the only aid to understanding the sudden greatness of those who found.

In short, a school has disappeared, the school at Bruges. Politics, war, travel, all those active elements which constitute the physical and moral being of a nation, helped to bring this about, and another school is formed at Antwerp. Italian creeds inspire it; it takes counsel from Italian art; princes encourage it, all the national requirements call for it; it is at once very active, undecided, brilliant, astonishingly fertile and almost obliterated. It is changed from top to bottom, until it is scarcely recognizable, until it reaches its decisive and last incarnation in a man born to adapt himself to all the needs of his age and country, taught in all the schools, and destined to be the most original expression of his own school—that is to say, the most Flemish of the Flemings.

Otto van Veen is placed in the Gallery at Brussels immediately at the side of his great pupil. It is to these two inseparable names that we should make our way as soon as we finish what precedes them. Along the whole horizon we can see them, one hidden in the glory of the other; and if I have not named them twenty times already, you must be grateful to me for having kept you waiting patiently.

CHAPTER II

RUBENS'S MASTERS

WE know that Rubens had three masters: that he began his studies with a landscape-painter very little known, Tobias Verhaeght, that he continued them with Adam van Noort, and finished them with Otto van Veen. Of these three masters only the last two need be considered; indeed, Van Veen is still credited with practically all the honour of that great training, one of the greatest to which any master has been able to lay claim, for he guided his pupil until the zenith of fame was reached, and did not leave Rubens until he was a man, at least

in talent, almost a great man. As for Van Noort, we are told he was a painter of true originality, but rather fantastic, that he treated his pupils harshly, and that Rubens spent four years in his workroom, took a dislike to him, and sought in Van Veen a master more easy to live with. That is almost all we are told about this intermediate instructor, who even so had a hand in training the child, and that at an age when childhood is most susceptible to impressions. And in my opinion it is not nearly enough to account for the remarkable influence he must have had over that young genius.

If Rubens learned the *elements* of his art with Verhaeght, and if Van Veen trained him in his *humanities*, Van Noort did something more; he showed Rubens in his own person a character totally distinct from all others, an unvanquished temperament—in fine, the only painter among his contemporaries who had remained Flemish when no one else in Flanders was so.

Nothing is so strange as the contrast between these two men, so different in character, so opposed, consequently, in regard to influences. And nothing, too, is so curious as the fate that called them one after the other to fulfil this delicate task, the education of a child of genius. Note that, in their differences, they corresponded exactly with the contrasts of which that manifold nature was composed—as circumspect as it was daring. Apart, they represented the opposite elements, the inconsistencies, so to speak; together, they reconstructed the genius in small, the entire man, with his united forces, his harmony, good balance and unity.

Now, however little we may know of the genius of Rubens in its fullness, and of the talents of his two instructors in their contradictions, it is easy to perceive, I shall not say which of them gave him the sounder advice, but which of them had the more vigorous influence; the one who spoke to his understanding or he who appealed to his temperament; the minutely correct painter who extolled to him the glories of Italy, or the man of the soil who, perhaps, showed him what he would be one day, by satisfying himself with being the greatest painter

in his own country. In all these cases there is one whose influence can be explained but rarely seen; there is another whose influence can be seen but not explained. And if we try with the utmost diligence to recognize a family trait on those features so strangely unique, I can find but one which has the character and persistency of an hereditary trait, and that trait comes to him from Van Noort. This is what I wanted to tell you about Van Veen, by reclaiming for a man too easily forgotten the right of taking the place at his side.

Van Veen was not an ordinary man. Without Rubens, he would have some difficulty in maintaining the position he holds in history; but at least the lustre thrown on him by his disciple lights up a noble figure, a personage of impressive bearing, high birth, high culture, a learned painter, sometimes even original in the variety of his treatment and almost natural talent, to such an extent had his education become part of his nature—in a word, one in whom both the man and the artist had been ideally nurtured. He had visited Florence, Rome, Venice, and Parma, and certainly it was at Rome, Venice and Parma that he stayed the longest. A Roman in scrupulousness, a Venetian in taste—above all, a Parmesan, by virtue of certain affinities which, though more rarely discernible, are nevertheless the most personal and true. At Rome and Venice he had found two schools of a form that could not be seen elsewhere; at Parma he had only met one solitary creator unblest with connexions or doctrines, who did not even pride himself that he was a master. Had he, by reason of these differences, more respect for Raphael, a more aesthetic enthusiasm for Veronese and Titian, a more deep-rooted affection for Correggio? I am sure he had. His happier compositions are a trifle hackneyed, empty too, and of little imagination; and the elegance that he owes to his person and his dealings with the best masters, as with the best company, the haziness of his convictions and preferences, the impersonal appeal of his colouring, his draperies lacking both truth and dignity, his heads without individuality, his strong vinous tones devoid of enthusiasm—all these traits, almost saturated with decorum,

would leave one with the impression of an accomplished but
mediocre man. We might speak of him as a professor who in
an admirable manner delivers lectures too admirable and too
difficult for himself. But he is better than that. I wish for no
stronger proof of that than his 'Mystic Marriage of St.
Catherine' (Pl. 19), which can be seen in the Gallery at
Brussels, on the right of and underneath the 'Adoration of the
Kings' by Rubens.

This picture caught my attention very considerably. It was
painted in 1589, and is steeped in that Italian essence on which
the painter had lived and thrived. At that time Van Veen was
thirty-three years old; he had returned to his native country,
and was held there in the greatest esteem as the architect and
painter of Prince Alexander of Parma. From his family
picture at the Louvre, dated 1584, to this one, that is, in five
years, the progress is enormous. It seems as if his Italian
recollections had slept during his stay at Liége with the prince-
bishop, and awakened at the Farnese Court. This picture, the
best and most astonishing product of all the lessons he had
learned, has this peculiarity, that it reveals a man at the sway
of many influences, that it shows us, at least, the trend of his
natural inclinations, and that we may learn from it his purpose
by seeing more distinctly the source of his inspiration. I shall
not describe it to you; but as the subject seemed to me to
deserve some attention, I stopped and took some hasty notes
which I shall transcribe.

'Richer, suppler, not so Roman, though at first glance the
tone seems Roman. Struck by a notable tenderness in the
figures, a capricious folding of the draperies, and a slight
mannerism in the hands, we feel that he has been introducing
the style of Correggio into that of Raphael. Angels are in the
sky, making there a lovely effect: a dark yellow piece of
drapery in clair-obscur is thrown like a tent, with its folds in
relief, across the branches of the trees. His Christ is charming;
his young and small St. Elizabeth is adorable. Observe her
downcast eye, the chastely infantine face, the beautiful well-
set neck, the unaffected air of Raphael's virgins, made human

by a slight touch of Correggio and a personal influence which
is very marked. The fair tresses which lose themselves in the
fairness of the skin, the whitish-grey robes which melt into
each other, the colours which blend or assert themselves,
which combine or are made distinct in a very capricious
manner according to new laws and the peculiar whims of the
painter—all this is pure Italian blood, let into a vein capable
of making new blood of it. All this prepares us for Rubens,
announcing and leading up to him.

'Certainly there is in this "Marriage of St. Catharine"
enough to illuminate and place immediately in the front rank
a mind of such delicacy, a temperament of such fire. The
elements, the arrangement, the parts, the chiaroscuro now
softer, more undulating; the yellow no longer Tintoretto's
though derived from him; the pearliness of the flesh-tints no
longer Correggio's composition, though it has a suggestion
of it; the skin more delicate, the flesh colder, the grace more
womanly, or of a more local type of womanhood; the bases
entirely Italian, but the warmth has left them in so far as the
dominant red gives place to the dominant green; infinitely
more individuality in the disposal of shadows, the light more
diffused and less rigorously subjected to the arabesques of
form—that is what Van Veen had extracted from his Italian
recollections. 'Twas a trivial attempt indeed at acclimatization,
yet there the attempt is. Rubens, for whose training nothing
was to be lost, found, when he came to Van Veen seven years
later in 1596, the prototype of a style eclectic already to a great
extent and considerably freed from the Italian shackles. This
is more than one might have expected of Van Veen: enough
to make Rubens indebted to him for a moral influence, if not
for an emphatic impression.'

As can be seen, Van Veen had more surface qualities than
depth of genius, more arrangement than wealth of imagina-
tion, an excellent training and education, little natural fire,
not a shadow of genius. He could give you good examples,
being an excellent example himself of the important bearing
on life of a fortunate birth, a well-balanced mind, a supple

understanding, an active and unrestrained volition, a remarkable aptitude for self-effacement.

Van Noort (Pl. 20) was the antithesis of Van Veen. He lacked practically everything that Van Veen had acquired; he possessed by nature what Van Veen himself lacked. He had neither culture nor breeding, elegance nor deportment, self-discipline nor balance; but, on the other hand, he had real talents, talents of very great acuteness. Savage, hasty, violent, and caustic—that was how nature had formed him; he had never ceased to be so, both in his life and his work. He was a man of many parts, rough-cast—perhaps ignorant and illiterate; but he was somebody, the opposite of Van Veen, the antithesis of the Italian type—in everything a Fleming, by birth and temperament, and a Fleming he remained.[1] With Van Veen he represented excellently the two elements, natural and foreign, which for one hundred years had divided Flemish genius between them, and of which the latter had almost stifled its fellow; after his manner, and allowing for the difference of the period, he was the last offshoot of that strong national tree from which Van Eyck, Memling, Quentin Matsys, old Brueghel, and all the portrait-painters had sprung, according to the genius of each century, the natural and vigorous product. Just as the old German blood had degenerated in the veins of the learned Van Veen, so it flowed rich, pure, and plentiful in that strong, uncultivated organization. By his tastes, instincts, and habits, Van Noort was of the people. He had their brutality, their taste, it is said, for wine, their high tone of voice, coarse yet frank language, their sincerity, ill-bred and offensive—everything, in a word, save their good humour. As strange to the world as to the academies, and as unpolished in one sense as in the other, but in every respect a painter, in his imaginative faculties, in his vision and swift keen touch, of an imperturbable assurance, he had two motives to make him exceedingly daring: he knew he could do everything without anybody's help, and he had no scruples in matters of which he was ignorant.

[1] See p. 357.

To judge from his works, now become very rare, and from the little that remains to us of a laborious career of eighty-four years, he loved that which in his own country was no longer prized: an action, even an historical action, expressed in its crude reality without any ideal whatever, mystic or pagan. He liked full-blooded, untidy men; he liked old men turning grey, tanned, wrinkled, hardened by rough work; thick glossy heads of hair, untrimmed beards, thick-set necks, and broad shoulders. In his technique he liked strong emphasis, glaring colours, great patches of light on loud powerful tones, the whole without a firm basis, and of a composition enormous, fiery and glistening, almost loud. His touch was quick, but certain and accurate. He had a way of striking the canvas and laying on a tone rather than a figure, which made it resound under the brush. He would pile up together a multitude of figures, sometimes the largest figures in a small space, dispose and arrange them in numerous groups, and draw out of the number a general relief which was added to the individual relief of each object. Everything that could shine, shone—the forehead, temples, moustache, the brightness of the eyes, the edge of the eyelashes; and by thus expressing the effect of vivid daylight on the blood, that moist, glistening contraction of the skin exposed to the burning heat of day, with a great deal of red sprinkled with silvery white, he gave all his figures an appearance of tenser activity, and, so to speak, of sweating.

If these traits are accurate, and I think they are, for they are to be seen in one of his most characteristic works, it is impossible not to notice the effect such a man must have had upon Rubens. The pupil certainly had in his blood a great deal of the master. He had indeed practically everything that went to make up his master's originality, but he had many other talents in addition, whence arose, as it must have done, the extraordinary copiousness and no less extraordinary habit of mind of this great genius. Rubens, it has been said, was *tranquil and lucid*, which means that his lucidity arose from his imperturbable good sense, and his tranquillity from the most remarkable good balance that perhaps ever existed in any brain.

It is no less true that there exist between Van Noort and Rubens family traits that are quite evident. If you have any doubt about it you need only consider Jordaens, his fellow-pupil and understudy. As he grew in years and training, the trait of which I speak may have disappeared in Rubens; in Jordaens it has endured under his extreme likeness to Rubens, so that today it is by the relationship of these two pupils that we can recognize the original symbol which unites them both to their common master. Jordaens would certainly have been quite different if he had not had Van Noort for instructor and Rubens for his constant model. Without this instructor and originator, would Rubens be all he is, and would he not lack an accent, that one vulgar accent which unites him to the heart of his people, and thanks to which he has been understood by them as thoroughly as by refined intellects and princes? However this may be, nature seems to have been feeling its uncertain way when, from 1557 to 1581, it was seeking the mould into which the elements of modern art in Flanders could be cast. We might say that it made an attempt to find it in Van Noort, hesitated at Jordaens, and only found what it required in Rubens.

We are now at the year 1600. Rubens is henceforward strong enough to dispense with a master, but not with masters. He sets out for Italy. What he did there is well known. He stayed there eight years, from twenty-three to thirty-one years of age. He stopped at Mantua, paid a visit to the Court of Spain by way of prelude to his embassies, returned to Mantua, went to Rome, then Florence, then Venice; then from Rome he went away to set up an establishment at Genoa. He met princes there, became famous, and made full use of his talents, fame, and wealth. When his mother died he returned to Antwerp, in 1609, and was soon easily acknowledged to be the greatest master of his time.

RUBENS IN THE GALLERY AT BRUSSELS

IF I were writing the life of Rubens, I should certainly not write the first chapter here. I should first go back to examine him in his earliest efforts, in the pictures painted before the year 1609; or again I would choose some decisive moment, and it would be from his arrival at Antwerp that I should follow up his definite and unswerving career, in which one can scarcely ever notice the fluctuations of a mind developing itself on broad lines and lengthening its paths, and never the hesitation and distraction of a mind unconscious of its own power. But suppose that I turn over a few pages of that immense work. Some loose pages of his life offer themselves by chance, and I accept them so. Besides, wherever Rubens is represented by a good picture, he is present—not, I must admit, in all the shades of his genius, but in one at least of the most beautiful.

The Gallery at Brussels has at least seven important pictures by him, a sketch, and four portraits. If this is not enough for us to judge Rubens by, it is at least sufficient to give us a magnificent, varied, and accurate idea of his value. With his master, his contemporaries, his fellow-pupils, or his friends, he fills the last row of the Gallery, and he diffuses there that restrained splendour, that mild yet strong radiancy which form the beauty of his genius. No pedantry, no affectation of vain grandeur or offensive pride: he compels attention quite naturally. If you imagine him to have the most violent and contrary neighbours, yet the effect is the same; those who resemble him, he eclipses—those who may be tempted to oppose him, he silences; at whatever distance, he warns you he is there. He isolates himself, and wherever he is there he makes himself at home.

The pictures, though not dated, are evidently of very different periods. Many years separate 'The Assumption of the Virgin' (Pl. 35) from the two dramatic pieces 'St. Lievin' (Pl. 39) and 'Christ Carrying the Cross' (Pl. 40). Not that we

find in Rubens those startling changes which mark, in the greater number of masters, a change from one age to another, and which are called their mannerisms. Rubens matured too early, and died too suddenly for his painting to have kept any obvious trace of his first attempts, or to have shown the least sign of a decline. From his youth he was himself. He had found his style and form, to all intents and purposes his models, and once for all the principal elements of his handicraft. Later, with experience he had acquired still more freedom; his palette, while it became richer, was more restrained. He accomplished more with less effort, and his most daring parts, if examined carefully, will only show us after all the skill, science, and expedients of a very great master who keeps himself in hand in his greatest extravagancy. At the start, his effects are rather thin and glossy, a trifle lively. His colour, in glistening layers, has more sheen, but less resonance; its basis is less carefully chosen, its substance not so delicate or deep. He was not afraid of tone; he had no doubts already as to the sound use he was to make of it one day. Yet at the end of his life, in his most vigorous age, when his invention and craft were at the full height of their activities, he came back to that comparatively timid mannerism once more. That is the reason why in the small anecdotic pictures which he painted with his friend Brueghel, to amuse the last years of his life, we could never recognize that hand of power, unruly or delicate, which painted at the same time the 'Martyrdom of St. Lievin', the 'Adoration' of the Gallery at Antwerp, or the 'St. George' at the Church of S. Jacques.[1] In reality, the spirit never changed, and if you would follow the progress of the age you must examine the outside of the man rather than the mysterious ways of his thought; you must analyse his palette, you must only study his craft, and above all, only look to his great works.

The 'Assumption' (Pl. 35) belongs to this first period, for it would be incorrect to say to his first style. It has been repainted a great deal; we are told that in this it loses a great part of its

[1] See p. 358.

merit; but I cannot see that it has lost what I expect of it. Here is a page of his art brilliant alike and cold, inspired in its conception, cautious and methodical in its execution. It is, like the pictures of that time, polished, smooth of surface, a trifle glittering. The mediocre types have an unnatural appearance; Rubens's palette already here struck out the few dominant notes—red, yellow, black, and grey—brilliantly, but with harshness. So much for the failings. As for the good qualities but newly acquired, they are applied here in a masterly manner. Great figures stooping over the empty grave, all the colours flickering over a black hole—the light, diffused round a central spot, large, powerful, high-sounding, undulating, fading away in the most delicate half-tints; to the right and left nothing but weak points, save two chance spots—two horizontal forces, which restore the scene to its natural setting about half-way up the picture. Below there are some greyish shades, above, a Venetian blue sky, with grey clouds and mists that soar; and in this misty azure, her feet hidden in azure films, her head in a halo of glory, is the Virgin, dressed in pale blue with a dark-blue cloak, and the three winged groups of angels who are with her, radiant in pearl-rose and silver. At the highest corner, touching the very top, a little lively cherub, beating his wings, glistening like a butterfly in the light, soars direct and flies through the open sky like a messenger, fleeter than all the others. Elasticity, amplitude, a spaciousness in the groups, a marvellous harmony between the picturesque and the great—save for a few imperfections, Rubens in this case is more than a bud ready to blossom. Nothing could be more tender, straightforward, and more impressive. As an improvisation in the happiest colour-effects, as life, as perfect blending for the eye, it is complete—a midsummer carnival.

His 'Pietà' is a work done in his later style—grave, greyish, and black; the Virgin in sombre blue, Magdalene in a dress the colour of scabious. The canvas has suffered a great deal in being moved, whether in 1794, when it was sent to Paris, or in 1815, when it was brought back here. It was held to be one of

Rubens's finest works, but it is so no longer. I limit myself
to the transcribing of my notes, which say all that need
be said.[1]

The 'Adoration of the Kings' (Pl. 29) is neither the first nor
the last expression of a conception which Rubens endeavoured
to produce several times. In any case, in whatever rank it
may be classed in these developed versions of one theme, it
has followed the 'Adoration' at Paris, and with equal certainty
it has preceded that at Malines, of which I shall speak to you
at greater length[2]. The idea is fully developed, the disposition
of figures more than complete. All the necessary elements
of which this work so rich in transformation will be com-
posed later on—characters, people in their costumes and usual
colours—are found here, each fulfilling its appointed part, and
occupying its allotted place on the stage. It is a huge page,
conceived, self-contained, concentred, and summary, just as
an easel-piece would be, less decorative in that than many
others. Great neatness, no annoying exactness or convention-
ality, none of that dryness which chilled the 'Assumption'
(Pl. 35), the greatest care added to the fullness of perfect
knowledge: all Rubens's school could find instruction in this
one example.

It is another case with the 'Christ Carrying the Cross' (Pl.
40). At that time Rubens has completed the greater part of his
master works. He is no longer young, he knows everything;
henceforth he could be only a loser, had not death delivered
him and taken him away before he began to decline. We have
here movement, disorder, excitement in the form, gestures,
faces, and disposal of the groups; in the oblique cast, diagonal
and well-balanced from top to bottom and from left to right.
Christ fallen under His cross, the mounted soldiers, the two
thieves, guarded and goaded on by their executioners, all are
travelling in the same direction, and seem to be climbing the
narrow path that leads to Calvary. Christ is fainting with
fatigue: St. Veronica is wiping His brow; the Virgin, in tears,
throws herself forward and holds out her hands to Him: Simon

[1] See p. 359. [2] See p. 361 and Pl. 28\

the Cyrenean holds up the cross. In spite of the infamous gibbet, these women in tears and mourning, this agonized figure, staggering along almost on his knees, whose gasping breath, sweating brow, and distraught gaze excite pity, in spite of the dismay, cries, death within two paces, it is clear to anyone who has eyes to see it that this equestrian pomp, these banners streaming in the wind, this centurion in armour who is leaning back with a fine gesture and in whom we can recognize the features of Rubens, that all this makes us forget the agony, and gives most clearly the idea of a triumph. Such is the logical train of ideas peculiar to this brilliant spirit. We might say that the scene is misread, that it is melodramatic, without depth of feeling, without majesty or beauty, without reverence, almost theatrical. The picturesque element which might have proved its destruction turns out to be its salvation. Imagination takes hold of it and raises it above its level. A ray of true feeling pervades and ennobles it. Some indefinable touch of eloquence deepens its tone. In short, some happy passion of feeling, some transport of real inspiration, make of this picture exactly what it was necessary that it should be, a picture of common death and apotheosis. I see now by making inquiries that the date of this picture is 1634. I was not mistaken, then, in attributing it to the last years of Rubens, to the most beautiful period of his life.

Is the 'Martyrdom of St. Lievin' (Pl. 39) of the same period? At least it is of the same style: but in spite of all that is awful in the conception, it is brighter in tone, construction, and colouring. Rubens had less respect for this than for the 'Calvary'. That day his palette was more radiant, the artist even more expeditious, and his mind less nobly disposed. Forget that the subject is an ignominious and barbarous murder of a holy bishop, whose tongue has just been torn out, from whose mouth the blood is gushing, and who is writhing in dreadful convulsions; forget the three executioners torturing him, one with a bloody knife between his teeth, the other with clumsy pincers holding out that horrible shred of flesh to the dogs. Only look at the white horse which rears itself in the white sky; the bishop's golden cloak, his white stole; the

dogs, speckled with white and black, four or five of them black; two red bonnets; the flushed, red-bearded faces; and all around in this vast field of canvas the delightful harmony of the greys, blues, the whites either dark or pale—and you will only have an impression of a beautiful blending of colour, the most wonderful perhaps and most unexpected that Rubens ever used to express, or, if you wish, to help out and lighten, a scene of horror.

Did Rubens try to produce this contrast? Was it necessary, for the altar it was to fill in the Jesuit's Chapel at Ghent, that this picture should be at once diabolical and heavenly, that it should have both horror and joy, agony and consolation? I think that the poetic nature of Rubens instinctively adopted these antitheses. And if he did so unwittingly, his nature must have inspired him with them. It is well from the first day to accustom one's self to those contradictions, which balance each other and form a genius apart; a great deal of blood and physical strength, but a soaring imagination, a man not afraid of what is horrible, but with a tender and truly calm soul; ugliness and brutality, a total absence of taste in forms, with an enthusiasm which turns ugliness into strength, bloody brutality into terror. That penchant for the apotheoses, of which I spoke when dealing with Calvary, can be seen in everything he does. If one understands them properly there is a glory in them; one can hear the sound of the trumpet in the coarsest of his works. He clings tenaciously to this earth, more than any of the masters whose equal he is; it is the painter who comes to the help of the draughtsman and the philosopher, and makes them free. Many people therefore cannot follow him in his enthusiasms. Indeed, we often surmise an imagination that cannot control itself. We only see that which binds him to common earth, the exaggerated realism, the thick muscles, the figures overdrawn or neglected, the gross types, the flesh, and the blood almost bursting through the skin while we do not notice that he has nevertheless certain formulae, a style and ideal, and that these excellent formulae, this style, and this ideal are in his palette.

Add to this his particular talent of eloquence. To be explicit, his style is what would be called in literature an orator's style. When he extemporizes, this style of his is not very beautiful, but when he chastens it, it is magnificent. It is prompt, sudden, fluent, and fiery; in all cases it is surpassingly convincing and persuasive. It strikes, it astonishes, it repulses you, it galls you, almost always it convinces you, and if there is occasion for it, it touches and softens you more than ever. There are some of Rubens's pictures which disgust us; there are others which make us weep, and this is rare enough in all the schools. He has the weaknesses, the digressions, and also the appealing fervour of great orators. He has to make his perorations, he has to harangue, to wave his arms in the air a little, but there are some things he says which no one else could say. Indeed, his ideas are usually such as cannot be expressed but by eloquence, pathetic gesticulations, and moving appeals.

You must remember, too, that his paintings are intended for walls, for altars facing the nave of the church; that he speaks to an enormous audience, and must make himself understood at a distance, must attract and charm us from a distance—hence his need of insistence, of coarsening his means, of raising his voice. There are laws of perspective and, so to speak, of acoustics which regulate this imposing and far-ranging art.

It is to this kind of declamatory eloquence, incorrect but very touching, that his 'Christ wishing to destroy the World' (Pl. 38) belongs. The earth is a prey to vices, crimes, civil wars, murders, violence of every description: we can form an idea of human perversity by a corner of animated landscape, painted as only Rubens could paint. Christ appears armed with thunderbolts, half flying, half walking; and while He hastens to punish this wicked world, a poor monk in his coarse robe asks pardon, and covers with his two hands an azure globe, around which is entwined the serpent. Is the saint's prayer enough? No. The Virgin too—a tall woman in widow's weeds—throws herself before Christ and stops Him. She neither begs nor prays nor commands; she is before her

God, but she appeals to her son. She draws back her black
robe, uncovering her virgin bosom, places her hand in it, and
shows it to Him whom she has nourished. The appeal is
irresistible. Everything in this picture of pure passion is open
to criticism, and at the first glance Christ seems only ridiculous,
St. Francis a frightened monk, the Virgin resembles Hecuba,
from a model of Helen Fourment; her gesture even seems
hazardous, if one thinks of Raphael's or even Racine's taste.
Yet it is true none the less that neither in the theatre nor in a
court of justice—for this picture reminds one of both—nor in
painting, its real domain, have there been found many pathetic
effects of such vigour and originality.

I am neglecting, and Rubens loses nothing thereby, the
'Assumption of the Virgin', a picture without soul, and
'Venus in Vulcan's Smithy', a canvas too much after the style
of Jordaens.[1] I am also passing by the portraits, which I shall
return again to consider. Five pictures out of his seven, you see,
give us a first impression of Rubens which is not without
interest. Supposing we had not seen him, or we had only seen
him at the Louvre in the Gallery of Medicis, the specimen
of his work would have been very badly chosen: yet now we
should begin to see him as he is, in his genius and workman-
ship, in his imperfections and power. Henceforward we should
see that we must never compare him with the Italians, or we
should not understand him and judge him badly. If we under-
stand by style the ideal of what is pure and beautiful turned
into formulae, then Rubens has no style. And if we understand
by grandeur the depth and penetration, the meditative power
and intuition of a great thinker, then he has neither grandeur
nor thought. If we look for taste, it is wanting in him. If we
like an art self-contained, concentrated, condensed—that of
Leonardo, for example—Rubens can only irritate and displease
us with his habitual digressions. If we examine all human
figures by the side of the 'Sistine Madonna', the 'Gioconda',
or the virgins of Bellini, Perugino, and Luini, the delicate,
refined, delineators of feminine grace and beauty, we shall

[1] See p. 359.

cease to have any regard for the massive beauty and fleshy charms of Helen Fourment. In short, if approaching more and more the sculptural manner we expect in Rubens's pictures exactitude, a rigid deportment, and the placid gravity found in the style of painting when Rubens began, we would be left with a Rubens of no great worth, a mere gesticulator, a lusty fellow, an imposing sort of athlete, without culture, of bad example; and in this case, as has been said, 'we salute him as we pass', but 'we don't look at him'.

The question is then to find, away from all comparison, a place apart to set up this glory of his, so very well deserved. We must find in the world of realism that path through which he walked as a master, and in the world, too, of the ideal, that region of lucid ideas, feelings, and emotions, to which his heart as well as genius are ever transporting him. We must explain these winged flights which give him a permanent place there. We must understand that light was his element, his means of raising himself was his palette, his aim the clearness and manifestation of things. It is not enough to look at his pictures in the spirit of a *dilettante* alone, to have our minds startled and our eyes charmed. There is something further to examine and say. The Gallery at Brussels is an *entrée* in subject-matter. Remember that we still have Malines and Antwerp.

CHAPTER IV

RUBENS AT MALINES

MALINES is a large town—melancholy, empty, extinct—wrapped in the shadows of its churches and convents, in a silence from which nothing can rouse it, neither its industry, nor politics, nor the controversies that occasionally resort to it. At this moment the streets are filled with mounted processions, crowds of burghers, friendly societies, and banners to celebrate the centenary jubilee. All this stir awakens it for one day. Tomorrow comes and the place again relapses into its sleepy provincial ways. There is little bustle about its streets, its

squares are deserted; in its churches there are many great black and white marble tombs, and statues of bishops—round about the churches the little green grass that tells of solitude grows between the flags of the pavement. In short, of this metropolitan—I shall not say necropolitan—town only two things of its magnificent past survive—its very wealthy churches and Rubens's pictures. These are two celebrated triptychs: the 'Adoration' in St. John's Church, and, no less celebrated, the 'Miraculous Draught of Fishes' in the church of Notre-Dame.

The 'Adoration of the Kings' (Pl. 28) is, as I told you before, a third version of the 'Adoration' at the Louvre and that at Brussels. The elements are the same, the principal characters are exactly the same, with the exception of an insignificant change of style in the heads and a few alterations in position, equally without importance. Rubens did not make much of an effort to renew this first conception. After the example of the best masters, he had the good sense to seek inspiration in himself and, once a conception seemed to him fertile in variations, to repeat it in various ways. This theme of the Wise Men, come from the four corners of the earth to worship a homeless Child, born on a winter's night under the roof of an old rickety stable, was one which pleased Rubens by reason of its pomp and contrasts. It is interesting to follow the development of the first inspiration as he makes experiments in it, enriches it, completes it, and makes it definite. Having completed the picture at Brussels, in which there was a great deal to satisfy him, he was still anxious, it would seem, to treat the theme even more finely, more richly, more freely, to give it that bloom of exactness and perfection which belongs only to works entirely matured. This is what he did at Malines: after which he returned to the subject again, took still greater liberties with it, worked in the new fancies of his brain, and astonished anew by the fertility of his resources; but he did not improve on it. The 'Adoration' at Malines may be considered as his definite expression of the subject, and as one of the finest pictures of Rubens in that class of spectacular painting.

The disposition of the central group is reversed from right to left, but apart from that it is practically the same. The three Wise Men are there—the European (as in the picture at Brussels) with long white hair, without the baldness of the other picture; the Asiatic in red; the Ethiopian, after his kind, has the same smiling face as before: that negro smile—ingenuous, tender, astonished, so well observed in that affectionate race, which is easily moved to laughter. But his place and part have been changed. He is consigned to a second row among the princes of the earth and the supernumeraries; the white turban he wears at Brussels here covers the fine head of a native, of reddish colour and Eastern appearance, whose body is cloaked in green. The man in armour too is here, half-way up the ladder; he is bareheaded, charmingly pink and white. Instead of facing the crowd to keep them back he makes a very happy counter-movement, leans back to admire the Child, and with a sweep of his hand keeps back the importuning crowd which even presses upon the ladder. Take away this elegant knight of the Louis XIII period and what is left is the East. Where did Rubens learn that in a Moslem country the people are importunate enough to jostle each other in a crowd to obtain a better view? As at Brussels, the accessory heads are the truest to type and the most beautiful.

The arrangement of colours and the distribution of lights have not changed. The Virgin is pale, the infant Christ is glistening white under His halo. The immediate surroundings are white: the Wise Man in the ermine robe with his grey beard; the silvery head of the Asiatic and the turban of the Ethiopian—a circle of white tinged with rose and pale gold. The rest is black, yellowish, or cold. The head blood-coloured, or of a reddish burnt-brick tint, a contrast with the surprising cold-blue effect of the faces. The ceiling is very sombre, melting into the upper air. A face of blood-red in the half-lights relieves, terminates, and sustains the whole arrangement of figures by connecting it to the roof with a knot of subdued but very definite colouring. It is a composition not to be described, for it expresses nothing precise, it has no pathos, no

emotion, above all, no pedantry. It chains the mind because it delights the eye; for a painter this painting must be priceless. It should give endless delight to the fastidious critic; in good truth it can easily confound the wisest. You should see how all this lives, moves, breathes, looks, acts, lights up, dwindles, falls back into its setting and rises out of it, fades away in the lighter parts, there to install and compose itself with the greatest effect and fitness. And as for the blending of clouds, the extreme richness produced by simple effects, the harshness of certain tones, the softness of others, the abundance of red, and yet the freshness of it all—as for the laws which govern such effects, these are points which are quite disconcerting to the spectator.

On analysis, we can only find some very simple formulae and very few; two or three master colours whose part is obvious, whose action is foreseen, and whose power is known today to any man who can paint. These colours are always the same in the works of Rubens; he has really no secrets in that. His subordinate combinations can be noted; his method can be described. It is so constant and clear in its applications that a student, it would seem, would only have to follow it. Never was handiwork more easy to understand, more straightforward or less secretive; for never was a painter less mysterious, either in thought or composition, colouring or execution. The only secret he has, one he has never divulged even to the wisest and best informed, not even to Caspar de Crayer, to Jordaens, or to Van Dyck, is that evanescent, unattainable point, that irreducible atom, that nothing, which in all things of this world is called inspiration, grace, or genius, and which is everything.

It is this that we must thoroughly understand, in the first place, when we speak of Rubens. Any man of this profession, or not of it, who cannot understand the value of genius in a work of art, in all the shades of colouring, inspiration, and fancy, is scarcely fit to taste the subtle essence of things, and I should advise him to never look at Rubens, nor indeed at many others.

I will spare you a description of the wings, though they are magnificent and not only of his best period but after his best manner, brown and silvered—the last word in his richness of style. You will find there a St. John of rare quality and an Herodias in dark grey with red sleeves, who is his eternal feminine.

The 'Miraculous Draught of Fishes' (Pls. 25-7) is also a beautiful picture, but not the finest, it is said, in Malines, in the district of Our Lady. The *curé* of St. John's will be surely of my opinion, and in good truth he would be right. This picture has just been restored; at present it is lying on the ground in a schoolroom, leaning against a white wall under a glass roof, which floods it with light, without a frame—in its crudity and natural harshness, as it was on the day of its inception. Examined in itself with the eye above it, and truly to its own disadvantage, it is a picture which I shall not call gross, for the touch relieves its style somewhat, but *material*, if the word expresses what I want it to express, ingenious in composition, but a trifle narrow, and vulgar in tone. It lacks something that is always seen in Rubens when he deals with the vulgar—a note, a touch of grace or delicacy, something like a beautiful smile, which redeems the grosser parts. Christ, placed on the right in the wings, as a mere accessory to this fishing scene, is as insignificant in gesture as in appearance, and His red cloak, not a fine red, looms up harshly against a blue sky, which I suspect has been considerably altered. St. Peter, a little neglected it is true, but of a fine strong quality, would be, if you thought of the Gospel in this picture painted for fishermen, and altogether after the models of fishermen, the only Biblical person of the scene. At least he seems to be saying to Christ just what an old man of his class and rusticity might say under such strange circumstances. He presses to his breast, in the reddish folds of his garment, his sailor's cap, a blue one, and it is not likely that Rubens could be mistaken in such a gesture. As for the two naked torsos—one inclined towards the spectator, the other turned to the back, and each seen from the shoulders—they are celebrated among the best academy pieces

that Rubens ever painted, by reason of the free and sure manner in which he painted them—no doubt in a few hours, at the first attempt, with a fresh palette, clear, balanced, abundant, not too flowing or thick, nor too careful or pompous. It is after the style of Jordaens, *sans reproche*, without too much red, without too much high light; or rather it is the best lesson his great friend could give him in the way to see the flesh and not the *meat*. The fisherman with a Scandinavian head, his beard streaming in the wind, his yellow hair, his bright eyes in his fiery face, his great sea-boots, his red sailor's blouse, is over-whelming. And as is usual in Rubens's pictures, in which a very great deal of red is used to temper the rest, it is this fiery-looking man who does so in this case, acting on the eye and preparing it to see the green in the surrounding colours. Note, too, among the supernumerary figures, a lad, a ship's boy, standing in the second boat, resting on an oar, clad—no matter how—in grey trousers, and a vest of faded purple colour, unbuttoned, open on his naked breast.

They are clumsy, red, sunburnt, tanned, and swollen by the sharp winds, from the tips of their fingers to their shoul-ders—from their foreheads to the back of their necks. All the corroding salts of the sea have roughened their skin wherever the wind could reach it, quickened their blood, entered their pores, swollen their veins, blotched their white flesh—and in a word, bespattered them with cinnabar. All this is brutal and exact—painted as he found it: seen, no doubt, on the quays of the Escaut by a man who sees things grossly but accurately —colour as well as form—who has respect for truth when it is expressive, not afraid to describe crude things crudely, who knows his handicraft perfectly and fears nothing.

What is really extraordinary about this picture—thanks to the circumstances which enabled me to examine it closely and to follow the workmanship, just as if Rubens were painting in front of me—is that it has the appearance of surrendering all its secrets and yet surprises us almost as much as if it had surrendered none of them. I have said this about Rubens already before I had this new proof given me.

The difficulty is not to know how he did it, but to know how it can be done so well in just that fashion. The means are simple and the method elementary. It is a beautiful canvas, smooth, clean, and exact, worked by a hand of magnificent skill, adroitness, sensitiveness, and balance. The hastiness one reads into it is rather a matter of feeling than a disorder in the manner of painting. The brush is as calm as the mind is heated, and the genius ready to burst forth. There is in a temperament such as his an understanding so exact, a correspondence so swiftly established between the sight, the feeling, and the hand, such perfect obedience of the one to the others, that the customary promptings of the mind which directs everything would lead us to believe they were tricks and surprises of the brush. Nothing is more deceiving than this apparent fervour, restrained by the greatest precautions, and served by a machinery that has proved its mettle against all trials. It is the same with the impressions on his eye, and consequently with his choice of colours. These colours are also very rudimentary, and only seem so complicated by reason of the use the painter makes of them and the part he makes them play. The number of primary tints could not be further reduced, and the way in which he contrasts them could not be more expected; nothing, again, is so simple as his way of blending them, and nothing more unexpected than the result. Not one of Rubens's tones is very rare in itself. If you take a red—his red—you can easily dictate its prescription; it is vermilion and ochre—not very finely crushed, and used just as they are after the first mixing. If you examine his blacks they are made of ivory-black, and serve with white to make all the imaginable combinations of heavy and light grey. His blues are accidental; his yellows— one of the colours which he could use least well with regard to intensity (saving his golden-yellows, which he excelled in rendering in their warm heavy richness)—have, like his reds, a double part to play: in the first place, to attract the light away from the whites; and in the second place, to exercise on the surrounding parts the indirect effect of a colour which changes the others—for example, to turn towards violet and

to brighten a dull grey which is very insignificant and alto-
gether neutral when seen on the palette. All this, perhaps,
someone will say, is not very extraordinary.

Some rather heavier browns with two or three active
colours to give the canvas an appearance of richness, some
greyish compositions obtained by dull mixtures, all the shades
of colour between pure black and white: consequently, little
colouring material and the greatest burst of colours—great
effect obtained at small outlay, light without excess of clear-
ness, a great noise from few instruments, a keyboard three
parts of which he never uses, but which he covers by skipping
a great number of notes, which he touches if necessary at its
two extremities—such is, in the mixed language of painting
and music, the workmanship of this great master. Whoever
has seen one of his pictures knows them all, and whoever has
seen him paint for one day has seen him paint practically the
whole of his life.

It is always the same method, the same coolness, the same
calculations. All his sudden effects are introduced by a serene
and masterly foresight. We can scarcely tell whence comes
the daring touch or when he breaks away and throws off
restraint. Is it when he achieves some discordant fragment,
some extravagant gesture, some stirring object, an eye that
glistens, a mouth that shouts, entangled hair, a bristling beard,
a grasping hand, a stinging foam-scud, a disorder in dress,
wind blowing through something light, or the irregular
splashing of turbid water through the meshes of a net? Is it
when he covers yards of canvas with fiery tints, when he
pours red on in streams, so that everything round it is be-
spattered with its reflections? Is it, on the other hand, when
he passes from one powerful colour to another and circles
round the neutral tones, as if this sticky, rebellious material
were the most manageable of all elements? Is it when he
makes a great noise? Is it when he draws out a note so delicate
and tender that it is difficult to hear? That painting which fires
the heart of all who see it, did it fire to the same extent him
from whose hands it came, flowing, easy, natural, wholesome,

and always fresh, no matter when you choose to visit it?
Where, in a word, is the effort in this art, which is said to be
so high-strung, while it is the intimate expression of a mind
that was high-strung never?

Have you ever closed your eyes during the playing of a
piece of brilliant music? The sound streams in from all parts.
It seems to leap from one instrument to another, and as it is
very unruly, despite the perfect harmony, one would think
that all is in turmoil, that the players' hands tremble, that the
same musical frenzy has seized the instruments and the
performers; and because the musicians move their audience
to such an extent, it seems impossible that they should remain
calm themselves in front of their music-stands; so that we are
surprised to see them cool, collected, anxious only to follow
the movement of the ebony baton that guides them and tells
each what he should do, and which is in itself nothing more
than the agent of a mind on the alert and of great technical
knowledge. It is the same with Rubens when he is at work:
there is the ebony baton which commands, leads, and super-
vises; there is the imperturbable will, that master-faculty
which also governs some very attentive instruments—I mean
the minor faculties.

Do you mind if we come back to the picture once more for
a moment? It is here before me, and this is an opportunity
which one seldom has, and which I shall never have again.
I shall take it.

It was done at the first attempt—altogether, or almost so;
that can be seen in the delicacy of certain coatings of colour—
especially in the St. Peter, in the transparency of the large,
smooth dark tints, as in the boats, the sea, and everything
belonging to that brown, pitchy, or greenish element; it can
be seen also in the construction, no less rapid, though more
carefully done, of the parts which require a full palette and
richer work. The brilliancy of tone, its freshness and shining
surface are due to that. The panel with a white groundwork
and smooth surface gives to the colouring, so boldly super-
imposed, that vitality natural to all tints applied on a clear,

hard, polished surface. Thicker, it would be heavy; more wrinkled, it would absorb all the luminous rays instead of reflecting them, and it would be necessary to double the effort to obtain the same effect of light; fainter or more timid, or less freely over-running the neighbouring colours, it would have that enamelled appearance which, though admirable in certain cases, would not suit Rubens's style nor his genius, nor the romantic part in his beautiful works. Here, as elsewhere, the proportions are perfect. The two torsos were as well done as a piece of the nude of this size can be done to suit the conditions of mural painting, and were completed with a very few sweeps of the brush: one laid over the other. Perhaps, indeed, on one of these days so regularly divided between work and rest, they were each the product of an afternoon of brisk, merry work—after which the painter, satisfied with his work, and that with good reason, laid down his palette, saddled his horse, and thought no more about it.

Still more naturally in all secondary parts inserted for the general effect, and to help out the whole, large expanses of moving air, accessories, ships, waves, nets, and fish, his hand runs rapidly and does not stop to retouch anything. A vast coating of the same brown, which is brown above and turns to green below, looks warm where light is reflected, becomes golden in the troughs of the sea, and stretches down from the ships to the bottom of the frame. It is across this abundant and liquid material that the painter found the true setting of each object, or as they say in the studios, 'found his setting'. A few flashes, a few reflections laid on with a fine brush, and you have the sea. The same with the net and its meshes, its supports and floats, the same with the fish which flounder about in the oozy water, and which, still streaming with the fresh colours of the sea, enforce an illusion of wetness; the same with Christ's feet and the boots of the radiant sailor. To tell you that the art of painting is at its best when it is severe and that it has to express ideal and epic things in great style as regards mind, eye, and technique, and to tell you to do likewise at all times, would be to express the ideas of Pascal in the imaginative,

picturesque, and fast-flowing language of our modern writers. In all these cases it is Rubens's own language and style, and consequently the medium that naturally suits his own ideas.

When one thinks of it, our astonishment is caused by the fact that the painter reflected so little, that, having conceived anything (it matters little what) and allowing nothing in it to rebuff him, this anything becomes a picture: that, having taken so little pains, he is never commonplace—in short, that by methods so simple he produces such an effect. If his knowledge of the palette is extraordinary, the sensitiveness of his tools is not less so, and a quality one would hardly expect of him comes to the help of all others: proportion and, I must add, restraint, in a quite technical sense, in his use of the brush.

There are a great many things in our day that we forget, that we seem to misunderstand, or try in vain to abolish. I scarcely know whence our modern school has got that taste for heavy coatings, that love for heavy layers which forms in the eyes of certain people the principal merit of certain works. I have never seen anywhere examples which would encourage such a point of view, save in certain painters obviously of a decadent school and in Rembrandt, who could not always make up his mind to pass it by, but who did so sometimes. In Flanders, it is a method fortunately unknown; and as for Rubens, the master to whom this outburst is attributed, the most violent of his pictures are often the least charged with it. I don't mean to say that he systematically thinned his high-lights, as was done until the middle of the sixteenth century, or that, on the other hand, he thickened everything that was of a heavy tint. This method, exquisite in its primary aim and result, has undergone all the changes brought about since by the requirements of thought and the more diverse demands of modern painting. Yet if it is far removed from the ancient and pure method, it is still farther removed from the practices in vogue since Géricault, to quote the recent example of an illustrious dead. The brush glides and never sticks; it never drags after it that sticky mortar which collects at the outstanding point of an object, and gives one the impression of a

great deal of relief because the canvas itself becomes more raised in that part. It never loads, it paints; it never piles up, it writes; it caresses, it glides over, and sustains. It passes from an immense, heavy coating of paint to the lightest, most fluid touch, and always with that amount of stability and lightness, that fullness or delicacy according as the piece he is doing requires. Thus, the free or sparing use of heavy or light coatings becomes a matter of local taste and choice; and the weight or extraordinary lightness of his brush is also the means of expressing more accurately why we should or should not insist on them.

Today, when our French School is divided up into various schools and, to tell the truth, there is nothing left but talent, more or less adventurous without fixed doctrines, the price of a picture well or ill done is scarcely noticed. A crowd of subtle questions lead us to forget the most necessary elements of expression. If we pay careful attention to certain contemporary pictures, whose merit, at least as an attempt, is often more real than we think, we shall perceive that the hand is no longer accounted for nothing among the agents the mind makes use of. According to recent methods, to carry out a piece of work is to fill up a shape or form with a certain tone or intensity of colour whatever may be the tool which directs this action. The mechanism of the operation seems of no import provided that the operation is successful, and it is wrongly supposed that the mind or thought can be served just as well by one instrument as by another. It is this very absurdity that all the skilful painters—that is to say, all the painters of feeling—in this country of Flanders and Holland have answered in advance by their technique, the most expressive and most feeling of all. And it is against this same error that Rubens raises a protest with an authority which ought to have extra weight. Take away from Rubens's pictures, take away from that one I have just been examining, the genius, variety, peculiarity of each touch, and you will take from it a word of significance, a necessary accent, and a trait of expression—indeed, perhaps you will take from it the only element

which infuses spirit into so much matter and transfigures a host of ugly images; for you will thus suppress all feeling, and referring things back to their primary cause, you will destroy its life, you will make it a soul-less picture. I will almost say: one touch less and a trait of the painter disappears.

This principle is so binding that in a certain order of productions there cannot be a work well thought or conceived but that it will naturally be well painted; and that every work in which the hand can be seen to have worked happily and brilliantly is by that same principle a work which belongs to the mind and is derived from it. Rubens gave on this matter some excellent advice, which I recommend for your perusal, if you are ever tempted to make light of a brush-stroke in the right place. There is not, in this great machine of such brutal appearance and such free practice, one detail large or small that was not inspired by feeling and immediately carried out by a happy touch. If the hand were not so quick, it would be left behind by the thought; if the conception were less sudden, the vitality imparted would be less; if the execution were more hesitating or less easy to understand, the work would become impersonal in the unnatural heaviness it acquired and the inspiration it took. You are to consider, moreover, that this unequalled dexterity, this careless ability of dealing with thankless substances, rebellious instruments, this fine working of a well-managed tool, this elegant manner of gliding over a free surface, the brilliant reflections from it, the flashes that seem to dart out from it, all that witchcraft of the great masters—which in others turns to mere mannerisms, affectation, or mediocrity—in him, I shall repeat it again and again, is nothing but the exquisite sensitiveness of a perfectly sound eye, of a hand in absolute subjection and obedience, and above all, of a mind truly open to everything; a mind happy, confident, and great. I defy you to find in all his manifold works one which is perfect. I defy you likewise not to feel even in the mannerisms, faults—I was going to say the fatuities—of this noble mind the mark of a greatness that cannot be contested. And this external mark, this seal at the bottom corner of his

thoughts, is the very impression of his hand. All this which I am telling you in sentences too long, and often in that particular phraseology difficult to avoid, might have been found better elsewhere. Do not think that the picture about which I was speaking is a specimen of the finest qualities of the painter. It is that in no respect whatever. Rubens has very often formed better conceptions, observed things better, and painted far better; but Rubens's technique, unequal as it may be as regards results, scarcely ever varies as regards principles, and the observations made about a picture of ordinary quality apply equally and with still more reason to his best ones.

<div align="center">

CHAPTER V

THE 'DESCENT FROM THE CROSS' AND THE 'RAISING OF THE CROSS'

ANTWERP
</div>

MANY people say 'Antwerp', but many, too, say 'the home of Rubens'; and this expression describes still more exactly everything that forms the charm of the place: a great town, a great man's career, a famous school, pictures renowned all over the world. All this makes an impression on us, and the imagination is fired a little beyond the ordinary when in the centre of the 'Place Verte' we see Rubens's statue, and further on the old church in which are kept the triptychs which, humanly speaking, have consecrated it. The statue is not a masterpiece; but it shows him in his own home. Under the form of a man who was only a painter, without any other attributes save those of a painter, it is in all truth the personification of the only Flemish royalty which has never been either questioned or threatened, and which certainly never will be.

At the far end of the square, Notre-Dame can be seen. It is seen in profile, and stretches out before us the full length

of one of its sides—the darkest, for it faces the storms. Its
surroundings of bright and low houses make it look darker
and larger. With its carefully wrought architecture, its rusty
colour, its blue shining roof, its enormous tower, in which
glitter the golden disc and hands of its dial in the stone dark-
ened and smoked by the fumes from the Escaut and by the
winter, it assumes tremendous proportions. When it is harassed
by storms, as today, the sky adds to its grandeur all the gro-
tesque beauties of the tempest. Imagine, then, a conception
of the Piranesi Gothic style, made strange by northern fancies,
madly lit up by a day of storms, a disorderly silhouette against
the vast background of a tempestuous sky that is intermittently
black and white. A more original or striking opening-scene
could not have been contrived. And in vain you may have
been to Malines and Brussels, in vain you may have seen the
'Adoration' and 'Calvary', in vain you may have formed an
accurate opinion and exact idea of Rubens, even made your-
self so familiar with him that you are quite at your ease in his
presence—in vain you will have done all this, for you will not
enter Notre-Dame as you would an Art Gallery.

It is three o'clock; the high belfry has just struck the hour.
The church is empty. The little noise made by a sacristan is
hardly audible in the naves, calm, empty, bright, just as Peter
Neefs has produced them, with an inimitable sense of their
solitude and grandeur. It is raining and the day is unsettled.
Lights and shadows follow each other upon the two triptychs,
hung simply in their thin brown wooden frames on the cold
smooth walls of the transepts, and that magnificent, haughty
painting only seems the more unyielding in the midst of those
high-lights and shadows struggling for its possession. Some
German copiers have set up their easels in front of the 'Descent
from the Cross' (Pl. 23); there is no one in front of the
'Raising of the Cross' (Pl. 22). This fact alone explains well
enough what is the world's opinion of these two works.

They are greatly admired, almost without exception, and
this is rare with Rubens; but the admiration is not equally
divided between them. Fame has chosen the 'Descent from

the Cross'. The 'Raising of the Cross' has had the power of moving more deeply the passionate or more convinced friends of Rubens. Nothing, in truth, can be slighter than the resemblance between these two works, conceived within two years of each other and inspired by the same effort of genius, but nevertheless bearing the impression of two very opposed tendencies. The 'Descent from the Cross' was painted in 1612, the 'Raising of the Cross' in 1610. I make a special point of the dates, as it is a matter of importance. Rubens has just come back to Antwerp, and it was, so to speak, on landing that he painted them. His education was completed. At that moment his very numerous studies lay a little heavy upon him; he would use them openly, once for all, but rid himself of them he must without delay. Of all the Italian masters he had studied, each, of course, had instructed him in a sense peculiar to himself. The excitable, imaginative masters had taught him to be very bold; the severe masters had taught him to keep himself in great restraint.

His nature, character, native abilities, old and modern lessons, all lent themselves to a cleavage into two parts. The undertaking itself required that he should make two parts of his splendid talents. He felt the occasion was apposite; availed himself of it; treated both subjects according to their sense and spirit, and embodied in them two contrary ideas, yet both correct: the first is the finest example we have of his learning, and the other the most astonishing *aperçu* of his fire and spirit. Add to the personal inspiration of the painter a very marked Italian influence, and you will understand better the extraordinary value posterity attaches to these paintings, which may be considered as his first mature works, and which were his first public act as the head of a school.

I will tell you how this influence is shown and by what characteristics it may be recognized. I need only tell you at first that it exists, so that the expression of Rubens's talent may lose none of its traits at the very moment when we examine it. Not that he is positively under the restraint of the canonical formulae which would cramp up others than him. Heaven

knows, on the contrary, with what ease he moves, what liberties he takes with them, with what skill and tact he disguises or openly avows them, according as he chooses to display in himself the learned man or the innovator. Yet whatever he may do, we can feel in him the *Romanist*, who has just spent several years on classic soil, who has just arrived, and has not yet become used to the new atmosphere. Something remains, although I cannot well say what, which recalls the visit—like a foreign perfume about his garments. And it is certainly to the good Italian perfume that the extraordinary popularity of the 'Descent from the Cross' (Pl. 23) is due. In short, for those who want Rubens to be a little as he is, but also a great deal as they fancy him to be, there is in this picture a mixture of the grave with the gaiety of youth, and a bright, well-studied grace of maturity which will soon disappear and can only be seen here.

This composition need not be further described. You would not be able to quote a more popular masterpiece and example of religious style. There is no one but can call to mind the regularity and effect of this picture—its great central high-light overlaid on dark surroundings, its magnificent parts, its distinct and massive divisions. We know that Rubens took his first idea of it from Italy, and makes no attempt to conceal his borrowing. The scene is powerful and grave. Its effect can be seen at a distance. It is most impressive on the wall; it is serious, and makes one feel serious too. When we think of the murders which cover Rubens's works with blood, the massacres, the executioners who torture, tear out flesh, and raise shrieks of agony, we perceive that this is a noble piece of torment. Everything is restrained, concise, laconic, as if it were a page of Holy Scripture.

No waving of arms, no cries, no horror, nor many tears. Scarce does the Virgin burst into a real sob, and the intense grief of the scene is just shown by an expression of unconsolable sorrow in the mother, by a face in tears and eyes red with weeping. The Christ is one of the finest, best-formed figures that Rubens ever conceived to paint as a God. There

is an indescribable slender grace—pliant, almost too thin—
which gives it all the delicacy of nature and all the impressive
appearance of a fine academic study. The proportion is
splendidly accurate, the taste perfect; the drawing of it almost
rivals the sentiment.

You have not forgotten the effect of that great body—a
little ungainly—whose small, delicate, fine-drawn head is
hanging on one side, so livid and so perfectly limp in its pale-
ness, not shrivelled or sunken in, without the grinning features
of death—from which all agony has disappeared, and which
comes down with such bliss, such beatitude, to find repose for
a short while in the strange beauty of the death of the just.
Remember how He hangs down with all the weight of His
body and how precious He is to hold up and sustain; in how
enfeebled a posture He glides into the winding-sheet and with
what loving anguish He is received in the outstretched arms
and hands of women. Can anything be more touching? One
of His feet, bluish in tint and pierced, touches at the base of the
cross the naked shoulder of Mary Magdalene. It does not rest
on it, it just touches it. That it actually touches even cannot be
seen; we guess it rather than see it. It would be profane to
insist that it does; it would be cruel not to believe that it does.
All the latent sensitiveness of Rubens is in this scarcely percep-
tible touch, which expresses so much in a respectful way and
softens everything.

The sinning woman is admirably done. Without a doubt it
is by far the best piece in the picture—the most delicate, most
personal, one of the best that Rubens ever painted in his
long career, so rich in creations of women. This delightful
figure has its story: how could it be otherwise, when its very
perfection has become storied? It is most likely that this pretty
girl with black eyes and steadfast gaze, with clean-cut profile,
is a portrait, the portrait of Isabella Brant, whom he had
married two years before, and who also sat to him, probably
in a state of pregnancy, for the Virgin in the wing of the
triptych of 'The Visitation'. And yet her ample propor-
tions, her pale yellow hair, her fullness of flesh, make one

think of all that would one day comprise the radiant and so distinctive charms of the beautiful Helen Fourment, whom he married twenty years later.

From the first to the last years of Rubens's life a certain ineffaceable form seems to have taken possession of his heart, an unchangeable ideal haunted his amorous and constant imagination. He takes delight in it, he completes it, he achieves it. He pursued it, after a manner, in both his marriages, just as he never ceased to repeat it in his works. There was always something of both Isabella and Helen in every woman he modelled upon one of them. In the first he seems to put a preconceived trait of the second; in the second he inserts a vague but indelible memory of the first. At the time of which we are speaking he possesses the first, and is inspired by her— the second is not yet born, and yet he forecasts her. Already the future is merged in the present, the real in the ideal conception. From the moment the image appears it has its double form. Not only is it delightful, exquisite, but not a trait is wanting. Does it not seem as if Rubens knew, when he thus created and fixed this ideal from the first day, that it would never be forgotten, neither by himself nor by anyone else?

For the rest, this is the only earthly adornment with which he has graced this austere picture—a trifle monastic, altogether Biblical, if we understand by that gravity of thought and manner, and if we think of the rigorous piety which the spirit of such a subject demands. This being so, you will see that a great part of his reserve comes from his Italian education as well as from the respect he had for his subject.

The canvas is dark and sombre in spite of its bright parts and the extraordinary whiteness of the winding-sheet. In spite of its reliefs, the picture is *level*. It is a picture of darkish groundwork, over which are spread large, clear, bright spaces altogether unshaded. The colouring is not rich—it is full, well-sustained, accurately calculated to produce the effect from a distance. He builds up the picture, frames it, gives expression to its strong and weak parts, and makes no effort to embellish it. It is composed of a dark green, which is almost black, of

pure black, of a dullish red, and of white. These four tones are laid on side by side, as abruptly as can be done with four colours of such violence. The contact is sharp, but does not harm the effect. In the great white space the body of Christ is drawn with a delicate, supple formation, and the solidity of its form is shown by its own reliefs, without any attempt at shading—thanks to a few flights or digressions of imperceptible values. No shining parts, not a division of one light from another, scarcely a detail in the dark parts. All this is of a peculiar breadth and stiffness. The edges are narrow, the mezzotints sharp, except in Christ, in whom the upper parts of ultramarine have spread and form today useless expanses of colour. The paint is polished and compact, of an easy and yet restrained flow. At the distance from which we are examining it the handicraft disappears; but it is easy to guess that it is excellent, and directed with the greatest confidence by a mind used to beautiful styles, which conforms and diligently tries to do well. Rubens recollects himself, watches himself, restrains himself, is complete master of his powers, keeps them in hand, and only makes use of half of them.

In spite of the restraint it is a work remarkably original, attractive, and strong. From it Van Dyck will take his finest religious inspirations. Philippe de Champaigne will only follow it, I fear, in its weak parts, and will form her French style of it. Van Veen must certainly have applauded it. But what would Van Noort think of it? As for Jordaens, he waited before following him in these new paths, until his fellow-workman had become more Rubens himself.

One of the wings, which represents 'The Visitation', is delightful in every respect. Nothing could be more austere, yet more charming; more sober, yet more rich; more picturesque, yet more nobly familiar. Never did Flanders put forth such *bonhomie*, grace, and nature in investing itself with the Italian style. Titian gave the cue, and after a manner furnished the tones; from him Rubens learned to paint the architecture a chestnut-brown; 'twas he that taught him that fine cloudy grey which shines in the cornices, perhaps too the

greenish-blue that looks so well between the pillars. But it was Rubens who invented the Virgin in her pregnant state, with her lowered gaze, her dress of red, fallow, and dark blue ingeniously combined, and her large Flemish hat. He it was who drew, painted, coloured, and caressed with eye and brush that beautiful hand, bright and tender, which rests like a pink flower on the iron balustrade; just as he too conceived the fair maid-servant with blue eyes, and cut her off with the frame, exposing only the stooping figure, round head with waving hair, and hands which might be holding a rush-basket. In short, is Rubens himself yet? Yes. Is he altogether himself and nothing else? I don't think so. Lastly, did he ever work better? According to foreign methods, no; but after his own manner, yes, certainly.

Between the central panel of the 'Descent from the Cross' and the 'Raising of the Cross', which adorns the northern transept, there is a very great difference: in the point of view, the tendencies, the bearing, even a trifle in the methods and influences which both works underwent, but in different manners. A glance is enough to tell you that. And if we go back to the time when these significant pictures appeared, we shall understand that if the one gave more satisfaction and was more convincing, the other caused far greater astonishment, and consequently gave signs of something far newer.

Less perfect in that it is more restless, and has no figure so delightful to see as Magdalene, the 'Raising of the Cross' (Pl. 22) says a great deal for the initiative of Rubens, for his flights of fancy and boldness, his happy touches—in a word, for the upheaval of that mind full of fervour for novelty and strange projects. It opens for him a wider career. Possibly it is a less masterly work, but it announces a master in quite other fashion, original, bold, and strong. The drawing is stiffer, less restrained, the form is more violent, the relief is less simple and more grandiose; but the colouring has already that deep warmth and vibration which will one day be the great resource of Rubens when he neglects the brightness of colour for its radiation. Suppose that the colouring were less flaming, the

contour not so hard, the mannerism that shows it up less abrupt; take away that touch of Italian stiffness, which is only a sort of politeness and fine deportment picked up on his travels: only look at what is really Rubens's, the youth, the fire, the convictions matured already, and you will almost have under your very eyes the Rubens of his famous days— that is, the first and last expression of his impassioned and rapid manner. The least relaxation of restraint would have been sufficient to make of this picture, comparatively severe in style, one of the most unruly he ever painted. Such as it is, with its dark yellows, its deep shadows, the low rumbling of its stormy harmonies, it is still one of those in which his fiery spirit bursts out with all the greater clearness as this spirit is sustained by the strongest effort, and stretched to the utmost by the determination not to fail.

It is a picture conceived in a moment around a boldly designed arabesque; one which in its complication of open and closed forms, of vaulted bodies, of outstretched arms, of continuous curves and of stiff straight lines, has yet retained to the very last moment of execution the instantaneous character of a sketch loaded with feeling in a few moments. The primary conception, the arrangement, the effect, the gestures, the facial expressions, the capricious disposition of light and shade, and the technique, all seem to have arisen at once from an irresistible, clear, and prompt inspiration. Never did Rubens use so much continued effort to deal with a subject of such sudden inspiration. Today, as in 1610, we can differ in opinion regarding this work, absolutely personal in spirit if not in method. The question which must have been discussed during the painter's lifetime still waits an answer: which of the two has been better represented in his own country and in history—Rubens before he was himself or Rubens as he always was?

The 'Raising of the Cross' and the 'Descent from the Cross' are the two moments of the drama of Calvary, of which we have seen the prologue in the triumphal picture at Brussels. At the distance which separates the two pictures we can

perceive the salient points, we can seize the dominant tonality—
I might almost say, we can hear the noise: enough to let us
take in at a glance their picturesque expression and make out
their meaning.

In the 'Descent from the Cross' we have the final scene, and
I have told you with what impressive soberness it is done. All
is over. It is night—at least the horizons are of a lead-coloured
black. All are silent and weep. They are taking away the
mortal remains of a beloved Master; their care and tenderness
are very touching. It is almost beyond them to speak the words
heard after the death of some loved one. The mother and the
friends are there, and above all, the most affectionate, most
frail of women—she in whose frailty are embodied grace and
repentance of all the sins of this earth: sins that have been
pardoned, expiated, and now redeemed. There is bright
colouring of flesh to oppose the paleness of death. There is
even some charm in death itself. Christ looks like some
beautiful flower plucked and withered. He no longer hears
either those who revile Him or those who weep for Him. No
longer is He of men, or of time, or subject to anger or pity;
He is beyond all, even death.

In the 'Raising of the Cross' there is nothing like this.
Compassion and tenderness, the mother and the friends are far
away. In the left wing of the triptych the painter has united all
the affection of grief in a violent group, in woeful attitudes
and filled with despair. In the right wing there are only
two guards on horseback—no mercy on that side. In the
centre, people are shouting, blaspheming, cursing, and stamp-
ing. With brute-like gestures, executioners with the mien of
butchers are setting up the cross and trying to fix it upright
on the canvas. Arms are strained, ropes creak and stretch—the
cross shakes and wavers, and is as yet but half-way to the
perpendicular. Death is certain. A Man nailed through his
four limbs suffers in agony, and pardons all. Of all His being
there is nothing left that is free, that belongs to Him. A pitiless
death has seized His body; His soul alone escapes. We can
easily see it in that averted look, which turns from the earth,

seeks elsewhere truth and reward, and goes straight to heaven. All the savage desire to kill, all the haste to complete its work that mortal hate is capable of, the painter expresses, as one who knows the effects of anger and how the dark passions act. All the meekness and readiness to die that a martyr's self-sacrifice can express—examine still more carefully how he produces it.

This Christ is in the light. He gathers almost into a narrow sheaf all the lights that are scattered over the picture. As regards relief, He is not so well done as in the 'Descent from the Cross'. A Roman painter would certainly have corrected the style. A Gothic painter would have liked the bones more prominent, the sinews more strained, the attachments more exact—the whole structure thinner, or at least more delicate. Rubens had, as you know, a preference for the rounded fullness of forms—a preference which came from his manner of feeling, still more from his manner of painting, without which he must have changed the greater number of his formulae. With this exception the figure is priceless in value: none other but Rubens would have imagined it such as it is—in the place it occupies, in the signification so highly picturesque that he gives it. And as for that beautiful head, inspired and suffering, manly and tender, with its hair hanging over the temples, its sweats, its fevers, its grief, its eyes that flash with a heavenly light, and its ecstasy—where is the true master who, even in Italy's greatest hours, would not have been impressed by what expression can do when it reaches this height, and who would not have recognized in it an absolutely new ideal of dramatic art?

Pure sentiment had just led Rubens, on a day of fever-heat and clear vision, as far as he could go. After this, he will free himself from all shackles still more; he will develop his powers. There will be, thanks to that style of his, fluent and wholly free, more result and notably more play in all parts of his work; internal or external design, colouring, and pigment. He will less assertively fix the contours which ought to disappear: he will less abruptly suppress the shadows which ought to dissolve: he will have more suppleness than he has yet: he will

find an easier diction, a speech of a more pathetic and personal note. Will he conceive anything more energetic or neat than that brilliantly imagined diagonal which cuts the painting in two, which at first disturbs its perpendicular, then corrects it, and leads it to the top, with the sharp, unhesitating flight of a noble idea? Will he find anything better than these sombre rocks, that darkened sky, that great white figure all effulgent against the shadows, motionless yet moving, drawn by some mechanical force slant-wise into the winding-sheet, with His pierced hands, His arms aslant, and that fine gesture of mercy which stretches them out over a blind, evil, and dark world?

If we had any doubts about the power of a happy curve, about the dramatic value of an arabesque or an effect, in fine, if we needed examples of the moral beauty of a picturesque conception, we should be convinced by this picture.

It was with this original and vigorous painting that this young man, absent since the beginning of the century, signalized his return from Italy. What he had acquired on his travels, his gifts, his good choice of studies, and above all, the practical manner in which he knew how to make use of them—all this was known. And no one had any doubts as to his great future, neither those for whom this picture had the surprise of a revelation, nor those whom it shocked as a scandal, whose doctrines it overthrew and who attacked it, nor those whom it turned into converts and disciples. The name Rubens was consecrated from that very day. Even today this first piece of work seems almost as finished as it seemed complete and decisive then. There is also in it something very personal—a sort of loud blast, which you will find rarely elsewhere in Rubens. An enthusiast would write *sublime*, and he would not be wrong if he took care to explain what he meant by this word. Have I not spoken to you at Brussels and Malines of the varied talents of this extemporizer of great flights, whose passion is, after a manner, a sort of exalted common sense? I have told you of his ideal so different from that of others, of his dazzling palette, of the brilliancy of his ideas all in a blaze, of his persuasive skill, of his rhetorical clearness, that

penchant for apotheoses which makes him soar, of that heat which stirs his invention almost to the point of overwhelming it. All this leads to a still more complete definition, to a word that I shall use to express everything. Rubens is a *lyrist*, the most lyrical of all painters. His prompt imagination, the intensity of his style, his sounding continuous rhythm, the fine bearing of this rhythm, his upright carriage, so to speak—call all this lyrical, and you will not be far from the truth.

There is in literature among others a heroic manner of writing called the *ode*. It is, as you know, the most nimble and brilliant of the varied forms of metrical language. There is never too much breadth nor too much violence in the ascending movement of the strophes, nor too much dazzlement at the summit. Well, I would quote you some paintings of Rubens as conceived, carried out, scanned, polished like the most stately Pindaric odes. The 'Raising of the Cross' would furnish me with the first example—an example all the more striking, as everything in it is in harmony, and the subject was one best expressed in this form. And I am using no subtle expressions when I say that this page of pure open-heartedness is written from one end to the other in that style rhetorically called *sublime*, from the soaring lines which cross it, and the conception which explains itself as it reaches its height, to the inimitable head of Christ, which is the culminating and expressive note of the poem, the note that glows and vibrates, at least as regards the meaning it bears—that is to say, the final strophe.

CHAPTER VI

RUBENS IN THE GALLERY AT ANTWERP

No sooner do you set foot in the first room of the Gallery at Antwerp than Rubens welcomes you. On the right an 'Adoration of the Kings' (Pl. 30), an enormous canvas done in his rapid and skilful manner—painted, they say, in thirteen days about 1624, that is to say, in the best part of his middle

age; on the left a very large picture, and famous too, a Passion called the 'Coup de lance' (Pl. 34). We cast our eye along the opposite side of the Gallery, and to the right and left we perceive that unique workmanship, strong and smooth, flowing and warm—Rubens, and still more Rubens. We begin with the catalogue in our hand. Do we always admire? Not always. Can we remain unmoved? Scarcely ever.

I shall copy out my notes: The 'Adoration' (Pl. 30), the fourth version of this since the one at Paris; this time with some noteworthy changes. The picture is less carefully studied than the one at Brussels, not so well done as that at Malines; but of a grander boldness, of a breadth, a vastness, an accuracy, and a self-possession that the painter has seldom surpassed in his more deliberate works. It is truly a *tour de force*—above all, if we think of the rapidity of this improvised work. Not a gap or break, not a sign of violence; a vast bright mezzotint and moderate lights envelop all the figures, each helping to support the other—all in visible colours; and these enhance the rarest, least expected, and yet most accurate gradations of colour, the most subtle and yet most distinct.

At the side of the ugliest figures the most beautiful can be seen in numbers. With his square face and thick lips, his reddish skin and large eyes strangely lit up, with his large frame girt in a robe with sleeves of peacock blue, the African Wise Man is an entirely original figure (Pl. 32), before whom Tintoretto, Titian, and Veronese would certainly have wrung their hands. On the left two enormous men on horseback stand with imposing solemnity—of an Anglo-Flemish style, and very strange too; altogether the rarest piece of colouring in the picture, with its dark harmony of black, greenish-blue, brown, and white. Add to this the silhouette of the Nubian camel-drivers, the supernumeraries, men in armour, negroes, and all in the broadest, most transparent and natural reflection. Some spiders' webs float down from the woodwork, and right at the foot an ox's head—a mere touch produced by several sweeps of the brush in the pitch-black colour—has no particular importance, and is only done in the same way as a

hasty signature is scrawled. The child is delightful. It might be quoted as one of the finest of the purely picturesque compositions of Rubens—the final expression of his knowledge of colouring, of his ability in practice when his power of vision was immediate and all-comprising, his hand careful and rapid and his meaning not too obscure; as the triumph of enthusiasm and knowledge—in a word, of self-confidence.

The '*Coup de lance*' (Pl. 34) is a loosely composed picture, with great gaps, disagreeable parts, enormous expanses a trifle too arbitrary—beautiful in themselves, but of doubtful connexion with the other parts. Two great patches of red, badly supported by the surrounding colours, are astonishing in their general discord with the rest. The Virgin is very beautiful, although her bearing is common; Christ, insignificant; St. John, very ugly, or very much altered or repainted. As often happens with Rubens and the picturesque and spirited painters, the best pieces are those of which the painter's imagination has accidentally become enamoured—such as the beautiful Virgin's head, so full of expression, the two thieves writhing on their crosses, and perhaps, above all, the soldier with the helmet, in black armour, who is coming down the ladder, resting against the cross of the unrepentant thief, and who turns round, raising his head. The blending of colour of the grey and brown horses outlined against the sky is magnificent. But to sum up, although we find in it some parts of the highest quality, a temperament of the first order and at every moment some master-stroke, the '*Coup de lance*' seems to me an incoherent piece of work—conceived, so to speak, in fragments, each of which reminds us of some of his finest work.

The 'Trinity', with its famous Christ, foreshortened in perspective, is a picture of Rubens's early youth before he went to Italy.[1] It is a pretty beginning—cold, delicate, smooth, and colourless—which already contains the germ of his style, as regards human form, his type as regards faces, and already the suppleness of his touch. All the other qualities are yet to be

born, so that if the drawing and design already have much of
Rubens in it, the painting does not foretell anything of what
Rubens will be ten years later.

His *'Christ à la paille'* (Pl. 24), a very celebrated picture
—too celebrated—is not much stronger or richer, nor does
it seem much more mature, although it belongs to a much
later period of his life. It is equally cold, delicate, and smooth.
We can see in it facility of style abused, the use of a hasty
flowing manner which is not good at all, the formula of
which might thus be expressed: a large greyish coating, the
flesh tones clear and shining, a great deal of ultramarine in the
mezzotints, too much vermilion in the reflections, a light
spontaneous colouring over a design. As a whole it is liquid,
flowing, shining, and careless. In this running style, if Rubens
is not very fine, he is not fine at all.

As for the 'Incredulity of St. Thomas' (No. 307), I find in
my notes this short and disrespectful remark: 'This a Rubens?
What a mistake!'[1]

The 'Education of the Virgin' (Pl. 37) is the most charming
decorative fantasy that could be seen anywhere. It is a little
panel for a private chapel or prayer-room—painted for the
eye rather than for the mind, but of a grace, tenderness, and
richness that cannot be equalled in its sweetness. A fine black,
a fine red, and in that expanse of blue shaded by changing
tones of mother-of-pearl or silver, there are, like two flowers,
two pink angels. Take away the figures of St. Anna and St.
Joachim, only keeping the Virgin with the two winged
figures, which might equally appropriately have come down
from Olympus as from Paradise, and you will have one of the
most delightful feminine portraits which Rubens ever
conceived and set forth in allegorical portrait, and of which
he made an altar-piece.

The 'Virgin with the Parrot' (Pl. 36) savours of Italy, calls
Venice to mind, and by its tendency, its power, the choice and
intrinsic nature of the colours, the quality of the backgrounds,
even the arabesque of the picture, the format of the canvas, its

[1] See p. 359.

square appearance, it makes us think of a Palma, but not quite severe enough. It is a fine picture, but almost impersonal. I don't know why I think that Van Dyck must have been tempted to derive inspiration from it.

I shall not mention the 'St. Catherine', a large 'Christ on the Cross', a small repetition of the 'Descent from the Cross' at Notre-Dame.[1] I leave them willingly in order to consider, with an emotion I shall not attempt to conceal, a picture which I think is only half-celebrated, and which nevertheless is an astonishing masterpiece, perhaps the one of all Rubens's works which does most honour to his genius. I mean the 'Sacrament of St. Francis of Assisi' (Pls. 31, 33).

A dying man, a priest who is offering him the sacrament, some monks standing round him, helping him, holding him up in tears—that is the scene. The saint is naked; the priest is in a golden chasuble just tinged with red; the priest's two acolytes in white stoles; the monks in coarse dark brown or grey garments. For the surrounding scenery there is narrow, sombre architecture, a reddish pulpit, a slope of blue sky, and in that blue space just above the saint three pink angels fly like heavenly birds, and form a radiant and sweetly beautiful crown. The simplest elements, the gravest colours, a most severe and perfect harmony—such is the appearance. On the first rapid glance at the picture you will only perceive a vast pitchy black canvas of severe style, in which everything is heavy and only three accidental touches can be seen at a distance with great clearness: the saint with his livid, thin face, the sacrament towards which he is stretching, and, above, at the top of that tenderly expressive triangle, a vista of pink and blue stretches over that blissful expanse of sky—a smile from the half-open heavens, which, I assure you, is very essential to the effect.

No pomp or decoration, no violence or impatient gestures, no grand airs or fine costumes, not a pleasant incident or one unnecessary to the general effect—nothing but monastic life at its most solemn moment. A man in the throes of death,

[1] See p. 359.

weakened by age and a saintly life. He has left his bed of ashes, has been carried to the altar, and wishes to die there while he is receiving the sacrament, yet fearing lest he may die before it has touched his lips. He makes an effort to rise on to his knees, but cannot. All his movements are checked, the chill of the last moment has seized his limbs, his arms have that drooping position which is a sure sign of approaching death; he is leaning forward, has lost his balance, and would fall heavily down were he not upheld under the armpits. He has no sign of life in him save his deep-set, moist, clear, blue eyes, feverish, glassy, red at the rims, staring in the ecstasy of heavenly visions, and on his lips, livid with agony, that wonderful smile of death and that still more wonderful smile of the just man who believes, hopes, and anxiously awaits the end, casting himself down before his salvation, and looking upon the sacrament as he would look upon his God.

Around the dying man they are weeping; and those who weep are serious, strong, well-tried, and resigned men. Never was grief more sincere or more affecting than this manly tenderness of men of stout heart and good faith. Some restrain themselves; others burst into tears. Some of them are strong, flushed, healthy, young men, who smite their bosoms with clenched fists, and whose grief would be overwhelming could it be heard. There is one greyish and bald, with a head of Spanish caste, sunken cheeks, straggling beard, and thin moustache, who sobs quietly to himself, with the puckered-up features and chattering teeth of a man under great restraint. All these fine heads are portraits. The type is admirably true to nature, the drawing simple, skilful, and strong, the colouring incomparably rich in its sobriety—shaded, delicate, and fine. Heads heaped together, hands clasped, convulsively locked and trembling; uncovered brows, burning looks; some are flushed with their feeling, whilst others are pale and cold, like ivory ornaments; the two servants, one of whom holds the censer and wipes his eyes with the back of his sleeve—all this group of men stirred in different ways, some self-possessed, others sobbing, form a circle around that wonderful head

of the saint and that little whitish crescent like the moon's disc held in the pale hand of the priest. I assure you it is inexpressibly fine.

So great is the moral value of this picture, unparalleled among the Rubens at Antwerp, and perhaps in all Rubens's work, that I am half afraid of profaning it by speaking of its external merits, which are no less great. I shall merely say that this great man was never more complete master of his thought, feeling, and hand; never was the conception more clear or far-reaching; never was his vision of the human soul deeper; never was he more noble, sound, rich in colour without ostentation, more careful in the drawing of the small parts, more free from reproach, which means more surprising in his treatment of the subject. This marvellous picture was painted in 1619. Fortunate years! We are not told how long he took to paint it; perhaps only a few days! But what days! After examining for a long while this peerless work, in which Rubens was transfigured, we can look at nothing further—no one, not the others, nor Rubens himself. We must leave the Gallery for that day.

CHAPTER VII

RUBENS AS A PORTRAIT-PAINTER

Is Rubens a great portrait-painter or is he only a good one? This great painter of man's physical and moral life, so apt at expressing a movement of the body by a gesture, a movement of the mind by the facial expression; this prompt and exact observer, this clear spirit who was never drawn from his scrutiny of externals by any ideal of human form; this painter of the picturesque, of chance traits, of peculiarities, of personal flashes; in fine, this master universal among all—had he all the requirements that we suppose him to have, and notably that particular faculty of revealing the human mind in its most intimate likeness?

Are Rubens's portraits good likenesses? I don't think anybody has ever said yes or no. We are compelled to admit the catholicity of his gifts, and because he has used portraiture more than anyone else as a natural element in his pictures, we have concluded that a man who excelled on every occasion in the painting of a living, active, thoughtful personality must all the more for that very reason be an excellent portrait-painter. The question is worth discussing. It touches one of the most singular phenomena of this many-sided temperament; consequently it offers a splendid opportunity of examining closely the very organism of his genius.

If we were to add to all the individual portraits he painted to gratify the wishes of his contemporaries—kings, princes, lords, doctors, abbots, priors—the incalculable number of living people whose features and forms he reproduced in his pictures, we could say that Rubens spent his life in painting portraits. Without a doubt his finest works are those in which he referred the greater part to real life, as, for example, his magnificent picture of 'St. George' (Pl. 42), which is nothing else than a family *ex voto*—that is to say, the most magnificent and curious document that any painter has ever left of his home affections. I need not speak of his own portrait, which he threw away like a prodigal; nor that of his two wives, of which he made, as you know, such a repeated and indiscreet use.

To make use of nature for all purposes, to take individuals in actual life and introduce them into his fiction, was a habit with Rubens—for it was one of his needs—a weakness as well as an excellence of his mind. Nature was his great, inexhaustible resource. In truth, then, what did he seek of it? Subject-matter? No; his subjects he borrowed from history, legends, the Bible, fables, and always more or less from his own imagination. Attitude, gestures, facial expressions? Not these either: expressions and gesture came naturally from himself, and were derived, by the logic of a well-thought-out subject, from the requirements of the action, usually dramatic, which he had to depict. What he sought of nature was that which

his imagination only imperfectly supplied him with, when he had to construct upright from head to foot a living being, as life-like as he required it: more personal traits, more exact characters, individuals and types. These types were accepted rather than chosen by him. He took them just as they existed round about him, in the society of his time, from all ranks, from all classes, if need be from all races—princes, swordsmen, churchmen, monks, craftsmen, blacksmiths, ferrymen, and above all, men of rough work. There was in his own town, on the banks of the Escaut, sufficient for all the requirements of his great Biblical works. He had a very keen sense of the relation between these people, whom life was always presenting to his eyes, and the necessities of his subject. When the application was not very rigorous, which often happened, and when common sense and taste raised a slight objection, his love for peculiarity carried the day over the proprieties— common sense and good taste. He never denied himself an eccentricity, which in his hands became a trait of genius, sometimes a happy venture. It was indeed by means of these incongruities that he came out victorious in subjects which were least congenial to him. He put into them sincerity, good humour, the extraordinary wantonness of his sallies; the work was nearly always retrieved by an admirable piece of almost textual imitation.

In these cases he invented little, great inventor as he was. He now, made up his mind, copied, or reproduced from memory with an accuracy of recollection which is as close as an actual copy. The scenery of court life, church life, monastic life, street life, life on the river, impressed itself on his mind in its most easily recognized form, in its sharpest accent, its most salient colour; so that beyond this reflected image of things he scarcely used his imagination, save for the setting and background. His works are, so to speak, a theatre of which he controls the stage and scenic effects and creates the parts, and of which life supplies the actors. The more original, affirmative, decided, and powerful he is when he paints a portrait, either from nature or from the immediate recollection of a

model, the poorer in inspiration is the gallery of his imaginary persons.

All the men or women who did not live actually in front of his eyes, whom he could not see, so as to give them the essential features of natural life, are consequently untrue to nature. That is why his Biblical figures are rather more humanized than one would wish, his heroic types too slight for their fabulous part, his mythological figures something which exists neither in reality nor in dreams, a perpetual contradiction, due to the muscular action, the brightness of the flesh, and the complete lack of meaning in their faces. It is clear that humanity delights him; that Christian dogmas disturb him a little; and that Olympus wearies him. Look at his great allegorical series in the Louvre: it does not take long to discover his indecision when he wants to create a type; his infallible accuracy when he has a model fixed in his mind; and the strength and weakness of his talents. There are several very mediocre parts, there are absolutely none which are invented; the best pieces you can find there are portraits. Every time Marie de Medicis comes into the scene she is perfect there. The 'Henry IV receiving the portrait of Marie de Medicis' (Pl. 41) is a masterpiece. Yet no one will dispute the insignificance of his gods—Mercury, Apollo, Saturn, Jupiter, and Mars.

It is the same with his 'Adoration of the Kings'; there are in it principals who are always insignificant, and supernumeraries who are always admirable. The European is never a happy creation. He is easily known: he is the man in the foreground, who always appears in the centre of the picture beside the Virgin, upright or kneeling. In vain Rubens clothes him in purple, ermine, or gold; in vain he makes him hold out the censer, the cup, or the ewer; in vain he makes him younger or older—strips his venerable head of its locks or covers it with thick shaggy hair; in vain he gives him a meditative or fierce appearance, soft gentle eyes, or the looks of a warrior lion—whatever he does to him, he always remains a hackneyed figure, whose sole part is to display one of the dominant colours of the picture. It is the same with the

Asiatic. The Ethiopian, on the other hand, of the greyish negro type, with his livid, high-cheeked, flat-nosed face, lit up by two shining flashes, the glitter of the eyes and the glistening of the teeth, is without a doubt a masterpiece of observation and nature; for he is a portrait, and a portrait of the same model without any alteration (Pl. 32).

What can the inference be but that by his instincts, needs, dominant faculties, even by his weaknesses (for he had these too), Rubens was destined above all others to paint some marvellous portraits? This is by no means so. His portraits are weak, of poor observation, superficially constructed, and conveying the vaguest likeness. When we compare him in this respect with Titian, Rembrandt, Raphael, Sebastiano del Piombo, Velazquez, Van Dyck, Holbein, Antonis Mor—I might exhaust the list of the most different and greatest of them, and then come down several degrees to Philippe de Champaigne in the seventeenth century, to the excellent portrait-painters of the eighteenth century—we perceive that Rubens lacked that attentive simplicity, disciplined yet strong, which the study of the human face, to be perfect, demands.

Do you know of any portrait of his that satisfies you as the result of faithful and profound observation, enlightens you as to the personality of his model, and instructs you—I shall say, too, which eases your doubts? Of all the men so different in age and rank, in temperament and character, whose portraits we have by him, is there one who compels the attention as revealing to us a distinct personality, or is there one whose features we call to mind as remarkable? Once they are out of sight they are forgotten; seen altogether they might be almost confused. The peculiarities of their lives have not differentiated them clearly in the mind of the painter, and differentiate them still less in the memory of those who have only seen them through him. Are they good likenesses? Yes, almost. Are they life-like? They are; more even than they are in life. I shall not say that this is hackneyed, and yet not accurate. Nor shall I say that the painter had bad observation; but I think that his

observation was superficial, only skin-deep, and biased perhaps by his habits, and certainly by formulae; and that he painted these portraits, whatever might be the sex or age, as the women are said to like it—beauty first and likeness after-wards. They are well done as regards their time, and not badly done as regards their rank—although Van Dyck, to take an example from the side of the master, fixes with still greater accuracy their date and distinction of rank; but they are all of the same stock; they have, above all, the same moral character, and all the external traits modelled on one uniform type. It is always the same bright eye, wide open, the same glance to the right, the same complexion, the same delicately parted moustache, setting off, with two black or fair twists, the corners of a virile mouth, which means a mouth a trifle ordinary. A good deal of red in the lips and pink in the cheeks, enough roundness in the oval of the face to convey, if not youth, at least manhood in its normal condition, with a robust constitution, a healthy body, and mind at ease.

So too with the women. A fresh tint, a raised forehead, large temples, little chin, eyes level with the brows—colour to match, expression almost identical, a beauty peculiar to that age, the plumpness of the Northern races, with an indefinable grace that belongs to Rubens, in which we feel there is a combination of a number of types; Marie de Medicis, the Infanta Isabella, Isabella Brant, and Helen Fourment. All the women he has painted seem to have contracted, in spite of themselves and him too, an indescribable air known to us by recollection of other portraits; and all seem more or less to belong to one or another of these four famous women, whose immortality will be safer in the care of history than in that of his brush. They all resemble one another like members of one family—a resemblance due to a very great extent to Rubens.

Can you picture in your mind the women of the Court of Louis XIII and Louis XIV? Can you form an accurate idea of Mmes de Longueville, de Montbazon, de Chevreuse, de Sablé, of that beautiful Duchess of Guéménée, to whom

Rubens, asked by the Queen, was bold enough to award the prize for beauty, as the most charming goddess of the Olympus of the Luxembourg; of that incomparable Mlle du Vigean, the idol of Chantilly society, who inspired so great a passion and so many pretty verses? Can you see Mlle de la Vallière, Mmes de Montespan, de Fontanges, de Sévigné, de Grignan better? And if you cannot see them as well as you could wish, whose fault is it?

Is the fault that of the period—one of pomp, politeness, formal manners, stately and strained? Or again, is it the fault of the women themselves, who all sought to realize some Court ideal? Were they indifferently observed, untruthfully painted? Or, on the other hand, was it agreed and settled that among so many types of grace and beauty there was but one which was in good odour, good taste, satisfying perfectly all the requirements of etiquette? One is almost at a loss to know what kind of nose, mouth, shape of face, colour, look, what degree of seriousness or levity, of delicacy or *embonpoint*—what soul, in short, should be given to each of these fine ladies, so alike have they become in their imposing character of favourites, fault-finders, princesses, or great ladies. You know what they thought of themselves, how they painted themselves, or how they were painted, just as they happened to draw their own or let some one else draw their literary portraits. From the Condé's sister to Madame d'Epinay that is, from the beginning of the seventeenth century right up half-way through the eighteenth—it was nothing but fine colours, beautiful lips, splendid teeth, shoulders, arms, and throats—all most enchanting. They uncovered themselves, or allowed themselves to be uncovered, without showing us anything more than their perfections, which are a trifle cold, but moulded on a model that is unquestionably beautiful according to the fashion and ideal of the time. Not Mlle de Scuderi, nor Voiture, nor Chapelain, nor Desmaret, nor any of the literary *beaux esprits* who have described to us the charms of these ladies, have ever thought of giving us another portrait of them, less flattering perhaps, but more true to life.

Only very rarely does one see in the Gallery at the *Hôtel de Rambouillet* a colouring less perfect, lips of less lovely form or less attractive tint.

It needed the most truthful and greatest portrait-painter of his time—Saint-Simon—to show us that a woman might be charming without positive beauty, and that the Duchess of Maine and the Duchess of Burgundy, for example, had in their expressions a quite natural grace and spirit, and many attractive parts, though one had a halting gait and the other a swarthy complexion, a thin figure, a wild appearance, and decayed teeth. Until then it was above all the 'golden mean' that guided the painter's hand. Something imposing and solemn, which I cannot well describe—something like the three dramatic unities, the perfection of a beautiful phrase, had clothed them all with that same impersonal air, almost royal, which to us moderns is anything but charming. The times changed; the eighteenth century upset and disregarded a great number of formulae, and consequently treated the human face with as little ceremony as the other unities. Yet our own century has brought to light again, among other tastes and fashions, this same tradition of impersonal portraits—the same pomp, less impressive, but still worse on that account. Think of the portraits of the period of the Directoire, the Empire, or the Restoration, those by Girodet and Gérard, and most of those though not all by David and Prudhon; make a gallery of the great actresses and ladies—Mars, Duchesnois, Georges, the Empress Josephine, Madame Tallien, nay, even that fine head of Madame de Staël and that pretty Madame Récamier— and tell me if they look real; if they can be distinguished one from the other; if they are as varied as a series of portraits by Latour, Houdon, or Caffieri.

Well, that, in due proportion, is what I feel about Rubens's portraits: no certainty and too much convention, the same gentlemanly appearance of the men, the same regal beauty about the women; nothing personal or individual which arrests us, grips our attention, causes us to think, and is never again forgotten. Not an ugly feature, no emaciation of the

well-rounded face, not a disturbing peculiarity in any movement or appearance.

Have you ever seen in his gallery of philosophers, politicians, and warriors any accidental and personal characteristic—such as the hawk-like face of a Condé, the startled eyes and somewhat overcast mien of a Descartes, the delicate, charming features of a Rotron, the angular, thoughtful face of a Pascal, or the unforgettable glance of a Richelieu? How is it that the most varied examples of human kind have crowded before the gaze of the great portrait-painters and yet never a truly original person sat to Rubens? Must I explain myself by the strongest of comparisons? Imagine Holbein to have had the *clientèle* of Rubens, and immediately you see quite a different collection—interesting to the moralist, equally admirable as regards Life or Art, and one which Rubens, we must admit, would not have enriched with a single example.

The Gallery at Brussels contains four portraits by Rubens, and it is just while recalling them that these belated reflections occur to me. The four portraits exactly illustrate the strong and mediocre parts of his talent as a portrait-painter. Two of them are very fine: the Archduke Albert and the Infanta Isabella.[1] They were commissioned to adorn the triumphal arch at Meïr, on the occasion of the visit of Ferdinand of Austria; and they were painted (we are told) each in a day. They are too magnificent to be natural—conceived, drawn, and treated in an Italian style, expansive, full of decoration, a trifle theatrical, and admirably suited for their purpose. You will find in them the style of Veronese so well combined with the Flemish manner that Rubens never had more style and yet never was more like himself. We see in it a way of filling the canvas, of constructing an imposing arabesque, with a body, two arms, and two hands, busied in different ways, a way of dignifying a hem or border, of making a doublet look majestically severe, of giving boldness and strength to an outline, of painting thickly yet with smoothness, which is not usually found in his portraits, and which reminds one of the better

[1] See p. 360.

parts of his pictures. The likeness, too, is the same as in those pictures which attract one's attention from a distance by several accurate summary strokes—it might be called a likeness of effect. The workmanship is of extraordinary rapidity, confidence, gravity, and (allowing for its kind) of an extraordinary beauty. It is altogether magnificent. Rubens was at home there, on his own ground, in his later element of imagination, clear vision, but precocious and a trifle pompous. He would not have set about otherwise on a picture: the success was certain.

The other two, recently purchased, are very well known: a great value is set on them (Pls. 48 and 49). May I presume to say that they belong to his feeblest work? They are two portraits of the homely order, two little busts, a trifle short, rather curtailed, drawn full-faced, without any preparation or arrangement—more carefully cut off in the picture than a study for a head would be. With a great deal of brilliancy, relief, apparent life, very skilfully yet quickly painted, they suffer precisely from the defect that they were seen close at hand and carelessly; diligently painted, but little studied—that they were, in a word, superficially treated. The setting into position is accurate, the drawing not at all so. While the craftsman has given them an appearance which seems life-like, the portrait-painter has not shown up any of the intimate traits of the model—any which lie under the surface; everything is superficial. From the physical point of view, one misses an inner force that has never been observed; from the moral point of view, one misses an inner expression that has not been divined. The painting is canvas-deep, the life is only skin-deep. The man is young, about thirty years; his mouth is mobile, his eye moist, his glance straight and clear. Nothing more. Who is this young man? What has he done? Has he thought or suffered? Could he actually have lived on the surface of things, just as he is represented, purposeless, on the surface of the canvas? These are the traits of expression which a Holbein would have given us before thinking of anything else, and which cannot be shown by a sparkle in the eye or a reddish touch on the nostril.

The art of painting betrays perhaps more than any other. It is an unmistakable reflection of the moral state of the painter at the moment he holds the brush. What he wished to do he has done; what he only feebly wished to do can be seen in his indecisions; what he did not wish to do is all the more certainly absent from his canvas, whatever he may say of it or whatever anyone else may say of it. A moment of distraction or forgetfulness, a cooling down of the emotions, a less penetrating vision, a less rigorous application, a less ardent love of his subject, the weariness of painting with its passion, all the shades of his nature, even to the momentary lapses in his sensitiveness—all this is manifest in the painter's works as clearly as if he had taken us into his confidence. We can tell with the utmost certainty the attitude of a careful portrait-painter in front of his models; and in the same way we can imagine that of Rubens in front of his.

When we look, only a few paces away from the portraits of which I am speaking, at the portrait of the Duke of Alba by Antonis Mor, we are certain that, fine gentleman as he was, and used to painting fine gentlemen, Antonis Mor was very grave, attentive, and considerably moved at the moment he sat down to paint that tragical man, dry, bony, with his dark tight-fitting armour, jointed like an automaton, his eye glancing sideways and downwards—that eye, cold, harsh, and black, as if the light of heaven had never softened its glistening hardness.

It was quite the contrary with Rubens when he painted, as a favour, Sir Charles de Cordes and his wife, Jacqueline van Caestre (Pls. 48 and 49). He was, you need have no doubt of it, in a good humour, but preoccupied, certain of his success, and hurried, as he always was. This was in 1618, the year of the 'Miraculous Draught'. He was forty-one years old; he was in the fullness of his talent, fame, and success. He hurried in everything he did. The 'Miraculous Draught' had just taken him exactly ten days' work. This young couple had only been married on 30 October 1617. The husband's portrait would be sure to please his wife, and the wife's her husband.

You see, now, under what circumstances this work was done—
you can imagine what time he gave to it; the result was a
hurried and brilliant painting, a pleasant likeness, an ephemeral
piece of work.

Many—I would almost say the greater part—of Rubens's
portraits are like this. Look at the portrait of Baron de Vicq at
the Louvre (No. 2111 in the Catalogue)—the same style
and quality, practically of the same period as that of Sir
Charles de Cordes of which I am speaking; look, again, at the
portrait of Elizabeth of France, and that of a lady of the
Boonen family (No. 2114 in the Catalogue), and as many
more such works as you wish—agreeable, brilliant, light,
lively, no sooner seen than forgotten.[1] Look, on the other
hand, at that portrait sketch of his second wife, Helen, with
her two children (Pl. 43)—that admirable rough draft, that
dream so faint that it can scarcely be seen, left in this state by
chance, or perhaps on purpose; and however little attention
you may give to the three works before this one, I shall have
no need to say anything further to explain what I mean.

In short, Rubens, considered only as a portrait-painter, was
a man who had his inspirations, when he had time for them,
with a vision admirably accurate, but shallow: a mirror rather
than a plummet—a man who troubled little about others, but
a great deal about himself; in mental as in physical life a man
who lived on the surface, marvellously but exclusively
adapted to grasp the outward semblance of things. That is why
it is best to remember there are in Rubens two distinct on-
lookers of very unequal power, and scarcely comparable in
their artistic value: the first, who makes use of the lives of
others to supply the needs of his conceptions, who keeps his
models subordinate and takes of them only what he requires
for his purpose; and the other, who does not rise to the level
of his task because he must, and cannot, make himself sub-
ordinate to his model.

That is why he has so often observed the human face so
accurately, and so often neglected it. That is why, in short, his

[1] See p. 360.

portraits are all a little alike, why they are like him somewhat, why they lack real life, and consequently moral likeness and depth of character; while the persons he portrays in his paintings have that degree of striking personality which increases still more the effect of their part, a flash of expression which scatters all doubt that they have really lived; and as for their moral basis, it is clear that they all have a fiery, active, impetuous spirit, and, so to speak, worn on their sleeves—a spirit Rubens gave them, nearly the same to all, because it is his own.

<center>CHAPTER VIII</center>

THE TOMB OF RUBENS

I HAVE not yet led you to the tomb of Rubens, at the Church of S. Jacques. The tombstone is laid in front of the altar. '*Non sui tantum saeculi sed omnis aevi Apelles dici meruit*'—thus says the inscription on the stone.

Without noticing this exaggeration, which neither adds nor subtracts anything from the world-wide fame and certain immortality of Rubens, these two lines of elegy make us reflect that a few paces away underneath the stone-flags lie the ashes of this great man. He was buried there the first day of June 1640. Two years later, by special authority, on 14 March 1642, his widow consecrated to him the little chapel behind the choir, and his fine picture of the St. George was hung there, one of his most charming pieces; composed, they say, entirely with the portraits of members of his own family—that is to say, with his affections, his lost loved ones and those still living, his regrets and hopes, the past, the present, and the future of his house.

You know that one regards all the persons who form this so-called 'Holy Family' as historical likenesses of the greatest value (Pl. 42). There side by side, they say, you will find his two wives, and first of all, Helen Fourment—a young girl of sixteen years of age when he married her in 1630, still a very young woman when he died, fair-haired, plump, amiable and

sweet-tempered, with very little to cover her charms, naked to the waist. Again, his daughter is supposed to be there, and his niece, the famous lady with the *straw hat*; his father and grandfather; finally, the youngest of his sons in the form of an angel—a tiny, delightful little baby, the sweetest child perhaps that he ever painted. As for Rubens himself, he figures in a glistening coat of mail, of dark steel and silver, holding in his hand the banner of St. George. He is now old, thinner, his dishevelled hair is now turning grey—a little battered by age, but splendid, looking full of hidden fire. Without any pose or ceremony he has laid low the dragon and set his mailed foot upon him. How old was he then? If we go back to the date of his second marriage, his wife's age, the age of the child born of this marriage, Rubens should then have been about fifty-six or fifty-eight years of age. It was now about forty years, then, since the brilliant battle against life—impossible to some, but easy to him and always successful—had begun. Through what enterprises, what activity and struggles had he not made himself successful and triumphant over all.

If ever a man at that solemn moment when he dwells on the past, when he thinks of years gone by, of a career now at its highest point of success, had the right to paint himself as victorious, that man, indeed, was he.

Its meaning, as you see, is one of the simplest; you have not to look for it. If the picture hides any emotion, it can easily be shared by any man with a warm heart who is moved by fame, and who makes a second religion of the memory of such men.

One day towards the close of his career, at the full height of his fame and perhaps, too, of his leisure, under a holy title, and under the invocation of the Virgin and that Saint for whom alone of all he thought he might take himself as model, he gave himself the satisfaction of painting in a small picture (about six feet wide) all that was venerable and delightful in the people he had loved. He certainly owed this proof of his love to his parents and to those women who had shared, made beautiful, charmed, ennobled, sweetened with grace, tenderness and purity his fine laborious career. This proof he gave

them as fully and perfectly as could be expected of his affectionate hand, of his genius in its greatest power. He put into it his knowledge, his love and respect, and (a rare thing with him) his greatest care. He made of the work what you know: a marvel, infinitely touching as the offering of a son, a father and a husband—above all, admirable as a work of art.

Shall I describe it to you? The disposal of figures is such that a note in the Catalogue enables you to recognize it. Shall I tell you of its individual qualities? These are all the qualities of the painter in their familiar meaning, in their most precious form. They do not give us a new idea of him, nor a higher opinion of him, but one perhaps more delicate and pleasing. It is the Rubens of his best days—more natural, more exact, with more fantasy, with more richness of colouring, more spontaneous power; with an eye more tender, a hand gentler and fonder, with a more loving labour, more intimate, and sounder. If I were to employ the technical terms of art, I should spoil the greater number of those subtle things which it is best to convey in the pure language of ideas, in order to preserve their true character and value. While I had little scruple about detailing or examining the workmanship in a practical picture like 'The Miraculous Draught', it is fitting that I should tone down and refine the language of handicraft when the artist's conception rises to such a height as in the 'Sacrament of St. Francis of Assisi'; or again, when his manner of painting becomes impregnated at once with genius, feeling, fire, conscience, affection for those whom he is painting, love for what he is doing—in one word, for what is ideal, as in the 'St. George'.

Was Rubens ever more masterly than he is here? I don't think so. Was he ever even as masterly? I have not found him so. There are in the lives of the great artists predestined works —not always their most ambitious works, indeed, they are often their most humble ones—which by a chance unison of the talents of the man and the artist have expressed, unknown to them, the purest essence of their genius. The 'St. George' is of this number.

The picture, moreover, marks, if not the end, at least those beautiful last years of Rubens's life; and with a sort of magnificent *coquetterie*, not ill-becoming in matters spiritual, it points out that this excellent organization knew neither fatigue nor weakness nor decline. Thirty-five years at least have passed between the 'Trinity' of the Gallery at Antwerp and the 'St. George'. Which is the younger of these two pictures? At which period had he more fire, more active love for all things, more suppleness in all the organs of his genius?

His life is almost over. We can close it, and take its measure. It would seem that he too foresaw his end that day when he glorified himself and all his family. He had raised and completed his monument himself: he could say this with as much assurance as a great many others, and without pride. Five or six years still remained for him to live. We find him now, happy, with peace of mind, a little disgusted with politics, retired from his embassies, more his own master than ever. Did he make the most of his life? Did he deserve well of his country, of his time, of himself? He had faculties that no others ever had: how did he avail himself of them? Fate loaded him with gifts: was he ever untrue to his destiny? In that great life, so straightforward, so open, so brilliant, so adventurous yet so transparent, so correct in its most astonishing vagaries, so stately yet so simple, so disturbing yet so exempt from meanness, so grand, so varied and so fertile, can you find one blot that causes regret? He was happy; was he ungrateful? He had his trials; was he ever embittered? He loved a great deal and violently; was he forgetful?

He was born at Siegen, in exile, on the threshold of a prison, of a mother admirably upright and generous, a father learned, an enlightened doctor, but of changeable feelings, weak conscience, and inconsistent, unstable character. At the age of fourteen we find him one of the pages of a princess, at seventeen in the studios; at twenty he is already ripe, and a master. At twenty-nine he comes back from travels devoted to study as from a victory gained abroad, and he returns home in triumph. They ask to see his rough sketches, and he has, so

to speak, nothing to show them but his accomplished works. He had left behind him strange pictures, yet they were immediately understood and appreciated. He had taken possession of Italy in the name of Flanders, left behind him tokens of his passage from town to town, and on his way laid the foundations of his fame and that of his native country—still more, of an art unknown to Italy. As trophies he brought back marbles, engravings, pictures, fine works of the best masters, and, above all, a national art, a new art, which of all the arts then known was the most ample in scope and surface, and the most fertile in resources.

As his name became famous and brilliant, as his talent became more known, his personality seemed to grow too, his brain seemed to expand, his faculties multiplied with every new demand made on him, with what people wanted of him, and what he wanted of them. Was he a shrewd politician? As a diplomatist he seems to me to have simply, faithfully and nobly understood and transmitted the wishes or wills of his masters, to have pleased everyone by his noble bearing, to have charmed everyone he approached by his wit, his culture, his conversation and his character, to have attracted them still more by his indefatigable ever-present genius of painting. He would come, often with the greatest state, would present his letters of credence, would talk and paint. He painted the portraits of princes and kings, mythological pictures for palaces, religious ones for cathedrals. We can scarcely make out very well which is best received—Peter Paul Rubens *pictor*, or Sir Peter Paul Rubens, Minister Plenipotentiary; but there is every reason to believe that the artist did help out the diplomatist a good deal. He succeeded in everything, to the satisfaction of those whom he served by word or brush. The only embarrassments, dullnesses, and the rare boredom that we find in his travels, so picturesquely interrupted with business, galas, riding and painting, are never due to kings or rulers. The real politicians were more punctilious and less easy to deal with: witness his quarrels with Philippe d'Arenberg, Duc d'Arschot, on the occasion of the last embassy entrusted

to him in Holland. Is this the only wound received in these delicate, dangerous functions? It is at least the only cloud we can see from a distance, which throws a little bitterness on a radiant existence. In everything else he is happy. His life from one end to the other is one of those which reconcile us with life. In everything he is a man who does honour to humanity.

He is handsome, perfectly well-bred, and cultured. He still retained from his rapid education in early life a taste for languages, and a skill in speaking them. He writes and speaks Latin; he has a love for sound and strenuous reading; some-body would read Plutarch or Seneca to him while he painted, *and he was as attentive to the reading as to the painting.* He lives in the greatest luxury, has a princely mansion; he has thorough-bred, valuable horses, which he rides in the afternoon; a unique collection of objects of art, which he enjoys in his moments of leisure. He lives by rule, is methodical and cold in the disciplining of his private life, in the management of his work, in the ordering of his mind, and, in a way, in the caring for the sound and vigorous health of his genius. He is simple, quite unaffected, exemplarily faithful in his relations with his friends, sympathetic to all talents, a never-failing source of encouragement to beginners: no success but he had helped with his purse or praise. His forbearance with regard to Brauwer is a famous episode in his life of beneficence and one of the most impressive testimonies he ever gave of his good-fellowship. He adores whatever is beautiful and never separates from it whatever is right.

He passed through the changing scenes of his wide official life without being dazzled or weakened in his character, without even being sensibly disturbed in his domestic habits. Fortune could no more spoil him than could honours. Women could no more disturb him than could princes. No compromising gallantry is known of him. Always, on the contrary, we find him at home, with regular habits in his household, from 1609 to 1626 with his first wife, and after 1630 with his second, with his numerous handsome children,

with devoted friends—that is, with amusements, affections and duties, everything that keeps his mind at rest and helps him to carry, with the natural ease of a giant, the daily weight of superhuman work. Everything is simple in his complicated occupations, be these pleasant or overwhelming. His life is in the full light of day: it is broad daylight there as in his pictures. No shadow of a mystery, no sorrow either, save the sincere grief at the loss of his first wife—nothing suspicious, nothing that need be concealed, or even any matter for conjecture, save one alone: the very mystery of that amazing fertility.

'*He relieved himself*', it has been written, '*by creating new worlds*.'[1] In this ingenious definition I can find but one word I could wish amended: '*to relieve*' presupposes a tension, a plethora, which was never found in that healthy, always untroubled mind. He created, as a tree produces its fruit, without any more discomfort or effort. When did he meditate? '*Diu noctuque incubando*'—that was his Latin motto; it means that he thought a great deal before he painted; we can see that from his rough drafts, his plans, his sketches. The improvisation of his hand followed that of his mind; there is the same accuracy and facility of putting forth in the one case as in the other. His was a soul without storm, without languor, untroubled, with no vain fancies. If ever the melancholy of work left its imprint anywhere it was not on Rubens's features, nor in his pictures. Born in the middle of the sixteenth century, he belonged to that strong race of thinkers and men of action with whom action and thought were one. He was a painter just as he would have been a warrior. He painted his pictures just as he would have waged war—with as much coolness as impetuosity, contriving well, deciding quickly, relying for the rest on the accuracy of his glance over the field of action. He takes things as they are, his fine talents as he received them; he exercises them as much as ever a man did, stretches them to their utmost extremities, expects of them nothing beyond; and with a clear conscience on that score, he pursues his work with the help of God.

[1] See p. 359.

His painted work comprises about fifteen hundred pictures; the greatest output from any human brain. We should have to combine the works of some of the most prolific painters to obtain a number approaching this. If, apart from the number, we consider the importance, the size, the complexity of his works, we have a sight which strikes us dumb with amazement and which gives us the highest idea of the human faculties—and, be it said, the most religious idea. Such at least is the lesson that seems to me to be taught by the breadth and power of a mind. In this respect he is unique, and in all respects he is one of the finest specimens of humanity. In our art we must go to Raphael, Leonardo, and Michelangelo—to the demigods—to find his equals, and in certain respects his masters, too.

'*He lacked nothing*', it has been said, '*but the very pure and very noble instincts*'.[1] Indeed, you will find two or three geniuses in the world of beauty who have gone farther, have soared higher, and, consequently, have seen closer the divine light and the eternal truths. There are likewise in the moral world, in the world of feeling, of insight, and of thought, depths into which Rembrandt alone descended, into which Rubens never penetrated, which indeed he never perceived. On the other hand, he took possession of the whole earth as no one else has done. The spectacular is his province. His eye is the most marvellous of all the prisms that have ever given us magnificent and true ideas of the light and the colouring of things. Drama, passion, attitudes of the body, expressions of the face—that is, the whole of mankind in the multifarious incidents of the world's stage—pass through his brain, take on in it stronger traits, more robust forms, are not purified but are amplified into one knows not what heroic semblance. Rubens leaves everywhere the impression of the distinctness of his character, the warmth of his blood, the solidity of his stature, the splendid balance of his nerves, and the magnificence of his everyday visions. He is unequal and oversteps the mark; he lacks taste when he draws, never when he colours. He forgets himself and becomes careless; but from the first day to the last

[1] See p. 359.

he makes amends for a mistake by a masterpiece, redeems a want of care, of earnestness, or of taste, by an instantaneous attestation of his self-respect, by a diligence that is almost touching, and by supreme good taste.

His grace is that of a man who sees things large and strong, and the smile of such a man is delightful. When he lays his hand on a rarer subject, when he touches a deep and distinct feeling, when his heart beats with a noble and sincere emotion, he paints the 'Sacrament of St. Francis of Assisi', and then, in the order of purely moral conceptions, he attains to that which is most beautiful in the true, and therein he is as great as any one in the world.

He has all the characteristics of inborn genius, and first—the most infallible of all—spontaneity, imperturbable temperament, in a way, no self-consciousness, and certainly the absence of all criticism: from which it follows that he is never hindered by a difficulty to be solved, or by one badly solved, never discouraged by a defective piece of work, never puffed up by a perfect one. He never looks behind, and is undaunted by what remains for him to do. He accepts tasks of tremendous difficulty and performs them. He suspends his work, abandons it, diverts his attention, turns away from it. Then he comes back to it after a long and distant mission, just as if he had not left it an hour. One day only it took him to paint the 'Kermesse' (Pl. 44), thirteen for the 'Adoration' at Antwerp, perhaps seven or eight for the 'Sacrament', if the time bears any relation to the price he was paid for it.

Did he love money as much as they say? Did he, as much as he is said to have done, commit the wrong of employing his pupils to help him, treat with too much disdain the art he honoured so much because he valued his pictures at one hundred florins a day? The truth is that in those days the painter's craft was really a craft, and it was not practised the less nobly or less well because it was regarded as a high profession. The truth is that there were apprentices, masters, bodies of workmen, a school that was positively a workshop—that the pupils were the collaborators of the master, and that

neither pupils nor master had reason to complain of this salutary and useful exchange of lessons and services.

More than anyone else, Rubens had the right to hold fast to the ancient practices. He is, with Rembrandt, the last great head of a school of painting, and, better than Rembrandt, whose genius could not be transmitted, he determined a great number of new fixed laws of aesthetics. He left the double heritage of good teaching and of superb examples. His studio recalls, with as much brilliancy as any other, the finest practices of the Italian schools. He trained disciples who were the envy of the other schools and the glory of his own. We shall always think of him surrounded by this cortège of original minds, of great talents, over which he exercised a sort of paternal authority, full of kindness, solicitude and majesty.

He had no troublesome old age, no great infirmities, no decrepitude. The last picture which he signed and which he had not time to send away, his 'Crucifixion of Saint Peter' is one of his best.[1] He speaks of it in a letter of 1638 as a favourite work which delighted him and which he wished to deal with at his ease. Scarcely had he been warned by several trifling ailments that there is a limit to our strength, when he died suddenly at the age of sixty-three, leaving to his children, with a very rich patrimony, the most solid inheritance of glory that ever a thinker, at least in Flanders, had acquired by the labour of his mind.

Such is this exemplary life which I could wish to see written by someone of great knowledge and magnanimity, for the honour of our art and the perpetual edification of those who practise it. It is here that it should be written, if it could be done, if any one knew how to do it, standing on his tomb and facing his 'St. George'. For as one would then have under one's eyes that of us which passes away and that which remains, that which comes to an end and that which lasts for ever, one would be able to judge with more proportion, certitude, and respect how much there is, in the life of a great man and in his works, that is ephemeral, perishable, and how much there

[1] See p. 360.

is that is truly immortal! And who knows whether, pondered over in the chapel where Rubens sleeps, the miracle of genius would not become clearer, and the *supernatural*, as we call it, better understood?

CHAPTER IX

VAN DYCK

THIS is what I should imagine a portrait of Van Dyck to be like, in a rough sketch, with unblended crayon strokes:

A young prince of royal blood, with everything in his favour—beauty, elegance, magnificent parts, precocious genius, unique education, and with all the chance happenings of fortunate birth before him; petted by his master, already himself a master among his schoolfellows, admired everywhere, invited everywhere, welcomed everywhere, abroad even more than in his own country; the equal of the greatest lords, the favourite and friend of kings; entering thus, at one stroke, into possession of all the most desirable things of this earth—talent, fame, honours, luxury, love, adventure; ever young, even in his mature years; never wise, even in his last years; a libertine, a gambler, greedy, prodigal, wasteful, playing the devil, and, as they would have said in his time, selling his soul to the devil for guineas, and then throwing them away open-handed, for horses, display, feasts, ruinous gallantries; enamoured of his art in the highest degree, yet sacrificing it to less noble passions, to less faithful amours, to less fortunate attachments; charming, of strong race, of slender, elegant stature, as happens in the second remove of great races; of a constitution already less virile, rather delicate, in fact; with the air of a Don Juan rather than of a hero, with a tinge of melancholy and an undertone of sadness underlying all the gaiety of his life, the impressionableness of a heart easily smitten, and that something of disillusionment proper to those whose hearts are too easily smitten; a nature inflammable rather than burning; at bottom, more sensuality

than real fire, less transport than unrestraint; less capable of grasping things than of allowing himself to be seized by them and of abandoning himself to them; a man delightful in his own attractiveness and sensible to all other attractiveness, devoured by that which is most consuming in this world—the muse and women; having abused everything—his charms, his health, his dignity, his talent; overwhelmed with needs, worn out by pleasure, drained of resources; an insatiable being who ended, they say, by keeping low company with Italian rascals and by seeking surreptitiously the Philosopher's Stone; an adventurer at his last resources, who married, by command so to speak, a charming, high-born lady, at a time when he had little to offer her—not much strength, not much money, no longer any great charm nor very certain life; the wreck of a man who, up to his last hour, had the good fortune—the most extraordinary of all—to keep his greatness when he painted; in short, a scamp, adored, decried, slandered later on, at bottom better than he was reputed to be, and a man who gained pardon for all his faults by a supreme gift, one of the forms of genius—grace; to put it plainly—a Prince of Wales dying as soon as the throne was empty, and who was not to reign.

With his considerable production, his immortal portraits, his mind open to the most delicate sensations, his very own style, his personal distinction, his taste, his sense of proportion, his charm in everything he had to do with—we may ask what Van Dyck would be without Rubens.

How would he have regarded Nature or conceived painting? What palette would he have created? What modelling would be his? What laws of colouring would he have fixed? What poetic ideal would he have adopted? Would he have been more Italian—would he have had a greater leaning towards Correggio or towards Veronese? If the revolution brought about by Rubens had been several years later or had never taken place, what would have been the fate of those delightful spirits for whom the master had prepared all the paths, who only had to watch his life, in order to live somewhat as he lived, to watch him paint in order to paint as no one had

painted before him; who had only to consider as one whole
his works such as he imagined them, and the society of their
time such as it had become, to perceive in their definite
relations, henceforward bound up one with the other, two
worlds equally new—a modern society and a modern art?
Who among them would have taken upon himself to make
such discoveries?

There was an empire to found: could they found it?
Jordaens, Crayer, Gerard Seghers, Rombouts, Van Thulden,
Cornelius Schut, Boeyermans, Jacques van Oost of Bruges,
Teniers, Van Uden, Snyders, Jan Fyt, all those whom Rubens
inspired, enlightened, trained, employed—his collaborators,
his pupils, or his friends would be able at most to share great
or small provinces, and Van Dyck, the best endowed of all,
was to have the most important and most beautiful. Take
away from them what they owe directly or indirectly to
Rubens, take away the central star and imagine what would
remain of those bright satellites.

Take away from Van Dyck the original type from which
his own was drawn, the style from which he took his style, the
feeling for form, the choice of subject, the turn of mind, the
manner of working and the technique which served him as a
model, and see what he would lack. At Antwerp, Brussels,
throughout Belgium, Van Dyck follows in the steps of Rubens.
His 'Silenus' and his 'Martyrdom of St. Peter'[1] are in Jor-
daens's style, delicate and almost poetic—that is to say, Rubens's
style in its nobleness, refined by a more delicate hand. His
Saints, Passions, Crucifixions, Entombments, beautiful dead
Christs, lovely women mourning and tearful, would not exist,
or would be different, if Rubens, once for all, had not revealed
in his two Antwerp triptychs the Flemish Gospel formula and
given Christ, the Virgin, the Magdalene, and the disciples a
definite local form.

There is always more sentimentality and sometimes more
deep feeling in the elegant Van Dyck than in the great Rubens;
yet are we quite certain of that? It is a question of degree and

[1] See p. 363.

of temperament. All the sons have, like Van Dyck, a feminine trait which is added to those of the father. Thus it is that the father's trait is sometimes embellished, made tender, altered and diminished. Between these two souls—so unequal otherwise—there is something like a feminine influence; there is first, so to speak, a difference of sex. Van Dyck lengthens the stature which Rubens made too thick; he puts less muscle, less relief, less bone and blood. He is less blustering and never brutal, his expressions are less heavy, he laughs little, is often moved, but does not know the deep sob of the strong man. He is never loud. He softens down much of the harshness of his master; he is at ease, for his talent is marvellously natural and facile; he is free, alert, but never bursts into passion.

Taken piece by piece, there are parts which he draws better than his master—an idle hand, a lady's wrist, a long finger adorned with a ring. He is more restrained, more civilized; one would say he kept better company. He is more refined than his master; for his master owes all to himself, and sovereignty of rank dispenses with and takes the place of many things.

He was twenty-four years younger than Rubens; nothing remained in him of the sixteenth century. He belonged to the first generation of the seventeenth, and that can be felt. It can be felt physically as well as morally, in the man and in the painter, in his handsome face and in his taste for beautiful faces; it can be felt above all in his portraits. On this ground he is extraordinarily of the world, of his own world and of his own epoch. Never having created an imperious type that distracted his attention from the true, he is exact; he sees accurately, and sees things as they are. Perhaps he gave the people who sat to him something of the grace of his own person (Pl. 46)—an appearance more habitually noble, a more gallant *déshabillé*, a more elegant draping of the garments, hands generally more beautiful, purer and whiter than they really were. In any case, he has more knowledge than has his master of the way things should be worn, of fashions, he has a taste for silky fabrics, for satins, shoulder-knots, ribbons, feathers and fanciful swords.

They are no longer knights, but cavaliers. The warriors have taken off their armour and helmets; they are now courtiers in unbuttoned doublets, flowing shirts, silk stockings, in carelessly adjusted small clothes, in high-heeled satin shoes—all these fashions and habits are his own, and he was better adapted than anyone else to reproduce them in their worldly perfection. In his own style and class, he is as a painter of contemporaries the equal of anyone, by the extraordinary harmony of his nature with the mind, the needs and elegancies of his time. His 'Charles I', in its deep significance of model and of subject, in the familiarity of the style and its nobility, in the beauty of everything in this exquisite piece of work, the drawing of the face, the colouring, in the untold rareness and appropriateness of its values, and in the quality of the work— this 'Charles I', I say, to take only one well-known example of his work in France, will bear comparison with the greatest portraits (Pl. 50).

His triple portrait at Turin is of the same kind and has the same significance (Pl. 51). Under this head he has done more than anyone after Rubens. He completed Rubens by adding to his works some portraits entirely worthy of Rubens himself, better than his, indeed. He created in his country an original art, and, consequently, he played his part in the creation of a new art.

Besides this he has done still more: he gave rise to a whole foreign school—the English School. Reynolds, Lawrence, Gainsborough—I might add almost all the *genre* painters who followed the English tradition—and the best landscape-painters are the direct descendants of Van Dyck and indirectly of Rubens through Van Dyck. That is a very considerable title to fame. And posterity, which is always most just and accurate in its findings, sets apart a special place for Van Dyck between the men of the first rank and those of the second. No one has yet been able to determine what should be his place of precedence in the procession of great men; and since his death, as during his life, he seems to have retained the privilege of sitting near the thrones, and of making a very good figure there, too.

Yet, to come back to what I was saying, with his personal genius, personal grace, personal talent, the whole Van Dyck would be inexplicable, were it not for the central orb whose beautiful light he reflects. We should try to find out who it was that showed him this new manner, that taught him this new language which has nothing of the old accent left in it. We should see in him lights that have come from somewhere else and were not the products of his own genius, and, finally, we should suspect that there must have been somewhere in his neighbourhood a great star that had disappeared.

We should then no longer call Van Dyck the son of Rubens; we should add to his name, *master unknown*: and the mystery of his birth would be worth the historian's study.

HOLLAND

CHAPTER X

THE HAGUE AND SCHEVENINGEN

THE Hague is certainly one of the least Dutch towns in Holland and one of the most original in Europe. It has just that degree of local singularity which gives it a peculiar charm and that shade of elegant cosmopolitanism which makes it better suited than any other place to serve as a rendezvous. Thus there is a little of everything in this town of composite manners and customs yet of very individual physiognomy, where spaciousness, neatness, elegant picturesqueness, and dignified grace seem a highly polite way of being hospitable. We find in it a native aristocracy moving around, a foreign aristocracy delighting in the place, people of very great fortune made in the Asiatic colonies settling down there very comfortably; and, lastly, at times—too often indeed for the world's peace—ministers plenipotentiary.

I should certainly advise a sojourn there to those whom ugliness, commonplaceness, noise and racket, sordidness and vulgar luxury have wearied, not of towns but of huge towns. And, as for me, if I had to choose a place for work, a place for pleasure, where I could be comfortable, breathe a delightful atmosphere, and see beautiful things—above all, if I were troubled with cares, worries, soul struggles, if I needed quietness to solve the problems and surrounding charms to soothe the cares, I should do as Europe does after its storms—I should establish my congress here.

The Hague is a capital, that is quite obvious—even a royal city: you would say that it had always been one. It needs but a palace worthy of its rank to have all the features necessary for its ultimate destiny. We can feel that it had princes for *stadtholders*; that these princes were, after their manner, Medicis; that they had a natural liking for the throne, would have to reign somewhere, and that it would not be their fault if they did not reign here. The Hague, then, is a royally distinguished

city; this is one of its rights, for it is very rich, and a duty, for fine manners and opulence are all one, when everything is well. It might have been tiresome, but it is only regular, correct, peaceful. It might be permitted to be haughty, yet it is only pompous and very attractive. It is clean, too, that goes without saying, but not as might be supposed and only because of its well-kept streets, brick pavements, painted houses, intact windows, varnished doors, polished brass-work; because its waters, perfectly beautiful and green—green with the reflection of their banks—are never sullied by the muddy wake of the galliots or by refuse from the seamen's open-air cooking.

Its woods are admirable. The outcome of the whim of a prince, the hunting rendezvous of the Counts of Holland, The Hague has a deep-rooted passion for trees, born of the natal forest which was its cradle. In the woods its walks are taken, its fêtes are held, its concerts, races, and military manœuvres take place; and if its fine woods are no longer of any use to it, it has always before its eyes that green, dark, and compact curtain of oaks, beeches, ashes, and maples, which the everlasting moisture of its lagoons seems to paint every day with a newer and intenser green.

Its great domestic luxury—the only one, indeed, which it proclaims ostensibly with the beauty of its waters and the splendour of its parks, the one with which its gardens, winter and summer drawing-rooms, bamboo verandas, perrons, and balconies are adorned—is an untold variety of lovely plants and flowers. These flowers come from everywhere and go everywhere; it is here that India becomes acclimatized before going to beflower Europe. It has, as a sort of heritage from the House of Nassau, retained a taste for the country—for carriage-drives through the woods, for cattle and sheep farms, for beautiful animals at liberty on the green sward. Its architectural style belongs to the latter part of the French seventeenth century. Its fantasies, some of its customs, its exotic ornament, and its atmosphere come from Asia. Its comfortableness has passed through England and has come back again, so that now it is difficult to say to which the original type belongs—to

London or to The Hague. Briefly, it is a town worth seeing, because it has a good deal of outside, but its inside is still better, for it contains much art hidden under its elegance.

Today we drove as far as Scheveningen. The road is a shady path, narrow and long, piercing the heart of the wood in a straight line. It is cool and dark there whatever may be the heat of the sun or the haze of the air. The sun leaves you at the entrance and rejoins you at the exit. At the exit is a vast undulating desert, thinly sown with meagre grass and with sand, as on the edge of a great beach. We drove through the village, looked at the casinos, bathing halls, the princely pavilions adorned with the colours and the coat-of-arms of Holland; we climbed the dune, we plodded heavily through it to reach the shore. Now we have in front of us—level, grey, reeking, and foaming—the North Sea. Who has not been there and seen that? We think of Ruysdael, of Van Goyen, of Van de Velde (Pl. 94). We can easily take up their points of view. I could tell you, as if their footmarks were still to be seen, the exact spot where they sat down: the sea is on the left hand, the dune stretches far away to the right, tapers, grows less and less, and at last fades gently away into the pale horizon. The grass is dull, the dune is pale, the shore colourless, the sea milky, the sky silky, cloudy, extraordinarily aerial, well modelled and well drawn and well painted, just as they used to paint in those days.

Even at high tide the beach is almost interminable. As formerly, the walkers upon it make specks, some soft, some bright, but all vivacious. Its blacks are full, its whites tasteful, simple, thickly laid on. The light is too strong and the picture is dull: nothing could be more variegated, and the whole is dreary. Red is the only vivacious colour that keeps its strength in this astonishingly dull scale, whose notes are so rich, whose tone remains so grave. There are children playing, skipping, paddling in the water, making circles and holes in the sand; women dressed in light garments; much display of white shaded with pale blue or soft pink, but not at all as they are painted in our days, but rather as it would be fitting they

would be painted—wisely, soberly, were Ruysdael and Van de Velde there to counsel us. Some boats at anchor near the shore with their delicate rigging, their black masts, their massive hulls, remind us of the old swarthy tinted sketches of the best sea-artists; and when a bathing machine happens to pass, we think of the carriage and six dapple-grey horses of the Prince of Orange.

Call to mind several simple pictures of the Dutch school and you will know Scheveningen; it is just as it was. Modern life has changed its accessory parts; each period renews its people, who bring their fashions and customs. But what does that mean? Just a tiny touch in a silhouette. The burgher of the past, the tourist of the present—they make only a little picturesque speck, moving and changing, ephemeral spots following each other through the centuries, between the open sky and the high sea, the immense dune and the gravelly beach.

Yet, as if to testify the better to the permanence of things in this grand setting, the same waves which had been studied so many times were regularly beating the shore, which sloped gently down to meet them. Each unfolded itself, rolled on and died away, with that continuous sound, intermittent and monotonous, which has not varied by a note since the world began. The sea was void. A storm was gathering in the distance and circling the horizon with stiff grey and immovable clouds. Tonight it will lighten, and tomorrow, were they still alive, Willem van de Velde, Ruysdael, who was not afraid of the wind, and Bakhuysen, who has never painted anything well but the wind, would come to observe the dunes in their lugubrious moments and the sea in its rage.

We went back to The Hague by a different route, along the new canal to *Princess Gracht*. There had been races in the *Maliebaan*. The crowd was still standing in the shelter of the trees, massed together against the dark curtain of foliage, as if the unbroken turf of the race-course were a carpet of great value which they ought not to trample upon.

A little less crowd, a few dark landaus under the trees, and I could describe to you, from having had it immediately before

my eyes, one of those delightful pictures by Paul Potter, so patiently embroidered as if with a needle, so ingeniously bathed in glaucous half-tints, which he painted in his days of hard work.

ORIGIN AND CHARACTER OF THE DUTCH SCHOOL

THE Dutch School begins with the first years of the seventeenth century. By a very slight abuse of dates we can fix the day of its birth.

It was the last of the great schools—perhaps the most original, certainly the most local. At the same time, under the same circumstances, we see appear a double and very concordant product—a new state and a new art. The origin of Dutch art, its character, object, method, its apropos, its rapid growth, its unprecedented physiognomy, and notably the sudden manner in which it was born on the morrow of an armistice, together with the nation itself, and as the eager and natural efflorescence of a people happy to be alive and anxious to recognize itself—all this has been told many times, succinctly and well. So I shall merely touch upon the historical part, so as to arrive the quicker at that which is of more import to us.

Holland had never possessed many national painters, and it is perhaps to this poverty that was due, later, her possession of so many entirely her own. While she was blended with Flanders, it was Flanders that took upon herself to think, invent, and paint for her. She had no Van Eyck, no Memling, nor even a Rogier van der Weyden. A reflection came to her for a time from the school of Bruges; she may take the credit of having given birth at the beginning of the sixteenth century to a native genius in the painter-engraver, Lucas of Leyden, but Lucas of Leyden formed no school; that flash of Dutch life went out with him. Just as Dirk Bouts faded away into the style and manner of the primitive Flemish school—so Mostaert,

Scorel, Heemskerck, in spite of all their worth, were not such individual talents as distinguish and characterize a country.

Moreover, the Italian influence had just reached every one who held a brush, from Antwerp to Haarlem—and this cause may be added to the others which destroy frontiers, mingle schools, and denationalize painters. Jan Scorel indeed had no longer any pupils living. The last and most illustrious, the greatest portrait-painter Holland can lay claim to with Rembrandt, by the side of Rembrandt—that cosmopolitan of so supple a nature, so masculine an organization, such fine education, such changing style, but such powerful talent, who, moreover, had retained nothing of his origin, not even his name—Antonis Mor, or Antonio Moro, *Hispaniarum regis pictor*, as he called himself—had been dead since 1577. Those who were alive could scarcely be called Dutch, nor were they grouped or capable of renewing the school; they were the engraver Goltzius, Cornelis of Haarlem the Michelangelist, Bloemaert, the follower of Correggio, Mierevelt, a good painter of features, learned, correct, concise, a trifle cold, truly of his time, of his country to only a slight extent, yet the only one who was not Italian either; and note well—a portrait-painter.

It was part of the destiny of Holland to love *what was like*, to return to it one day or another, to survive and find its salvation in the portrait.

Yet with the approach of the end of the sixteenth century, and grafting themselves on to the portrait-painters, other painters were being born or trained. From 1560 to 1597 we notice a great number of these new-born painters; already it is like a half-awakening. Thanks to a number of dissimilarities and, consequently, to a number of aptitudes in different directions, the attempts followed the lines of the tendencies, and the paths multiplied. Efforts were made, they tried all kinds of painting, the whole scale was touched; they were divided between the *light* style and the *brown* style—the light supported by the draughtsmen, the brown inaugurated by the colourists and counselled by the Italian Caravaggio. They

entered upon the picturesque and made attempts to regulate the chiaroscuro. The palette was emancipating itself and so was the land. Rembrandt had already direct forerunners. *Genre* proper was shaking itself free from the obligations of historical painting; they were very near the definitive expression of modern landscape. In fact a style almost historical and deeply national was created: the civic picture; and after this acquisition—the most formal of all—the sixteenth century ended and the seventeenth began. In this type of large canvases with multiple portraits, the *doelen* or *regentenstukken* (to follow rigorously the appellation of these specially Dutch works) something different may be done, but certainly nothing better.

Here, as may be seen, is the seed of a school, not the school yet, though. Not that talent is wanting; that abounds. Among these painters who are learning and making up their minds, there are skilful artists; indeed there are one or two who will be great painters. Moreelse, descended from Mierevelt, Jan Ravesteyn, Lastman, Pijnas, Frans Hals, an incontestable master, Poelenburg, Van Schooten, Van de Venne, Thomas de Keyser, Honthorst, Cuyp the elder, lastly, Esaias van de Velde and Van Goyen have their names on the register of births for this year, 1597.[1] I quote their names without remarks. You will easily recognize those of whom history should keep some recollection; above all you will be able to distinguish the experiments they represent individually, the future masters they announce, and you will understand what Holland still lacked, and what it was absolutely necessary that it should possess, if these great hopes were not to be frustrated.

The moment was critical. Here in Holland there was no assured political peace, and all the rest was in the hands of chance; in Flanders, on the other hand, there was the same awakening added to a certainty of life which Holland was far from having acquired. Flanders was overflowing with painters already trained or nearly so. At that very time it was going to found a new school—the second one in a little more

[1] See p. 365.

than a century—as brilliant as the first, and in a much more dangerous proximity, extraordinarily powerful and new. It had a tolerable government, of better origin and motives, with ancient customs, a definitive and more compact organization, traditions, a society. To the impulses from above were added the needs of luxury and, consequently, the needs of art more stimulating than ever. In a word, the most energetic, stimulating influences and the strongest reasons led Flanders to become for the second time a great focus of art. It now needed but two things: some years of peace—it was going to have them; a master to found the school—he was there.

In this same year 1609, which was to decide the fate of Holland, Rubens came on the scene.

Everything depended on a political or military accident. Beaten and subdued, Holland was, in every sense of the word, subjected. Why two distinct arts among the same people under the same régime? Why a school at Amsterdam, and what would have been its role in a country devoted henceforward to Italo-Flemish inspirations? What would have happened to those spontaneous talents, so free, provincial, and so ill adapted to a state art? Admitting that Rembrandt might have obstinately persisted in practising a class of art difficult enough to practise outside his own environment, can you imagine him belonging to the Antwerp school, which would have continued to hold sway from Brabant to Friesland, the pupil of Rubens, painting for the cathedrals, decorating palaces, and pensioned by the arch-dukes?

In order that the Dutch people might be born, that Dutch art might see the light with it, it was necessary then (and that is why the history of each of them is so conclusive) that a revolution should take place; that it should be deep in its effect, and that it should be fortunate. It was necessary, moreover (and this was Holland's claim to the favours of Fortune), that it should be a just revolution, having on its side right, reason and necessity; that the people should deserve all they wished to obtain, that they should be resolute, convinced, laborious, patient, heroic and wise, without unnecessary

turbulence, and that in all points they should show themselves worthy of self-government.

One could almost say that Providence had its eye on this little nation, that it examined its wrongs, considered its claims, made certain of its power, found the whole according to its designs, and when the day came, performed a unique miracle in its favour. The war, instead of impoverishing it, enriched it; the struggle, in place of weakening it, strengthened it, elated it and tempered it. What it did against so many physical obstacles—the sea, the flooded land, the climate—it did against the foreigner. It succeeded. That which was to have annihilated it was put to its service. It had no longer any concern save one: certainty of life; it signed, at intervals of thirty years, two treaties which first liberated it and then consolidated it. There now remained, to affirm its actual existence and give it the lustre of prosperous civilizations, but one thing—to produce immediately an art which should consecrate it, be a credit to it and represent its inner being—and this happened as the result of the twelve years' truce. This result was so prompt, so explicitly the outcome of the political event to which it corresponds, that the right to have a national and free school of painting, and the certainty of having it on the morrow of peace, seem to be laid down in the stipulations of the treaty of 1609.

At that very moment a lull seems to have made itself felt. A breeze of milder air seems to have passed over the minds, to have reanimated the earth, to have found the seeds ready to burst and to have made them burst. As with the spring-times of the north, with their sudden vegetation, their rapid growth after the severities of a long winter, it is truly an unexpected sight to see in so short a time—thirty years at the most—in so small a space, on this thankless, desert soil, in this dreary environment, this harsh circumstance, such an outburst of painters—aye, and of great painters, too.

They were born everywhere and all at once—at Amsterdam, at Dordrecht, at Leyden, at Delft, at Utrecht, at Rotterdam, at Enckhuisen, at Haarlem—sometimes indeed beyond

the frontiers, as if from seed fallen beyond the field. Two
alone were just before this time—Van Goyen, born in 1596,
and Wijnants in 1600. Cuyp was born in 1605. In the year
1608—one of the most prolific—were born Terborch,
Brouwer, and Rembrandt, within a very few months; Adriaen
van Ostade, the two Boths, and Ferdinand Bol were born in
1610; Van der Helst, Gerard Dou in 1613; Metsu in 1615;
Aert van de Neer between 1613 and 1619; Wouwerman in
1620; Weenix, Everdingen, and Pynacker in 1621; Berghem
in 1624; Paul Potter is the glory of the year 1625, Jan Steen
of 1626; the year 1630 is for ever memorable as having
produced the world's greatest landscape painter—with Claude
Lorrain—Jacob Ruysdael.

Is the sap exhausted? Not yet. The date of the birth of Pieter
de Hooch is uncertain, but it may be placed between the years
1630 and 1635. Hobbema was a contemporary of Ruysdael;
Van der Heyden was born in 1637; and, finally, Adriaen
van de Velde—the last of the great ones—was born in 1639.[1]
In the year that put forth this tardy shoot Rembrandt was
thirty years of age; and taking as the central date the year in
which the 'Anatomy Lesson' appeared, 1632, you will see that
twenty-three years after the official recognition of the United
Provinces, and allowing for a few that were behind their time,
the Dutch School reached its first blossoming.

When we read the history of this time we know what to
expect of the designs, the character and future of the school;
but before Van Goyen and Wijnants opened the path, before
Terborch, Metsu, Cuyp, Ostade, and Rembrandt had shown
what they meant to do, we could very reasonably ask what
these painters were going to paint, at such a time, in such
a country.

The revolution which had just made the Dutch people free,
rich and so ready to undertake everything, stripped them of that
which everywhere else made up the vital element of the great
schools. It changed the beliefs, suppressed the needs, limited
the habits, laid bare the walls, abolished the representation

[1] See pp. 365, 367.

of the old fables as well as of the Gospel, cut short the vast enterprises of mind and hand, the church pictures, the decorative pictures, the great pictures. Never did a country place its painters on the horns of so strange a dilemma, or constrain them more expressly to be original men or nothing at all.

The problem was this: given a *bourgeois* people, practical, not inclined to dreams, very busy withal, by no means mystic, of anti-Latin tendency, with broken traditions, a worship without images, parsimonious habits—to find an art to please such a people, an art whose fitness should be apparent to them and which should represent them. A writer of our time, very enlightened in these matters, has given the very ingenious answer that there remained nothing for such a people to propose to themselves but a very simple and daring thing—the only thing, in fact, which they had succeeded in doing for fifty years—to paint its own *portrait*.[1]

This word says everything. Dutch painting, as one very soon perceives, was not and could not be anything but the portrait of Holland, its external image, faithful, exact, complete, life-like, without any adornment. The portrait of men and places, of *bourgeois* customs, of squares, streets, and countryside, of sea and sky—such was bound to be, reduced to its primary elements, the programme adopted by the Dutch School; and such it was, from its first day until its decline.

In appearance nothing was simpler than the discovery of this *terre à terre* art; since men began to paint, nothing had been thought of that was so vast or newer.

At one blow everything is changed in the manner of conceiving, seeing and rendering—point of view, ideal, poetry, choice of study, style and method. Italian painting in its best moments, Flemish painting in its noblest attempts, were not sealed letters, for they were still understood and appreciated; but they were dead letters, for they were no longer consulted.

There was then a habit of thinking highly, grandly, an art which consisted in choosing among things, in embellishing

[1] See p. 364.

them, rectifying them, which lived in the absolute rather than in the relative, which perceived Nature as she is, but was pleased to paint her as she is not. Everything was related, more or less, to the human personality, depended on it, was subordinate to it and copied closely from it, because, in truth, certain laws of proportion and certain attributes such as grace, strength, nobleness, beauty, wisely studied in men and reduced to a doctrine, were applicable also to what was not man. There resulted from this a sort of universal humanity or humanized universe, of which the human body, in its ideal proportions, was the prototype. History, vision, beliefs, dogmas, myths, symbols, emblems—the human form almost alone expressed everything that could be expressed by it. Nature existed vaguely around this absorbing personality. Hardly was it even considered as a framework which ought to grow smaller and disappear of itself as soon as man took his place in it. Everything was elimination and synthesis. As every object had to take its plastic form from the same ideal, nothing was forfeited. Now, by virtue of these rules of historic style, it was agreed that the planes should be reduced, the horizons limited, the trees diminished, the sky less changeable, the atmosphere more limpid and equal, and man more like himself, more often naked than dressed, more habitually finished in stature, beautiful of countenance, so as to be more king-like in the part he had to play.

But now the theme was simpler. The problem now was to give everything its own interest and standing, to put man back into his place, and, if necessary, to do without him.

The moment was come to think less, to aim less high, to look at things closer, to observe better, to paint just as well but differently. It was the painting of the crowd, of the citizen, of the working-man, of the first and last comer, entirely made of him and for him. It was now a matter of becoming humble when dealing with things humble, small for things small, subtle for things subtle, of gathering them all in without omission or disdain, of entering familiarly into their intimacy, affectionately into their manner of being; it is a matter of

sympathy, of attentive curiosity, of patience. Henceforward genius will consist in never judging beforehand, in not knowing that we know, in letting oneself be surprised by one's model, in asking it only how it wishes to be represented. As for embellishing, never; ennobling, never; punishing, never; all that is so much untruth or useless trouble. Is there not in every artist worthy of the name a something which naturally and without effort undertakes this?

Even without crossing the borders of the Seven Provinces, the field of observation would have no limits. Whoever speaks of a northern corner of the earth with water, woods, maritime horizons, speaks by that very fact of a universe in small. In its relation to the tastes and instincts of those who observe carefully, the smallest country, scrupulously studied, becomes an everlasting field of discovery, as crowded as life, as fertile in sensations as the heart of man is fertile in ways of feeling. The Dutch School may grow and work for a whole century; Holland will have enough to satisfy the insatiable curiosity of her painters, so long as their love for her does not die.

Enough will be found there, without leaving the fields and polders, to hold every inclination. Things will there be found for fastidious as well as for coarse minds, for melancholic and ardent dispositions, for such as love to laugh and such as love to dream. There you will find dull days and happy, sunny days, seas smooth and glistening, stormy and black; there are fields with farms, sea-shores with boats, and nearly always the visible movement of the air above; always the strong breezes from the Zuider Zee, which heap the clouds together, level the trees, drive along the shadows and lights and turn the windmills. Add to this the towns and the exteriors of towns, life indoors and out-of-doors, the fairs, the low manners and customs, the good manners and customs and the elegancies, the distresses in the lives of the poor, the horrors of winter, the idleness of the taverns with their tobacco, their pots of beer and their frolicsome servants, the suspicious trades and corners on all their floors—and, on the other hand, security in the household, the benefits of work, abundance in the fertile

fields, the sweetness of living under the open sky after work is done, cavalcades, siestas, hunts. Add, finally, public life, civic functions, civic banquets, and you will have the elements of an altogether new art with subjects as old as the world.

From this follows the most harmonious unity in the spirit of the school, and the most astonishing diversity, too, that was ever produced in one and the same mind.

The school is described as a *genre* school. If you divide it up into its component parts you will find in it painters of group pieces, landscapes, animals, sea-pieces, official paintings, still life, flowers, and, in each category, almost as many sub-divisions as temperaments, from the picturesque painters to the ideologists, from the copiers to the adapters, from the rover to the stay-at-home, from the humorists who are delighted and captivated by the comedies of life to those who fly from it, from Brouwer and Ostade (Pl. 98) to Ruysdael, from the impassible Paul Potter to the turbulent and jesting Jan Steen (Pl. 102), from the lively, intelligent and pleasant Van de Velde (Pl. 94) to that sour-minded great dreamer, who, though not living apart, had no dealings with any of them, who imitated none, but who was a *resumé* of them all—who seemed to paint his period, his country, his friends, himself, and who really only painted one of those unknown recesses of the human mind—Rembrandt.

As the point of view, so the style, and as the style, so the method. If you take away Rembrandt—an exception in his own country and everywhere else—you will see but one style and one method in all the studios of Holland. The object is to imitate that which *is*, to make what is imitated loved, to express clearly one's simple, strong, deep feelings. The style, then, will have the simplicity and clarity of the principle. Its law is to be sincere, its obligation to be truthful. Its first condition is to be familiar, natural, expressive; it follows from a concourse of moral qualities—*naïveté*, patient goodwill, and uprightness. We might almost call them domestic virtues, taken from private life and used in the practice of art, which serve equally to guide one aright and to enable one to paint well. If you take

away from Dutch art that which might be called probity, you will no longer understand its vital element; and it will no longer be possible to define either its morality or its style. But just as there are in the most practical of lives motives and influences that ennoble the behaviour, so in this art, held to be so positive, among these painters, held for the most part to be mere copiers of detail, we feel a loftiness and a goodness of heart, an affection for the true, a love for the real, that give their works a value the things do not seem to possess. Thence their ideal, somewhat misunderstood, somewhat despised, indubitable to all who are willing to grasp it, and very attractive to those who can enjoy it. At times a touch of warmer sensibility turns them into philosophers, nay, even into poets; in its place, I shall tell you in which rank I would place, in our history of art, the inspiration and style of Ruysdael.

The basis of this sincere style and the first effect of this honesty and goodness of heart is the drawing—the perfect drawing. Any Dutch painter who does not draw irreproachably is not worth consideration. There are some, like Paul Potter, whose genius consists in taking measurements—in copying a trait of character or appearance. Elsewhere and in his own way, Holbein had done nothing else, which makes for him, in the centre and outside all schools, an individual glory which is almost unique. Every object, thanks to the interest it offers, ought to be examined in its form and drawn before it is painted. In this way nothing is secondary. A landscape with its distances, a cloud with its movements, a piece of architecture with its laws of perspective, a face with its physiognomy, its distinctive traits, its passing expressions, a hand with its gesture, a garment in its natural folds, an animal with its carriage, its frame, the inmost characteristic of its kind, and its instincts—all this is, for the same reason, part of this impartial art, and, so to speak, enjoys the same privileges in its drawing.

For centuries it was thought—it is still thought in many schools—that to express the wideness of space, the height of the zenith and the ordinary changes in the atmosphere, it was

enough to spread aerial tints and to touch them sometimes with blue, sometimes with grey. Now consider that in Holland a sky often forms half the picture—sometimes the whole —and that in it the interest distributes itself and varies (Pls. 82, 94). The sky should move, and move us with its movement; it should rise and take us with it; the sun should set and the moon rise; it should be really day or evening or night; it should be hot or cold; we should shiver with horror or delight; should draw delight or serenity from it. If the drawing employed on such problems is not the noblest of all, at least we may convince ourselves that it is not without depth or merit. And if we had our doubts about the knowledge and genius of Ruysdael and of Van der Neer, we need only set out to find another painter in the whole world who can paint a sky as they can, who can express so many things and express them so well. Everywhere it is the same drawing—close, concise, precise, natural, artless; it seems the result of daily observations, which, as we have said, is very learned but not known to be so.

One word sums up the particular charm of this ingenuous knowledge, of this experience without pretension, the common worth and the true style of these right minds: we find among them painters, some more, some less strong—we never find a pedant.

As for their colouring, it is as good as their drawing; it is neither better nor worse, and that is the source of the perfect unity of their method. All the Dutch painters paint alike and no one has painted or paints like them. If you look carefully at a Teniers, a Brueghel, a Paul Brill, you will see, in spite of certain analogies of character and almost similar aims, that neither Paul Brill nor Brueghel, nor even Teniers, the most Dutch of the Flemish painters, has the Dutch education.

Every Dutch painting can be recognized from the outside by several unmistakable signs. It is of small format, of powerful and sober colour, of concentrated effect, as it were, concentric. It is a painting that has been diligently worked at, in an orderly manner, which denotes a steady hand, the artist seated

at his work, which requires perfect self-possession and inspires it in those who study it. Mind has meditated to conceive it, mind meditates to understand it. It is as if there was an easily followed progress of exterior objects through the painter's eye and thence through his mind. No painting gives a clearer idea of this triple and silent operation—feeling, reflecting, expressing. Neither is any painting more condensed, for none encloses in so small a space so many things or is forced to say so much in so small a setting. And thus everything assumes a conciser, preciser form, a greater density. The colouring is stronger, the drawing more intimate, the effect more central, the interest more circumscribed. Never does a picture sprawl or run the risk of either losing itself in the frame, or of escaping from it altogether. One must have Paul Potter's ignorance or perfect ingenuity to take so little care as to this arrangement of the picture for effect, which seems to be a fundamental law in the art of his country.

Every Dutch painting is concave; I mean that it consists of curves described round a point determined by the interest of the picture—of circular shades around a dominating light. It is drawn, coloured, and illumined like an orb, with a strong powerful base, a vanishing ceiling and rounded corners converging to the centre; from which it follows that it is deep, and that there is distance between the eye and the objects reproduced in it. No painting leads with greater certainty from the foreground to the background, from the border to the horizons. We live in the picture, we walk about in it, we look into its depths, we are tempted to raise our heads to look at its sky. Everything unites to produce this illusion—the accuracy of the aerial perspective, the perfect relationship of the colouring and of the values with the plane the object occupies. All painting foreign to this school of the ceiling, of the aerial envelope, of the far-off effect, seems flat and laid without relief on the canvas. With rare exceptions, Teniers, in his airy and light-toned pictures, is the descendant of Rubens; he has his spirit, his fire, his rather superficial touch, his style of work, elaborate rather than intimate; it might be

said, in forcing the expression a little, that he decorates rather than paints profoundly.

I have not said all, but I stop. A complete study would require the examination, one after the other, of the elements of this art, so simple yet so complex. The Dutch palette would have to be studied, its basis, its resources, its extent and use; we should have to know why it is so reduced—almost monochromous, yet so rich in its results, common to all and yet so varied; why its lights are rare and narrowed, its shades dominating; what is the most general law of this lighting, which seems to contradict the laws of Nature, especially in the open air; and it would be interesting to determine how much conscious art this painting really contains, how much of contrivance, how much of set purpose, and, generally, how much of ingenious system.

Then would come the technique, the fine use of the brush, the care—the extraordinary care—the use of smooth surfaces, the delicacy of the coatings, their brilliant quality, their glitter as of metal and precious stones. It would then remain to discover how these excellent masters performed the various parts of their work—whether they painted on light or dark grounds, whether, after the example of the early schools, they coloured in the material or over it.

All these questions, especially the last, have been the subject of many conjectures and have never yet been properly elucidated or settled.

But these running notes are not a deep study nor a treatise, nor yet a course of lectures. The idea one commonly has of Dutch painting, and which I have endeavoured to sum up, is sufficient to make a considerable distinction between it and that of other schools; and the idea people have of the Dutch painter at his easel is right and in every way expresses the fact. We imagine an attentive man, a little bowed, with a fresh palette, clear oils, and clean, well-kept, fine brushes; his look reflective, his hand careful, painting in a half-light—above all, hating dust. They may all be looked upon as like Gerard Dou or Mieris, and the portrait will be approximately correct.

They were, perhaps, less meticulous than they are commonly thought to have been, laughed with a little more abandon than is usually supposed. Genius did not show itself in the professional orderliness of their good habits. Van Goyen and Wijnants had, at the beginning of the century, fixed certain laws. The lessons were passed on from master to pupil, and for one hundred years, without any digression, they lived on this fund.

<div style="text-align:center">

CHAPTER XII

THE FISH-POND

</div>

THIS evening, a little tired of examining so many paintings, of admiring, of arguing with myself, I went for a walk on the borders of the Fish-pond known as the *Vijver*.

I arrived towards the end of the day, and stayed late. It is a strange place, very solitary, not without its melancholy at such an hour to one away from home, when the escort of happy years has quitted one. Imagine a huge basin between rigid, grim-looking quays and black palaces. On the right a deserted promenade bordered with trees, beyond, the great houses all shut up for the night; on the left the *Binnenhof*, with its foundations in the water, its brick façade, its slate roof, its morose appearance, its expression of another age—of all ages—its tragic recollections; in short, that inexpressible something proper to certain places inhabited by history. In the distance the spire of the cathedral, lost to sight towards the north, already chilled by the night and looking like a light wash of some colourless tint; in the pool a greenish islet and two swans gliding softly in the shadow of the banks, leaving only the slightest undulations behind them; above, martins flying quickly and high in the evening air. Perfect silence, complete repose, entire forgetfulness of all things past or present. Clearly defined but colourless reflections plunged to the bottom of the sleeping waters with the somewhat dead immobility of recollections which distant life has fixed in a memory three-parts faded.

I was looking at the Museum, the *Mauritshuis*, which forms
the southern corner of the Vijver and terminates at that point
the taciturn line of the Binnenhof, whose violet brick-work
looks, in the evening, sorrowful beyond conception. The
same silence, the same shadow, the same loneliness enveloped
all the phantoms shut up in the Stadtholder's Palace and in the
Museum. I was dreaming of what the Mauritshuis contained,
I was thinking of what happened in the Binnenhof. There,
Rembrandt and Paul Potter, but here, William of Orange,
Barneveldt, the brothers de Witt, Maurice of Nassau, Heinsius
—these are some names worth remembering. Add to this
the remembrance of the States, that assembly chosen by the
country in the country, among the most enlightened citizens—
the most vigilant, the most resisting, the most heroic; that
living element—that soul of the Dutch people who lived
within the walls, always the same, constant ever, renewed
itself there, sat there during fifty years, the most stormy
Holland has ever known, held its own against Spain, against
England, laid down conditions to Louis XIV, and without
which neither William nor Maurice nor the great Pensionaries
would have been anything.

Tomorrow morning at ten o'clock a few pilgrims will go
and knock at the door of the Museum. At that hour there will
be no one in the Binnenhof, nor in the Buitenhof, and no one,
I think, will pay a visit to the cavaliers' room where there are
so many spider-webs—which means where there is usually
so much solitude.

If Renown, which, they say, watches night and day over
Glory, should come down here to rest, where do you think
she would stay her flight? Over which of these palaces would
she fold up her golden wings—her tired wings? Over the
States Palace or over the Palace of Potter and Rembrandt?
What a singular distribution of favours, of forgetfulness! Why
so much curiosity about a picture and so little interest about
a great public life? There were here strong politicians, great
citizens, revolutions, *coups d'état*, torturings, martyrdoms,
controversies, rendings—everything that is found at the

birth of a people when this people belongs to another people from which it is breaking away, to a religion it is transforming, to a European political state from which it is separating itself, and which it seems to condemn by that very separation. All this is told in history; do the people remember it? Where do you find living echoes of these extraordinary emotions?

At that same time a young man was painting a bull in a field; another, to please a doctor friend, was painting him in the dissecting-room, surrounded by his students, his scalpel in the arm of a corpse (Pls. 88 and 60). In doing this they immortalized their names, their school, their century, and their country.

To what, then, belongs our gratitude? To that which is of most worth, to that which is most true? No. To that which is greatest? Sometimes. To that which is most beautiful? Yes, always. What, then, is beauty, that great lever, that great motive, that great magnet—that might be called the only attraction of history? Might it be nearer than anything else to the ideal towards which man, in spite of himself, has cast his eyes? And is the *great* attractive only because it can be more easily confused with the beautiful? We must be well advanced in morals or very strong in metaphysics to be able to say of a good action or of a truth that it is beautiful. The simplest man says it of a great action. At bottom we love naturally only that which is beautiful. Our imagination turns towards it, our sensibilities are stirred by it, all our hearts rush towards it. If we sought truly for what humanity, considered as a whole, is most touched by, we should see that it is not what interests, nor what convinces, nor yet what edifies it; it would be that which charms it or causes wonder.

So when an historical character has not introduced into his life this element of powerful attractiveness, he seems to lack something. He is understood by moralists and the learned, but unknown to other men. If the opposite happens, his memory is safe. A people disappears with its laws, customs, politics, and conquests; nothing remains of its history but a piece of marble or bronze—and this testimony suffices. There was a man, a

very great man by his enlightenment, his courage, political wisdom, public actions: perhaps his name would be unknown were he not embalmed in literature, and were it not for a sculptor friend whom he employed to decorate the frontals of temples. Another was a coxcomb, fickle, a spendthrift, very clever, a libertine, valiant at times: he is spoken of more often and more universally than Solon, Plato, Socrates, or Themistocles. Was he wiser or braver? Did he serve better truth, justice, his country's welfare? He has this charm above all, that he passionately loved the beautiful—women, books, pictures, and statues. Another was a poor general, a very ordinary politician, an unsteady head of a state; but he had this good fortune, that he loved one of the most enchanting women of history—and that woman was, they say, beauty itself.

About ten o'clock the rain began to fall. The night was close, the pool now gave back no perceptible reflections, like a remnant of twilight forgotten in a corner of the town. Renown did not appear. I know what can be objected to her preferences, and my intention is not to judge them.

CHAPTER XIII

THE *SUBJECT* IN DUTCH PICTURES

ONE thing strikes you when you study the moral basis of Dutch art—the total absence of what we call today *a subject*.

From the day when Dutch painting ceased to borrow from Italy its style and poetry, its taste for history, for mythology, for the Christian legends, to that moment of decline when it went back to Italy—from Bloemaert and Poelenburg to Lairesse, Philip van Dyck, and, later, Troost—there passed by nearly a century during which the great Dutch School seemed to think of nothing but of painting well. It was satisfied to look around and to do without imagination. The nude, which had no place in this depictment of actual life, disappeared. Ancient history was forgotten, and, strangest phenomenon of all, so was contemporary history! We scarcely

notice, so swamped are they by this vast number of *genre* pictures, a canvas like the 'Peace of Munster' by Terborch, or several war scenes represented by ships cannonading each other, as, for example, 'The Arrival of Maurice of Nassau at Scheveningen' (Cuyp, Six Gallery), a 'Departure of Charles II from Scheveningen' (2 June 1660) by Lingelbach—and this Lingelbach is not a very inspiring painter. The greater painters scarcely ever dealt with such subjects as these. And, indeed, outside the sea-painters, or the painters of pictures exclusively military in character, none seemed to have the ability to deal with such subjects. Van der Meulen, that fine painter, descended through Snayers from the Antwerp School, very Flemish though adopted by France, pensioned by Louis XIV and the historiographer of our French glories—Van der Meulen gave the Dutch anecdotal painters a very attractive example which was followed by no one. The great civic pictures by Ravesteyn, Hals, Van der Helst, Flinck, Karel Dujardin, and others are, as is well known, portrait pictures in which there is no action, and which, although they are historical documents of great interest, have no room for the history of their time.

If we recollect what great events the history of Holland in the seventeenth century contains, the seriousness of its military actions, the energy of this people of soldiers and sailors, its struggles, its sufferings; if we imagine the spectacle this country offers to our eyes in those terrible times, we are altogether surprised to see that painting can be to such a degree indifferent to that which was the very life of the people.

There was fighting abroad, on land and sea, on the frontiers and even in the heart of the country; in the interior they were rending each other. Barneveldt was beheaded in 1619, the brothers de Witt were massacred in 1672; at an interval of fifty-three years the struggle between the Republicans and the Orangemen was complicated by the same religious or philosophic discords—here *Arminians* against *Gomarites*, there *Vœtians* against *Cocceians*—and brought about the same

tragedies. There was continual war: with Spain, with England, with Louis XIV; Holland was invaded, and defended itself as is known; the Peace of Munster was signed in 1648, the Peace of Nimuegen in 1678, the Peace of Ryswyk in 1698. The War of the Spanish Succession opened with the new century, and it might be said that all the painters of this great peaceful school died without having spent a day in which the roar of the cannon was not heard.

What they were doing during that time their works show us. The portrait-painters were painting their great warriors, their princes, their most illustrious citizens, their poets, their writers, themselves, or their friends. The landscape painters dwelt in the fields, dreaming, drawing animals, copying huts, living farm life, painting trees, canals, and the sky, or they travelled; they set out to Italy, established a colony there, met Claude Lorrain there, forgot themselves in Rome, forgot their country, and died there, like Karel, without recrossing the Alps.[1] Others seldom left their studios except to ferret round the taverns or prowl about houses of ill-fame, to study their customs when they did not go in on their own account, which was rarely.

The war did not prevent people from living somewhere in peace; it was to this peaceable spot, indifferent, so to speak, that they brought their easels, here they sheltered their work, and pursued their meditations, their studies, their charming and pleasant task with surprising calmness. And, as everyday life still went on none the less, it was the domestic customs of private life, of the country and of the town, that they set about to paint in spite of everything, in the face of everything, to the exclusion of everything which caused the uneasiness, the anxiety, the patriotic efforts, and the greatness of their country. There is not a sign of trouble or anxiety in this sheltered world which we might take for the golden age of Holland, did not history inform us to the contrary.

The woods are calm, the roads safe, the boats come and go on the canals, the country shows are still held. People still

[1] See p. 375.

smoke on the thresholds of their huts, they still dance within, they still hunt and fish and go for walks. Little streams of smoke still rise silently from the roofs of the farm-houses, in which there is no appearance of danger. The children go to school, and inside the houses all is order and peace, the imperturbable feeling of security which belongs to blessed days. The seasons follow each other, people skate on the water they sailed upon; there is a fire on the hearth, the doors are closed, the curtains drawn: the harshness comes from the climate and not from men. It is always out of the regular course of things that nothing disturbs, and out of the permanent fund of little everyday facts, that good pictures are painted with so much pleasure.

When a painter skilled in equestrian scenes happens to show us a canvas in which there are charging horses, in which people are fighting with pistols or blunderbusses or swords, in which they are trampling on each other, or cutting each other's throats, or killing each other very quickly—all this butchering happens in places that are far away, the danger is remote; all savours of anecdotal fancy, and we do not see that the painter himself is greatly moved by it. It is the Italians, Berghem, Wouwerman, Lingelbach, the not-very-true-to-nature *picturesque* painters, who occasionally amuse themselves with all this. Where have they seen skirmishes? On this or that side of the Alps?

There is something of Salvator Rosa, without his style, in these poor imitations of skirmishes or of great battles, of which we can tell neither the cause, nor the epoch, nor the scene, nor really very clearly, either, the parties who have come to blows. The very title of the picture sufficiently shows how much it is due to the painter's imagination. There are in the Museum at The Hague two such great pictures, very fine and very sanguinary, in which blows fall thick and wounds are not spared. The one, by Berghem, a very valuable picture of astonishing execution, a veritable *tour de force* in its action, its tumult, the admirable order of its effect and the perfection of its details—a canvas by no means historical—has for its

title: 'Attack on a Convoy in a Mountain Defile'. The other, one of the largest pictures signed by Wouwerman, is entitled 'A Great Battle'. It reminds one of the picture in the Gallery at Munich, known by the name 'Battle of Nördlingen'; but there is nothing more explicit, and the historical national value of this very remarkable picture is no better established than that of Berghem's. Everywhere else there are pictures of brigandage or unknown encounters which were certainly not uncommon in their country, but which yet all have the appearance of having been painted from hearsay, during or after their travels in the Apennines.[1]

Dutch history, then, has counted for nothing or practically nothing in the painting of these troubled times, and does not seem to have agitated for a moment the minds of the painters.

Note, moreover, that even in their really anecdotic or picturesque painting we cannot see the least sign of anecdote. There is no well-determined subject, no action requiring a thoughtful, expressive, or particularly significant composition; no invention, not a scene that breaks the monotony of this country or town life, which is so dull, commonplace, devoid of learning, of passion, one might say of sentiment. Drinking, smoking, dancing, kissing the maids can scarcely be called either rare or attractive incidents. Milking cows, taking them to water, loading a cart with hay—these are not remarkable scenes in an agricultural country.

One is always tempted to question these indifferent, phlegmatic painters and to say to them: Is there then nothing new? nothing in your stables, nothing on your farms, nothing in your houses? There has been a high wind, did it do no damage? The thunder has roared and the lightning flashed, was nothing struck—neither your fields, your beasts, your roofs, nor your workmen? Children are born—are there no celebrations? They die—is there no mourning? You get married—are there no fitting rejoicings? Does no one ever weep in your country? You have all been in love, but how do we know? You have sorrowed, you have had compassion on the sufferings

[1] See pp. 374, 375.

of others; you have had before your eyes all the scars and sorrows, all the calamities of human life: where can we see that you had even one day of tenderness, of disappointment, of real pity? In your time, as in all others, there have been quarrels, passions, jealousies, deceptions of gallantry, duels— what do you show us of all this? A good deal of licentiousness, drunkenness, coarseness, sordid laziness, people embracing each other as if they were fighting, and here and there fisticuffs and sabot kicks, exchanged in the exasperation of love or drink. You love children: they are beaten, they scream, do dirty things in the corners—and there are your family pictures.

Compare epochs and countries. I do not speak of the contemporary German School nor of the English School, in which subject, delicacy, purpose are everything as in the drama, comedy, vaudeville—in which painting is too much imbued with literature since it lives on nothing else—and in the eyes of some people dies of it too; but take a French exhibition catalogue, read the titles of the pictures, and cast your eyes over the catalogues of the Museums at Amsterdam and The Hague.

In France every picture that has not its title, and which, consequently, has no subject, runs great risk of being accounted a work without conception or serious purpose. This is not a thing merely of today; it has lasted one hundred years. From the day when Greuze conceived the sentimental picture and, with the high approval of Diderot, conceived a picture as one would a scene for the stage, and painted the common drama of family life—from that day on what do we see? Has *genre* painting done anything since then in France but invent scenes, search history, illustrate literature, paint the past, a little of the present, very little of contemporary France, very often the peculiarities of foreign customs and climates?

It is sufficient merely to quote names in order to evoke a long series of stirring or beautiful pictures—ephemeral or famous, all with some meaning, all representing facts or sentiments, expressing passions or relating anecdotes—all with their principal character and hero—Granet, Bonington,

Léopold Robert, Delaroche, Ary Scheffer, Roqueplan, De-
camps, Delacroix, and I shall not mention the living ones.
Think of the many 'Francis I', 'Charles V', 'Duc de Guise',
'Mignon', 'Marguerite', 'Lion Amoureux', 'Van Dyck in
London'; all the pictures borrowed from Goethe, Shakespeare,
Byron, Walter Scott, the history of Venice—the 'Hamlets',
'Yoricks', 'Macbeths', 'Mephistopheles', 'Polonius', the
'Giaours', the 'Laras', and 'Goetz von Berlichingen', the
'Prisoner of Chillon', 'Ivanhoe', 'Quentin Durward',
'Bishop of Liége', and then the 'Foscari', 'Marino Faliero',
'Don Juan's Boat', and again the 'History of Samson', the
'Cimbres', at the head of the Eastern scenes. And since then
if we draw up a list of the *genre* pictures which have from year
to year charmed us, moved us, taken our fancy—from the
'Scenes of the Inquisition', the 'Conference of Poissy', to the
'Charles V at the Monastery of St. Yuste'—if we turned up,
I say, in these last thirty years all the most outstanding and
worthiest *genre* pictures the French school has produced, we
should find that the dramatic, pathetic, romantic, historical,
or sentimental elements have contributed almost as much as
the painter's talent to the success of his work.

Do you find anything like this in Holland? The handbooks
are hopelessly insignificant and vague: the 'Spinner and the
Flock'—that is what The Hague has to represent Karel
Dujardin; Wouwerman is represented by 'The Arrival at the
Hostelry', 'The Halt of the Huntsmen', the 'Riding School
in the Open', 'The Chariot' (a famous picture) (Pl. 93), an
'Encampment', the 'Huntsmen at Rest', etc.; and Berghem
by 'The Boar-Hunt', 'An Italian Ford' (Pl. 95), a 'Pastoral',
etc.; for Metsu there are 'The Huntsman', the 'Music Lovers';
for Terborch, 'The Despatch', and so on for Gerard Dou,
Ostade, Mieris, even for Jan Steen, the most wide-awake of all
and the only one who, in the deep or coarse meaning of his
anecdotes, is really original, an ingenious caricaturist, a
humorist of the family of Hogarth, who is a *littérateur*, almost
a comic writer in his facetiousness. The finest works are hidden
under the same platitudinous titles. That very fine Metsu at

the Van der Hoop Gallery is called 'The Hunter's Gift', and
no one will have any doubt that under the title of 'Rest by a
Barn' is an incomparable picture by Paul Potter—the pearl
of the Arenberg Gallery. We know the significance of Paul
Potter's 'Bull', 'The Cow looking at Itself', or—still more re-
nowned—'The Cow' at St. Petersburg. As for the 'Anatomy
Lesson' and the 'Night Watch', I must ask leave to think
that it was not the significance of the subjects that assured
them the immortality they have acquired.

Everywhere save in the Dutch School, they seem to have
all the gifts of heart and mind, sensibility, tenderness, generous
sympathies for the dramas of history, extraordinary experience
in those of life; they are pathetic, touching, interesting,
unforeseen, instructive. And the school which devoted most
of its time to the actual world seems to be that one among
them all which has least recognized the moral interest; and,
again, that one which gave itself up most passionately of all
to the study of the picturesque seems less than any other to
have perceived its living sources.

What motive had a Dutch painter in painting a picture?
None. And notice that he is never asked for one. A peasant
with a drunken red nose looks at you with his heavy eye and
laughs with open mouth showing his teeth, raising a jug; if it
is well painted it has its value. With us, when there is no subject
at least its place must be filled by a keen, a true sentiment, and
by the felt emotion of the painter. A landscape that is not
deeply tinged with the colour of a man is a failure. We cannot,
like Ruysdael, paint a picture of perfect rareness with foaming
water dashing down between brown rocks. A beast in the
field which *has not its idea*, as the peasants say of the instincts
of animals, is not a thing to paint.

A very original painter of our day, of rather lofty soul,
of sad temperament, of good heart, of genuinely rural sym-
pathies, has said about the country and country people, about
the hardness, the melancholy, and the nobleness of their work,
things that would never have entered a Dutchman's head. He
has said them in rather barbaric language and according to

formulae in which the thought has greater vigour and concise-
ness than the hand. We have been infinitely obliged to him
for his tendencies; in them we have seen, in French painting,
almost the feeling of a Burns less skilful at making himself
understood. Taking everything into consideration, has he
painted and left behind him fine pictures, or not? His form,
his language—I mean that external covering without which
the works of the mind cannot be or live—has it the qualities
necessary to consecrate him a fine painter, and assure for him
that he will live long? He is a deep thinker by the side of Paul
Potter and of Cuyp—an attractive dreamer compared with
Terborch and Metsu; he has something, I cannot tell what, that
is incontestably noble when we think of the trivialities of
Steen, Ostade, or Brouwer; as a man he can put them all to
shame, but as a painter, is he as good as they?[1]

What conclusion is to be drawn from this, you ask?

In the first place is it very necessary to draw any conclusion?
France has shown a great deal of inventive genius, but little
real faculty for painting. Holland has not imagined anything,
but it has painted miraculously well. That, truly, is a great
difference. But does it follow from this that we absolutely
must choose between qualities which distinguish one people
from another, as if there were between them some contra-
diction which renders them irreconcilable? I do not quite
know. Up to now thought has sustained only great works
of art. In diminishing itself in order to enter into works of an
average order, all virtue seems to have gone out of it.

Feeling has been the salvation of some, curiosity has spoilt
a great number, mind has ruined them all.

Is this the conclusion we must draw from the preceding
observations? Certainly another could be found, but for the
moment I cannot see it.

[1] See p. 365.

PAUL POTTER

WITH the 'Anatomy Lesson' and the 'Night Watch', the 'Bull' of Paul Potter is the most celebrated picture in Holland (Pls. 88–9). The Museum at The Hague owes to it a great deal of the curiosity of which it is the object. It is not the largest of Paul Potter's paintings, but at least it is the only one among his great pictures which deserves serious attention. The 'Bear Hunt' of the Museum at Amsterdam, if it is authentic, even when freed from the repaintings which disfigure it, was never anything but the extravagance of a young man, the greatest mistake he ever made. The 'Bull' is priceless. Judging it by the ordinary valuation of Paul Potter's works it would realize in the auctions of Europe a fabulous price. Is it then a fine picture? Not at all. Does it deserve the importance attached to it? No doubt about that. Is Paul Potter then a great painter? Very great. Does it follow, then, that he paints as well as people think? Not precisely. There is a misunderstanding about this, which it is well to clear up.

The day on which this fictitious sale by auction of which I speak would open, that is, the day when the merits of this famous work would be discussed without reserve, if any one dared to speak the real truth, he would say something like this:

'The reputation of this picture is at once greatly overestimated and very legitimate: there is something equivocal about it. It is considered an exceptional piece of painting, and that is wrong. It is supposed to be an example to be followed, a model to be copied, from which ignorant generations may learn the technical secrets of their art. In that again they made a great mistake. The work is ugly and without conception; the painting is monotonous, thick, heavy, wan, and dry; the composition is of the poorest. Unity is wanting in this picture, which begins no one knows where, which does not end, which receives light without becoming lit up, distributes it

anyhow—it comes from everywhere, and leaves the frame, so entirely is it without relief. It is too full and yet not occupied. Neither its lines, nor its colouring, nor the distribution of effect gives it those primary conditions of existence indispensable to all work that lays any claim to composition. The animals are ridiculous. The tawny cow with a white head is made up of some hard material. The ewe and the ram are moulded in plaster. As for the shepherd, no one defends him. Two parts only of this picture seem made to suit each other—the vast sky and the huge bull. The cloud is in its right place, it is light where it should be, and is likewise coloured where it is suitable, according to the requirements of the principal object, whose aim it is to accompany and to bring out the relief. By a wise understanding of the law of contrasts, the painter has diminished the lights and shades of the animal. The darkest part is placed in opposition to the light of the sky, and that which is most energetic and in deepest relief in the beast to that which is most limpid in the atmosphere; but that is scarcely a merit when we consider the simplicity of the problem. The rest is *hors d'œuvre* which we might well take away without regret and to the great improvement of the picture.'

That would be brutal but just criticism. And yet public opinion, less punctilious or more clear-sighted, would say that the signature was well worth the price.

Public opinion is never altogether wrong. By uncertain paths—often not the best chosen—it arrives at last at the expression of a true sentiment. When it takes sides with any-one its motives are not always the best, but always some other good reasons are found which justify its attachment. It makes mistakes about desert, sometimes mistakes faults for good qualities; it values a man for his method, and that is the least of his merits; it thinks that a painter paints well when he paints badly and because he paints with great detail. What surprises us in Paul Potter is the imitation of things carried to a fault. One does not know or does not notice that in such a case the painter's soul is worth more than the work and that the manner of feeling is infinitely superior to the result.

When he painted the 'Bull' in 1647, Paul Potter was not yet twenty-three years of age. He was a very young man; judging by what most young men are at twenty-three he was a mere child. To what school did he belong? To no school. Had he had any masters? We do not know him to have had any save his father, Pieter Simonsz Potter, an obscure painter, and Jacob de Wet (of Haarlem), who were neither of them strong enough to have any influence on the young painter either for good or evil. Paul Potter, then, at home and in the studio of his second master, heard only simple words of advice and no doctrines whatever; extraordinarily enough the pupil wished for nothing better. Until 1647 Paul Potter lived between Amsterdam and Haarlem; that is to say, between Frans Hals and Rembrandt, in the most active centre of art— the most stirring, the richest in celebrated masters which ever existed in the world save in Italy the century before. Professors were not wanting; he had but an embarrassment of choice. Wijnants was forty-six years of age, Cuyp forty-two, Terborch thirty-nine, Ostade thirty-seven, Metsu thirty-two, Wouwerman twenty-seven, Berghem, about Potter's own age, was twenty-three.[1] A number of the younger ones were members of the Saint Luke *confrérie*. And the greatest of them all, the most illustrious, Rembrandt, had already produced the 'Night Watch', and was a master who offered some temptation.

What became of Paul Potter? How did he isolate himself in this teeming and rich school in which practical skilfulness was very great, talent universal, manner of rendering a trifle too similar, and yet—a delightful thing in its best moments—the manner of feeling was very individual? Had he fellow-workers? We cannot see that he had, nor do we know his friends. He was born—that is the only accurate fact we know about him, and in what year. He revealed his ability early. At the age of fourteen he signed a charming engraving; at twenty-two, though ignorant in many points, he yet in some showed unexampled maturity. He worked and produced picture after picture; some were admirable. He accumulated them in

[1] See p. 372.

several years with haste and abundance, as if death were dogging him, yet with a diligence and patience which make this prodigious work a thing miraculous. He married, young for another, yet old for him, on 3 July 1650; and on 4 August 1654, four years afterwards, death took him in all his glory, but before he had learned all his handicraft. What could be simpler, shorter, more complete? Genius without instruction, hard study, an ingenuous and learned product of attentive observation and of reflection; add to this great natural charm, the gentleness of a meditative mind, the diligence of a most scrupulous conscience, the sadness inseparable from lonely work, and perhaps that melancholy natural to ill health, and you will have Paul Potter.

In virtue of all this the 'Bull' at The Hague represents him perfectly—charm alone excepted. It is a great *study*—too great from a common-sense point of view, but not too great for the research of which it was the object, nor for the instruction the painter derived from it.

Remember, when you compare Paul Potter with his brilliant contemporaries, that he knew none of the devices of his handicraft: I say nothing of the tricks which he, in his candour, never suspected. His special studies were forms and aspects in their naked simplicity. The smallest artifice was something that would have embarrassed and hindered him, for it would have spoilt his clear vision of things. A great bull in a vast plain, a great sky, and, so to speak, no horizon—what better opportunity could be found for a student to learn once for all a great number of very difficult things, and to know them, as we say, by rule and by measure? The movement is simple; none was needed; the attitude is true to nature, the head admirably lifelike. The animal is its right age, correct in type, in character and temperament, in length and height, in joint, bone and muscle, in rough and smooth, short and curly hair, in loose and tight skin—the whole is done to perfection. The head, the eye, the neck and shoulders, the breast and forelegs are, from a simple and strong point of view, a very rare piece of work—perhaps, even, one without equal. I am

not saying that the subject is beautiful, nor that the colouring is well chosen; subject and colouring are here too clearly subordinated to pre-occupation with form for us to be able to ask much under this heading when the painter has given all or nearly all under another. Moreover, the very tone and the labour in these very violently observed parts succeed in making nature what it really is, in its relief, its fine shades, its power, even, almost, in its mystery. It would be impossible to have a more circumscribed and more explicit aim, and to attain it with more success. We say the 'Bull' of Paul Potter; that is not enough, I assure you: we might say the 'Bull', and that would be to my mind the greatest praise we could offer to this piece of work, mediocre in its feeble parts and yet so decisive.

Nearly all Paul Potter's pictures are like that. In most of them he has set out to study some physiognomic accident of nature or some new branch of his art, and you may be certain that on that very day he succeeded in putting on the canvas at once whatever he set out to learn. The 'Meadow' at the Louvre— of which the principal object, the ruddy-grey ox, is the reproduction of a study which must have served him many a time— is at once a feeble or a very strong picture according as it is looked upon as the painting of a master or as the exercise of a pupil. The 'Meadow with Animals' of The Hague Museum, 'The Shepherds and Their Flock', the 'Orpheus Charming the Animals' of the Amsterdam Museum, is, each in its kind, an occasion for studies, a pretext for studies, and not, as one might be tempted to believe, one of those conceptions in which the imagination plays the least possible part. They are animals examined at close quarters, grouped without much art, drawn in simple attitudes or in difficult positions of foreshortening—they never provide any very complicated or striking effect.

The workmanship is meagre, hesitating, sometimes laboured. The touch is a trifle childish. Paul Potter's extraordinarily exact eye, whose penetrating energy nothing could tire, took in every detail, scrutinized, expressed all too carefully, never

became confused, but never ceased work. Paul Potter knew not the art of sacrifice, nor did he yet know that things must sometimes be taken for granted, sometimes be summed up. You know how insistent he was with his brush and the desperate embroidery that he used in depicting the compact foliage and the thick grass of the meadows. His talent as a painter grew out of his talent as an engraver. Even to the end of his life, in his most perfect works, he never ceased to paint as if he were engraving. The tool became more supple and lent itself to other uses; under his heaviest painting one can still detect the fine point, the sharp groove, the biting touch. It was only gradually and with an effort, by a continued and entirely individual education, that he succeeded in manipulating his palette like everybody else; from the moment he succeeded, he excelled.

We may, by choosing certain of his pictures between the dates 1647 and 1652, follow the movement of his mind, the significance of his studies, the nature of his researches, and, at a given hour, the almost exclusive preoccupation to which he was giving himself up. We should thus see the painter gradually separating himself from the draughtsman, the colour becoming determined, the palette more skilfully composed, and lastly, chiaroscuro spontaneously appearing as a discovery for which this innocent mind owed nothing to anyone.

That collection of animals gathered around a charmer in doublet and high boots, playing the lute—that piece called 'Orpheus'—is the ingenious effort of a young man ignorant of all the secrets of his school, who is studying the varied effect of half-tint on the colouring of animals' coats. It is weak, yet it shows great knowledge; the observation is accurate, the execution timid, the aim delightful.

In the 'Meadow with Animals' the result is still better, the representation is excellent, the workmanship alone persists in its childish evenness.

The 'Cow Looking at Itself' (Pl. 90) is a study of light—of full light—done at about noon on a fine summer's day. It is a

very famous picture, and, you may believe me, extremely weak, disconnected, confused with a yellowish light which, though studied with the greatest patience, has little interest or truth, is full of uncertainty in its effect, very evidently laboured. I should omit this schoolboy's exercise, one of his least successful, if, even in this fruitless effort, we did not recognize the admirable sincerity of a seeking mind which does not know all, wishes to know all, and is the more intent upon this as its days are numbered.

In compensation, without leaving the Louvre and the Low Countries, I shall mention two pictures by Paul Potter that show him to be a consummate painter, which are certainly *works* in the highest and rarest sense of the word; and, a remarkable thing, one of them was painted in 1647—the year in which he signed the 'Bull'.

I mean the 'Little Inn' at the Louvre, catalogued under this title: 'Horses at the Door of a Cottage' (No. 2526). It is an evening scene. Two horses unfastened, but harnessed, are standing in front of a water-trough; one is bay, the other is white; the white one is emaciated. The carter is just coming back from the river where he has been for water; he is climbing up the bank, one arm upstretched and holding a bucket in the other hand; he stands out in a soft silhouette against a sky reflecting the beams of the sun which has sunk below the horizon. It is unique in its sentiment, its drawing, in the mystery of its effect, the beauty of its tone, and the delightful and ingenious intimacy of the labour.

The other one, done in 1653, the year before Paul Potter's death, is a wonderful masterpiece from every possible point of view—composition, picturesque masses, acquired knowledge, persistent artlessness, firmness of drawing, power of workmanship, accuracy of eye, and charm of touch. The Gallery of the Duke of Arenberg, which possesses this jewel, has nothing more precious. These two incomparable pieces would prove, if you look at them alone, what Paul Potter meant to do—what he would have done with more amplitude if he had had the time.

Thus it is said that whatever Paul Potter learned from experience he owed to himself alone; he was learning from day to day—every day; the end came, let us not forget, before he had finished learning. Just as he had had no masters, so he had no pupils. His life was too short to contain any teaching. Besides, what would he have taught? The way to draw? That is an art one may give counsel upon, but scarcely teach. Composition and the science of effects? He hardly even suspected this to his last day. Chiaroscuro? It was taught in all the studios of Amsterdam much better than he practised it himself—for it was a thing, as we have said already, that the sight of the Dutch countryside had revealed to him only at last and rarely. The art of setting up a palette? We see the trouble he had in making himself master of his own. And as for skill in the execution, he was no better fitted to give counsel about it than were his works to give proof of it.

Paul Potter painted fine pictures which were not all fine models. He gave, rather, good examples, and his whole life was one excellent counsel.

More than any other painter of this straightforward school, he stood for simplicity, patience, circumspection, persevering love for what is true. These precepts were perhaps the only ones he had received, and most certainly they were the only ones he could transmit. All his originality comes from that, and so does his greatness.

He had a decided liking for country life, an open mind, calm, stormless, no nerviness, a profound and wholesome sensibility, an admirable eye, a sense of proportion, a taste for clearly defined things, skilful balance in form, exact relationship between masses, an instinct for anatomy; lastly, he was a constructor of the first order; in short, he showed in everything that virtue which a master of our own day has called the *honesty of talent*; an inborn preference for drawing, but such an appetite for what was perfect that, later on, he confined himself to painting well and that already he succeeded in painting excellently; an astonishing division of labour, an imperturbable coolness in effort, an exquisite nature, judging

by his sad and suffering face—such was this young man,
unique in his time, unique always, happen what may, and
such he appears from his first gropings to his masterpieces.

What a rare treat to come upon a genius—sometimes a
talentless genius—and what good fortune to be able to admire
to such a degree a simple man who had nothing in his favour
but fortunate birth, a love for truth, and a passion for the
highest!

CHAPTER XV

TERBORCH, METSU, AND PIETER DE HOOCH AT THE LOUVRE

WHEN one has not visited Holland, yet knows the Louvre,
is it possible to form an accurate idea of Dutch art? Very
certainly. With a few rare gaps, where a certain painter is
almost unrepresented, or another is not represented in his best
style—and the list of these would be short—the Louvre offers
us, of the school as a whole, of its genius, character, perfections,
of its diversity in kind (with the exception of pictures of
corporations and *regents*), an almost decisive historical view, and
therefore an inexhaustible fund of matter for study.

Haarlem has a painter of its own of whom we knew nothing
but the name, until he was very recently revealed to us by
springing into clamorous and well-deserved favour. That man
is Frans Hals, and the tardy enthusiasm of which he is the object
was scarcely understood outside Haarlem and Amsterdam.

Jan Steen is not much better known to us. He is a not very
attractive spirit, with whom one must keep company in his
own territory, who must be cultivated at close quarters, with
whom you must have much converse not to be too shocked
at his brilliant sallies and licences—he is not so giddy as he
looks, less coarse than one would think, very unequal, for he
painted at all times and seasons—after drinking as before

(Pl. 102). In fine, it is good to know what Jan Steen was worth when he was fasting and the Louvre gives us only a very imperfect idea of his temperance and great talent.

Jan van der Meer is practically unknown in France (Pl. 96), and since he has some points of view which are rather strange even in his own country, a journey would not be without its use to one who cared to inform himself upon this peculiarity of Dutch art. Beyond these discoveries and a few others of little value there are no notable ones outside the Louvre and its branches—I mean by this certain French collections which have the value of museums on account of the beautiful examples they contain. One might say that Ruysdael painted for France, so numerous are his works there, so clear is it today that he is appreciated and respected. To get at the native genius of Paul Potter or the expansive power of Cuyp, some effort of induction would perhaps be necessary; but it can be arrived at. Hobbema might have painted nothing but the 'Mill' at the Louvre; he would certainly gain by being known only by this masterpiece (Pl. 81). As for Metsu, Terborch, the two Ostades, and above all, de Hooch, you might see them at Paris and that would be almost enough.

I have thought, too, for a long time—and this is an opinion which is confirmed here—that someone would do us a great service by writing a description of a journey round the Louvre —or merely one round the *salon carré*—nay, even just round a few pictures, among which might be chosen, I suppose, the 'Visit' by Metsu, the 'Soldier' and the 'Young Woman' by Terborch, and the 'Dutch Interior' by Pieter de Hooch (Pls. 99–101).

Assuredly this would be, without going very far, an original exploration, and a very instructive one in these days. An enlightened critic, who would take upon himself to reveal to us all that these three pictures contain, would cause great astonishment by the abundance and novelty of his exposition. We should be convinced that the most modest work of art might serve as a text for long analyses, that its study is a labour in depth rather than in extent, that it is not necessary to extend

its limits in order to increase its significance, and that there
are very great laws in a little object.

Who has ever defined in its intimacy the manner of these
three painters—the best, the most skilful draughtsmen in the
school, at least in the matter of figures? The 'Lansquenet' of
Terborch, for example (Pl. 101), that big man in war harness,
with his breastplate, his buff leather doublet, his great sword,
his funnel-shaped boots, his felt hat on the ground, his big face
illuminated, ill-shaven, a trifle moist with perspiration, with
his oily hair, his little watery eyes, and his large hand, fat and
sensual, in which he holds out pieces of gold, the very attitude
of which tells us what manner of man he is and the object
of his visit; this figure, one of the finest Dutch pieces we have
at the Louvre—what do we know of it? We have indeed been
told that it was painted from very nature, that the expression
was most true, that the painting of it was excellent. *Excellent*
is not very conclusive, it must be admitted, when it is a
question of the why and wherefore of things. Why excellent?
Is it because nature is so well copied in it that we seem to
catch it in the act? Is it because no detail is omitted? Is it because
the painting is smooth, simple, clean, limpid, pleasant to look
upon, easy to understand, and that it is not faulty in any
respect—in minutiae or carelessness? How does it come to pass
that ever since people practised painting costumed figures, in
their familiar acceptation, posed, and certainly posed to the
painter, no one has ever drawn or modelled or painted like
that?

Where can you see the drawing, unless in the result—
which is quite extraordinary in its truth to nature, its accuracy,
its amplitude, its delicacy and reality without excess? Can you
find a trait, a contour, an emphasis, a gradation, that tells of
instruments and of measurings? The perspective of those
shoulders, that long arm so well set in its sleeve and resting on
the thigh, that big rotund body, laced high, so well-defined
in its thickness, so softened in its exterior outlines; those two
supple hands which, enlarged to the scale of nature, would
have the extraordinary appearance of a moulding—do you not

think that all this was cast, at one stroke, in a mould which bears hardly any resemblance to the angular, timid or pre-sumptuous, uncertain or geometrical lines, in which drawing is usually confined nowadays?

Our time takes to itself the credit—and rightly—of counting among its painters some tried observers who draw strongly, delicately and well. I shall mention one who, physiognomic-ally, draws an attitude, a movement, a gesture, a hand in its perspective, its framework, its action and contractions, in such a way that, by this merit alone—and he has greater ones than this—he would be an uncontested master in our present school. Compare, if you please, his fine, expressive, energetic pencil with the almost impersonal drawing of Terborch. Here, you will perceive formulae, a science that can be possessed, an acquired knowledge that helps examination, sustains it at need, takes its place, and, so to speak, tells the eye what it should see, the mind what it should feel. There, nothing of the kind: an art which adapts itself to the nature of things, a knowledge that is forgotten in presence of special circumstances in life, nothing preconceived, nothing which precedes the simple, strong and sensitive observation of what is; so that one might say of the great painter of whom I speak that he *has a manner of drawing*, while it is impossible to perceive at the first glance what the manner of drawing is in the works of Terborch, Metsu, or Pieter de Hooch.

Turn from one to the other. After having examined the gallant weather-beaten soldier of Terborch, turn to that thin-looking personage, a trifle stiff, of another world and another epoch, who presents himself rather ceremoniously, standing, and saluting as a man of rank, that delicate-looking woman with thin arms and nervous hands, who is receiving him into her house and sees no harm in it (Pl. 100). Then pause before the 'Interior' of Pieter de Hooch (Pl. 99); go into this deep picture, stuffy and shut up, in which the light is so sifted, in which there is a fire, a silence, an appearance of comfort, a pleasant mystery—and notice, near to the woman with bright eyes, red lips, dainty teeth, that big boy, rather foolish looking,

who reminds us of the son of Molière's M. Diafoirus, standing straight up on his spindle shanks, awkward in his big stiff clothes, so strange with his rapier, so awkward in his false balance, so right for the part he plays, so marvellously created that we cannot forget him. Here again is the same hidden art, the same impersonal drawing, the same incomprehensible mixture of nature and art. There is not an inkling of any set purpose in this expression of things—so ingenuously sincere that no formula for it could be found, no *knack*, which means, in the language of the studio, no bad habits, no ignorance affecting capability, and no mania.

Make an attempt, if you can use a pencil; copy the outline of these three figures; try to *put them in place*; set yourself the difficult task of extracting from this undecipherable painting what might be called its drawing. Try it likewise with the modern draughtsmen, and perhaps, without any further information, you will discover for yourself, by succeeding with the moderns and failing with the ancients, that there is an abyss of art between them.

The same astonishment will seize you when you study the other parts of this exemplary art. The colouring, the chiaroscuro, the modelling of solid surfaces, the play of the encircling air, lastly, the workmanship—that is to say, the operations of the hand—everything is perfection and mystery.

Taking the workmanship only superficially, do you think that it resembles at all what has been done since? And do you consider that we have improved or not on this manner of painting? In our time, is it for me to say? It must be one of two things: either we paint carefully and not always very well, or we put more trickery into it and scarcely paint at all. It is heavy and summary, reasoned and witty and careless, sensitive and very shirked, or else it is conscientious throughout, rendered according to the laws of copying; and no one, even those who practise it, will dare to say that this painting is any more perfect for being more scrupulous. Each one makes to himself a craftsmanship after his own taste, his degree of ignorance or education, the heaviness or refinement of his

nature, according to his physical or moral complexion, according to his temperament, according to his nervous system. We have renderings that are lymphatic, nervous, robust, debilitated, fiery or steady, impertinent or timid; some only virtuous, in which case people call them tiresome; and some exclusively sensitive, in which case they are said to have nothing in them. Briefly, so many individuals, so many styles and formulae as to drawing, colouring, and as to the expression of all the rest by the action of the hand.

There are some rather heated discussions as to which of these diverse painters is right. In all conscience no one is precisely wrong, but facts clearly prove that no one is entirely right.

The truth which would set us all at one still remains to be demonstrated; it would consist in determining that there is in painting a handicraft which can be learnt, and which, consequently, can and should be taught, an elementary method which equally can and ought to be transmitted—that this handicraft and method are as necessary in painting as the art of speaking well and writing well are for those who use the word and the pen—that there is no objection to these elements being common to us all, that to pretend to distinguish one's self by the coat when one cannot be distinguished by himself, is a poor and vain way of showing that one is somebody. Long ago it was just the contrary, and the proof is in the perfect unity of the schools in which the same family likeness is found in very different and lofty personalities. Well, this family likeness came to them from a simple, uniform, intelligent, and, as we can see, most salutary education. Now what was this education of which we have not a single trace left?

That is what I could wish might be taught—what I have never heard said from a professor's chair, nor in a book, nor in a course of aesthetics, nor in oral lessons. It would be one more professional teaching at a time when nearly all professional lessons are given us save this one.

Do not let us weary ourselves studying together these fine models. Look at this flesh, these heads, hands, bare throats: take notice of their softness, their fullness, their very true

colouring—almost colourlessness, their compact fine texture, so close yet not too close. Examine likewise the apparel, the satins, furs, stuffs, velvets, silks, felt hats, feathers, swords, the gold, the embroidery, the carpets, the beds with tapestry hangings, the floors so perfectly smooth, so perfectly solid. See how everything is alike with Terborch and Pieter de Hooch, and yet how everything differs—how the hand behaves in the same way, how their colours have the same elements, and yet how, here, the subject is dissimulated, elusive, veiled, profound, how the half-tints transform, cast into shadow, put all the parts of this admirable canvas into perspective, how they give everything its mystery, its spirit, a meaning that can be better grasped, a warmer and more inviting intimacy—while with Terborch things take place with less secret practice; the true light is everywhere; the bed is scarcely dissimulated by the dark colour of the tapestry, the relief is natural, firm, full, shaded with simple tones, little transformed, only chosen, so that colour, framework, evidence of tone, evidence of form, evidence of fact—everything unites to show that with such persons there should be neither windings nor circumlocutions nor half-tints. And recollect that in Pieter de Hooch as in Metsu, in the most reserved as in the most communicative of these three famous painters, you will always distinguish one element of sentiment, which is proper to each, which is his secret, and another of method and education received, which is common to them, and which is the secret of the school.

Do you think that they colour well, one preferring grey, the other brown or dark gold? Do you consider that their colouring has not more brilliancy than ours for all that it was duller, more richness for all that it was more neutral, more power for all that it had less visible strength?

When by chance you find, in an old collection, a modern *genre* picture, though it should be of the best and one of the finest conceived in every respect, it is, if you will let me use the word, something like a *print*—that is to say, a painting which tries to look coloured and is not coloured enough,

which tries to be painted and is fading, which tries to look
solid and does not always succeed either by its heaviness when
it is thick or by the glossiness of its surface when, by chance,
it is thin. What is the meaning of this, for it is enough to cause
consternation among men of instinct, sense, and talent who
happen to be struck by these differences?

Are we much less endowed with talent? Perhaps. Less
inquiring? Quite the contrary. We are, above all, not so
well taught.

Let us suppose that, by a miracle not sufficiently in demand,
and which, were it prayed for as it should be, would never
take place in France—a Metsu or a Pieter de Hooch were born
again in our midst, what seed he would sow in the studios and
what a rich and generous soil he would find to grow good
painters and fine works in! Our ignorance, then, is extreme.
We might say that for a long time the art of painting has been
a lost secret, and that the last masters of great experience who
practised it took the key away with them. We need it, we ask
for it, no one has it any longer; we look for it and it cannot
be found. The result is that the individualism in method is
nothing more, really, than the effort of each to imagine what
he has not learned; that in certain skilful practice we can see
the laboured efforts and expediences of a mind in difficulty;
and that nearly all the so-called originality of modern practices
covers incurable uneasinesses. Would you have an idea of the
investigations of those who search and of the truths that we
bring to light after prolonged efforts? I shall give only one
example.

Our pictorial art—historical subjects, *genre* pictures, land-
scapes, still life—has been complicated for a long time by a
very fashionable question which deserves indeed our attention,
for its object is to give back to painting one of its most delicate
and necessary means of expression. I mean the question
of *values*.

By this word of rather vague origin, of obscure meaning,
is understood the amount of light or dark that is found in a
tone. Expressed in drawing or engraving, the shade is easily

perceived: such and such a black will have, in relation to the paper which represents the unity of lightness, more value than such and such a grey. Expressed in colour, it is an abstraction not less positive but less easy to define. Thanks to a series of not very profound observations, and to an analytical operation well known to chemists, we can extract from a given colour that element of light or of shade that combines with its colouring principle, and scientifically we come to consider a tone under the double aspect of colour and of value, so that, in a violet for example, we must not only calculate the quantities of red and blue which may multiply the shades *ad infinitum*, but take into account the quantity of light or of strength which brings it near either to the unity of lightness or to the unity of darkness.

The interest of this inquiry is this: a colour does not exist of itself, for it is modified, as we know, by the influence of a neighbouring colour. All the more, then, has it neither virtue nor beauty in itself. Its quality comes to it from its surroundings—called also its complementaries. We can thus, by means of contrasts and favourable oppositions, give it very diverse characters. To colour well—I shall say it more definitely elsewhere—is either to know or to feel by instinct the necessity of these oppositions; but to colour well is, besides and above all, to know how skilfully to oppose the values of the tones. If you take away from a Veronese, from a Titian, or from a Rubens this accurate relationship of the values in their colouring, you will have nothing left but an unharmonious mass of colour without strength, without delicacy, without rareness. In proportion as the colouring principle diminishes in a tone, the element, value, predominates. If it comes to pass, as it does in the half-tones in which all colour pales, as in the pictures of exaggerated chiaroscuro in which all shade vanishes, as in Rembrandt, for example, in whom at times everything is monochromous—if it happens, I say, that the element of colouring disappears almost entirely, there remains on the palette a neutral principle, subtle and yet actual, the abstract value, so to speak, of the things that have disappeared, and it

is with this negative principle, colourless, infinitely delicate, that the rarest pictures are sometimes made.

These things—dreadful to tell in French, and the exposure of which is really allowed only in a studio with closed doors— I have had to mention or I should not have been understood. Now this law, which it is a question of putting in practice today—don't think that it has just been discovered; it has been found again among some old forgotten pictures in the archives of the art of painting. Few painters in France have had the conscious feeling of it. There were whole schools which had no idea of it, did without it, and were not the better off for that, as can be seen now. If I were writing the history of French art in the nineteenth century I should tell you how this law has been now observed, now unnoticed, who was the painter who used it, who was he that knew it not, and you would have no difficulty in agreeing that he was wrong not to know it.

An eminent painter, too much admired for his technique, who will live, if he does live, by the depth of his sentiment, by some very original flights, and by a rare instinct for the picturesque—above all, by the perseverance of his efforts— Decamps—never troubled to know that there were values on a palette; this is an infirmity which is beginning to strike the more knowing spirits, and to greatly trouble the fastidious ones. I will tell you, too, to what sagacious observer the modern landscape painters owe the best lessons they have learned; how, by special grace, Corot—that sincere soul, so essentially a lover of the simple—had a natural *sense* of the values in all things, studied them better than anyone else, established their laws, formulated them in his works, and gave of them from day to day happier and happier proofs.

This, henceforward, will be the principal care of all those who seek, from those who seek in silence to those who seek more noisily and under eccentric names. The doctrine which is called *realist* has no other real basis than a saner observation of the laws of colouring. We must certainly submit to the evidence and recognize that there is something of good in these aims, and that if the realists knew more and painted

better, there are among their number some who would paint very well. Their eyes, in general, catch very accurate glimpses, their feelings are particularly delicate, and, singularly enough, the other parts of their handicraft are no longer delicate at all. They have some of the rarest faculties; they lack what ought to be the most common; so much so, that their qualities, which are great, lose their value through not being employed as they ought to be, so that they have the appearance of revolutionaries because they pretend only to admit the half of the necessary truths, and so that they are both very near to and very far from being strictly right.

All this was the A B C of Dutch art—it ought to be the A B C of our own. I don't know what was, to speak doctrinally, the opinion of Pieter de Hooch, of Terborch, and of Metsu on values, nor what name they gave to it, nor yet whether they had a name to express the shading, relativity, softness, smoothness, subtlety in their relations, that colours should have. Perhaps colouring in its entirety implied at once all these qualities, whether positive or impalpable. At any rate the life of their work and the beauty of their art are due precisely to the wise use of this principle.

The difference that separates them from modern attempts is this : in their time they attached a great value and meaning to chiaroscuro only because it seemed to be the vital element of all well-conceived art. Without this artifice—in which imagination plays the principal part—there was no more fiction, so to speak, in the reproduction of things, and consequently the man absented himself from his work, or at least no longer participated in it at the moment in his labour when his sensibility ought especially to intervene. The daintiness of a Metsu, the mystery of a Pieter de Hooch, are due, as I have told you, to there being a great deal of air around the objects, many shades around the lights, much softening of the vanishing colours, a great deal of transposition of the tones, much purely imaginary transformation of the aspects of things—in a word, the most marvellous use ever made of chiaroscuro, or, in other terms, the most judicious application of the law of values.

Today the contrary holds. Every value that is a little rare, every colour carefully observed, seems to have as its object the abolishment of the chiaroscuro and the suppression of the air. What served before to unite now only serves to disconnect. All painting called original is a patchwork, a mosaic. The abuse of unnecessary rounding has thrown into excess smooth surfaces, bodies without thickness. Form disappeared on the very day when the means of expressing it seemed improved and was to have made it more erudite; so that what was an advance for the Dutch is for us a step backwards, so that, after having left archaic art under the pretext of innovating further, we are returning to it.

What shall we say to that? Who will show us the error into which we have fallen? Clear, impressive lessons—who will give us them? There would be a safer expedient—to paint a fine work which should contain all the ancient art, with the modern mind, which should be the nineteenth century and France, which should resemble, trait for trait, a Metsu, and yet should not allow it to be seen that the painter had him in mind.

CHAPTER XVI

RUYSDAEL

Of all the Dutch painters Ruysdael is the one who bears the most noble resemblance to his country. He has its amplitude, its sadness, its rather gloomy placidity, and its monotonous and tranquil charm.

With tapering lines, a severe palette, in two great expressly physiognomic traits—grey limitless horizons, grey skies, skies which vie with infinity—he must have left us a portrait of Holland; I will not say a familiar one, but an intimate portrait, attractive, admirably faithful and one which does not grow old. By other claims, too, Ruysdael is, I certainly think, the greatest figure of the school after Rembrandt; and that is no small glory for a painter of so-called still landscape

who never painted a living soul—at least not without the help of someone else.

Consider that, taking him bit by bit and in detail, Ruysdael would perhaps be inferior to a number of his fellow-country-men. In the first place he is not adroit at a time and in a class of painting in which skill was the current coin of talent, and perhaps it is to this want of dexterity that he owes the attitude and the ordinary burden of his thought. Neither is he very clever. He paints well, and does not affect any originality in his work. What he wishes to say he says clearly, with accuracy, but as if slowly, without hidden meanings, vivacity, or archness. His drawing has not always the sharp and incisive character, the eccentric accent proper to certain pictures by Hobbema.

I do not forget that at the Louvre, in presence of the 'Water Mill' of Hobbema (Pl. 81), an excellent work, which, as I have told you, has not its equal in all Holland, it has sometimes happened that I have felt a cooling in my enthusiasm for Ruysdael. The 'Mill' is so delightful a work, so precise, so firm in its construction, its workmanship is from beginning to end so purposeful, its colouring is so strong and beautiful; the sky is of so rare a quality, everything in it seems to have been carefully engraved before being painted, and very well painted over that hard engraving—in fine, to make use of an expression that will be understood in the studio, it is so piquant when framed, and *looks so well in the gold*, that sometimes, perceiving two paces from it the little 'Bush' of Ruysdael (Pl. 84) and thinking it yellowish, mealy, a little casual in treatment, I have almost concluded in favour of Hobbema, and almost com-mitted a mistake which would not have lasted, but which would be unpardonable had it been only for the instant.

Ruysdael never knew how to introduce a figure into his pictures, and, in this respect, the ability of Adriaen van de Velde would be much more diverse; he has not an animal either, and, in this respect, Paul Potter would have a great advantage over him as soon as Paul Potter succeeded in becoming perfect. He has not the fair atmosphere of Cuyp, and the ingenious habit of setting in this flood of light and

gold, ships, towns, horses and horsemen, all drawn as we know Cuyp draws when he is excellent in all respects. His form, though of the most skilful when he applies it either to vegetation or to aerial surfaces, does not offer the extreme difficulties of the human form of Terborch or Metsu. However experienced his eye may be, it is less in proportion to the subjects he treats. Whatever may be the value of moving water, of a fleeting cloud, of a bushy tree tormented by the wind, of a waterfall crashing among the rocks, all this, when we think of the complication of the undertakings, of the number of the problems, of their subtlety, is not so good as regards strictness of solution, as the 'Intérieur Galant' of Terborch, the 'Visit' of Metsu, the 'Dutch Interior' of Pieter de Hooch, the 'School' and the 'Family' of Ostade, which we see at the Louvre (Pls. 98–101), or as the marvellous Metsu at the Van der Hoop Gallery in Amsterdam. Ruysdael shows no humour, and in this respect, too, the humorous Dutch masters make him appear a little morose.

To consider him in his normal habits, he is simple, serious and robust, very calm and earnest, very much the same always, to such a degree that his qualities no longer strike us, so sustained are they; and before this style of expression, scarcely ever relaxed, before these pictures of almost equal merit, we are sometimes astounded by the beauty of the work, but seldom surprised. Cuyp's sea-pictures, such as, for example, the 'Moonlight' of the Six Gallery (Pl. 92), are spontaneous works, absolutely unpremeditated, and they cause us to regret that Ruysdael had not a few outbursts of this kind. In short, his colour is monotonous, strong, harmonious, and not very rich. It varies only from green to brown; a bituminous background constitutes its basis. It has little brilliancy, it is not always pleasant, and in its primary essence it is not of very exquisite quality. A nice painter of interiors would have no difficulty in finding fault with him for the parsimony of his medium, and would often consider his palette too abridged.

With all this, in spite of all, Ruysdael is unique: it is easy to be convinced of this at the Louvre by his 'Bush', the 'Ray

of Sunshine' (Pls. 83–4), the 'Tempest', the 'Little Landscape' (No. 2561). I make exception of the 'Forest', which was never very beautiful, and which he has compromised by asking Berghem to paint some people in it.[1]

At the Exhibition of Old Masters, held for the benefit of the people of Alsace-Lorraine, one might say that Ruysdael reigned with an obvious sovereignty, although the exhibition was one of the richest in Dutch and Flemish masters, for there were there Van Goyen, Wijnants, Paul Potter, Cuyp, Van de Velde, Van der Neer, Van der Meer, Hals, Teniers, Bol, Salomon Ruysdael, and Van der Heyden with two priceless works. I appeal to the memories of those to whom this exhibition of excellent work was a flash of light—-was not Ruysdael there as a master and, still more worthily, as a great mind?[1] At Brussels, at Antwerp, at The Hague, at Amsterdam the effect is the same; wherever Ruysdael appears he has his own way of comporting himself, obtruding himself, impressing you with respect, attracting your attention—he warns you that you have before you the soul of someone of high race, and that he has always something important to tell you.

This is the only reason for the superiority of Ruysdael, and this reason is sufficient: there is in the painter a man who thinks, and in each one of his works a conception. As learned in his own kind as the most learned of his fellow countrymen, equally endowed by nature, more thoughtful and more moved—better than anyone else he adds to his gifts a balance that makes the unity of work and the perfection of works. You perceive in his pictures an air of plenitude, of conviction, of profound peace, which is the distinguishing characteristic of his personality, and which proves that harmony has not, for a single moment, ceased to reign over his fine natural faculties, his great experience, his ever-living sensibility, and his ever-present thought.

Ruysdael paints as he thinks—sanely, strongly, broadly. The exterior quality of the work shows very well the ordinary dealings of his mind. There is in this sober, careful, rather

[1] See p. 371.

proud painting, something of a sorrowful loftiness which can be seen from afar, and which at close quarters enchants you by a charm of natural simplicity and noble familiarity entirely his own. A canvas by Ruysdael is an entirety in which we can feel there is composition, a grasp of the whole, a master purpose, the .wish to paint once for all one of the traits of his country; perhaps, too, the desire to fix the remembrance of a moment of his life. A solid basis, a need to construct and organize, to subordinate the details to the whole, the colour to the effect, the interest of things to the plane they occupy; a perfect knowledge of natural and technical laws, and withal a certain contempt for what is unnecessary, too agreeable or superfluous, great taste with great sense, a very calm steady hand with a beating heart—this is what one finds on analysing a picture by Ruysdael.

I do not say that everything pales by the side of this painting with its mediocre brilliancy, its prudent colouring, its constantly hidden processes, but everything becomes disorganized, empty, and disconnected.

Place a canvas by Ruysdael by the side of the best landscapes of the school, and you will at once see appear in them gaps, digressions, weaknesses, an absence of drawing just where drawing is required, strokes of wit where they are not required, ill-disguised want of knowledge, obliterations which savour of omission. By the side of a Ruysdael a fine [Adriaen] Van de Velde is meagre, pretty, finical, never very masculine or matured (Pl. 94); a William van der Velde is dry, cold, thin, nearly always well drawn, rarely well painted, hurriedly observed, little thought out. Isaac Ostade is too russet, his skies are too null. Van Goyen is far too uncertain, volatile, evaporated, mealy; we feel the light and swift traces of a fine intention; the sketch is charming, the work has not succeeded because it has not been substantially nourished by preparatory studies, by patience and hard work (Pl. 86). Cuyp himself suffers appreciably from this searching juxtaposition, so sane and strong though he is. The cheerfulness of his continual gilding tires one by the side of the sombre and bluish greens of his

great emulator; and as for that profusion of atmosphere which looks like a reflection caught from the south to embellish his pictures—we cease to believe it on even the merest acquaintance with the banks of the Meuse or the Zuider Zee.

In general, we notice in the Dutch pictures—I mean the open-air pictures—a purposeful forcing of the high-lights, which gives them a great deal of relief, and in the language of painters, a circumstantial authority. In them the sky plays the part of the aerial, the colourless, the infinite, the impalpable. In reality it serves to measure the powerful values of the field, and consequently to cut out in a firmer, more decided manner the silhouette of the subject. Whether this sky is done in gold, as with Cuyp; in silver, as with Van de Velde or·Salomon Ruysdael; flaky, greyish, softened into a light reek, as in Isaac Ostade, Van Goyen, or Wijnants—it makes a gap in the picture, rarely preserves a general value of its own, and scarcely ever combines with the gold of the frames in really definite relationship. If you compute the strength of the landscape, it is extreme. Try to compute the value of the sky, and the sky will surprise you by the extreme lightness of its groundwork.

I could quote thus certain pictures whose atmosphere one forgets, and certain aerial backgrounds, which might be repainted afterwards without any loss to the picture. Many of the modern works are like that. It is even noticeable that— with certain exceptions, which I need not specify if I have made myself understood—our modern school in its entirety seems to have adopted the principle that the atmosphere, being the most void and least easily grasped part of the picture, may also be the least coloured and most null.

Ruysdael felt things differently and fixed once for all a much truer and more audacious principle. He regarded the immense vault, which arches the country or the sea, as the actual, compact and stable ceiling of his pictures. He curves and spreads it, measures it, determines its value in relation to the variations of light on the terrestrial horizon; he shades its great surfaces, gives them forms, executes them, in a word, as a piece of work

of the highest importance. He discovers in it arabesques which carry on those of the subject, disposes dull masses in it, brings down light from it, and puts light in it only in cases of necessity.

That grand eye open to everything that lives, that eye accustomed to the height of things as to their breadth, passes continually from the ground to the zenith, never looks at an object without observing the corresponding point of the atmosphere, and thus, without omitting anything, travels over the circular field of vision. Far from losing himself in analyses, he constantly synthetizes and sums up. What Nature disseminates he concentrates within a certain number of lines, colours, values, and effects. He frames all this in his imagination as he wished it to be framed within the four angles of his canvas. His eye has the property of a camera obscura: it reduces, diminishes the light and preserves in things the exact proportions of their form and colouring. A picture by Ruysdael, whichever one it may be—the most beautiful are, of course, the most significant—is a whole painting—full and strong in its principle, greyish above, brown or greenish below—which is firmly set from the four corners to the bright flutings of the frame, seems obscure from a distance, fills with light as we approach it, and is beautiful in itself, without any emptiness, with few digressions; it might be called a lofty and sustained thought expressed in language of the strongest fibre.

I have heard it said that nothing is harder to copy than a picture by Ruysdael, and I believe it, just as there is nothing so difficult to imitate as the diction of the great French writers of the seventeenth century. In the one case and in the other it is the same feat, the same style, in a way, the same spirit—I could almost say the same genius. I don't know why, but I imagine that if Ruysdael had not been a Dutchman and a Protestant, he would have belonged to Port-Royal.

You will notice in Amsterdam and at The Hague two landscapes which are—one on a large, the other on a small scale—a repetition of the same subject (Pl. 82). Was the small canvas the study which served for the large one? Did

Ruysdael draw or paint from Nature? Did he derive his inspiration from it, or did he copy directly? That is his secret, as it is that of most of the Dutch masters, save perhaps Van de Velde, who certainly did paint in the open air and excelled in direct studies, but, in the studio, lost a great deal of his power, whatever may be said about it. At any rate these two works are charming, and would go to prove what I have just said of Ruysdael's customs.

It is a scene taken at some distance from Amsterdam, with the little town of Haarlem, blackish, bluish, springing out of the trees and lost, under the vast undulation of a cloudy sky, in the rainy mist of a narrow horizon; in front, as sole foreground, a reddish-roofed laundry with washing spread out on the grass of its meadow. Nothing could be simpler or poorer, as a starting point, nor yet truer either. You should see this picture, one foot eight inches high, in order to learn of a master, who never feared to condescend because he was not a man to descend, how a subject can be ennobled by a lofty mind—how there is nothing ugly to an eye which sees beautifully, no pettiness to lofty feelings—in a word, what the art of painting becomes when it is practised by a noble mind.

The 'View of a River' at the Van der Hoop Museum is the best expression of this lofty and magnificent manner of painting. This picture would be better called the 'Wind Mill', and under this title it would preclude further attempts to treat, without disadvantage, a subject which, by the hand of Ruysdael, found its incomparable and typical expression (Pl. 85).

In a few words here are the data: a corner of the Meuse, probably; on the right a rising ground with trees, houses, and for summit a black mill, with its arms spread out to the wind, well up on the canvas; a jetty against which the waves of the river are gently washing the dull, soft, admirable water; a little corner of far-away horizon, very tenuous, very firm, very pale and very distinct, against which rises the white sail of a boat—a flat sail, unswelled by any wind, of soft and altogether exquisite value. Over all a great sky cloud-laden with interstices of a subdued azure—grey clouds climbing to

the top of the canvas; so to speak, no light anywhere in this powerful colour scheme composed of dark browns and dark slaty tints; one single gleam in the centre of the picture—a ray that from all distance comes like a smile to lighten the disc of a cloud. A large, square, *grave* picture (there is no fear of abusing this word with Ruysdael), of an extreme sonorousness in the lowest register; and my notes add—*marvellous in the gold.* At bottom, I mention it and insist upon it merely in order to arrive at this conclusion: that beyond the worth of its detail, its beauty of form, its grandeur of expression, the familiarity of its sentiment, it is also a singularly imposing piece of work when regarded only as a decoration.

Here is the whole Ruysdael: lofty treatment of his subject, little charm unless by chance, great attraction, an intimacy which manifests itself in moderation, a complete technical knowledge, very simple means. Imagine him in accordance with his painting, try to think of him by the side of his pictures, and you will have, if I am not mistaken, the multiple yet most concordant picture of an austere dreamer, a warm heart, a laconic mind and a taciturn man.

I have read somewhere—so evident is it that the poet reveals himself through the restraints of form and despite the conciseness of his language—that his work was like an elegiac poem in an infinity of songs. That is saying a great deal when we think of how little literature is possible in an art in which technique has so much importance—in which subject has so much weight and value. Elegy writer or not, certainly a poet, if Ruysdael had written instead of painted, I suspect he would have written in prose rather than in verse. Verse admits of too much fantasy and too many stratagems, prose requires too much sincerity, for this truthful spirit not to have preferred it to poetry. As to the depth of his nature, he was a dreamer, one of those men of whom many exist in our day, but who were rare at the time when Ruysdael was born—one of the *solitary ramblers* who fly from the town, frequent the outskirts, sincerely love the country, who feel it without exaggeration and describe it without phrases, who are made

uneasy by distant horizons, charmed by large plains, affected by a shadow, and enchanted by a ray of sunshine.

We imagine Ruysdaël not very young nor very old; we cannot see that he has had any youth; we cannot feel either any effect on him of the weight of years. If we did not know that he died before he was fifty-two years of age we should think of him as a man between two ages, as a mature man, or of precocious maturity, very serious, master of himself very early, with the sad reflections, the regrets, the reveries of one who looks back and whose youth has not known the oppressive uneasiness of hope. I do not think he had a heart that would cry: '*Arise, welcome storms!*' His melancholy, for he is full of it, has something very manly and reasonable, neither the turbulent childishness of early years nor the nervous tearfulness of old age; it only tints his picture with a more sombre hue, as it would have tinted the thoughts of a Jansenist.

What had life done to him that he should have so contemptuous or so bitter a feeling for it? What had men done to him that he should retire into solitude and should, to such a point, avoid having anything to do with them—even in his pictures? We know nothing or almost nothing of his life, save that he was born about 1630 and died in 1681, that he was a friend of Berghem, that he had Salomon Ruysdaël for elder brother and probably for first adviser.[1] As to his travels, they are supposed and doubted his waterfalls, his mountainous regions, his wooded parts with their rocky slopes would lead one to think he must have studied in Germany, Switzerland, Norway, or that he made use of the studies of Everdingen and drew his inspiration from them. His laborious life did not enrich him, and his title of citizen of Haarlem did not prevent him, it would seem, from being very little known. We should have, indeed, a sufficiently heart-rending proof of this, if it is true that, rather out of pity for his distress than regard for his genius, which perhaps no one suspected, he was admitted to the hospital at Haarlem, his birthplace, and that he died there. But before he arrived at this point what happened to him?

[1] See p. 371.

Had he any joys in life, since he certainly had sorrows? Did fate give him an opportunity of loving anything else beside clouds, and from which did he suffer most, if he did suffer— the torment of painting well or that of living? All these questions remain unanswered, and yet posterity concerns itself with them.

Would you think of asking as much about Berghem, Karel Dujardin, Wouwerman, Goyen, Terborch, Metsu, even about Pieter de Hooch? All these brilliant painters painted, and that is enough, it would seem. Ruysdael painted, but he lived, and that is why it matters so much to know how he lived. I know in the Dutch School only three or four men whose personality is interesting to this degree: Rembrandt, Ruysdael, Paul Potter, Cuyp perhaps—and that is more than we need in order to class them.

CHAPTER XVII

CUYP

CUYP, too, was not much appreciated in his lifetime, but that did not prevent him from painting as he chose—from being diligent or careless at his own free will—or from following, in his free career, the inspiration of the moment. Besides, he shared this disfavour, natural enough if we think of the taste for the extremely *finished* which was then in vogue, with Ruysdael; he shared it, too, with Rembrandt when, about 1650, Rembrandt suddenly ceased to be understood. He was thus in good company. Since then he has been well avenged— by the English first, and later by the whole of Europe. In any case Cuyp is a very fine painter.

In the first place he has the merit of being universal. His work is such a complete repertoire of Dutch life, especially in its rural environment, that his scope and variety would suffice to give him considerable interest. Landscapes, sea-pictures, horses, cattle, people of all conditions, from men of fortune and leisure to shepherds, great and small figures, portraits, and

pictures of farmyards, such is the curiosity and aptitude of his talent that he must have contributed more than anyone to enlarge the basis of local observation upon which his country's art unfolded. Born one of the first in 1605, by his age, by the diversity of his researches, by the vigour and independence of his behaviour, he must have been, in every way, one of the most active promoters of the school.

A painter who, on one hand, touches Hondecoeter, and on the other Ferdinand Bol, and without imitating Rembrandt; who paints animals with as much ease as Van de Velde, skies better than does Both; horses, and big horses too, more strictly than Wouwerman or Berghem painted theirs in small; who has a keen feeling for the sea, for rivers and their banks; who paints towns, ships at anchor, and great sea-pictures with a confidence such as William van de Velde did not possess; a painter who, moreover, had a way of seeing that was entirely his own, a true and very beautiful colouring, a powerful and free hand, a taste for rich, thick, abundant materials, a man who reached out, renewed himself and became stronger with age—such a personage is a man of vast scope. If we remember, too, that he lived until 1691, that he thus survived the great number of those whose birth he had seen, and that, during this long career of eighty-six years, except for a very marked touch of his father in his works, and, later, a glimpse of the Italian sky, which came to him perhaps from the brothers Both and from his friends the travellers, he remained himself, without alloy or admixture, and without falling off, either— we must agree that his was a strong mind.

If our Louvre gives us a fairly complete idea of the diverse forms of his talent, of his manner and colouring, it does not give us the whole measure of the man, nor does it show us to what point of perfection he could attain and sometimes did attain.

His great landscape (Pl. 87) is a beautiful work though better in the whole than in detail. No one could go farther in the art of painting light, of rendering the pleasant and restful feelings with which a warm atmosphere envelops and penetrates you.

It is a picture. It is true without being too true. It was observed, not copied. The air which bathes it, that amber-coloured warmth which it has imbibed, that gilding which is only a veil, those colours which are only a result of the light that floods them, of the air that circulates about them, and of the feeling of the painter who transforms them; those very soft values in such a strong whole—all this comes at once from nature and from a conception; it would be a masterpiece if there had not slipped into it some inadequacies, which seem to be the work of a young man or of an absent-minded draughtsman.

His 'Setting out for a Walk', and his 'Walk', two equestrian pictures of fine execution and noble style, are also filled with his finest qualities: everything basks in the sun and is steeped in the gilded waves, which are, so to speak, the ordinary colour of his mind.[1]

Yet he has done better, and we owe still rarer things to him. I do not mean those little over-praised pictures exhibited at various times in our French Old Master exhibitions. Without leaving France we have seen, at sales of private collections, some of Cuyp's works, not indeed the most delicate ones, but more powerful and thorough. A fine, real Cuyp is a painting at once subtle and gross, tender and strong, aerial and massive (Pl. 91). What appertains to the impalpable, such as the backgrounds, the containing lines, the clouds, the effect of air on distance, and of full light on colouring—all this corresponds to the light side of his mind, and to render it, his palette becomes volatilized, his workmanship more supple. As for the objects of more solid substance, of sharper outline, whose colouring is more evident and which have more body, he does not fear to enlarge the drawing, to fill out the form, to emphasize the firm parts, to be a little heavy so as never to be weak, either in the handling of a subject, or in tone, or in touch. In such a case he no longer refines, and as with all the good masters at the beginning of strong schools, it does not cost him anything at all to lack charm when charm is not the essential character of the object he is presenting.

[1] See p. 373.

That is why his cavalcades of the Louvre are not, in my opinion, the last word of his fine, sober, rather coarse, exuberant, altogether masculine manner. There is in them an excess of gilding, of sun and all that goes with it—ruddiness, glittering, reflection, shadow. Add to this a sort of mixture of open air and studio daylight, of actual truth and contrivance, indeed, something improbable in the costumes and suspicious in the elegancies, and the result is that, in spite of extraordinary qualities, these two pictures are not absolutely convincing.

The Hague Museum has a 'Portrait of Pieter de Roovere directing the salmon-fishing somewhere near Dordrecht', which reproduces, though with less brilliancy and with still more obvious defects, the intention of the two pictures of which I speak. The personage is one whom we know. He is in a coat of poppy-colour, gold-embroidered, edged with fur, a black toque trimmed with pink feathers, and a curved sabre with a gilded handle. He is riding one of those great dark bays, whose arched head, rather heavy frame, stiff legs, and mule's hoof you know already. The same gildings are in the sky, in the background, in the waters, on the faces; the same too bright reflections, as happens in a brilliant light when the air spares neither the colour nor the exterior borders of the objects. The picture is natural and well posed, ingeniously divided, original, personal, convincing, but, by dint of truth, the abuse of light would make one suspect errors of understanding and of taste.

But now, see Cuyp at Amsterdam in the Six Gallery, and consult the two great pictures of that unique collection.

One represents 'The Arrival of Maurice of Nassau at Scheveningen'. It is an important sea-picture, with ships laden with people. Neither Bakhuyzen (need it be said?) nor Van de Velde, nor anyone else would have had the power to construct, conceive, or colour in such a way a state picture of this kind and of this significance. The first boat on the left, against the light, is an admirable piece of work.

As to the second picture—that very famous effect of moonlight on the sea—I shall take from my notes the brief expression

of the surprise and mental pleasure it caused me (Pl. 92). 'An astonishing and marvellous thing; big, square—the sea, a steep coast, a canoe on the right; at the bottom, a fishing-smack with a figure in it wearing a costume dappled with red; on the left two sailing ships; no wind, a tranquil night, serene, waters quite calm; full moon half-way up the picture, a little to the left, absolutely clear-cut in a large opening in the pure sky; the whole is incomparably true and fine—in colour, in power, in transparency, in limpidity. A night Claude Lorrain, graver, simpler, fuller, more naturally executed in accordance with an accurate impression—a veritable still-life deception with the most learned *art*.'

As is plainly visible, Cuyp succeeded with each new enterprise. If one took the trouble to follow him—I do not say in his variations, but in the variety of his attempts—one would perceive that in each kind he has dominated for the moment, were it only once, all those of his contemporaries who shared around him the extraordinarily wide domain of his art. One would have to understand him very badly, or know one's own power very little, in order to paint after him a 'Moonlight', a 'Disembarkment of the Prince', in great naval pomp, a 'Dordrecht and its Surroundings'. What he has said is said, because he has said it in his way and because his way in a given subject is worth all the others.

He has the practical ability of a master, the eye of a master. He has created—and in art that is enough—a fictitious, quite individual formula of light and its effects. He had that uncommon power of first imagining an atmosphere and then making of it not only the vanishing, fluid, and breathable element, but also the law, and, so to speak, the ruling principle of his pictures. It is by this sign that he is recognizable. If you cannot perceive that he has had an influence over his school, all the more you may be sure that he came under no one's influence. He is one; although diverse, he is himself.

Yet, for in my opinion there is a *yet* in this fine painter, he lacks that indescribable something which makes the indispensable master. He was a supreme craftsman in all styles; he

has created neither a style nor an art; he does not personify in his name a whole manner of seeing, of feeling or of painting, as we say: That is a Rembrandt, or a Paul Potter, or a Ruysdael. He reaches a very high rank, but is certainly fourth-rate in that exact classification of talent in which Rembrandt sits enthroned afar off—in which Ruysdael is the first. If Cuyp were absent, the Dutch school would lose some superb works: but perhaps there would not be a great gap to fill up in the inventions of Dutch Art.

DUTCH INFLUENCE ON FRENCH LANDSCAPE PAINTING

ONE question arises, among many others, when we study Dutch landscape painting and recollect the corresponding movement that took place in France about forty-five years ago. We ask what was the influence of Holland in this innovation—if it influenced us, how, to what extent, and until when; what it was able to teach us; and, lastly, for what reasons it has—without ceasing to please us—ceased to instruct us? This very interesting question has never, so far as I know, been pertinently examined, and I certainly shall not attempt to treat it. It touches too closely upon things too near to us, it touches contemporary individuals, the living. It will be understood that I should feel ill at ease with it. I should like simply to lay down the terms of the proposition.

It is certain that for two centuries we have had in France but one landscape painter, Claude Lorrain. Very French albeit very Roman, very much a poet, but with that strong good sense which, for a long time, has given reason for doubt whether we ever were a race of poets—a very good-natured fellow at bottom, though solemn; this very great painter was, with more naturalness and less breadth, the counterpart, in his kind, of Poussin in history painting. His painting is an art

which marvellously represents the worth of our mind, the aptitudes of our eye, which does us honour, and which was, one day or another, to pass into the category of classic art. We consult it, admire it; we don't make use of it; above all, we don't abide by it, we don't come back to it, any more than we come back to the art of *Esther* and *Bérénice*.

The eighteenth century paid hardly any attention to so-called landscape painting, unless to put into it gallantries, masquerades, so-called *fêtes champêtres*, or diverting mythological pictures in panels. The whole school of David openly disdained it, and neither Valenciennes nor Bertin nor their followers in our time were in any better mind to make it liked. In all sincerity they adored Virgil and nature; in all truth we may say that they had no delicate perception of either. They were Latinists who scanned hexameters nobly, painters who saw things as in an amphitheatre, rounded off a tree rather pompously and put in the details of its foliage. At bottom perhaps they appreciated Delille more than Virgil, executed a few good studies, and painted badly. With a great deal more verve than they, more fancy and greater real gifts, old Vernet, whom I was forgetting, is not either what I should call a very penetrating landscape-painter, and I should classify him before Hubert Robert, but, with him, among good decorators of museums and royal vestibules. I say nothing of Demarne, half French, half Flemish, for whom neither France nor Belgium cares to put in a very warm claim, and I think I may omit Lantara without great disadvantage to French painting.

At the end of its reputation, there must have been a great lack and the nation must have set about retracing its steps, as a nation does when it changes its taste, for there to appear, in letters and in art at once, a sincere love of things rural.

The awakening began among the prose writers. Between the years 1816 and 1825 it had passed into verse; lastly, from 1824 to 1830, the painters, now aroused, began to follow. The first impulse came to us from English painting; and consequently, when Géricault and Bonington acclimatized the painting of Constable and of Gainsborough in France, it was

at first an Anglo-Flemish influence that prevailed. Van Dyck's colour in the backgrounds of his portraits, the audacity and fancifulness of Rubens's palette—this is what helped to draw us away from the coldnesses and conventions of the preceding school. The palette gained much by it, poetry lost nothing by it, but truth was only half-satisfied with it.

Note that at the same epoch and by reason of a love for the marvellous, which corresponded to the literary fashion for ballads and legends, and to the rather ruddy colour of the imagination at that time, the first Dutchman to whisper something into the ears of painters, was Rembrandt. Visibly and latently the Rembrandt of the warm haze is a little everywhere at the beginning of our modern school. And it is precisely because Rembrandt and Rubens were vaguely felt, hidden in the wings, that those who are called the romantics were received with such dark looks when they first came upon the scene.

About 1828 something new was seen. Some very young men—there were children among them—exhibited one day some very small pictures, which were considered, one after the other, to be strange and charming. I shall mention of these eminent painters only the two who are dead, or rather I shall name them all, reserving the right to speak only of those who can no longer hear me. The masters of contemporary French landscape painting appeared together; they were MM. Flers, Cabat, Dupré, Rousseau, and Corot.

Where had they been trained? Whence came they? Who had helped them on to the Louvre rather than elsewhere? Who had conducted them, some to Italy, the others to Normandy? We might truly say, so uncertain is their origin, so fortuitous do their talents seem to be, that we are dealing with painters dead two centuries ago, whose history had never been well known.

Whatever may have been the education of these sons of Paris, born on the quays of the Seine, trained in the outskirts, taught we can scarcely tell how, two things appeared at the same time as they—unaffectedly, truly rustic landscapes and Dutch formulas. This time Holland had found someone who

understood her; she taught us to see, to feel, and to paint. Such was the surprise that the inward originality of the discoveries was not examined too closely. The new thing seemed as new in all respects as it seemed happy. We admired; and Ruysdael the same day entered France, a little obscured, for the moment, by the fame of these young men. At the same time we learned that there were French countrysides, a French art of landscape, and galleries with ancient pictures which might be able to teach us something.

Two of the men of whom I speak remained almost faithful to their first affections—or, if they turned away for a moment, it was but to return later. Corot from the first day left them. The road that he followed is well known. He frequented Italy, and brought away from it something that cannot be forgotten. He was more lyric, as rural, less rustic. He loved the woods and the water, but in a different manner. He invented a style; his exactitude in observing things was less than his delicacy in laying hold of that which he was to extract from them, that which stood out in them. Thence that entirely individual mythology, that ingeniously natural paganism, which was only, under its rather vaporous form, the personification of the very spirit of things. No one could be less Dutch than that.

As to Rousseau—a complex artist very much disparaged, very much vaunted, very difficult to define with moderation— what we can say with most truth of him is that he represents, in his fine exemplary career, the efforts of French genius to create in France a new Dutch art: I mean an art as perfect, while yet national—as precious, while yet more diverse—as dogmatic, while yet more modern.

By his date and his rank in the history of our school Rousseau is an intermediate, he belongs to the period of transition between the Dutch painters and those of the future. He descends from the Dutch painters, and goes away from them. He admires them, and forgets them. In the past, he offers them a hand, with the other he provokes and diverts towards himself a stream of enthusiasm and good will. In nature he discovered thousands of unpublished things. The repertoire of

his feelings is immense. Every season, every hour of day, evening, and dawn, all the inclemencies of weather, from the hoar-frost to the dog-days.; all the altitudes from the strand to the hills, from the downs to Mont Blanc; the villages, the meadows, the brushwood, the forests, the naked earth, and the foliage with which it is covered—there is nothing that has not tempted him, arrested him, won him over by its interest, persuaded him to paint it. It seems as if the Dutch painters had done nothing but revolve about themselves, when we compare them with the ardent course of this seeker after new impressions. All of them taken together, they would have completed their course with a selection of Rousseau's cartoons. From this point of view he is absolutely original, and by that very fact he is the product of his age. Once involved in this study of the relative, the accidental and the true, one goes on to the end. Not indeed alone, but for the greater part, he contributed to the creation of a school which might be called the *school of the sensations*.

If I were studying rather intimately our school of contemporary landscape-painting, instead of merely sketching its few characteristic traits, I should have some other names to add to the above. We should see, as in all schools, contradictions, cross-currents, academic traditions which continue to filter through the vast movement that is bringing us to the truly natural—recollections of Poussin, influences of Claude, the spirit of synthesis pursuing its obstinate work in the midst of very multifarious analysis and the labours of simple observation. We should notice, too, some outstanding personalities— though slightly dominated—who, as it were, understudied the great ones without resembling them too much, who doff the bonnet to them without seeming to do so. In fine, I should quote names which do us infinite honour, and I should take care not to forget an ingenious painter, brilliant, multiform, who has touched on many things—fantasy, mythology, landscape— who loved the country and the ancient painting, Rembrandt, Watteau, and especially Correggio—who passionately loved the copses of Fontainebleau—and, above all, perhaps, the

contrivances of a rather chimerical palette; who, of all contemporary painters—and this speaks much for him too—was the first to make out Rousseau, to understand him and make him understood, to proclaim him a master and his own, the first to place at the service of that inflexible originality his suppler talent, his better understood originality, his already accepted influence, his fame that was already made[1].

What I wish to make clear, and that will suffice here, is that from the first day the impulse given by the Dutch School and by Ruysdael—the direct impulse—stopped short or was diverted, and that two men especially contributed to substitute the exclusive study of nature for the study of the Northern Masters: Corot, who had no bonds with them; and Rousseau, who had a livelier affection for their works, a more exact recollection of their methods, but also an imperious desire to see more, to see differently, and to express all that had escaped them. There resulted two consequent and parallel facts—studies became subtler, if not better carried out; processes became more complicated, if not more learned.

That which Jean-Jacques Rousseau, Bernardin de Saint-Pierre, Chateaubriand, Sénancour, our first landscape masters in literature, observed in an all-embracing glance and expressed in terse form was to be no longer anything but a very incomplete abridgement, a very limited *aperçu*, when literature became purely descriptive. In the same way the needs of painting, analytical, imitative, and others, were to find themselves ill-provided for in foreign style and methods. The eye became more curious and more precious; the sensibility, without becoming more active, became more nervous, the drawing closer, there was increased observation; nature, studied at closer quarters, teemed with details, incidents, effects, and shades; a thousand secrets were demanded of it which it had kept to itself, either because it had not been known that they existed or because painters had not wished to interrogate it on all these points. A language was needed to express this multitude of new sensations; and it was Rousseau almost alone who

[1] See p. 365.

invented the vocabulary we use today. In his sketches and rough drafts, in his finished works, you will perceive the attempts, the efforts, the happy or unsuccessful devices, the excellent neologisms or the risky words with which this profound seeker of formulas worked to enrich the ancient tongue and grammar of painters. If you take one of his pictures, the best, and place it by the side of one by Ruysdael, Hobbema, or Wynants, of the same kind and distinction, you will be struck by the differences, almost as you would be struck if you read a page of some modern descriptive writer immediately after having read a page of the *Confessions* or of *Obermann*; there is the same effort, the same enlarging of studies, and the same result as to the works. The expression is more physiognomic, the observation rarer, the palette infinitely richer, the colour more expressive, the construction itself more scrupulous. Everything seems fuller of feeling, more thoughtful, more scientifically reasoned and calculated out. A Dutchman would stand agape at so many scruples, and stupefied at such faculties of analysis. And yet are the works better, more highly inspired? Are they more living? When Rousseau paints a 'Plain under Frost', is he nearer the true than are Ostade and Van de Velde with their 'Skaters'? When Rousseau paints a 'Trout Fishing', is he graver, more damp and shady than Ruysdael with his sleeping waters or his sombre cascades?

Thousands of times people have described in travels, in novels, or in poems the waters of a lake beating against a deserted shore at night just as the moon is rising, while a nightingale sings afar off. Did not Sénancour, once for all, sketch off the picture in a few earnest, short, and ardent lines? A new art, then, was born on the same day under the double form of the book and the picture, with the same tendencies, of artists endowed with the same spirit, with the same public to appreciate it. Was this progress, or the contrary of progress? Posterity will decide better than we.

Certain it is, however, that in twenty or twenty-five years, from 1830 to 1855, the French school had attempted much, produced enormously, and advanced things considerably,

since, having set out from Ruysdael with the 'water-mills', the 'sluices' and 'bushes'—that is to say, a very Dutch spirit, in very Dutch formulas, it had got so far as, on one hand, to create an entirely French style with Corot, and on the other, to prepare the way for a still more universal art with Rousseau. Did it stop there? Not altogether.

The love of home has never been, even in Holland, anything but an exceptional feeling and a somewhat peculiar habit. At all times there have been men whose feet burned to be off somewhere else. The tradition of travels in Italy is perhaps the only one common to all the schools—Flemish, Dutch, English, French, German, and Spanish. From the brothers Both, Berghem, Claude, and Poussin, to the painters of our day, there have been no landscape-painters but have wished to see the Apennines and the country around Rome, and never has there been a local school strong enough to prevent Italian landscape-painting from insinuating into it that foreign touch that has never produced anything but hybrid effects. During the last thirty years they have gone much farther. Distant travel has tempted painters and changed many things in painting. The motive of these adventurous excursions is, in the first place, the need, proper to all populations accumulated to excess in one place—to open up new ground, the curiosity to discover, and, so to speak, an obligation to go away in order to invent. It is also the counter-blast of certain scientific studies, progress in which is secured only by travels round the world, round climates and races. The result was the style of painting that we know: a cosmopolitan art, new rather than original, not very French, which will represent in our history, if indeed history takes any notice of it, only a moment of curiosity, of uncertainty, of uneasiness, and what was, in truth, only a change of air, tried by people who were pretty ailing.

Yet, without leaving France, they still seek a more decisive form for landscape-painting. An interesting work might be written about this latent, slow, and confused elaboration of a new manner that has not yet been found, and, indeed, is far enough from being found; and I am surprised that criticism

did not examine the fact more closely while it was taking place under our eyes. There is taking place today among painters a certain unclassing. There are fewer categories, I could easily say fewer castes, than there used to be. History borders on *genre*, which itself borders on landscape and even on still life. Many frontiers have disappeared. How many reconciliations pictorial art has brought about! There is less stiffness on the one hand, less daring on the other, the canvases are less huge, the necessity to please and be pleased is apparent, there is country life which opens many eyes—all this has mingled the styles, transformed the methods. It cannot be told to what degree the bright daylight of the fields, entering into the most austere of studios, worked change and confusion.

Landscape-painting makes every day more proselytes than progress. Those who follow it exclusively are not the more skilful for that; but there are very many more painters who practise it. The *open air*, diffused light, the *real sun*, assume nowadays in painting, and in all styles of painting, an importance never attributed to them before, and, let us say frankly, that they do not deserve.

All the fantasies of the imagination, that which was called the mystery of the palette at a time when mystery was one of the attractions of painting, gave place to the love of absolute truth and of the textual. Photography in questions of the appearance of bodies, photographic studies in questions of the effects of light, have changed most of the ways of seeing, of feeling, and of painting. At the present moment painting is never light enough, distinct enough, formal enough, crude enough. It seems that the mechanical reproduction of that which is, constitutes nowadays the last word in experience and knowledge, and that talent consists in struggling with an instrument for supremacy in accuracy, precision, and imitative power. Any personal meddling of the sensibilities is an intrusion. Anything imagined by the mind is as an artifice, and all artifice, I mean all convention, is banished from an art that can be but a convention. Thence arise controversies in which the students of nature have the greater number on their side. There

even exist disparaging epithets to describe the contrary prac-
tice. It is called *antiquated*; one might as well say it is an oldish,
doting, and old-fashioned way of comprehending nature by
putting something of oneself into it. Choice of subject, draw-
ing, palette—all participate in this impersonal manner of seeing
and treating things. Here we are far from ancient customs—I
mean those of forty years ago, when bitumen flowed liberally
on the palettes of the romantic painters and passed for the
auxiliary colour of the ideal.

There is a time and a place in the year in which these new
fashions are exposed with much splendour—it is in our Spring
Exhibitions. However little you may keep yourself in touch
with the novelties produced there, you will notice that the
most recent painting has for object the desire to strike the eye
with salient, textual reproductions, easily recognizable in their
truth, stripped of artifice, and to give us exactly the impression
of the things we could see in the street. And the public is quite
disposed to welcome an art which represents with such fidelity
its clothes, its face, its habits, its taste, its inclinations, and its
mind. But historical painting? you will say. In the first place,
at the rate things are going, is it quite certain that there is still
a school of history? Then, if this term belonging to the old
régime were still applied to traditions brilliantly defended
but very little followed, do not imagine that history painting
has escaped the general fusion of styles and that it has resisted the
temptation to enter the stream itself. There is indeed some
hesitation, there are even a few scruples, but finally the plunge
is taken.

Look, from year to year, at the conversions that come about,
and without examining them to the roots, consider only the
colouring of the pictures: if from dark it becomes light, if
from black it becomes white, if from being deep it rises to
the surface, if from being supple it becomes stiff, if the oily
substance becomes dead and the chiaroscuro becomes Japanese
paper, you have seen enough of it to learn that there is in it a
spirit that has changed its environment and a studio that has
been opened to the light of the street. If I were not so extremely

cautious in this analysis I should be more explicit, and should put my finger on truths that cannot be denied.

What I wish to conclude from it is that, in its concealed state as well as in the professional study, landscape-painting has invaded everything, and that, strangest of all, while awaiting its own formula, it has overthrown all the formulas, disturbed many clear spirits, and compromised some talents too. It is none the less true that we are working for it, that the attempts made are made for its advantage, and that, to excuse the harm it has done to painting in general, it is much to be desired that at least it should find what it expected.

In the midst of changing fashions there is, so to speak, a vein of art that is still worked. You may perceive, on going through our exhibition rooms, here and there pictures which attract attention by a breadth, earnestness, power of range, an interpretation of effects and things, pictures in which we can feel almost the palette of a master. There are in them neither figures nor embellishments of any kind. Grace, even, is entirely absent; but the elements are strong, the colouring is deep and dull, the pigment thick and rich, and sometimes a great delicacy of eye and hand is apparent under the intentional negligence or the rather jarring roughness of the workmanship. The painter of whom I speak, and whom I should be pleased to name, unites to the true love of the country the no less evident love of ancient painting and of the best masters. His pictures prove this, his engravings and drawings also bear witness to it. Surely this must be the bond which unites us still to the schools of the Low Countries. In any case, it is the only corner in modern French painting in which we can detect a trace of their influence.

I do not know which of the Dutch painters predominates in the studio of which I speak. And I am not too certain that Van der Meer of Delft is not more generally listened to there, for the moment, than Ruysdael. It looks like it from a certain disdain for drawing, for difficult and delicate construction, for carefulness of rendering which the master of Amsterdam would neither have advised nor approved. At any rate there

is in it the living and present reminder of an art forgotten everywhere else.[1]

This strong and earnest trace is of good augury. There is not a seeing mind but can feel that it comes in a very straight line from the country *par excellence* where they knew how to paint, and that by following it persistently modern landscape-painting would have some chance of finding its path again. I should not be surprised if Holland did us still another service; if, after having led us back from literature to nature, she some day or other, after long circuits, led us back from nature to painting. To this point we must return sooner or later. Our school knows a great deal, it exhausts itself in roaming; its source of studies is considerable; it is so rich, indeed, that it delights in it, forgets itself in it, and that it expends in collecting documents strength that would be better employed in producing and in working up.

There is a time for everything, and the day when painters and people of taste become convinced that the best studies in the world are not worth a good picture, the public mind will once more have looked into itself, which is the surest way of making progress.

CHAPTER XIX

THE 'ANATOMY LESSON'

I AM greatly tempted to say nothing about the 'Anatomy Lesson' (Pl. 60). It is a picture that one ought to consider very beautiful, perfectly original, almost perfect, under penalty of committing, in the eyes of many sincere admirers, an error in taste and good sense. It has left me very cold, I regret to confess it. And having said this, I must explain myself, or, if you will, justify myself.

Historically, the 'Anatomy Lesson' is of great interest, for we know that it is descended from analogous works lost or preserved, and that thus it bears witness of the way in which

[1] See p. 365.

a man of great destiny appropriated to his own use the endeavours of his predecessors. In virtue of this it is an example not less celebrated than many others of the right to take what you want where you find it, when you are Shakespeare, Rotrou, Corneille, Calderon, Molière, or Rembrandt. Note that, in this list of inventors for whom the past worked, I mention only one painter, and I might mention them all. Then, by its date among Rembrandt's works, by its conception and its merit, it shows the path he had travelled since the uncertain gropings which two over-valued pictures at the Hague Gallery reveal to us: I mean the 'Simeon' (Pl. 59) and a portrait of a 'Young Man', which seems to me evidently his and which in any case is the portrait of a child, done with a certain degree of timidity by a child.

When we remember that Rembrandt was a pupil of Pijnas and Lastman, and if we have seen only a work or two of the latter, we ought to be less surprised, it seems to me, at the novelties that Rembrandt showed in his first attempts. To tell the truth, and rightly speaking, neither in his devices nor in his subjects, nor in that picturesque marriage of small figures with great architecture, nor even in the type and Israelitish rags of those figures, nor, lastly, in the greenish vapour or the rather sulphurous light which bathes his canvases, is there anything really unexpected or consequently really his own. We must come to 1632, that is, to the 'Anatomy Lesson', to catch a glimpse at last of something like the revelation of an original career. And even then it is right we should be just, not only towards Rembrandt but towards everybody. We must remember that in 1632 Ravesteyn was fifty to sixty years of age, that Frans Hals was forty-eight, and that from 1627 to 1633 this marvellous craftsman had painted the most perfect of his beautiful works.

It is true that both—Hals especially—were what are called painters of exterior; I mean that the outside of things struck them more than the inside, that they made more use of their eyes than of their imagination, and that the only transfiguration they worked upon nature was to see it elegantly coloured and

posed, physiognomic and real, and to reproduce it with the best palette and the best hand. It is yet true that the mystery of form, of light, and of tone did not exclusively preoccupy them, and that by painting without much analysis, and according to ready impressions, they painted only what they saw, did not add much shadow to the shadow nor much light to the light, and that in this way Rembrandt's great invention in chiaroscuro remained with them an everyday method, not one for use on special occasions—as poetry, so to speak. It is no less true that, if we set Rembrandt, in this year 1632, among professors who had enlightened him a great deal and masters who were extremely superior to him in practical ability and experience, the 'Anatomy Lesson' cannot fail to lose a great deal of its absolute value.

The real merit of the work, then, is to mark a stage in the career of the painter. It indicates a great step, reveals with clearness what he was setting out to do, and if it does not yet permit us to measure all that he was to become in a few years, at least it gives us the first warning of it. It is the germ of Rembrandt: there would be cause for regret if it were already he, and to judge him by this first evidence would be to misunderstand him. The subject having been already treated with the same conception—a dissecting-table, a foreshortened corpse, and the light acting in the same manner on the central object which had to be shown up—there would remain to Rembrandt the credit of having treated the subject better perhaps, certainly of having felt it more delicately. I shall not go so far as to seek out the metaphysical meaning of a scene in which the pictorial effect and the cordial sensibilities of the painter suffice to explain all; for I have never really understood all the philosophy supposed to be contained in his grave and simple heads, gestureless personages, and in his rather symmetrical posing—which is a mistake for portraits.

The most living figure of the picture, the most real, the one that has *come out* best, as one might say in thinking of the limbos through which a painted figure must successively pass in order to enter the realities of art—the most like, too—is that

of Doctor Tulp. Among the others are some which are rather dead, which Rembrandt left by the way, and which were neither well observed nor well thought out nor well painted. Two, on the other hand—I could count three by including the accessory figure of the middle distance—if you look at them well, reveal most clearly that distant point of view, that indescribable quantity of spirit and lightness, of indecision and fire, that make up the whole of Rembrandt's genius. They are grey, stumped, perfectly constructed without visible outlines, modelled from the interior, in everything alive with a peculiar life that is infinitely rare and that Rembrandt alone would have discovered under the surface of real life. That is a great deal, since in all that concerns this, we may already speak of the art of Rembrandt and of his methods as of an accomplished fact; but it is too little when we think of what there is in a complete work of Rembrandt's, and when we think of the extraordinary celebrity of this one.

The general tone is neither cold nor warm; it is yellowish. The execution is thin and rather spiritless. The effect is striking without being strong, and in no part of the fabrics, the background, the atmosphere in which the scene is placed, is the work or the tone very rich.

As to the corpse, it is generally agreed that it is swollen, badly constructed and lacks study. I will add to these reproaches two others that are more serious: the first is that, apart from the smooth and, so to speak, macerated whiteness of the tissues, it is not a dead body; it has neither the beauty nor the uglinesses, neither the characteristic symptoms nor the terrible signs of one; it was looked upon by an indifferent eye, seen by an absent mind. In the second place, and this defect results from the first, the corpse is simply nothing more—let us make no mistake about it—than the effect of a wan light in a dark picture. And as I shall have to tell you later on, this pre-occupation with light, come what may, independently of the object to be illuminated, I might say without pity for the object illuminated—was, during the whole of Rembrandt's life, to do him either marvellous good service or great

disservice, according to the case. This is the first memorable circumstance in which manifestly his fixed idea deceived him into saying something other than what he had to say. He had to paint a man—he did not trouble sufficiently about the human form; he had to paint death—he forgot it in order to seek in his palette a whitish tone which should be light. I ask leave to think that Rembrandt has frequently been more attentive, more moved, more nobly inspired by the scene he had to render.

As to the chiaroscuro of which the 'Anatomy Lesson' offers us an almost formal example, as we shall see it elsewhere applied in a masterly fashion, in its diverse expressions of intimate poesy or of a new art of modelling, I shall have other, better occasions to speak of it.

To sum up, I think I may say that, happily for his fame, Rembrandt has given us, even in this class, some decisive notions which singularly diminish the interest of this first picture. I shall add that, if the picture were of small dimensions, it would be judged a weak one, and that, if the format of this canvas gives it a peculiar value, it cannot make a masterpiece of it, as has been too often said.

CHAPTER XX

FRANS HALS AT HAARLEM

HAARLEM

IT is at Haarlem, as I have said, that a painter seeking beautiful and strong lessons ought to give himself the pleasure of seeing Frans Hals. Everywhere else, in our French galleries or collections, in the Dutch galleries and collections too, the idea one forms of this brilliant and unequal master is attractive, pleasant, clever, rather futile, and is neither true nor just. The man loses as much there as the artist is diminished. He astonishes and amuses. With his unexampled celerity, the prodigious good-humour and the eccentricities of his style, he stands out by his bantering humour and touch, against the severe

background of the painting of his time. Sometimes he strikes you; he makes you think that he is as learned as he is gifted, and that his irresistible verve is nothing but the happy grace of a profound talent; almost immediately he compromises himself, discredits himself and discourages you. His *portrait*, which is at the Amsterdam Museum (Pl. 52), and in which he has painted himself life-size, standing, posing on a rural slope by the side of his wife, shows him to us pretty well as we should imagine him in his impertinent moments, when he is jesting and rather making fun of us. Painting and gesture, style and physiognomy, everything in this much too easy-going picture, is appropriate. Hals is laughing in our face, the wife of this merry jester is doing the same, and the painting, skilful as it is, is not much more serious.

Such is, to judge him only on his lighter side, the famous painter whose renown was great in Holland during the first half of the seventeenth century. Today the name of Hals is reappearing in our school at the moment when the love of the natural is coming back into it with some little noise and no less excess. His method serves as a programme for certain doctrines, in virtue of which the most commonplace exactitude is wrongly taken for truth, and the most perfect practical care-lessness is taken for the last word in knowledge and taste. By calling in his evidence in support of a thesis to which he never gave anything but the lie by his beautiful works, we are deceived and thereby do him an injury. Among so many high qualities do we, by chance, see nothing and extol nothing but his faults? I fear it is so, and I will tell you what makes me fear it. It is, I assure you, a new error and an injustice.

In the great room of the Haarlem Academy, which contains many pictures analogous to his, but in which he compels you to look at his alone, Frans Hals has eight huge canvases, whose dimensions vary from two metres and a half to more than four metres. There are first 'The Assembly of Officers of the St. George's Guild', 'The Assembly of Officers of the Andreas Guild', then, later, the 'Regent Pieces'. The figures in them are of life-size and very numerous; all is most imposing.

These pictures belong to every period of his life, and the series embraces the whole of his long career. The first, of 1616, shows him at thirty-two years of age; the last, painted in 1664, shows him only two years before his death—at the extreme age of eighty years. We see him, so to speak, at his entry into life, we see him growing and groping his way. He blossomed late, towards the middle of his life—indeed, a little on the other side of it; his talent strengthened, he developed at the height of old age; at last we are present at his decline, and we are quite surprised to see the self-possession of this indefatigable master—when first his hand failed him and then his life.

There are few painters, if indeed there are any at all, of whom we have so well-mapped and so precise a mass of information. To take in at a glance fifty years of the work of an artist, to be present at his inquiries, to catch him at his successes, to judge him by himself in his most important and best works, is a spectacle that is rarely given us. Moreover, all his works are placed breast-high; one can consult them without effort; they give up to you all their secrets, supposing that Hals was a secretive painter, which he was not. If we had watched him at his work we could not know more about it. He was not long in making up his mind, his judgement was rapid. Hals was only a practical painter, I warn you at once of that; but as a practical craftsman he is one of the most skilful and expert masters that ever existed anywhere, even in Flanders, in spite of Rubens and Van Dyck, even in Spain, in spite of Velazquez. Allow me to transcribe my notes: they will have the merit of being short, of having been taken on the spot, and of analysing things according to their interest. With such an artist, we are tempted to say either too much or too little. About the thinker all is soon said; with the painter we could go much farther: we must restrain ourselves and give him only his due share.

Number 123, 1616: His first great picture. He was thirty-two years of age; he was feeling his way; he has before him Ravesteyn, Frans de Grebber, Cornelisz van Haarlem, who enlighten him but do not tempt him at all. Is his master, Karel van Mander, any more capable of setting him on his

way? The painting is strong in tone, reddish in principle; the modelling is loud and laborious; the hands are coarse; the darks are ill conceived. With that the work is already very physiognomic. Three charming heads are to be noted.

Number 125, 1627—eleven years afterwards. Already himself—here he is in his prime. Painting grey, fresh, natural, dark harmony. Scarves of fawn, orange, or blue, white ruffles. He has found his register and fixed his elements of colouring. He uses true white, colours light with a little glazing, and adds a little patina. His dark and dull backgrounds seem to have inspired Pieter de Hooch and to suggest Cuyp's father. The physiognomies are less studied, the types perfect.[1]

Number 124, 1627—the same year, better still (Pl. 53). Better touch, the hand more skilful and freer. The execution changes; he varies it. The same tone; the whites lighter; the detail in the ruffles shown with more caprice. In everything the ease and grace of a man certain of himself; a scarf of soft azure, which is Hals to perfection. Heads unequally beautiful as to rendering, all expressive and astonishingly individual. The standard-bearer standing in the centre, his face warm in value and full against the silk of the banner, with his head a little on one side, his eye twinkling, his delicate little mouth thinned by a smile—from head to foot a delightful piece. The darks are more mat; he disengages them from the russet, composes them, amalgamates them in a larger, sounder fashion. The modelling is flat; the air becomes rare; the tones are juxtaposed without contrived transitions. There is no use of chiaroscuro—it is the open air of a room in which the light is strong and equal. Hence gaps between tones which nothing blends, softnesses when values and natural colours depend upon each other, hardness when the harmony is more distant. There is some system. I see very clearly what our present school has concluded from it. It is right in thinking that Hals is still excellent in spite of this accidental set purpose; it would be wrong if it considered that his merit depended upon it. Number 126, 1633, might give it an inkling of this.

[1] See p. 366.

Hals is forty-seven years of age. Here is his most masterly work in this dazzling kind with its rich range of colours (Pl. 54); it is entirely beautiful, not the most piquant of his works, but the most lofty, the most exuberant, the most substantial, the most learned. In it there are no set purposes, no affectation of placing his figures outside the air rather than in it, and of creating a void round about them. None of the difficulties are evaded of an art which, if it is well understood, accepts them all and solves them.

Perhaps, taken individually, the heads are less perfect than in the preceding number, less spiritually expressive. With the exception of this accident, which might be as much the fault of the models as of the painter, the picture as a whole is superlatively good. The background is dark, and consequently the values are reversed. The black of the velvets, the silks, the satins, has a more fantastic effect; the lights unfold, the colours stand out with a breadth, a conviction, and in harmonies which Hals never surpassed. As beautiful, as accurately observed in their shades as in their lights, in their strength as in their soft-ness, it is a delight to the eye to see their richness and simplicity, to examine their choice, their number, their infinite shades, and to admire their most perfect union. The left half, in full light, is astonishing. The pigment itself is of the rarest; thick flowing colours, firm and full, thickly or thinly laid on according to need; the execution is free, wise, supple, daring, never wild, never insignificant. Each thing is treated according to its interest, its true nature, and its worth. In certain details we can detect a painstaking care, while others have been merely skimmed over. The guipures are flat, the lace is light, the satins glistening, the silks heavy-looking, the velvets more absorbent—all this without minutiae or narrowness. The picture discloses in its author a spontaneous feeling for the substances of things, a sense of proportion without the least error, the art of being precise without explaining too much, of making you understand everything with half a word, of omitting nothing, but taking the unnecessary for granted; the touch expeditious, prompt, and rigorous; the right word in

the right place, and nothing but the right word, found at the first attempt and never overdone; there is no turbulence and nothing superfluous; as much taste as in Van Dyck, as much practical skill as in Velazquez, in spite of the hundredfold difficulties of an infinitely richer palette, for instead of being limited to three tones it is the entire repertoire of all the tones that are known—such are, at the height of his experience and his verve, the almost unique qualities of this fine painter. The central personage with his blue satins and greenish yellow close coat, is a masterpiece. Never has anyone painted better nor ever will.

It is with these two excellent works, numbers 124 and 126, that Frans Hals defends his name against abuse. Certainly he is more natural than anybody else, but you must not say that he is ultra-simple. He certainly colours with a full brush; he models flat and avoids vulgar roundness; but though he has his own particular modelling, he none the less observes nature's relief: his figures have a back when seen from the front, and are not plates. Certainly, too, his colours are simple, cold in basis, blended; they suggest oil as little as possible; their substance is homogeneous, their foundation firm; their great radiancy comes from their originally good quality as much as from their shades; but he is neither miserly nor even sparing with these very choice colours, which are so sober, too, and in perfect taste. He lavishes them, on the contrary, with a generosity that is hardly imitated by those who take him as an example, and it is not sufficiently noticed, thanks to his unfailing tact, how he multiplies them without their damaging each other. Finally, most assuredly he allows his hand to take great liberties; but until then you cannot notice one single negligence in him. His execution is like that of everybody else, only he shows his craftsmanship better. His skill is incomparable, he knows it and is by no means displeased that it should be noticed; on this point in particular his imitators bear little resemblance to him. You must agree, too, that he draws marvellously—a head in the first place, then hands, then all that belongs to the body, clothes it, helps its gesture, contributes to its attitude, completes its physiognomy.

In fine, this painter of beautiful *entire effects* is none the less for this a consummate, a great, portrait-painter, far more delicate, elegant, and life-like than Van der Helst, and this is certainly not the usual merit of the school that takes to itself the exclusive privilege of really understanding him.

Here ends at Haarlem the florid manner of this excellent painter. I pass over number 127—1639, executed in about his fiftieth year, and which, by a mischance, closes the series rather clumsily.

With number 128, dated 1641, two years later, we enter upon a new mood, the grave mood; its range is entirely black, grey, and brown, to conform to the subject. It is the picture of the 'Regents of St. Elizabeth's Hospital' (Pl. 55). With its strong and simple meaning, its heads standing out, its clothes of black, the quality of the flesh and of the garments, its relief and earnestness, and with the richness of its sober tones, this magnificent picture represents a quite different Hals but not a better. The heads, as beautiful as they possibly can be, have all the more value in that nothing about them competes with the interest of the living element. Is it to this example of rare soberness, to this absence of colouring united to the perfect science of the colourist, that these neo-colourists of whom I speak are more especially attached? I do not yet see any very evident proof of this; but if this were, as they like to say, the very noble object of their research, what torture must not these studious men undergo at the sight of the profound scruples, the learned drawing, the edifying conscientiousness which make up the strength and beauty of this picture!

Far from calling to mind rather vain attempts, this masterly picture, on the contrary, makes one think of masterpieces. The first recollection it awakens is of the 'Syndics'. The scene is the same, the data similar, the conditions to be fulfilled correspond exactly. A central figure—as beautiful as any that Hals has ever painted—would suggest striking comparisons. The relation of the two works forces itself upon the attention. With them appears the difference between the two painters: contrary points of view, opposition of two natures, equal

power in manner, superiority of hand in Hals, of mind in Rembrandt—contrary result. If, in the room of the museum at Amsterdam where the 'Staalmeesters' (Pl. 79) figure, we were to replace Van der Helst by Frans Hals, the 'Musqueteers' by the 'Regents' (Pl. 55), what a decisive lesson that would be and what misunderstandings would be avoided! We might make a special study of these two canvases of the 'Regents'. We should have to be careful not to see in them all the multiple qualities of Hals nor all the still more numerous faculties of Rembrandt; but almost as in competition, we should witness the two craftsmen being tested on a common theme. At once we should see where each one excels and fails, and we should know why. We should learn without any hesitation that there are still a thousand things to discover under Rembrandt's craftsmanship—that there is not much to guess at behind the beautiful craftsmanship of the painter of Haarlem. I am surprised that no one has made use of this text to speak once for all the truth on this subject.

At last Hals is old, very old—he is eighty years of age. We are now in the year 1664. That same year he signed the last two pictures to which he put his hand: 'The Governors of the Haarlem Almshouse' and 'The Women Governors of the Haarlem Almshouse' (Pls. 56 and 57). The subject coincided with his age. The hand was there no longer. He displays instead of painting; he does not execute, he coats. The perception of the eye is always life-like and accurate, the colours very abridged. Perhaps in their primary composition they have a simple masculine quality that betrays the last effort of an admirable eye and speaks the last word of a consummate education. We could not imagine more beautiful blacks or finer greyish whites. The Regent on the right with his red stockings, which we can see above his garter, is a priceless morsel to a painter, but you will no longer find any consistent drawing or construction. The heads are foreshortened, the hands do not exist if we look for their form and articulations. Touch, if indeed there be any, is flung carelessly, almost at random; and no longer means anything. This absence of all

rendering, these failings of the brush, he makes up for by tone which gives a semblance of being to that which is no more. Everything fails him—clearness of vision, certainty of hand. So much the more is he bent upon making things live in powerful abstractions. The painter is three parts worn out; there remain to him—I do not say thoughts, I can no longer say a tongue—but feelings of gold.

You have seen Hals at his beginning—I have tried to show you him in his full vigour: this is how he ends; and if, taking him only at the two extremities of his brilliant career, I were given the choice between the hour when his talent began and the far more solemn hour when his amazing talent left him, between the picture of 1616 and that of 1664, I should not hesitate, and it is, of course, the latter I should choose. At that extreme moment Hals is a man who knows all, because in difficult undertakings he has successively learned all.There are no practical problems that he has not attacked, unravelled, and resolved, no perilous exercises he has not accustomed himself to. His rare experience is such that it survives practically intact in this wreck of an organization. It still reveals itself, and the more strongly that the great virtuoso has disappeared. Yet, as he is now, nothing more than the shadow of himself, don't you think that it is full late to consult him?

The error, then, of our young comrades is nothing more than an error in *apropos*. Whatever may be the astonishing presence of mind and the vivacious freshness of this expiring genius, however worthy may be these last efforts of his old age, they must agree that the example of a master eighty years of age is scarcely the best one to follow.

CHAPTER XXI

AMSTERDAM

AMSTERDAM

A NETWORK of narrow streets and canals has led me to the *Doelen Straat*. The day is closing. The evening is soft, grey, and

veiled. Light summer mists bathe the extremities of the canals.
Here, even more than in Rotterdam, the air is filled with that
pleasant odour that tells you you are in Holland, and intro-
duces you to the peat by a sudden and altogether new sensation.
A scent will tell you everything—the latitude, your distance
from the pole or the equator, from the coal-pit or the aloes,
it will tell you climate, season, places and things. Anyone who
has travelled a little knows that: the only favoured countries
are those whose fumes are aromatic, whose hearths speak
to the remembrance. As for those which have nothing to
recommend them to the memory of our senses but the con-
fused exhalations of animal life and of crowds, they have other
charms, and I don't say that they are forgotten, but they are
remembered otherwise. Thus inundated in its odorous vapours,
seen at such an hour, crossed through its centre, not muddy
but just made damp by the falling night, with its workmen
in the streets, its multitude of children on the steps, its shop-
keepers outside their doors, its little houses covered with
windows, its merchant vessels, its port in the distance, its
luxury quite away in the new quarters Amsterdam is just
what we imagine when we do not dream of a northern Venice
whose *Amstel* would be the *Giudecca*, whose *Dam* another *Saint
Marc's Square*—when, moreover, one thinks of Van der Heyden
(Pl. 97) and forgets Canaletto.

It is oldish-looking, middle-class, stuffy, busy, swarming,
with a Jewish look about it, even outside the Jewish quarters—
less grandiosely picturesque than Rotterdam seen from the
Meuse, less nobly picturesque than The Hague, yet still
picturesque because of its interior rather than in its outside
appearance. You must know the profound simplicity, the
filial love, the affection for little corners, which distinguish the
Dutch painters, in order to understand the amiable and
attractive portraits they have left us of their native town. The
colours are strong and sad, the forms symmetric, the façades
kept new, there is no architecture, no art, the little trees along
the quais are lank and ugly, the canals dirty. We can feel that
it belongs to a people eager to take possession of the conquered

mud—anxious about its business, commerce, industries, labour, rather than its well-being, and which never, even in its greatest days, ever thought of building palaces there.

Ten minutes spent on the great canal of Venice and ten other minutes spent on the *Kalverstraat* will tell you all that history can teach us of these two towns, of the genius of the two peoples, of the moral state of the two republics, and, consequently, of the spirit of the two schools. By merely seeing the lantern-like houses in which glass takes up as much room as and seems to be more indispensable than stone, the little balconies carefully yet poorly adorned with flowers and the mirrors fixed to the windows, we understand that in this climate the winter is long, the sun faithless, the light miserly, the life sedentary and perforce careful—that open-air contemplation is rare, enjoyment within closed doors very keen, and that the eyes, the mind, and the soul contract there that form of patient, attentive, minute, rather strained, and, so to speak, peering investigation common to all the Dutch thinkers, from the metaphysicians to the painters.

Here I am, then, in the native land of Spinoza and Rembrandt. Of these two great names, which represent, in the order of abstract speculation or purely ideal invention, the intensest effort of the Dutch brain, one alone concerns me— the latter. Rembrandt's statue is here and the house in which he lived during his happiest years, and his two most famous works—that is more than is necessary to eclipse a great many glories. Where is the statue of the national poet, Juste van den Vondel, his contemporary and, in his time, his equal at least in importance? They tell me it is in the New Park. Shall I go to see it? Who goes to see it? Where did Spinoza live? What has become of the houses where Descartes lived, where Voltaire stayed, where Admiral Tromp and great Ruyter died? What Rubens is at Antwerp, Rembrandt is here. The type is less heroic, the prestige is the same and the sovereignty equal. But instead of dwelling resplendent in the tall transepts of the churches, on sumptuous altars in votary chapels, or on the glittering walls of some princely gallery, Rembrandt is found

here in the little dusty rooms of an almost commonplace house. The destiny of his works remains in conformity with his life. From my lodging at the corner of the *Kloveniers Burgwal*, I catch a glimpse on the right, on the edge of the canal, of the reddish, smoked façade of the *Trippenhuis* Gallery—that is to say, through the closed windows and in the pale light of these soft Dutch twilights I can already see, glittering like a cabalistic glory, the dazzling fame of the 'Night Watch'.

I need not conceal the fact that this work—the most famous in Holland, one of the most celebrated in the world—is the object of my journey (Pl. 69). It inspires in me great admiration and also very great doubts. I do not know any picture about which there has been more discussion, more reasoning, and, naturally, more false reasoning. It is not that it enchants equally all those in whom it inspires enthusiasm; but certainly there is no one, at least among the writers on art, whose clear common-sense has not been disturbed by the merits and by the oddness of the 'Night Watch'.

From its title—which is a mistake—to its lighting, the key to which has scarcely yet been found, people have been pleased—I don't know why—to mingle all sorts of enigmas with technical questions, which do not seem to me so very mysterious, though they are a little more complex than elsewhere. Never anywhere, except in the *Sistine Chapel*, has less simplicity, good nature, and precision been brought to the examination of a painted work; it has been praised beyond measure, admired without any real reason being given, discussed a little—but very little—and always as if with fear and trembling. The most daring, treating it as an undecipherable piece of mechanism, have taken it to pieces, examined all its parts, but have not much better revealed the secret of its strength and its evident weaknesses. One point alone has put them all in agreement, those whom the work delights and those whom it shocks: it is that, perfect or not, the 'Night Watch' belongs to that sidereal group in which universal admiration has brought together, like so many stars, certain

almost celestial works of art! They have gone so far as to say that the 'Night Watch' is '*one of the wonders of the world*', and that Rembrandt is '*the most perfect colourist that ever existed*'— all of which is so much exaggeration or mock praise, for which Rembrandt is not responsible, and which, certainly, would have offended that great, thoughtful, and sincere mind; for better than anyone else he knew well that he had nothing in common with the thoroughbred colourists, with whom they compare him, nor anything to do with perfection as they understand it.

In two words, taken altogether—and even an exceptional picture could not disturb the rigorous economy of this strong genius—Rembrandt is a unique master in his country, in all the countries of his time, in all times: a colourist, if you will, but after his own manner; a draughtsman too, if you will, but like no one else—more might be said, but that would have to be proved; very imperfect, if we think of perfection in the art of expressing beautiful forms and of painting them well with simple media; admirable, on the other hand, in things involved, independently of his form and colour, in his very essence; incomparable in the literal sense of the word, in that he resembles no one, and in that he eludes the mistaken comparisons which he has been subjected to, and in this sense, too, that in the delicate points in which he excels, he has no like and, I should think, no rival.

A work which represents him as he was at the height of his career—at thirty-four years of age—exactly ten years after the 'Anatomy Lesson', could not fail to reproduce, in all their splendour, several of his original faculties. Does it follow that it has expressed them all? And is there not in this somewhat forced attempt something that stood in the way of the natural working of what was rarest and profoundest in him?

The enterprise was new. The subject was vast and complicated. It involved—a unique thing in his work—movement, gesticulation, and sound. It was not of his choice; it was a portrait picture. Twenty-three well-known people expected him to paint them in full view, doing something and yet in the dress of militiamen. This theme was too commonplace to

do without some kind of embellishment and yet too definite to allow of much fancy. He had, whether they pleased him or not, to accept types, paint physiognomies. In the first place likeness was insisted on, and great portraitist as he is called, and is, in fact, in several ways, formal exactness of trait is not his strong point. Nothing in this parade composition precisely suited his visionary's eye, his soul apt to wander from the true—nothing, unless the fantasy he intended to put into it, and which the least touch too much might have changed into phantasmagoria. Will he do with the same ease and with equal success what Ravesteyn, Van der Helst, Frans Hals did so freely or so excellently—he the antipode in every way of these perfect physiognomists, these fine craftsmen who achieved their end at a stroke?

The effort was great. And Rembrandt was not one of those to whom tension gives strength or equilibrium. He inhabited a sort of *camera obscura*, in which the true light of things was transformed into strange contrasts, and lived in an environment of strange reveries, into which this intrusion of armed men would bring some upheaval. Here he is, then, during the painting of these twenty-three portraits, constrained to attend to others, very little to himself, belonging neither to them nor to himself, tormented by a demon that hardly ever left him, busy with people who were posing and who did not intend to be treated as romance. Anyone who knows the retiring and fantastic habits of such a spirit will understand that it was not in these circumstances that the inspired Rembrandt of his best moments would be likely to appear. Wherever Rembrandt neglects himself—I mean in his compositions—whenever he does not put himself into it and whole-heartedly, the work is incomplete, and were it an extraordinary work, we might say, *a priori*, that it would be faulty. This complicated nature has two distinct faces—the one interior and the other exterior, and this latter one is seldom the finer. The errors one is inclined to make in judging him are due to this, that often we look at the wrong face and that we are looking at it back to front.

Is the 'Night Watch', then—can it be?—the last word in Rembrandt's art? Is it only the most perfect expression of his manner? Are there not in it obstacles natural to the subject, difficulties of arrangement, circumstances that were new to him and were never repeated in his life? This is the point that must be examined. Perhaps some enlightenment may come from the examination. I don't think that Rembrandt will lose anything by it. There will only be a legend less in the history of his work, a prejudice less in current opinion, a superstition less in criticism.

With all its rebellious appearances the human mind at bottom is but an idolater. Sceptic, 'tis true, but credulous withal; its most imperative need is to believe and its natural tendency to submit. It changes masters and changes idols; its subject nature lives through all these upheavals. It does not like to be shackled and it shackles itself. It doubts, it denies, but it admires—this is one of the forms of faith—and, the moment it admires, one gets from it the most complete abandonment of that faculty of free examination it pretends to be so jealous of. In the matter of political beliefs, creeds, philosophies, is there one it has respected? And notice that at the same time, by subtle self-examination, in which we should discover under its revoltings the vague need to adore and the proud sense of its grandeur, it creates to itself near by, in the world of art, another ideal and other cults, not suspecting to what contradictions it exposes itself in denying the true in order to cast itself at the feet of the beautiful. It seems that it does not really see the perfect identity of the one and the other. The things of art seem to be its own domain, in which its reason has no fear of surprises, with which it can comply without restraint. It chooses within it celebrated works of art, makes of them its patent of nobility, clings to them, and will no longer allow its title to them to be contested. There is always something well founded in their choice—not everything, but something. We could, by going through the works of the great artists of the last three centuries, draw up a list of these persistent credulities. Without going too closely into whether its preferences are

always rigorously correct, we should see, at least, that the modern mind has not such a great aversion for the conventional, and we should discover its secret liking for dogmas by noticing all those with which it has strewn its history—for good or evil. There are, it would seem, dogmas and dogmas. There are those which irritate, and those which please or flatter one. It is not difficult for anyone to believe in the sovereignty of a work of art that we know to be the product of a human mind. Every man, however little instructed he may be, believes fondly—because he judges it and says he understands it—that he holds the secret of this visible and tangible thing come from. the hands of his fellow-man. What is the origin of that thing of human appearance, written in the language of all, painted alike for the minds of the wise and for the eyes of the simple— so like to life? Whence comes it? What is inspiration—a phenomenon of natural order or a true miracle? All these questions give one a great deal to think about, but no one gets to the bottom of them; we admire, we proclaim a great man, a masterpiece, and all is said. No one troubles about the inexplicable making of a work fallen from heaven. And, thanks to this inadvertency which will reign over the world as long as the world lasts, the very man that scoffs at the supernatural will bow down before it without seeming to know what he is doing.

Such are, I think, the causes, the empire and the effect of superstitions in the matter of art. We might quote more than one example of it, and the picture of which I wish to speak is perhaps the most notable and striking. I already need some boldness to awaken your doubts; what I shall add will be still more daring.

CHAPTER XXII

THE 'NIGHT WATCH'

WE know how the 'Night Watch' is hung (Pl. 69). It faces the 'Banquet of Musqueteers' by Van der Helst, and

whatever may have been said about it, the two pictures do not harm each other. They contrast with each other as night with day, as the transfiguration of things with a rather commonplace and skilful literal imitation. Admit that they are as perfect as they are famous and you have before you a unique antithesis—what La Bruyère calls 'an opposition of two truths which illuminate each other'. I shall not speak of Van der Helst today, nor probably any day. He is a fine painter whom we may envy the possession of to Holland, for in certain days of penury he would have rendered great services to France as a portrait-painter and a painter of state display; but in the matter of imitative and merely sociable art Holland has far greater ones.[1] And when one has just seen Frans Hals at Haarlem, one may without disadvantage turn his back on Van der Helst to give one's attention exclusively to Rembrandt.

I shall surprise no one when I say that the 'Night Watch' has no charm whatever, and this fact is without parallel among the beautiful works of pictorial art. It astonishes and disconcerts, it obtrudes itself upon us, but it absolutely lacks that primary insinuating attraction which convinces and persuades us, and nearly always at first sight it displeases. For in the first place it wounds that logic and habitual rectitude of the eye which likes distinct forms, lucid ideas, clearly formulated enterprises; something warns you that the imagination, like the reason, will be only half-satisfied, and that the mind most easily won over will submit only in the long run, and then will not surrender without a dispute. This is due to several causes which are not altogether the fault of the picture—to the light, which is detestable; to the dark wooden frame in which the painting is lost, which does not determine either its mean values, its bronze tone, or its power, and which makes it look still more smoky than it really is, and, lastly and above all, it is due to the exiguity of the situation, which does not allow the canvas to be hung at a suitable height, and, contrary to all the laws of the most elementary perspective, obliges you to look at it on a level, at close quarters.

[1] See p. 369.

I know that, on the contrary, it is generally considered that the place is in perfect congruity with the subject, and that the force of illusion which we obtain by thus exposing it comes to aid the painter's efforts. Here we have much false reasoning in few words. I know but one way of hanging a picture, and that is to determine what is its spirit, to consult, consequently, what are its requirements, then to hang it according to these requirements.

When we speak of a work of art—above all of one by Rembrandt—we speak not of an untruth, but of something imagined which is not its contrary either, which is never the exact truth, but which in any case is separated from the realities of external life by the profoundly calculated approximations to reality. The people who move about in this special atmo-sphere—for the greater part fictitious—and whom the painter has placed in that distant perspective proper to inventions of the mind, could leave their positions, were any unwitting disturbance of point of view to displace them, only at the risk of ceasing to be what the painter made them and yet of not becoming what they are wrongly wished to become. There exists between them and ourselves a barrier. Here this barrier is already very close. If you examine the 'Night Watch' you will perceive that by a rather risky arrangement on the canvas the two first figures of the picture, placed in the same plane as the frame, have scarcely the retreat that the requirements of chiaroscuro and the obligations of a well-thought-out effect would demand. We ill understand Rembrandt's spirit, the character of his work, his aims, his incertitudes, and his instability in some directions, if we submit him to a test which Van der Helst could sustain, it is true, but we know under what conditions. I add also that a painter's canvas is a cautious thing that tells only what it means to tell—tells it from afar when it does not suit it to tell it close at hand, and that any picture that has a care for its secrets is badly hung if you force it to avowals.

You are aware that the 'Night Watch' passes, rightly or wrongly, for a practically incomprehensible work, and therein

lies one of the great causes of its prestige. Perhaps it would have made far less noise in the world if, for two centuries, people had not been in the habit of looking for its meaning instead of examining its merits, and if they had not persisted in the folly of regarding it as a picture which was, above all things, enigmatic.

To take it in an absolutely literal manner, what we know of the subject seems to me to suffice. In the first place we know the names and the quality of its personages, thanks to the care the painter has taken to write them on a cartouche at the bottom of the picture; and this proves that if the fancy of the painter has transfigured many things, the first elements belonged to the region of local life. We do not know, it is true, for what purpose these people came out in arms, whether they are going to shooting practice, on parade, or elsewhere; but as there is little matter for profound mystery, I am persuaded that if Rembrandt did not trouble to be more explicit, it is because he did not want to be or did not know how to be more explicit, and there you have a whole series of hypotheses which would be explained very simply by something like want of power or by voluntary reticence. As to the question of the hour of day—the most disputed of all and also the only one that might have been settled from the first day—there was no need, in order to fix it, to discover that the stretched-out hand of the captain threw its shadow on the flap of a coat. It was enough to remember that Rembrandt never dealt otherwise with light, that nocturnal darkness is his habit, that shadow is the usual form his poetry takes, his usual means of dramatic expression, and that in his portraits, in his interiors, in his legends, in his anecdotes, and in his landscapes, in his etchings as in his paintings, it is generally with night that he makes day.

Perhaps in reasoning thus by analogy, and by means of certain deductions of sober common-sense, we might raise further doubts, and there remain at the end of the reckoning, as unsolvable obscurities, only the embarrassments of a mind in difficulty before the impossible, and the shortcomings of a subject made up, as this one had to be, of unsufficing reality and of a fantasy there was little scope for.

I will undertake, then, what I would wish had been undertaken long ago—a little more criticism and less exegesis. I shall pass over the riddles of the subject in order to approach, with all the care that it demands, a work painted by a man who was seldom deceived. Once this work is offered to us as the highest expression of his genius and as the most perfect expression of his manner, there is cause to examine very closely an opinion so universally accepted, together with the reasons for this opinion. So I shall not shun, I warn you, the technical controversies that the discussion will necessitate. I ask your pardon beforehand for some slightly pedantic expressions that already I feel escaping from my pen. I shall try to be clear; I do not undertake to be as brief as I should, or not to scandalize at first certain fanatic spirits.

The composition does not constitute, it is agreed, the principal merit of the work. The subject had not been chosen by the painter, and the fashion in which he intended to treat it did not allow the first conception to be very spontaneous or very lucid. So the scene is very undecided, the action almost nil, the interest, consequently, very divided. An inherent defect in its first idea, a sort of irresoluteness in the manner of its conception, its distribution, and its posing, is apparent from the beginning. Some people walking, others stopping, one priming his musket, another loading his, another firing, a drummer, posing for the head, beating his drum, a rather theatrical standard-bearer, in short, a crowd of figures fixed in the immovability proper to portraits—these are, if I am not mistaken, as regards movement, the only pictorial traits in the picture.

Is this indeed enough to give it the physiognomic, anecdotic, and local meaning which we expect of Rembrandt when he paints places, things, and men of his time? If Van der Helst, instead of painting his musketeers seated, had given them some kind of movement, do not doubt but that he would have given us the most accurate, if not the most delicate, indications as to what manner of men they were. And, as to Frans Hals, you may imagine with what clearness, what orderliness, and

how naturally he would have disposed the scene; how piquant, ingenious, exuberant, and magnificent he would have been. The subject conceived by Rembrandt is of the most ordinary, and I venture to say that most of his contemporaries must have thought it poor in resource, some because its abstract line is uncertain, curtailed, symmetric, meagre, and singularly disconnected; the others, the colourists, because this composition full of gaps, of ill-filled spaces, did not lend itself to that large and generous use of colours which is the ordinary exercise of learned palettes. Rembrandt was the only one who knew how, with a particular object in view, to get out of this scrape; and the composition, whether good or bad, ought to have been sufficient for his design, for his design was to resemble in nothing either Frans Hals, or de Grebber, or Ravesteyn, or Van der Helst, or anybody else.

So there is no truth and little pictorial invention in the general disposal. Have the figures individually any more? I cannot see one which could be pointed out as a choice bit of work.

What strikes one's eyes is that there exist between these figures disproportions for which there is no cause, inadequacies in each of them and, so to speak, an anxiousness to give them character which nothing justifies. The captain is too tall and the lieutenant too short—not only by the side of *Captain Cocq*, whose size overwhelms him, but by the side of the accessory figures, whose length or breadth give this undersized young man the appearance of a child with a too early moustache. Considered each and all, they are unsuccessful portraits, of doubtful likeness, of thankless physiognomy— and this failure is surprising in a portrait-painter who in 1642 had given proof of his skill; it somewhat excuses *Captain Cocq* for sitting later to the infallible Van der Helst. The guardsman who is loading his musket—has he been any more carefully observed? And what do you think, also, of the musketeer on the right, and of the drummer? We might say that, in all these portraits, the hands are lacking, so vaguely sketched are they and so meaningless is their action. The result of this is

that whatever they hold is badly held—muskets, halberds,
drumsticks, canes, lances, the banner—and that the gesture
of an arm is abortive when the hand which ought to be acting
does not act neatly, quickly, with energy, accuracy, or spirit.
I shall not speak of the feet which are for the most part hidden
in the shadow. Such are, in fact, the exigencies of the system
of containing lines adopted by Rembrandt, and such is the
set purpose of his method, that one and the same dark cloud
invades the bases of the picture, and that the forms float in
this to the great detriment of the points of support.

Must it be added that the costumes resemble the likenesses,
that they are half-conceived, odd and unnatural, stiff and
disobedient to the lines of the body? They look as if they are
ill put on. The helmets are set on awry, the felt hats are queer-
looking and unbecoming. The scarfs are in their right place
and yet clumsily knotted. There is nothing of that natural
elegance, unique bearing, of that *négligé* in dress surprised and
caught exactly, with which Frans Hals knew how to apparel
all ages, all statures, all habits of body, and certainly, too, all
ranks. We are no more satisfied on this point than on a great
many others. We ask ourselves if there is not in all this a sort
of laboured fancy, an endeavour to appear strange, which is
neither pleasant nor striking.

Several of the heads are very fine; I have mentioned those
which are not. The best ones—the only ones in which can be
seen the hand of the master and the feeling of a master—are
those which, from the depths of the picture, beam upon you
with their vague eyes and the keen flash of their mobile glance.
Do not examine their construction very severely, nor their
perspective, nor their anatomical structure; accustom yourself
to the palish grey of their tint, interrogate them from afar, as
they look at you from a long distance, and if you would know
how they are alive, look at them as Rembrandt wishes we
should look at his human effigies, attentively, long, at the
lips and the eyes.

There remains an episodic figure which up to the present
has baffled all conjectures, because it seems to personify in its

traits, its dress, its strange brilliance, and its little bearing on the subject, the magic, the romantic meaning, or, if you like, the counter-sense of the picture (Pl. 71). I mean the little person with the look of a witch, childish yet very old, with comet-like head-dress and ornamented tresses, who glides, we scarcely understand why, among the legs of the guards, and who—a thing no less inexplicable—wears suspended from her waist a white cock, which we might take at first for a purse.

Whatever reason it may have had for mixing with this assembly, this small figure seems to have nothing human about it at all. It is colourless, almost shapeless. Its age is doubtful because its traits are indefinable. Its appearance is that of a doll and its behaviour automatic. It has the ways of a beggar, and something like diamonds all over the body—the air of a little queen, with garments that look like rags. One might say that she came from the Jewish quarter, from the old clothes shop, from the theatre or some Bohemian place, and that, awakening from a dream, she dressed herself in the most singular fashion. She has the glimmerings, the uncertainty, and the flickerings of pale fire. The more one examines the less can one seize the subtle lineaments which serve as a covering for her incorporeal existence. We come to see in her nothing but a sort of extra-ordinarily strange phosphorescence which is not the natural light of things, nor yet the ordinary brilliancy of a well-regulated palette, and which adds a witchery the more to the strangeness of the physiognomy. Note that in the place she occupies in one of the dark corners of the canvas, rather low, in the middle distance, between a man in dark red and the captain dressed in black, this eccentric light has the more activity, that the contrast with the surroundings is more sudden, and that, without extreme precautions, this explosion of accidental light would have been enough to disorganize the whole picture.

What is the meaning of the little being, imaginary or real, which, though but a supernumerary, seems to have taken possession of the principal role? I cannot undertake to tell you. Men more skilful than myself have not failed to ask themselves

what this might be, what it is doing there, and have not been able to discover a satisfactory solution.

One thing alone astonishes me, and that is that people argue with Rembrandt as if he himself were a reasoner. They are enraptured with the novelty, the originality, the absence of all rule, the free flight of an entirely individual imagination, which make up, as has been well said, the great attraction of this venturesome work; and it is precisely the fine flower of his somewhat disordered imagination that people subject to an examination by logic and pure reason. But if, to all these rather vain questions about the why and wherefore of so many things which probably have none at all, Rembrandt were to reply thus: 'This child is a caprice, no less odd than, and for that matter quite as plausible as, many others in my engraved and painted work. I have set it there, as a narrow light between great masses of shade, because its slightness gave it more vibration, and it suited me to enliven one of the dark corners of my picture with a streak of light. Its get-up is, moreover, the ordinary dress of my figures of women, great or small, young or old, and you will find in it the type which, more or less like, is continually found in my works. I like whatever shines brightly, and that is why I have dressed it in brilliant apparel. As to the phosphorescent glimmer which seems to cause you so much astonishment here, while in other places it passes unnoticed, it is in its colourless sparkle, and in its supernatural quality, the light that I usually give my personages when I want them to shine rather vividly.' Don't you think that such an answer would have in it sufficient to satisfy the most exacting, and that finally, the rights of the producer being reserved, he would have nothing to answer to us for save on one point: the manner in which he has treated the picture?

We know the effect produced by the 'Night Watch' when it appeared in 1642. This memorable attempt was neither understood nor appreciated. It further noised abroad the fame of Rembrandt: made him greater in the eyes of his faithful admirers, compromised him in the eyes of those who had

followed him only with some effort and were watching him at this decisive point. It made of him a stranger painter—a less safe master. It impassioned and divided people of taste according to the heat of their blood or the coldness of their reasoning power. In short, it was regarded as an entirely new but perilous venture, which brought him a great deal of applause, not a little blame, and which at bottom satisfied nobody. If you know the judgements passed on this subject by Rembrandt's contemporaries, his friends and pupils, you must see that opinions have not materially varied for two centuries and that we repeat pretty nearly what that great rash man must have heard during his lifetime.

The only points about which opinion is unanimous, especially in our time, are the colouring of the picture, which is called *dazzling, blinding,* and *unheard-of* (and you will agree that such words would be rather likely to spoil the praise), and the execution, which it is agreed to call masterly. Here the question becomes very delicate. We must, cost what it may, leave the easy paths, enter the thicket, and 'talk shop'.

If Rembrandt were not a colourist in any sense, no one would ever have made the mistake of taking him for a colourist, and in any case nothing would be easier than to indicate for what reasons he is not one; but it is evident that his palette is his most ordinary and most powerful means of expression, and that, in his etchings as in his paintings, he expresses himself still better in colour and in effect than in drawing. Rembrandt is then, with a great deal of reason, classed among the most powerful colourists that ever were. So that the only way to separate him, and to bring out in him the gift which is his own, is to distinguish him from the great colourists known as such, and to establish what is the profound and exclusive originality of his notions in the matter of colouring.

We say of Veronese, Correggio, Titian, Giorgione, Rubens, Velazquez, Frans Hals, and Van Dyck that they are colourists, because in nature they perceive colour more delicately than form, and because they colour better than they draw. To colour well is, following their example, to grasp the shades,

choose them well on the palette, and juxtapose them well in
the picture. One part of this complicated art is regulated in
principle by certain precise enough physical laws, but the
greater part is bound up with the aptitudes, customs, instincts,
caprices, and the sudden sensibility, of each artist. There is
much that might be said on this score; for colouring is a thing
of which people unacquainted with our art speak very freely
without really understanding it, and on which the people of our
profession have never, so far as I know, said their word.

Reduced to its most simple terms, the question may be
formulated thus: to choose colours beautiful in themselves,
and secondarily, to combine them in beautiful, skilful, and
exact relationship. I will add that the colours may be deep or
light, rich in tint or neutral, that is to say duller, *bold*, that is to
say nearer the *mother-colour*, or graded and *blended*, as we say
in technical language, and lastly, of diverse value (I have told
you elsewhere what is meant by that)—all this is a matter of
temperament, of preference, and also of suitability. Thus
Rubens, whose palette is very limited as regards the number
of colours, but very rich in *mother-colours* and has the most
extensive range—from true white to true black—can subdue
himself when necessary and blend his colour when a toning
down is required. Veronese, who proceeds quite otherwise,
gives way no less than Rubens to the requirements of the
circumstances; nothing could be more florid than certain
ceilings in the Ducal Palace—nothing is more sober in its
general keeping than the 'Meal at Simon's House' at the
Louvre. It must be said that it is not necessary to *colour* much
to be a great colourist. There are men, as Velazquez for
example, who colour marvellously with the most dishearten-
ing colours. Black, grey, brown, white tinted with bitumen—
what masterpieces has he not executed with these dull tones!
It suffices that the colour should be rare, delicate or strong, but
resolutely composed by a man skilful in feeling shades and in
meting them out. The same man, when it pleases him, can
extend his resources or reduce them. The day when Rubens
painted in various tones of bistre the 'Sacrament of St. Francis

of Assisi' was, to speak only of the adventures of his palette, one of the best inspired of his life.

Finally—and this trait must be kept well in mind in this more than summary definition—a colourist properly so called is really a painter who can keep for the colours whatever they may be—rich or not, blended or not, complicated or reduced—their principle, their properties, their resonance, their accuracy, and that at all times and in all places, in the shade, in the half-tones and even in the brightest light. It is in this, above all, that men and schools distinguish themselves. Take some unsigned painting, examine the quality of its local tone, what it becomes in the light, if it holds out in the half-tints and in the deepest shade, and you will be able to decide with certainty if this painting is or is not the work of a colourist, to what epoch, to what country, to what school it belongs.

Technical language usually formulates all this in the following manner. Whenever colour undergoes all the modifications of light and shade without losing anything of its constituent qualities, the light and shade are said to be of the *same family*; which means that they both retain, whatever happens, the most obvious relationship to the local tone. The ways of understanding colour are very diverse. There are, between Rubens and Giorgione and between Velazquez and Veronese, differences and varieties which prove the immense elasticity of the art of painting, and the astonishing freedom as to the form genius may take without changing its aim; but one law is common to them all and is observed only by them, whether at Venice or Parma or Madrid, or Antwerp or Haarlem: and it is nothing less than the connexion between the light and the shade and the identity of the local tone through all changes in the light.

Is it thus that Rembrandt proceeds? You have but to look at the 'Night Watch' to see the contrary.

Save one or two bold colours, two reds and a dark violet, except one or two sparks of blue, you can see nothing in this colourless and violent canvas which recalls the palette and the ordinary method of any of the known colourists. The heads

have the semblance rather than the colouring of life. They are red, vinous or pale, yet without having, for all that, the true paleness that Velazquez gives to his faces, or those sanguine, yellowish, greyish, or purple shades which Frans Hals places in opposition, with so much delicacy, when he wishes to specify the temperaments of his characters. In the clothes, the head-dresses, the various parts of the drapery, the colour is no more accurate or expressive than is, as I have said, the form itself. When a red appears, it is a red not very delicate in its nature and expresses indefinitely silk, cloth, or satin. The guardsman loading his musket is dressed in red from head to foot, from his felt hat to his shoes. Do you perceive that the physiognomic peculiarities of this red, its nature and substance, which a true colourist would never have failed to seize, here occupied Rembrandt's attention for a single moment? They say that this red is admirably consequent in its light and in its shade. In truth, I don't think that a man, however little accustomed to manipulate a tone, could be of such an opinion—and I don't suppose that either Velazquez or Veronese, Titian or Gior-gione, to say nothing of Rubens, would have accepted its original composition or its employment. I challenge anyone to tell me how the lieutenant is dressed, or of what colour is his dress. Is it white tinted with yellow? Is it yellow uncoloured so as to seem almost white? The truth is that, as this person had to express the central light of the picture, Rembrandt clothed him in light—very skilfully as regards brilliance, very carelessly as regards colouring.

Now—and it is here that Rembrandt begins to betray him-self—to a colourist, there is no abstract light. Light in itself is nothing: it is the result of colours variously illumined and variously radiating, according to the nature of the ray that they reflect or absorb. Such and such a very dark tint may be extraordinarily luminous; another very light one may, on the contrary, not be so at all. Not a student but knows that. To the colourist, then, the light depends exclusively on the choice of colours employed to render it and is so closely bound up with the tone that we might say in all truth that to him light

and colour are but one. In the 'Night Watch' there is nothing like this. The tone disappears in the light, just as it disappears in the shade. The shade is blackish, the light whitish. Everything is brightened or darkened, everything radiates or is obscured by an alternative effacement of the colouring principle. Values are averted rather than tones contrasted. And this is so true that a fine engraving, a well-rendered drawing, a Mouilleron lithograph, a photograph of it, gives us exactly the idea of the picture in these great intentional effects, and that a print, merely diminished from light to dark, destroys nothing of its arabesque.

If I have been well understood, this is what proves, with evidence, that management of colour, such as it is usually understood, is not a strong point with Rembrandt, and that we must continue to look elsewhere for the secret of his real power and for the expression proper to his genius. Rembrandt is in all things an abstractor whom one cannot define, save by a process of elimination. When I have said with certainty what he is not, perhaps I shall then manage to determine exactly what he is.

Is he a great craftsman? Assuredly. Is, then, the 'Night Watch' in its workmanship and with reference to himself, is it, compared with the masterly works of the great painters, a fine piece of execution? I don't think so: which is another misunderstanding it would be well to dispose of.

The work of the hand, as I said when speaking of Rubens, is nothing but the consequent and adequate expression of the sensations of the eye and the workings of the mind. What, in itself, is a well-turned phrase, a well chosen word, if not the instantaneous testimony to what the writer wished to say and to the intention he had to say it thus and not otherwise? Consequently, to paint well is, in general, either to draw or to colour well, and the manner in which the hand acts is no more than the definitive pronouncement of the painter's intentions. If we examine those craftsmen who are sure of themselves, we shall see how obedient the hand is, how prompt to respond to the dictates of the mind, and what shades of sensibility,

ardour, delicacy, spirit, depth, pass into the tips of their fingers, be they armed with rough-casting tool, brush, or graver. Each artist then, be he painter, sculptor, or engraver, has his own manner—and Rembrandt no more escapes from this common law than does anyone else. He executes in his own manner, and he executes extremely well; we might say he executes like nobody else, because he feels, sees, wills like nobody else.

How does he execute in the picture with which we are dealing? Does he treat a material well? No. Does he express ingeniously, vividly, its folds, its suppleness, its tissue? Most certainly not. When he puts a feather in a felt hat does he give this feather the lightness, the waviness, the grace that we see in Van Dyck or Hals or Velazquez? Does he show by a few bright, glossy touches on a dull background, by their form, or by their following the lines of the body, the human physiognomy of a well-adjusted garment, rumpled by some movement or creased by wear? Can he, in a few summary touches, and proportioning his labour to the value of the occasion, indicate a piece of lace, suggest jewellery or rich embroidery?

There are in the 'Night Watch' swords, muskets, partisans, shining helmets, embossed gorgets, funnel-shaped boots, be-ribboned shoes, a halberd with its streamer of blue silk, a drum, and lances. Imagine with what ease, with what simplicity, and what swift manner of suggesting things without insisting on them, Rubens, Veronese, Van Dyck, Titian himself, and lastly Frans Hals—that workman of unparalleled cleverness—would have briefly indicated and superbly swept away all these accessories. Do you really think that Rembrandt in the 'Night Watch' excelled in so treating things? Look, I beg—for in this punctilious discussion we must have proofs—at the halberd which the little *Lieutenant Ruytenburg* holds at the length of his stiff arm; see its foreshortened point—look, above all, at the floating silk, and tell me if a craftsman of this worth could have expressed with more sign of effort an object which ought to come to life under his brush almost without his noticing it.

Look at the slashed sleeves, which are praised so much, at the
ruffles and the gloves; examine the hands. Notice well how,
in their carelessness, affected or not, the form is emphasized,
how the foreshortenings are expressed. The touch is heavy
and laboured, almost clumsy and hesitating. It looks as if it
were 'out of the perpendicular': applied across when it should
be along, level when anyone else would have applied it in a
circular direction; it confuses the form rather than determines it.

Everywhere there are *high-lights*—that is to say, decisive
accentuations—which are unnecessary, inaccurate, and unjusti-
fiable. There are thicknesses which are overloadings, rugosities
which nothing can justify, unless it be the need to give
consistency to the lights and the obligation his new method
puts upon him to work on rugged tissues rather than on a
smooth basis; projections that try to seem real and don't
succeed disconcert the eye and are accounted to him for
original craftsmanship; things taken for granted that are really
omissions; things neglected that seem to point to incapacity.
In all the salient parts we see proof of a convulsive hand, a
difficulty in finding the exact word, a violence of terms, a tur-
bulence of action which clashes with the slightness of the reality
obtained and with the rather dead immobility of the result.

Do not take my word for this. Go and see elsewhere good
and beautiful examples among the most serious and among the
most witty; seek out successively the work of rapid hands and
of diligent hands; look at their finished works, their sketches;
then come back to the 'Night Watch' and compare. I will
say more: go to Rembrandt himself when he is at his ease, at
liberty with his ideas, free in his workmanship, when he
imagines, when he is moved, nervous yet without too much
exasperation, and when, master of his subject, of his feeling,
and of his tongue, he becomes perfect—that is, admirably
skilful and profound, which is better than being adroit. These
are circumstances in which the handicraft of Rembrandt is on
a par with that of the best masters and reaches the height of his
finest gifts. That is when it is by chance subjected to the
obligations of the perfectly natural, or else when it is animated

by the interest of an imaginary subject. Outside that, and this is the case in the 'Night Watch', you have nothing but a mixture of Rembrandt—that is, the ambiguities of his mind and the false appearance of skill in his hand.

At last I come to the incontestable interest of the picture, to the great effort of Rembrandt in a new direction: I mean the application on a grand scale of that manner of seeing which is his own, and which has been called *chiaroscuro*.

Here no error is possible. What we attribute to Rembrandt is certainly his own. Chiaroscuro is, there can be no doubt about it, the natural and necessary form of his impressions and ideas. Others as well as he used it; no one used it so continuously and ingeniously as he. It is the mysterious form *par excellence*, the most disguised, the most elliptical, the richest in suggestion and surprise, that there is in the picturesque language of painters. In virtue of this it is, more than any other, the form of intimate feelings or ideas. It is light, vaporous, veiled, discreet; it lends its charm to elusive things, incites to curiosity, adds an attraction to moral beauty, gives a grace to the speculations of the inner consciousness. It has a share in fact, feelings, emotions, in the uncertain, the indefinite and the infinite, in dreams and ideals. And that is why it is, as it had to be, the poetic and natural atmosphere in which the genius of Rembrandt never ceased to live. Rembrandt's work, then, in all its inwardness and truth, might fittingly be studied in this the usual form of his thought. And if, instead of skimming over the surface, I were to go down into the depths of this vast subject, you would see his whole psychological being appear of itself from out of the mists of the chiaroscuro; but I shall say only what I must say, and Rembrandt will stand out none the less, I hope.

In very ordinary language and in the practice common to all schools, chiaroscuro is the art of making the atmosphere visible, and of painting an object enveloped in air. Its aim is to create all the picturesque accidents of shade, half-tint, and light, of relief and distance, and, consequently, to give more variety, unity of effect, caprice and relative truth—maybe to the forms,

maybe to the colours. The contrary is a more ingenuous and abstract acceptation of things in virtue of which they are shown as they are, seen close at hand, the atmosphere being suppressed, and consequently with no perspective save the linear perspective which results from the diminution of objects and from their relation to the horizon. Whoever speaks of aerial perspective takes for granted a certain amount of chiaroscuro.

Chinese painting ignores it. Gothic and mystic painting did without it, witness Van Eyck and all the primitives, whether Flemish or Italian. Must it be added that if it is not contrary to the spirit of fresco, chiaroscuro is not indispensable to its needs? At Florence it began late, as everywhere the line has precedence of colour. At Venice it did not appear until after the Bellinis. As it corresponds to entirely personal ways of feeling, it did not always follow a very regular chronological path in the schools, keeping pace with their progress. Thus in Flanders, after having been seen foreshadowed in Memling, it disappeared for half a century. Among the Flemings who came back from Italy very few had adopted it among those who nevertheless had lived with Michelangelo and Raphael. At the same time that Perugino and Mantegna considered it unnecessary in the abstract expression of their ideas and continued, so to speak, to paint with the tool of the engraver or goldsmith, and to colour according to the process of the window painter—a great man, a great mind, a great soul found in it the rarest elements of expression for the height or depth of his feeling, and the means of expressing the mystery of things by a mystery. Leonardo da Vinci, to whom Rembrandt has been compared not without some reason, on account of the torment caused to both by the need to formulate the meaning of things, is, in truth, at the height of the archaic period, one of the least foreseen exponents of chiaroscuro. Following the course of time, in Flanders, from Otto van Veen we come to Rubens. And if Rubens is a great painter of chiaroscuro, although he makes more frequent use of the *chiaro* than of the *oscuro*, Rembrandt is no less its definitive and absolute expression for many reasons, and not merely because he uses the

oscuro more easily than the *chiaro*. After him the whole Dutch School from the beginning of the seventeenth century up to the height of the eighteenth, the beautiful and prolific school of half-tints and restrained lights, moves only in this element common to all, and affords such a rich and diverse whole only because, having once admitted this mode, it knew how to vary it by the most delicate metamorphoses.

Anyone else than Rembrandt in the Dutch School might sometimes make one forget that he was obeying the fixed laws of *chiaroscuro*; with him this can never be forgotten. He has drawn up, co-ordinated, and, so to speak, promulgated its code, and if one could think of doctrines at this moment of his career when instinct causes him to act much more than reflection, the 'Night Watch' would redouble in interest, for it would then assume the character and the authority of a manifesto.

To envelop, to immerse everything in a flood of shade, to plunge light itself into it, reserving the right to draw it out again in order to make it appear more remote or more radiating; to twirl dark waves round about illuminated centres, to shade them, deepen them, thicken them, yet render the darkness transparent, the half-darkness easy to pierce, in fine, to give to the strongest colours a sort of permeability which prevents them from being black—such is the first condition, such are also the difficulties of this very special art. It goes without saying that if anyone excelled in it, it was Rembrandt. He did not invent, he perfected everything, and the method he used oftener and better than anyone else bears his name.

The consequences of this manner of seeing, feeling and rendering the things of actual life, can be guessed. Life has no longer the same appearance. Containing lines become attenuated or effaced, colours are volatilized. The modelling, no longer imprisoned in a rigid contour, becomes more uncertain in its stroke, more undulating in its surfaces, and when it is treated by a knowing and tender hand, it is the most life-like and real of all, because it contains a thousand artifices thanks to which it lives, so to speak, a double life—

the one it owes to nature and the one that comes to it from communicated emotion. To sum up, there is a manner of deepening the canvas, of throwing back, of bringing near, of dissimulating, of making evident, and of sinking the true in the imaginary, which is *art*—and, to call it by its name, *the art of chiaroscuro*.

Does it follow that, because such an art authorizes a great many licences, it permits them all? Neither a certain relative exactitude, nor truth of form, nor its beauty when that is aimed at, nor permanence of colour, could suffer from the fact that many of the principles are changed in the manner of perceiving things and of interpreting them. On the contrary, it must certainly be said that among the great Italians, taking Leonardo da Vinci and Titian for our examples, if the custom of introducing a great deal of shade and little light expressed better than another the feeling they had to render, this purposeful treatment did not injure, and was far from injuring, the beauty of the colouring, of the outline and of the work. The matter was all the lighter for it, the language the more exquisitely transparent. The language lost nothing by it, either in purity or in clearness; it became, as it were, the rarer for it, more limpid, more expressive, and stronger.

Rubens did nothing but embellish and transform, by innumerable artifices, what seemed to him to be life in his favourite acceptation of it. And if his form is not more chastened it certainly is not the fault of the chiaroscuro. Who knows, on the contrary, what service this incomparable envelope rendered to his drawing? What would he be without it, and when he is well inspired what does he not become, thanks to it? The man who draws, draws better still by its aid, and he who colours, colours so much the better when he admits it to his palette. A hand does not lose its form, a physiognomy its character, a likeness its exactitude, or a fabric, if not its texture at least its appearance, a metal, the shine of its surface and the density natural to its substance, and, lastly, a colour does not lose its local tone—that is to say, the very principle of its existence, for being bathed in dim fluidity. It

must be quite other and yet remain equally true. The learned works of the Amsterdam School are the proof of it. With all the Dutch painters, with all the excellent masters to whom chiaroscuro was the common and current language, it enters into the art of painting as an auxiliary; and with them all it helps to produce a more homogeneous, more perfect and truer effect. From the works, so picturesquely true, of Pieter de Hooch, Ostade, Metsu, and Jan Steen, to the higher inspirations of Titian, Giorgione, Correggio, and Rubens, we see everywhere the use of half-tints and large shadows arising out of the need to express with more prominence *things perceptible*, or out of the necessity to embellish them. Nowhere can they be separated from the architectural line or the human form, from the true light or the true colour of things.

Rembrandt alone, on this point as on all the others, sees, thinks and acts differently; and I am not then wrong in questioning the possession by this strange genius of most of the external gifts which are the usual endowment of the masters, for I am only bringing out the dominant faculty which he shares with no one.

If anyone tells you that his palette has the virtue proper to the rich Flemish, Spanish, and Italian palettes, I have told you the reasons for which you may be permitted to doubt it. If anyone tells you he has a swift and adroit hand, prompt to express things clearly, that it is natural in its play, brilliant and free in its dexterity, I must ask you not to believe anything of this, at least in presence of the 'Night Watch'. Lastly, if anyone speaks to you of his chiaroscuro as a discreet and light envelopment, intended merely to veil very simple ideas, or very positive colours, or very distinct forms, consider if there is not in that a new error, and if, on this point as on the others, Rembrandt has not disorganized the whole system of the customs of painting. If, on the contrary, you hear someone, hopeless of classifying him and for want of a word, call him a *luminarist*, ask yourself what this barbarous word means, and you will perceive that this exceptional term expresses something very strange and very right. A luminarist would be, if I

am not mistaken, a man who conceived light outside of the accepted laws, attached an unusual meaning to it, and would make great sacrifices to it. If this be the meaning of the neologism, Rembrandt is at once defined and judged. For beneath its displeasing form the word expresses an idea difficult to render, a true idea, a rare eulogy, and a criticism.

I have told you, in connexion with the 'Anatomy Lesson' (Pl. 60), a picture which would fain be dramatic and is not, how Rembrandt used light when he used it unsuitably; there is the *luminarist* when he strays. I shall tell you later how Rembrandt uses light when he makes it express what never a painter in the world has expressed by known means: you will judge by that what the *luminarist* becomes when he approaches with his dark lantern the world of the marvellous, of consciousness, and of the ideal; you will see then that he has no longer a master in the art of painting, because he has no equal in the art of showing the invisible. Rembrandt's whole career, then, turns about this haunting objective—to paint only with the aid of light, to draw only with light. And all the varied criticisms which have been passed upon his works, beautiful or faulty, doubtful or incontestable, may be put into this simple question: Was it or not the time to attach so exclusive an importance to light? Did the subject demand it? Could it support it or did it exclude it? In the first case, it is the consequence of the spirit of the work; infallibly it should be admirable. In the second case, its consequence is uncertain, and nearly always the work is questionable or abortive. It would be useless to say that light, in the hands of Rembrandt, is like a marvellously subdued and docile instrument, of which he was sure. Examine his work carefully, take it from his first years to his last days, from the 'Simeon' (Pl. 59) at The Hague, to the 'Jewish Bride' at the Van der Hoop Gallery (Pl. 80), to the 'St. Matthew' at the Louvre (Pl. 75), and you will see that this dispenser of light did not always dispose as he should nor even as he could have wished; that it possessed him, governed him, inspired him even to the sublime, led him to the impossible, and sometimes betrayed him.

Explained according to this tendency of the painter to express a subject only by the lightness and darkness of things, the 'Night Watch' has, so to speak, no more secrets. All that could make us hesitate is now deducted. The qualities have now their *raison d'être*; as for the errors, we can now understand them. The difficulties of the craftsman when he executes, of the draughtsman when he constructs, of the painter when he colours, of the *costumier* when he apparels, the want of consistence in the tone, the amphibological effect, the uncertainty of the hour, the strangeness of the figures, their fulgent appearance in the deepest shadows—all this is here the chance result of an effect conceived in defiance of all likelihood, pursued in spite of all logic, unnecessary, and whose theme was this: to illumine a real scene by a light that was not real; that is to say, to give a fact the ideal character of a vision. Look for nothing beyond this most daring project which smiled upon the aims of the painter, clashed with all established data, opposed customs with a system, an audacity of the mind with the skill of the hand, and whose rashness certainly did not fail to goad him on right up to the day when, I think, insurmountable difficulties revealed themselves, for, if Rembrandt solved some of them, there were many that he could not solve.

I appeal to those who do not unreservedly believe in the infallibility of the best minds: Rembrandt had to paint a company of men in arms; he was simple enough to tell us what they were going to do; he said it so carelessly that he is still not understood even in Amsterdam. He had to paint likenesses: they are doubtful; physiognomic costumes: for the most part they are apocryphal; a picturesque effect, and this effect is such that the picture becomes thereby indecipherable. The country, the place, the time, the subject, the men, the things have disappeared in the stormy phantasmagoria of the palette. Generally he is excellent in rendering life, he is marvellous in painting fictions, his habit is to think, his master faculty is to express light; here fiction is not in its place, the life is lacking, the thought makes up for nothing. As to the light, it adds an inconsequence to an approximation.

It is supernatural, disturbing, artificial; it radiates from within to without, it dissolves the objects it illuminates. I can see many brilliant centres, but I can see nothing illuminated; it is neither beautiful nor true nor appropriate. In the 'Anatomy Lesson' death is forgotten in favour of a trick of the palette. Here two of the principal figures lose their corporality, their individuality, their human significance in the glimmer of an *ignis fatuus*.

How, then, does it come about that such a mind made such a mistake as not to have said what he had to say and to have said precisely what was not asked of him? He who was so clear when it was necessary, so profound when there was occasion to be, why is he here neither profound nor clear? Has he not, I ask you, drawn better and coloured better, even in his own manner? As a portrait-painter has he not painted portraits a hundred times better? Does the picture we are dealing with give even an approximate idea of the power of this inventive genius when he is peaceably occupied with his own thoughts? And, lastly, his ideas—which always show up at the bottom of the marvellous, as the 'Vision' of his Doctor Faust appears in a dazzling circle of rays—those rare ideas, where are they? And if the ideas are not there, why so many rays? I think that the answer to all these doubts is contained in the preceding pages if these pages have any clearness.

Perhaps now you perceive, in this genius made up of exclusions and contrasts, two natures which up to now have not been properly distinguished, which nevertheless contradict each other and are practically never found together in the same work and at the same time: a thinker who bends uneasily to the exigencies of the true, while he becomes inimitable when the obligation to be truthful is no longer present to hinder his hand, and a craftsman who can be magnificent when the visionary does not disturb him. The 'Night Watch', which represents him in a very equivocal light, is not then either the work of his mind when it is free, or the work of his hand when it is healthy. In a word, the true Rembrandt is not here at all; but, very happily for the honour of the human

mind, he is elsewhere, and I think I shall not have diminished so high a fame if, thanks to works less famous, and yet superior, I show you, one after the other in all their splendour, the two sides of this great mind.

CHAPTER XXIII

REMBRANDT AT THE SIX AND VAN LOON GALLERIES—REMBRANDT AT THE LOUVRE

AMSTERDAM

REMBRANDT, indeed, would be inexplicable if we did not see in him two men of adverse nature who disturb and embarrass each other. Their power is almost equal, their reach has nothing that may be compared; as to their objectives, they are diametrically opposed. They have tried to put themselves in harmony with one another and have succeeded only in the long run, in circumstances which have become famous but which are very rare. As a rule they acted and thought apart, which was always successful. The sustained efforts, the temerities, the few failures, the last masterpiece of this great double man—the 'Syndics'—are nothing but the struggle and final reconciliation of these two natures. The 'Night Watch' may have given you an idea of the poor understanding which existed between them, when, doubtless too soon, Rembrandt undertook to make them collaborate in the same work. I have now to show you each one in his own domain. When you see to what an extent they were contrary one to the other and complete in themselves, you will understand better why Rembrandt had so much difficulty in finding a composite piece of work in which they might both manifest themselves without injuring each other.

In the first place there is the painter whom I shall call the external man: clear mind, rigorous hand, infallible logic, opposed in everything to the romantic genius to which the admiration of the world has been given almost without

reserve, and sometimes, as I have just told you, rather too quickly. In his own fashion and at his own times the Rembrandt of whom I wish to speak is himself a superior master. His manner of seeing is of the soundest; his manner of painting edifies by the simplicity of its medium; his manner of being bears witness that he wishes to be, above all, comprehensible and truthful. His palette is wise, limpid, tinted with the true colours of the light, and without cloud. His drawing makes itself overlooked but overlooks nothing. He is excellently physiognomic. He expresses and characterizes in their individuality traits, looks, attitudes, and movements, that is to say, the normal habits and the passing accidents of life. His execution has the propriety, the loftiness, the close tissue, the power and conciseness natural to craftsmen who are past masters in the art of fine language. His paint is grey and black, dull, full, extremely thick, very thickly laid, and pleasing. It has for the eye the charm of an opulence that hides away instead of displaying itself, and of a skill that is betrayed only by sallies of the highest genius.

If you compare it with the painting of the same mode and of the same range that distinguishes the Dutch portrait-painters, Hals excepted, you will perceive by an indescribable superiority in richness of tones, an indefinable inward warmth of shade, in the flow of the paint, in the glow of the construction—that a temperament of fire is concealed beneath the apparent tranquillity of the method. Something warns you that the artist who paints thus is making a great effort not to paint otherwise, that the palette affects a sobriety suited to the circumstances, in fact, that this unctuous and grave pigment is really far richer at bottom than it seems to be, and that, being analysed, it would yield, as a magnificent alloy, reserves of gold in a blended state.

It is under this unexpected form that Rembrandt reveals himself each time he comes out of himself to lend himself to quite accidental obligations. And such is the power of such a mind, when it is turning with sincerity from one world to another, that this thaumaturgus is another of those witnesses

most capable of giving us a faithful and new idea of the
external world such as it is. His works thus conceived are not
numerous. I do not think, and the reason for it is easily grasped,
that one of his pictures, I mean one of his imagined or imagin-
ary works, was ever garbed in this relatively impersonal form
and colour. Nor will you find in him this manner of feeling
and painting save in a case when through fancy or necessity he
subordinates himself to his subject. In this list might be
included several remarkable portraits scattered throughout the
collections of Europe, which would deserve a separate study.
It is also to those moments of rare abandon, in the life of a man
who rarely forgot himself and gave himself up only out of
complacency, that we owe the portraits of the Six and Van
Loon Galleries and it is to these perfectly beautiful works I
should advise anyone to have recourse if he wishes to know
how Rembrandt treated the human personality when, for
motives that we may guess, he consented to attend only to
his model.

The most celebrated is that of the 'Burgomaster Six'
(Pl. 78). It is dated 1656, the fateful year, in which Rembrandt,
grown old and ruined, retired to the *Rozengracht* (the *Rose
Canal*), retaining of his past prosperity only one thing which
was worth all the others—his intact genius. We are surprised
that the Burgomaster, who had lived with Rembrandt in the
closest familiarity for fifteen years, and whose portrait he had
already engraved in 1647, should have waited so long before
having himself painted by his illustrious friend. While
admiring Rembrandt's portraits, had Six some reason to doubt
their resemblance? Did he not know how the painter had
behaved formerly with 'Saskia', with what little scruple he
had painted himself thirty or forty times already, and did
he fear for his own picture one of those infidelities of which
he, oftener than anyone, had been witness?

At any rate, this time among others, and certainly out of
regard for the man whose friendship and patronage followed
him in his ill-fortune, Rembrandt suddenly mastered himself
as if his mind and hand had never made the least step aside. He

is free but scrupulous, pleasant and sincere. Of this un-chimeri-cal personage he made an un-chimerical picture, and with the same hand that signed, two years before, in 1654, the 'Bath-sheba' of the Lacase Gallery (Pl. 73)—a spontaneous and rather bizarre study—he signed one of the best portraits he ever painted, one of the best pieces of workmanship he ever executed. He abandoned himself still more than he controlled himself. Nature was there directing him. The transformation he makes things undergo is imperceptible, and you would have to hold up to the canvas a real object in order to perceive artifices in that delicate yet so masculine piece of painting—so skilful and so natural is it. The execution is rapid, the pigment rather heavy and smooth, flowing and abundant, laid on at a stroke without unnecessary relief. There is no straining, no abruptness, not a detail but has a primary or a secondary interest.

A colourless atmosphere floats about this personage who had been observed in his own house in his ordinary habits and everyday clothes. He is not altogether a gentleman, neither is he quite a *bourgeois*; he is a gentlemanly man, well dressed, easy in manner; his eye is steady without being fixed, his expression calm, his look rather absent. He is going out, he has his hat on, he is putting on gloves of a greyish colour. The left hand is already gloved, the right hand is bare; neither the one nor the other is finished nor could be, so positive is the sketch in its want of finish. In this case the rightness of the tone, the truth of gesture, the perfect correctness of the form are such that everything is expressed just as it should be. The rest was a matter of time and pains. And I can reproach neither the painter nor the model for being so well satisfied with such a clever approximation. The hair is reddish, the felt hat is black; the face is as recognizable by its tint as by its expression, as individual as it is lifelike. The doublet is of a soft grey; the short cloak thrown over the shoulder is red trimmed with gold lace. Each has its own colour, and the choice of these two colours is as delicate as the relation of the two colours is right. As moral expression it is charming, as truth it is positively sincere, as art it is of the highest quality.

What other painter would have been capable of painting a portrait such as this one? You can test it by the most redoubtable comparisons; it stands them all. Would Rembrandt himself have brought to it so much experience and abandon—that is, such a concord of mature qualities—before having passed through the deep researches and perilous risks which had just occupied the most laborious years of his life? I don't think so. Nothing is lost by the efforts a man makes, and everything helps him, even his mistakes. You will find in this picture the good humour of a mind giving itself up to relaxation, the easiness of a hand that is resting, and, above all, that manner of interpreting life which belongs only to thinkers inured to the deepest problems. In this connexion, and if one thinks of the attempts of the 'Night Watch', the perfect success of the portrait of Six is, if I am not mistaken, an unanswerable argument.

I don't know whether the portraits of Martin Day and his wife—the two important panels which adorn the great Salon in the Hotel Van Loon (Pls. 62 and 63)—are better than or not so good as that of the Burgomaster. In any case they are more spontaneous and much less known, for the names of the personages were not so well known. Besides, they do not really belong to Rembrandt's first nor to his second manner. Much more than the portrait of Six they are an exception among the works of his middle years, and the need one has to classify the works of a master in accordance with such and such an ultra-famous picture has caused them to be regarded as pictures without a type, and for that reason to be somewhat neglected. The portrait of the husband was done in 1634, two years after the 'Anatomy Lesson', that of the wife in 1643, a year after the 'Night Watch'. Nine years separate them, and yet they have the appearance of having been conceived at the same time, and if nothing in the first calls to mind the timid, diligent, thin, and yellowish period of which the 'Anatomy Lesson' remains the most important specimen, nothing, absolutely nothing, in the second bears any trace of the daring attempts upon which Rembrandt had just entered. I indicate

here, by brief notes, the fundamental value of these two admirable portraits.

The husband is standing, facing the spectator, in black doublet, black small clothes, black felt hat, guipure collarette, guipure cuffs, a knot of guipure at his garters, large guipure cockades on his black shoes. His left arm is folded and the hand hidden under a black cloak adorned with black satin; his right arm is stretched out before him, he holds a skin glove. The background is blackish, the ground grey. A fine head, gentle and grave, rather roundish; fine eyes regarding well; the drawing is charming, grand, easy and familiar, and most perfectly natural. The painting equal, firm in outline, of such consistency and fullness that it might be thin or thick without our exacting either more or less; imagine a more spiritual and meditative Dutch Velazquez. As to the rank of the personage there is the most delicate way of marking it: he is not a prince, scarcely a great lord; he is a gentleman of good birth, fine education, elegant habits. The race, the age, the temperament— in a word, the life, in its most characteristic features—all that was wanting in the 'Anatomy Lesson', all that later would be lacking in the 'Night Watch', you will find here in this work of pure good faith.

The wife, too, is standing, against a blackish background and on a grey ground, and likewise dressed altogether in black, with pearl necklace, pearl bracelet, knots of silver lace at her waist, cockades of silver lace fixed on the delicate slippers of white satin. She is thin, pale and tall. Her pretty head, slightly bent, looks at you with calm eyes, and her tint of uncertain colour borrows a most vivid brilliancy from the warmth of her hair, which inclines to auburn. A slight rounding of the figure, very discreetly indicated under the fullness of her dress, gives her the appearance of a young and infinitely estimable matron. In her right hand she holds a fan of black feathers with a little gold chain; the other, pendant, is white, thin, slender, of exquisite race.

Black, grey, white, nothing more, nothing less, and the colour scheme is unequalled. An invisible atmosphere and yet

air; low relief and yet all the relief possible; an inimitable way of being precise without pettiness, of opposing the largest masses with the most delicate work, of expressing by the tone the luxury and value of things; in a word, a sureness of eye, a sensibility of palette, a certitude of hand which would be sufficient to give him the fame of a master: these are, if I am not mistaken, the astonishing qualities obtained by the same man who a few months before had signed the 'Night Watch'.

Was I not right in appealing from Rembrandt to Rembrandt? If one were to suppose, in fact, the 'Anatomy Lesson' and the 'Night Watch' thus treated—with the necessary respect for things, the physiognomies, the costumes, the typical features—would not he be an extraordinary example to meditate upon and follow in this class of portrait compositions? Did not Rembrandt run a great risk of complicating himself? Was he less original when he kept to the simplicity of his fine workmanship? What sound and strong language, a little traditional, but so entirely his own! Why change it completely? Had he then such a pressing need to create for himself a strange idiom, expressive but incorrect, which nobody after him has been able to speak without falling into barbarisms? Such are the questions that would suggest themselves if Rembrandt had given up his life to painting the people of his time, such as Doctor Tulp, Captain Cocq, Burgomaster Six, Mr. Martin Day; but Rembrandt's care was not in that direction. If the painter of *outsides* had found his formula at once and achieved his aim at the first attempt, it was not so with the inspired creator we are going to see at work. This latter was much more difficult to satisfy, because he had to express things that could not be treated like fine eyes, pretty hands, rich lace on black satin, and for which something more than a positive sketch, a clear palette, and a few frank, neat, and concise locutions, is required.

Do you remember the 'Good Samaritan' we have at the Louvre (Pl. 67)? Do you remember that man, half dead, doubled in two, supported by the shoulders, held by the legs, broken, his whole body twisted, panting to the motion of the

walking, his legs bare, his feet held together, his knees touching, one arm folded awkwardly over his hollow chest, his forehead in a bandage on which we can see blood? Do you remember that little suffering face, with its half-shut eyes, its dull regard, its expression of a dying man, one eyebrow raised—that groaning mouth and those lips parted in an imperceptible grimace in which the moan expires? It is late, everything is in shadow, with the exception of one or two flitting glimmers, which seem to move across the canvas, so capriciously are they disposed, so mobile and light, nothing disturbs the tranquil uniformity of the twilight. Scarcely in the mystery of the closing day do you notice, on the left of the picture, the horse in such fine style and the sickly-looking child who raises himself on tiptoe, looks over the horse's shoulder and, without much pity, follows with his eyes as far as the inn this wounded man who has been picked up by the wayside, whom they are carrying off carefully, and who hangs in his supporters' arms, heavily groaning.

The canvas is smoky, impregnated throughout with sombre golds, very rich beneath and very grave. The pigment is muddy and yet transparent, the touch is heavy and yet subtle, hesitating and resolute, laboured and free, very unequal, uncertain, vague in certain parts, of astonishing precision in others. There is a something which invites you to collect yourself, and would warn you, if distraction were possible in presence of such an imperious work, that the author was himself singularly attentive and collected when he painted it. Stop, look at it from a distance, then close at hand; examine it for a long time. There is no apparent contour, no emphasis is given by rote, there is an extreme timidity which is not the timidity of ignorance and which comes, one might say, from the fear of being banal, or from the value attached by the thinker to the immediate and direct expression of life; things have a structure which seems to exist of itself, almost without the help of any known formula, and which renders, without out any means that can be discovered, the incertitudes and precisions of nature. Bare legs and feet of irreproachable

construction—of perfect style too; we cannot forget them in the smallness of their dimensions any more than we can forget the legs and feet of the Christ in the 'Entombment' of Titian. In this pale, thin, and groaning face there is nothing that is not an expression, something coming from the soul, from within: feebleness, suffering, and as it were a sad joy in feeling oneself gathered up when one is dying. There is not a contortion, not a disproportionate feature, not a touch, in this manner of rendering the inexpressible, that is not pathetic and restrained— all this dictated by a deep emotion and interpreted by altogether extraordinary means.

Look round about this picture that has not a very remarkable exterior and yet attracts from afar the attention of those who know how to see, merely by the power of its range of colour. Go through the great gallery, even come back to the Salon Carré; consult the strongest and most skilful painters, from the Italians to the shrewdest Dutchmen—from Giorgione in his 'Concert' to Metsu in his 'Visit', from Holbein in his 'Erasmus' to Terborch and Ostade; examine the painters of sentiment, of physiognomy, of attitude, the men of scrupulous observation or of verve; try to understand what they set out to do, study their researches, measure their domain, weigh their language, and ask yourself if you perceive anywhere such an insight in rendering the expression of a face, and in depicting emotion of this nature, such ingenuity in the manner of feeling, anything, in a word, so delicate to conceive, so delicate to express, which is expressed in terms either more original or more exquisite or more perfect.

We might, up to a certain point, define what makes up the perfection of Holbein, or even the strange beauty of Leonardo da Vinci. We might say pretty well to what strong and attentive observation of human traits the former owes the very evident likeness of his portraits, the precision of his form, the clearness and rigour of his language. Perhaps we might suspect in what ideal world of lofty standards or of dream types Leonardo divined what the Gioconda should be in herself, and how from this first conception he drew forth the

expression of his Saints John and his Virgins. We might, even more easily, explain the rules of drawing followed by the Dutch imitators. Nature is everywhere to teach them, sustain them, restrain them, and to assist their hand as well as their eye. But Rembrandt? If we look for his ideal in the higher world of forms, we perceive that he saw in it only moral beauties and physical uglinesses. If we look for his standpoints in the actual world we discover that he excludes everything others made use of, that he knows it as well, looks at it only imperfectly, and that, if he adapts it to his requirements, he scarcely ever conforms to it. Yet he is more natural than any-one while being less near to nature, more familiar while being less near to earth, more trivial and quite as noble, ugly in his types, extraordinarily beautiful in the significance of his physiognomies, less adroit of hand; that is to say, he is less constantly, less equally sure of his fact, and yet of such a rare skill, so fecund and of such compass that he can go from the 'Samaritan' to the 'Syndics', from 'Tobias' to the 'Night Watch', from the 'Carpenter's Family' to the 'Portrait of Six', to the 'Martin Day' portraits; that is to say, from pure sentiment to almost pure parade, from the things of deepest insight to the most gorgeous things.

What I said about the 'Samaritan' I shall say of 'Tobias' (Pl. 66)—I shall say it with all the more reason of the 'Disciples of Emmaüs', a marvellous piece of work, rather lost in a corner of the Louvre, which may be counted among the masterpieces of the great painter (Pl. 74). This little picture of poor appearance, of no arrangement, of wan colour, of timid, almost awkward construction, would be enough to establish for all time the greatness of a man. Without speaking of the disciple who understands and who joins his hands, of the one who is astonished, lays his napkin on the table, looks straight into the face of Christ and clearly expresses what in ordinary language we might translate by the exclamation of a stupefied man—without speaking of the young attendant with the black eyes who is bringing a plate and who sees but one thing—a man who was going to eat, but does not eat and

crosses himself with compunction—we might preserve of this unique work nothing but the Christ, and that would be sufficient. Where is the painter that has not painted a Christ in Rome or Florence, in Siena, Milan, Venice, Basle, Bruges or Antwerp? From Leonardo da Vinci, Raphael, and Titian to Van Eyck, Holbein, Rubens, and Van Dyck how has He *not* been deified, humanized, transfigured, shown in some period of His life, in His passion or death? How have they *not* related the adventures of His earthly life, conceived the glory of His apotheosis? Has He ever been imagined *thus* before—pale, emaciated, seated full-faced, breaking bread as He had done the night of the Last Supper, in His pilgrim's robe, with His blackish lips on which torture had left its trace, His great brown eyes, gentle, wide, dilated, and raised to Heaven, with His cold halo—a sort of phosphorescence around Him which sets Him in a dim glory—and that something of a living, breathing man who has passed through death? The attitude of this divine *revenant*, that gesture impossible to describe and most emphatically impossible to copy, the intense ardour of that face—whose type is expressed without traits and whose physiognomy depends upon the movement of the lips and upon the glance—these things inspired from we know not whence, produced we know not how—all this is priceless. No art reminds us of them; no one before Rembrandt, no one after him has said these things.

Three of the portraits signed by his hand and possessed by our gallery are of the same essence and value: his 'Self-Portrait' (No. 2553 in the Catalogue, Pl. 58), the fine bust of the 'Young Man' with the little moustache and long hair (No. 2545, Pl. 77), and the 'Portrait of a Woman' (No. 2547, Pl. 65)—perhaps, too, that of 'Saskia' at the end of a short life. To multiply examples, that is to say, witnesses to his flexibility and power, to his presence of mind when he dreams, to his prodigious lucidity when he discerns the invisible, we must quote the 'Carpenter's Family' (Pl. 68), in which Rembrandt throws himself wholeheartedly into the wonderful light, this time with complete success, because light is in the

truth of his subject, and, above all, the 'Two Philosophers'—
two miracles of chiaroscuro which he alone was capable of
working into this abstract theme—'Meditation' (Pl. 61).

Here, if I am not mistaken, in a few canvases, and those not
the most famous, is an exposition of the unique faculties and
the fine manner of this great mind. Note that these pictures
are of all dates, and that, consequently, it is scarcely possible
to establish at what moment of his career he was most master
of his thought and craft, considered as a poet. It is certain that
after the 'Night Watch' there was a change in his material
processes, sometimes a progress, sometimes only a set purpose,
a new habit; but the true and profound merit of his work has
scarcely anything to do with the innovations in his work. He
returns, moreover, to his easy and incisive language, when the
need to say profound things, expressly, outweighs in his mind
the temptation to say them more energetically than formerly.

'The Night Watch' was done in 1642, the 'Tobias' in 1637,
the 'Carpenter's Family' in 1640, the 'Samaritan' in 1648, the
'Two Philosophers' in 1633, the 'Disciples of Emmaüs', the
most transparent and sensitive, in 1648. And if his 'Self-
Portrait' is of the year 1634, that of the 'Young Man', one
of the most finished that ever left his hand, is of 1658. What I
conclude merely from this enumeration of dates is that six
years after the 'Night Watch' he signed the 'Disciples of
Emmaüs' and the 'Samaritan'; now, when after such a
brilliant outburst, at the height of fame—and what clamorous
fame!—applauded by some, contradicted by others, one
becomes calm enough to remain so humble, so self-possessed,
as to return from so much excitement to so much wisdom, it
is because at the side of the innovator who seeks, of the painter
who strives to perfect his resources, there is the thinker who
pursues his work as he can, as he feels it, nearly always with
the power of clairvoyance proper to brains enlightened by
intuition.

THE 'SYNDICS'

WITH the 'Syndics' we know what to count upon in the final Rembrandt (Pl. 79). In 1661 he had but eight years to live. During these last years—unhappy, difficult, abandoned, always full of labour, his craftsmanship was to become heavier; as to his manner, that was to change no more. Had it then changed so very much? Taking Rembrandt from 1632 to the 'Syndics', from his departing point to his arriving, what are the variations that have come about in this obstinate genius so little connected with others? The mode became more expeditious, the brush is freer, the pigment thicker and more substantial, the groundwork firmer. The solidity of the first construction is the greater that the hand has to act more sweepingly over the surfaces. It is what is called treating a canvas more *magisterially*, because in truth such elements can scarcely be handled, because often instead of controlling them at one's ease, one is their slave, and because it needs a long past of successful experiment to be able to use such expedients without too great risk.

Rembrandt had arrived at this degree of assurance gradually and rather by jerks, by rapid impulses, by turnings back. Sometimes very wise works followed, as I have said, works which were not so; but at last, after this long journey of thirty years, he had settled all the points, and the 'Syndics' may be regarded as the summing up of his acquisitions or, rather, as the brilliant result of his convictions.

This painting is a number of portraits in one picture—not the best portraits, but worthy of comparison with the best he did in these last years. Of course they do not remind us at all of the 'Martin Day' portraits (Pls. 62 and 63). Nor have they, either, the freshness or the clearness of colouring of 'Six' (Pl. 78). They are conceived in the shadowy, tawny, and powerful style of the 'Young Man' at the Louvre (Pl. 77)— and are much better than the 'St. Matthew', which is dated the same year and in which traces of old age are already

apparent (Pl. 75). The garments and felt hats are black, but through the black you can perceive very deep reddish tints; the linen is white, but highly glazed with bistre; the faces, extremely lifelike, are animated by fine, brilliant, and direct eyes, which do not precisely look at the spectator, but yet follow you, question you, listen to you. They are individual and like. They are indeed bourgeois, merchants, but they are also notables, at home round a red-covered table, their open register occupies them and we surprise them in full council. They are busy without action, they speak without moving their lips. Not one of them is posing, they are living. A warm atmosphere whose value is increased tenfold envelops all in rich and grave half-tints. The linen, the faces, the hands stand out in an extraordinary manner, and the extreme vividness of the light is as delicately observed as if nature itself had given its quality and measure. One could almost say of this picture that it is one of the most restrained and moderate, so exact is it in its equilibrium, if one did not feel through all that self-possessed maturity a great deal of nervous tension, impatience, and fire. It is superb. Take some of his fine portraits conceived in the same spirit, and there are many of them, and you will have an idea of what an ingeniously disposed grouping of four or five portraits of first-class quality can be. The whole is grandiose; the work is decisive. We cannot say that it reveals either a stronger or a more daring Rembrandt; but it proves that the seeker has turned over the same problem many times in his mind and that at last he has found the solution.

The picture is too famous and too rightly honoured for there to be any need for me to insist further. What I am anxious to thoroughly establish is this—it is at once very real and very imaginary, copied and conceived, prudently dealt with and magnificently painted. All Rembrandt's efforts, then, have gone home, not one of his researches has been vain. What then, in brief, did he set out to do? He intended to treat living nature almost as he treated fiction, to mingle the ideal with the true. Through several paradoxes he succeeded. He thus connected all the links of his fine career. The two men

who for a long time had divided the power of his mind, linked hands in this hour of perfect success. He closed his life by an understanding with himself and with a masterpiece. Was he such a one as could know peace of mind? At least, when he signed the 'Syndics' he could believe that this day had arrived.

A last word to have done with the 'Night Watch'. I have told you that its subject matter seemed to be too real to admit of so much magic, and that consequently the fantasy that disturbs it seemed scarcely in its place—that, considered as the representation of an actual scene, the picture is not too intelligible, and that, looked upon as art, it lacks some of the resources of the ideal, Rembrandt's natural element, in which he asserts himself with all his merit. I have told you, moreover, that an incontestable quality already manifests itself in this picture: the art of introducing, in a broad setting and in a scene also largely expanded, a new idea of the pictorial art, a transformation of things, a power of chiaroscuro, the secrets of which no one before him or after him has known so well. I have taken the liberty to say that this picture by no means showed that Rembrandt was a fine draughtsman within the ordinary meaning of the term, that it bore witness to all the differences which separate him from the true colourists; I have not said by how much difference, because between Rembrandt and the great masters of the palette there are only unlikenesses and not degrees. Finally, I have tried to explain why, in this work in particular, he is not, either, what one would call a good craftsman; and I have used the Louvre pictures and his portraits of the Six family to establish that, when he consents to see nature as it is, his technique is admirable, and that, when he expresses a sentiment, though this sentiment should appear inexpressible, he is then a craftsman without an equal.

Have I not in all this drawn the outlines and the limitations of this great mind? Is it not easy now for you to form a conclusion?

The 'Night Watch' is an intermediary picture in his life which it divides pretty nearly in half. It is the central spot in the domain of his mind. It reveals, it manifests all that can be

expected from so flexible a genius. It does not contain him, it does not mark his perfection in any one of the kinds of painting he attempted, but it makes us feel that in many kinds he may be perfect. The heads at the back, and one or two physiognomies in the nearer distances, show us what the portrait-painter should be, and show us his new method of treating resemblance by means of abstract life—by life itself. Once for all, the master of chiaroscuro had given a definite, distinct expression to that element, till then confused with so many others. He had proved that it exists in itself, independently of external form and of colour, and that it would be able by its power, the variety of its use, the strength of its effects, the number, the depth, or the subtlety of the ideas it expresses, to become the principle of a new art. He had proved that weightiest comparisons may be asserted without colour, by the mere action of light on shade. He had thus formulated, more definitely than anyone else, the *law of values*, and rendered incalculable service to our modern art. His imagination was led astray by the subject matter in this rather commonplace picture. And yet the little girl with the cock, appropriately or inappropriately, is there to attest that the great portrait-painter is above all a visionary, that this very exceptional colourist is first of all a painter of light, that his strange atmosphere is the air that suits his conceptions, and that there are outside nature, or rather in the depths of nature, things which this pearl-fisher alone has discovered.

A great effort and interesting testimonies—there you have, in my opinion, the most positive things the picture contains. It is incoherent only because it attempts to carry out many contrary aims. It is obscure only because the subject matter itself is uncertain and the conception not very clear. It is violent only because the mind of the painter strained to grasp it, and excessive only because the hand that painted it was less resolute than daring. We look in it for mysteries that are not there. The only mystery I can discover in it is the eternal and secret struggle between reality such as it asserts itself, and truth such as it is conceived by a brain carried away by chimeras. Its

historical importance comes to it from the greatness of the
work and the importance of the attempts of which it is the
summing up; its fame comes from the fact that it is strange;
its least doubtful title, indeed, comes to it not from what it is,
but, as I have said, from what it affirms and announces.

A masterpiece has never been, as far as I know, a faultless
piece of work; but it is usually the formal and complete
exposition of the faculties of a master. In virtue of this, is this
work at Amsterdam a masterpiece? I don't think so. Could a
judicious study of this many-sided genius be written with this
single picture for evidence? Could one take his measure by it?
If the 'Night Watch' disappeared what would happen?
What gap would there be? What vacant space? And what
would happen, too, if certain pictures, certain singled-out
portraits disappeared? Which of these losses would diminish
most or least the glory of Rembrandt, and which of them
would posterity suffer for most? In short, do we know
Rembrandt perfectly when we have seen him in Paris, in
London, in Dresden? And should we know him perfectly if
we had seen him only in Amsterdam in the picture which
passes as his master work?

I think it is pretty nearly the same with the 'Night Watch'
as it is with Titian's 'Assumption'—it is a paramount and most
significant picture, yet by no means one of his best. I imagine,
too, without making any comparison as regards the merits
of the works, that Veronese would be unknown if he were
represented only by the 'Rape of Europa', one of the most
famous and certainly one of the most bastard of pictures—a
work which, far from predicting a step forward, announced
the decadence of the man and the decline of a whole school.

The 'Night Watch' is not, as we see, the only misunder-
standing that there is in the history of art.

REMBRANDT

THE life of Rembrandt is, like his painting, full of half-tints and dark corners. Whereas Rubens shows himself as he was in the full light of his works and of his public and private life, clearly outlined, bright and sparkling with wit, good-tempered, full of lofty grace and grandeur, Rembrandt seems to steal away and to be always hiding either something he has painted or something he has lived through—we see no palace, no grandee's style of living, no galleries after the Italian fashion. His dwelling is the mediocre, dark-looking home of a little shopkeeper with all the confusion of a collector of books, prints, and curiosities. No public business takes him out of his studio and makes him take part in the politics of his time, no great favour attaches him to any prince. No official honours, no orders, no titles, no badges, nothing to connect him closely or remotely with any deed or person that would have saved him from oblivion—for history in speaking of them would incidentally have mentioned him. Rembrandt was of the third estate—hardly even the third—as they would have said in France in 1789. He belonged to the crowd in which individuals are lost, whose behaviour is commonplace, whose habits have no stamp that takes them out of the common; and even in this country of so-called social equality—protestant, republican—without aristocratic prejudices, the distinction of his genius did not prevent the social mediocrity of the man from keeping him down in the obscure strata and from concealing him in it.

For a long time nothing was known of him except what Sandrart or his pupils—Hoogstraeten and Houbracken—said of him, and it all comes to a few studio-tales, a few doubtful facts, some hasty judgements, mere gossip. All they could see in him was eccentricity, manias, trivialities, faults, almost vices. He was said to be self-interested, greedy, rather unscrupulous, even miserly, and on the other hand, he was said to be a

squanderer and spendthrift—witness his ruin. He had many pupils, he put them in little separate apartments, saw that they had no connection one with another, nor influenced each other, and drew from this meticulous system of instruction large sums of money. They quote several fragments of oral lessons collected from tradition, which are truths of simple good sense, but are not of great consequence. He had not seen Italy, did not advise a journey there, and this was, to his ex-pupils, masters of aesthetics, a grievance and an occasion of regret that their master had not added this necessary culture to his sound doctrines and original talent. He was known to have strange tastes—a love for old clothes, Oriental frippery, helmets, swords, Asiatic carpets. Before people knew more accurately the details of his artistic furniture and all the instructive and useful curiosities with which he had littered his house, they could see in it only a disorderly accumulation of anomalous things relating to natural history and bric-à-brac, savage outfits, stuffed animals, dried herbs. It savoured of chaos, the laboratory, a little of occult science and cabalistic dealing, and this eccentricity, added to his supposed passion for money, gave to the thoughtful and gruff-looking figure of this ardent worker something of the compromising appearance of an alchemist.

He had a mania for posing before a mirror and painting himself, not as Rubens did it in heroic pictures, in the guise of a knight, as a warrior and indiscriminately associated with the heroes of epics, but all alone, in a small compass, eyes looking into his own, for himself, and for the mere satisfaction of obtaining a crisp light or a rarer half-tint, working at the rounded surfaces of his big face. He turned up his moustache, put air and some play into his curling hair; he smiled with strong red lips, and his little eye, almost lost in the projecting eyebrows, darted a peculiar glance in which there was fire, steadiness, insolence, and contentment. It was not everybody's eye. The face was strongly draughted, the mouth expressive, the chin headstrong. Between the two eyebrows work had traced two little vertical furrows, swellings, and these wrinkles,

contracted by the habit of frowning, natural to concentrated minds, refract the sensations received and make an inward effort. He decked himself, moreover, and dressed himself up as actors do. He borrowed from his robing-room wherewithal to clothe himself, to dress his hair or adorn himself; he put on turbans, velvet toques, felt hats, doublets, cloaks, sometimes a breastplate; he added ornaments of precious stones to his headgear, hung golden chains with jewels round his neck (Pl. 58). And if one had been never so little in the secret of his researches one would have come to ask oneself if all this obliging behaviour of the painter towards the model was not the pandering of the man to his weaknesses. Later, after his mature years, in his days of difficulty, we see him appear in graver, more modest, more veracious garb; without gold, without velvet, in dark garment with a handkerchief around his head, his face saddened, wrinkled, emaciated, his palette in his rugged hands. This garb of disillusion was a new form that the man took when he was upwards of fifty years of age, but it only complicated still further the true idea one would like to form of him (Pl. 76).

All this together did not make a very concordant whole, did not hold together, nor shape well with the feeling and meaning of his works, the lofty reach of his conceptions, the profound seriousness of his aims. The outstanding features of this ill-defined character, the revelations as to his unusual behaviour stand out with some sharpness against the background of a dull, neutral existence dimmed with uncertainty and, from a biographical point of view, rather confusing.

Since then the light has spread over practically all the parts that remained doubtful in this shadowy picture. The life of Rembrandt has been written and very well written in Holland, and in France, following the Dutch writers. Thanks to the works of one of his most fervent admirers, M. Vosmaer, we now know of Rembrandt, if not all that we should, at least all that ever will be known, and that is sufficient to make us love, pity, esteem, and, I think, understand him well.[1]

[1] See p. 367.

Judged from without he was a good man, fond of home life and of the fireside, a family man, by nature a husband rather than a libertine, a monogamist who could never endure the state either of bachelor or widower, and who was obliged by circumstances which are not well understood to marry three times; stay-at-home—that goes without saying; not economical, for he could not square his accounts; not a miser, for he ruined himself, and if he spent but little upon his comfort, he spent largely, it would seem, to satisfy his intellectual curiosity; hard to live with, perhaps easily taking umbrage, solitary—in everything and in his modest sphere, a singular being. He made no display, but kept a sort of hidden wealth—treasures sunk in art—which gave him great joy, which he lost in a total disaster, and which, under his very eyes, before an inn, was sold on an unlucky day for a wretched price. It was not all bric-à-brac—we can easily see that from the inventory drawn up at the time of the sale—that personal property about which posterity busied itself for a long time without understanding it. There were Italian and Dutch paintings, marbles, a great number of his own works—above all, etchings and those of the rarest, for which he had exchanged his own or paid a high price. He cared for all these things— beautiful, curiously selected and choice, as the companions of his solitude, the confidants of his thoughts, inspirers of his mind, the witnesses of his work. Perhaps he treasured up as a dilettante, as a learned man, as a fastidious man, for the sake of intellectual enjoyment, and such is probably the unusual form of an avarice the inner meaning of which was not understood. As to his debts, which overwhelmed him, he already had them at the time when, in some correspondence that is still preserved, he called himself rich. He was proud, and signed bills of exchange with the carelessness of a man who does not know the value of money and does not reckon up very carefully either what he has or what he owes.

He had a charming wife, Saskia, who was like a ray of light in that perpetual chiaroscuro and who during years only too few, in default of elegance and real charms introduced into it

something like a more vivid brightness. What is wanting in this dull interior, as well as in this morose, intensive work, is overflowing warmth, a little youthful love, feminine grace and tenderness. Did Saskia bring him all this? We cannot tell very clearly. He was smitten by her, they say, painted her often, dressed her up, as he had himself, in eccentric or magnificent disguises, enveloped her thus, just as he had enveloped himself, in a sort of second-hand luxury, painted her as a 'Jewess', as 'Odalisk', as 'Judith', perhaps as 'Susannah', and as 'Bathsheba' (Pl. 64), never painted her as she really was, and did not leave a portrait of her, dressed or not, that we should like to think was a faithful likeness. That is all we know of his domestic joys, which passed away too soon. Saskia died young in 1642, the same year in which he produced the 'Night Watch'. Of his children, for he had several from his three marriages, we never find the pleasant and smiling face in a single one of his pictures. His son Titus died several months before him. The others disappeared in the obscurity which veiled the last years of his life and followed his death.[1]

We know that Rubens, in his large, seductive, and ever fortunate life, had, on his return from Italy when he felt himself a stranger in his own country, and again after the death of Isabella Brant when he found himself a widower and alone in his house, a moment of great weakness and a sort of sudden collapse. The proof of this is in his letters. With Rembrandt it is impossible to say what the heart suffered. Saskia died, his work went on without a day's arrest; we know this from the dates of his pictures, and, better still, from his etchings. His fortune wastes away, he is taken before the Bankruptcy Court. Everything that he loves is taken away from him: he carries off his easel and installs himself elsewhere, and neither his contemporaries nor posterity have heard a cry or a complaint from that strange nature, which might have been thought to be completely crushed. His work neither weakens nor falls off. Favour abandons him at the same time as fortune, happiness and ease; he replies to the injustices of fate, to the changeableness

[1] See p. 367.

of opinion, by the portrait of 'Six' and by the 'Syndics', to say nothing of the 'Young Man' at the Louvre, and a great number of other works classified among his steadiest, most convincing, and most vigorous. In the midst of his mourning, in his humiliating misfortunes he retains an indescribable impassibility which would be altogether inexplicable did we not know what power of recovery, of indifference, of forgetfulness lies within a mind occupied with profound visions.

Had he many friends? It is believed that he had not. Certainly he had not all those he deserved: not Vondel, who used to go often to the Six House; nor Rubens, whom he knew well, who came to Holland in 1636, visited all the famous painters there with the exception of him, and who died in the year preceding the 'Night Watch' without the name of Rembrandt figuring either in his letters or collections. Was he welcomed, surrounded by admirers, much in public light? Not at all. When he is mentioned in the 'Apologies', in the writings, in the little ephemeral and topical poems of the time, it is in the second rank, and rather from a sense of justice or by chance, without enthusiasm. The literary people had other favourites, after whom came Rembrandt—the only illustrious man among them. In the official ceremonies, on the great days of display he was forgotten, or, rather, he was not to be seen in the first rank on the platforms.

In spite of his genius, his fame, and the prodigious infatuation which drove all painters to him after his first pictures, what is called society was, even at Amsterdam, a social environment whose doors were perhaps opened to him, but of which he never was. His portraits carried no more recommendation with them than did his person. Though he had made some magnificent ones of people of rank and fashion, yet his work was not of the agreeable, natural, obvious kind which could set him in a certain circle, where he would be appreciated and admitted. I have told you already that Captain Cocq, who figures in the 'Night Watch', compensated himself by sitting later on to Van der Helst; as to Six, a young man in comparison with him, and who, I persist in believing, got himself painted

only in self-defence—when Rembrandt went to the house of this official personage it was rather to the Burgomaster or to his Mæcenas that he went than to his friend. By habit and preference he mixed with smaller people—shopkeepers, the lower middle class. These friendships and acquaintances have been set lower than they really were—they were humble but not degrading, as people said. They had only to go a little further to reproach him with debauched habits—he who scarcely frequented the pot-houses—a rare thing then—because ten years after the death of his wife someone thought he could see that Rembrandt had suspicious relations with his servant. For this the servant was reprimanded and Rembrandt considerably decried. At this moment, moreover, everything was going wrong—fortune, honour—and when he left Breestraat, homeless, penniless, but right with his creditors, neither talent nor acquired fame stood him in good stead. We lose all trace of him, he is forgotten, and for the moment his personality disappears into that straitened and obscure life from which he had never really emerged.

In everything, as can be seen, he was a man out of the ordinary, a dreamer, perhaps taciturn, although his face speaks to the contrary; perhaps he was difficult to get on with and rather abrupt, highly strung, determined, not easy to contradict, still less easy to convince, amenable at bottom, but rigid in appearance, most certainly an original character. If he was famous and petted and praised at first, in spite of jealous or short-sighted people, in spite of pedants and fools, they made up for it when he was no longer there.

As to his handicraft, he neither painted nor sketched nor engraved like anybody else. His works were even enigmas as to process. They were admired but not without some uneasiness; he was followed without being very well understood. It was especially when he was at work that he looked like an alchemist. Seeing him at his easel with a very bedaubed palette, from which he drew thick pigments and set free so many subtle substances, or bent over his copper plates and engraving in a manner that was contrary to all rules—one

expected to see secrets from other worlds issuing from his engraving tool or his brush. His manner was so new that it baffled the strong minds and excited the simple ones. All the youthfulness, enterprise, insubordination, and giddiness among the student painters flowed towards him. His direct disciples were very mediocre; the tail of his following was detestable. It is a remarkable thing, after the individual teaching in private cubicles of which I have spoken, that not one of them preserved his independence. They imitated him as never master was imitated by servile copyists, and of course derived from him nothing but the worst of his mannerisms.

Was he learned, educated? Had he even read? Because he had a gift for arrangement, because he touched on history, mythology, and Christian dogmas, it is said that he had. It is said that he had not because, when his belongings were examined, innumerable engravings and no books were found. Was he, lastly, a *philosopher*, as that word is understood? What did he draw from the Reformation? Did he, as people have taken it into their heads to do in these days, contribute his part as an artist to destroy the dogmas and reveal the purely human side of the Gospel? Has he intentionally given his opinion upon the political, religious, and social questions which for so long a time had disturbed his country and which very fortunately had been solved at last? He painted beggars, outcasts, vagabonds more often than rich people—Jews more often than Christians; does it follow from this that he had for the unhappy classes anything more than picturesque predilections? All this is more than conjectural, and I do not see any necessity to deepen work that is already so deep, or to add a hypothesis to so many hypotheses.

The fact is that it is difficult to isolate him from the moral and intellectual movement of his country and time, that he inhaled, during the seventeenth century in Holland, the native air by which he lived. Had he come earlier he would be inexplicable; born anywhere else he would have played still more strangely that role of comet that is attributed to him outside the sphere of modern art; had he come later, he would

not have had the very great merit of having closed a past and
opened one of the great doors of the future. In every way he
deceived a great number of people. As a man, he lacked
presence, from which it has been concluded that he was
coarse. As a student he upset more than one system, from
which it has been concluded that he lacked scholarship. As a
man of taste, he sinned against all the common laws, from
which it has been concluded that he lacked taste. As an artist
moved by the beautiful he gave us some very ugly ideas of the
things of earth. It does not seem to have been noticed that he
was looking elsewhere. In short, however greatly he may be
praised, however maliciously he may be depreciated, however
unjustly he may have been taken to be, in good as in evil, for
the very reverse of his nature, nobody suspected exactly his
true greatness.

Notice that he is the least Dutch of the Dutch painters, and
that, if he is of his time, he is never altogether of it. What his
fellow-countrymen noticed, he did not see; what they turned
from he turned to. They had left the fable behind, he returned
to it; they left the Bible behind: he illustrated it; the Gospels:
he delighted in them. He clothed them in his own individual
way, but he showed in them a unique, new, and universally
comprehensible meaning. He dreamed of Simeon, Jacob,
Laban, the Prodigal Son, Tobias, the Apostles, the Holy
Family, King David, Calvary, the Samaritan, Lazarus, the
Evangelists. He haunts Jerusalem and Emmaüs; we can feel
always that he is tempted by the synagogue. These time-
honoured themes he brings forward in nameless surroundings
and in senseless costumes. He conceives them and formulates
them with as little care for tradition as regard for local truth.
And yet such is his creative power that this very special and
individual mind gives the subjects it treats a general expression,
an inner and typical meaning that great thinkers and epic
draughtsmen do not always reach.

I have told you somewhere in this study that his principle
was to extract from things one element from among all the
others, or rather to take them all away in order to seize

expressly only one of them. He has thus done the work of an
analyst, a distiller, or, to speak in nobler terms, of a meta-
physician even more than of a poet. Never did reality in the
whole take hold of him. Judging from the way he treated
bodies, one might well doubt whether he took an interest in
the outside of things at all. He liked women, and has painted
only misshapen ones; he liked fabrics, and never imitated
them; but, to make up for this, in default of grace, beauty,
purity of line, and fineness of flesh, he expressed the nude body
by suppleness, curves, elasticity, with a love of substance, a sense
of the living being, which are the delight of the craftsman. He
decomposed and reduced everything, colour as well as light,
so that by eliminating from appearances all that was compo-
site, by condensing all that was dispersed, he came to be able
to draw without outline, to paint a portrait almost without
apparent traits, to colour without colouring, to concentrate
the light of the solar world into a single ray. It is not possible
in plastic art to push any farther the interest of a human being
as a human being. For physical beauty he substituted moral
expression, for the imitation of things their almost complete
metamorphosis, for examination the speculations of the
psychologist, for clear, wise, simple observation the vision-
ary's glimpse and such sincere apparitions that he himself was
their dupe. By this faculty of double sight, thanks to this
somnambulist's intuition, he saw farther into the supernatural
than anyone else. The life he perceives in thought has an
indescribable flavour of the other world, which makes real life
seem cold and pale. Look at his 'Portrait of a Woman' in the
Louvre, two paces from the 'Mistress' of Titian. Compare
the two beings, question the two paintings, and you will
understand the difference between the two brains. His ideal,
pursued as in a dream with closed eyes, is light: the halo round
the objects is phosphorescence against a dark background. It
is fugitive, uncertain, composed of imperceptible lines, quite
ready to disappear before they can be fixed, ephemeral, and
dazzling. To arrest the vision, fix it on the canvas, give it its
form, its relief, preserve its fragile texture, render its brilliancy

so that the result might be a solid, masculine, and substantial painting, more real than any other, that could stand comparison with Rubens, Titian, Veronese, Giorgione, Van Dyck— that is what Rembrandt attempted. Did he succeed in doing it? Universal testimony is there to say that he did.

One last word. By proceeding as he proceeded, by extracting from this vast work and from this multiple genius that which represents him in his principle, by reducing him to his native elements, by eliminating his palette, his brushes, his colouring oils, his glazes, his pigments, all the mechanism of the painter, we should come at last to grasp the primary essence of the artist in the engraver. The whole Rembrandt is in his etchings —his mind, tendencies, imagination, reverie, good sense, chimeras, difficulties of rendering the impossible, realities in nothingness—twenty etchings by him reveal him, foreshadow the whole and, still better, explain him. It is the same craftsmanship, the same set purpose, the same carelessness and insistence, the same strangeness of style, the same desperate and sudden success achieved by expression. I see no difference between the 'Tobias' of the Louvre and any copperplate. There is no one but places this engraver far above all other engravers. Without going so far when it is a question of his painting, it would be well to think oftener of the 'Hundred-Guilder print' when we find difficulty in understanding him in his pictures. We should then see that all the scoria of this art, one of the most difficult in the world to purify, does not alter in any way the incomparably beautiful flame that burns within, and I think that we should at last change all the names that have been given to Rembrandt and give him the opposite ones.

In truth he had a brain that was served by the eye of a noctiluca, by a clever but not very skilful hand. This painful labour came from a spritely and acute mind. This very insignificant man, this rummager, this costumier, this wise man nurtured in incongruities, this lowly man of such high flight; this moth-like nature attracted by whatever shone, this soul so sensitive to certain forms of life, so indifferent to

others; this ardour without tenderness, this lover without visible flame, this nature of contrasts, contradictions, equivocations, moved and not eloquent, loving and not lovable, this ill-favoured man who was so gifted, this so-called materialist, this *trivial*, *ugly* man was a pure *spiritualist*, in a word, an *ideologist*—I mean a mind whose domain is the domain of ideas and whose language is the language of ideas. There is the key to the mystery.

If we take him thus Rembrandt is quite explained—his life, his work, his tendencies, his conceptions, his poetry, his method, his processes, even to the varnish of his paint, which is nothing but a daring and carefully sought out spiritualization of the material elements of his handicraft.

BELGIUM

THE BROTHERS VAN EYCK, AND MEMLING

BRUGES

I COME back by way of Ghent and Bruges. It is from here that in good logic I ought to have started had I thought to write a well-ordered history of the schools of the Low Countries; but chronological order does not matter a great deal in these studies, which, as you will have perceived, have neither plan nor method. I am going up-stream instead of down. I have followed its course very irregularly with much carelessness and much omission. I have left it, in fact, far from its estuary and have not shown you how it ends, for, from a certain point, it ends in insignificancies and is lost in them. Now I hope that I am at the source, and that I am going to see spring up the first wave of clear, pure inspiration from which the vast movement of northern art arose.

Other countries, other times, other ideas. I am leaving Amsterdam and the Dutch seventeenth century. I leave that school after its great brilliant period: let us suppose this to be about 1670, two years before the assassination of the brothers De Witt and the hereditary stadtholderate of the future King of England, William III. At this date, of all the great painters whose birth this country had seen in the first thirty years of the century, who was left? The great ones are dead or about to die—preceding Rembrandt or following him closely. Those who are still left are old men at the end of their careers. In 1683, with the exception of Van der Heyden and Van der Neer, who represent in themselves an extinct school, not one survives. It is now the reign of the Tempestas, Mignons, Netschers, Lairesses, and the Van der Werfs. All is over. I go through Antwerp. I see Rubens again, imperturbable and full of power, like a great spirit that contains in itself good and evil, progress and decadence, and who terminates with his own

life two epochs—the one preceding his and his own. I see after
him, as after Rembrandt, people who did not rightly under-
stand him, had not the power to follow him, and who do him
harm. Rubens helps me to pass from the seventeenth century
to the sixteenth. It is no longer Louis XIII, nor Henry IV, nor
the Infanta Isabella, nor the Archduke Albert; no longer is it
even the Duke of Parma, nor the Duke of Alba, nor Philip II,
nor Charles V.

We follow up still further through politics, customs, and
painting. Charles V is not yet born, nor near to being born,
nor yet his father. His grandmother, Marie de Bourgogne, is
a young woman of twenty, and his great-grandfather, Charles
the Bold, has just died at Nancy—when ends at Bruges, by a
series of peerless masterpieces, that astonishing period between
the first appearance of Van Eyck and the disappearance of
Memling, or at least his supposed departure from Flanders.
Situated as I am between the two towns of Ghent and Bruges,
between the two names which illustrate them most by the
novelty of their attempts and the pacific scope of their genius,
I am between the modern world and the Middle Ages—and
I am here in full recollection of the little Court of France and
the great Court of Burgundy, with Louis XI, who wishes to
make a France, with Charles the Bold, who dreams of un-
making it; with Commines, the historian diplomatist, who
passes from one house to another. I have no call to speak to
you of those times of violence and subterfuge, of trickery in
politics and savagery in deed, of perfidies and betrayals, of
oaths sworn and violated, of revolts in the towns and massacres
on the battlefield, of democratic efforts and feudal down-
treading, of intellectual half-culture and unheard-of display.
Call to mind only that high Burgundian and Flemish society,
that Court at Ghent, so luxurious in dress, refined in elegancies,
careless, brutal, unclean at bottom, superstitious and dissolute,
pagan in its feasts, religious through it all. Look at the eccle-
siastical and princely pomp, the galas, carousals, feasts with
their gormandizings, the plays and their licentiousness, the
gold of the chasubles, the gold of the armour, the gold of the

tunics, the precious stones, the pearls and diamonds; imagine underneath the state of the souls and of this picture, bear in mind but one trait—that the greater number of the primordial virtues were lacking, in those days, in the human conscience: uprightness, sincere respect for holy things, the sentiment of duty, of patriotism, and, with the women as with the men, shame. This, above all, must be borne in mind when in the midst of this brilliant and hideous society, we see the blossoming of an unexpected art, which was, it seems, to represent its moral basis together with its surface.

It was in 1420 that the brothers Van Eyck settled in Ghent. Hubert, the elder, set about the magnificent triptych of Saint-Bavon (Pls. 1–4). He conceived it, composed its plan, carried out a part of it, and died at the task about 1426. Jan, his young brother and pupil, went on with the work, finished it in 1432, founded at Bruges the school which bears his name, and died in 1440 on 9 July. In twenty years the human mind, represented by these two men, had found, in painting, the most ideal expression of its beliefs, the most physiognomic expression of faces, not the noblest, certainly, but the first correct manifestation of bodies in their exact forms, the first picture of the sky, of the air, of clothes, of the country, of external richness by means of true colours; it had created a living art, invented or perfected its mechanism, determined its language and produced imperishable works. All that was to be done was done. Van der Weyden (Pl. 6) had no other historical importance than to have attempted at Brussels what was being done marvellously at Ghent and Bruges—to have gone, later, to Italy, to popularize there the Flemish spirit and methods, and, above all, to have left among his works a unique masterpiece—I mean a pupil who was called Memling.

Whence came the Van Eycks when they were seen to settle at Ghent in the midst of a body of painters who were there already? What did they bring with them and what did they find there? What is the importance of their discoveries in the use of oil-colours? What, lastly, was the part of each of the two brothers in that imposing picture of the 'Pascal Lamb'?

All these questions have been proposed, learnedly discussed and poorly answered. What is probable, with regard to their collaboration, is that Hubert was the inventor of the work, that he painted the most important parts—the great figures— God the Father, the Virgin, St. John, certainly, too, Adam and Eve in their detailed and scarcely decent nudity. He conceived the feminine type, and especially the masculine type which was to serve his brother as a model. He put heroic beards on faces which, in the society of that time, did not wear them; he drew those full ovals with their prominent eyes, their fixed gaze at once tender and fierce, their frizzy beards, their curly hair, their haughty, sulking looks, their violent lips; in short, all that assemblage of characters, half Byzantine, half Flemish, so strongly impressed with the spirit of the age and place. *God the Father*, with His sparkling tiara with strings, His hierarchical attitude, His sacerdotal garb, is the twofold symbol of the divine idea such as it was conceived on earth in its two formidable personifications, the empire and the pontificate.

The *Virgin* has already the hooked cloak, the fitted robes, the bulging forehead, the very human character and physiognomy devoid of grace that Jan would give a few years later to all his Madonnas. The *St. John* has neither rank nor type in the social scale from which this observant painter took his forms. He is a man of no certain class, thin, elongated, rather ailing, a man who had suffered, languished, fasted, something like a vagabond. As to our first parents, it is at Brussels that they should be seen in the original panels, where they are rather too unclothed for a chapel, and not in the Saint-Bavon copy, where they are odder still in the leather aprons in which he dressed them. Don't look for anything, of course, which would call to mind the Sistine or the Vatican. They are two savage beings horribly hairy, both of them as though they were coming, without any feeling of their ugliness, out of some primeval forest, ugly, with great heavy bodies and thin legs. Eve's figure is the too-evident symbol of the first motherhood. All this, in its artless fantasticalness, is strong, rugged

and very imposing. The touch is rigid, the painting firm, smooth and full, the colour distinct, grave, already equal in energy, in measured radiance, in brilliancy and consistency, to the bold colouring of the future school of Bruges.

If, as everything leads us to believe, Jan van Eyck is the author of the central panel and the lower wings, of which, unfortunately, we no longer possess anything at Saint-Bavon but the copies made a hundred years later by Coxie, he had nothing more to do than to develop his mind, and that after his brother's manner. From his own fund he added more truth to the faces, more humanity to the physiognomy, more luxury and minute reality to the architecture, the fabrics and the gildings. Above all he introduced, too, the open air, the view of the flowery country, bluish horizons. In fine, what his brother had secured in the splendour of myth and upon a Byzantine background, he brought down to the level of terrestrial horizons (Pl. 3).

The time has come full circle. Christ has been born and is dead. The work of redemption is accomplished. Would you like to know how, as a painter and not as an illuminator of missals, Jan van Eyck understood the exposition of this great mystery? This is it—a vast lawn all dotted with spring flowers; in the front the 'Fountain of Life', a beautiful jet of water falling in sheaves into a marble basin; in the centre an altar draped with purple, and on the altar a 'White Lamb'; immediately around a garland of little winged angels, nearly all in white, with a few touches of pale blue and rosy grey. A great empty space isolates this august symbol, and on its untrodden grass there is nothing but the dark green of the thick growth and hundreds of starlike Easter daisies. The foreground to the left of the picture is filled with kneeling prophets and by a large group of standing men. There are here all those who, believing beforehand, announced the coming of Christ, and also the pagans, the doctors, the philosophers, the incredulous—from ancient bards down to the citizens of Ghent, with heavy beards, flat noses, pouting lips, entirely living physiognomies; little action, attitudes; it is a little *résumé* in

twenty figures of the moral world, before and since Christ, taken from outside the confessors of the new faith. Those who still doubt, hesitate and collect themselves, those who had denied are confused, the prophets are in ecstasy. The foreground on the right, a pendant to that of the left—and with that intentional symmetry without which there would be no majesty in the idea nor rhythm in the composition— the foreground on the right is occupied by the group of the twelve kneeling apostles and by the imposing assembly of the true servants of the Gospel—priests, abbots, bishops and popes—all beardless, fat, wan and calm, scarcely looking on, certain of the fact, adoring in all blessedness, magnificent in their red garments, with their chasubles of gold, their mitres of gold, their crosiers of gold, their stoles embroidered with gold, the whole covered with pearls, loaded with rubies and emeralds, a glistening heap of jewellery against that glowing purple which is Van Eyck's red. In the third distance, far behind the 'Lamb' and on raised ground which leads right back to the horizon, a green wood, a grove of oranges, roses and myrtles, all in flower or fruit, from which emerges, on the right, the long cortège of 'Martyrs', on the left, that of the 'Holy Women' crowned with roses and carrying palms. These latter, clothed in soft colours, are all in pale blue, pink and lilac. The 'Martyrs', for the most part bishops, are in blue cloaks, and nothing could be more exquisite than the effect of these two distant, delicate, distinct, always life-like processions, thrown up by these notes of light or dark blue against the austere tapestry of the sacred wood. Finally, a line of darker hills and Jerusalem represented by the silhouette of a town or rather by church steeples, high towers and spires, and away in the extreme background, blue mountains. The sky has that immaculate serenity fitting to such a moment. Pale blue, faintly tinted with ultramarine at its summit, it has the pearly whiteness, the morning clearness and the poetic significance of a beautiful dawn.

So I describe, or rather calumniate in a cold summing up, the central panel and the masterly portion of this colossal

triptych. Have I given you an idea of it? Not at all. The mind could ponder before it for ever, and dream of it for ever without coming to the bottom of what it expresses or what it evokes. The eye, too, could delight in it without exhausting the extraordinary riches of the enjoyment it causes or the lessons it teaches. The little picture of the 'Adoration' (Pl. 15) at Brussels is but the delightful pastime of a jeweller by the side of this truly great man's powerful concentration of soul and his manual gifts.

When you have seen that, there remains for you to consider attentively the 'Virgin and St. Donatian' of the Bruges Museum (Pl. 5). This picture, a reproduction of which may be found in the Antwerp Museum, is the most important that Van Eyck ever signed, at least with regard to the size of the figures. It was done in 1436 and consequently four years after the 'Mystic Lamb'. In arrangement as well as in the style and character of form, colour and workmanship, it calls to mind the 'Virgin with a Donor' at the Louvre. It is not more scrupulous in finish nor more delicately observed in detail. The ingenuous chiaroscuro which floods the little composition at the Louvre, that perfect truth and that idealization of all things obtained by the skill of the hand, the beauty of the work, the inimitable transparence of the pigment; that mingling of careful observation and reverie followed up in the half-tones— these are the superior qualities that the picture at Bruges attains but does not get beyond. But in this case everything is broader, riper, more grandly conceived, constructed and painted. And the work becomes more masterly for it, in that it enters fully into the aims of modern art and that it is on the point of satisfying them all.

The Virgin is ugly. The Child, a rickety infant with very sparse hair, copied without any alteration from some poor little ill-nourished model, holds a bunch of flowers and is stroking a parrot. To the right of the Virgin, St. Donatian with a golden mitre and a blue cope; on the left, and forming a side scene, St. George, a pretty young man, an androgynous sort of person in embossed armour, is raising his helmet,

saluting the Child-God with a strange look and smiling at him. Mantegna, when he conceived his 'Minerva Driving Away the Vices', with her chased cuirass, her golden helmet, and her beautiful angry face, would not have engraved the St. George of which I am speaking with a firmer tool, would not have outlined it with a more incisive stroke and would never have painted nor coloured it in this way. Between the Virgin and the St. George can be seen on his knees George de Pala (Van der Paele), the donor. This is undoubtedly the strongest bit of work in the picture. He is in a white surplice; he holds in his clasped hands, in his short, square, wrinkled hands, an open book, gloves, and horn spectacles; over his left arm hangs a band of grey fur. He is an old man. He is bald; a little down plays about his temples, the bone of which is visible and hard under the thin skin. The face is thick, the eyes sunk, the muscles diminished, hardened, seamed and crevassed by age. This great face, flaccid and wrinkled, is a marvel of drawing and physiognomic painting. All the art of Holbein is in it. Add to the scene its framework and ordinary furniture —the throne, the dais with a black background and red decorations, a complicated architecture, dark marble, a portion of a church window through whose lentiform panes trickles Van Eyck's greenish light, a marble pavement, and under the feet of the Virgin that beautiful Oriental, old Persian carpet— perhaps actually copied as a still-life deception, but in any case kept like the rest in perfect subordination to the picture. The tone is grave, dull and rich, extraordinarily harmonious and strong. The colour overflows into it. It is one, but very skilfully composite and blended still more skilfully into subtle values. In truth, when you concentrate upon it, it makes you forget everything else, and leads you to think that the art of painting has spoken its last word, and that in its first hour. And yet, without changing theme or mode, Memling was to say something further.

The story of Memling, such as tradition handed it down, is original and touching. A young painter attached after the death of Van Eyck to the house of Charles the Bold, perhaps

a young soldier of the wars in Switzerland and Lorraine, a fighter of Granson and Morat, came back to Flanders very much disabled; and one evening in January 1477, on one of those freezing days that followed the defeat at Nancy and the death of the Duke, he came and knocked at the door of St. John's Hospital, asked for lodging, rest, bread, and nursing. They gave him all this. He recovered from his fatigue and wounds, and the following year, in the solitude of this hospitable house, in the tranquillity of the cloister, he set about painting the 'Shrine of St. Ursula', then the 'Marriage of St. Catherine', and the other little diptychs or triptychs that can be seen there today.

Unhappily, it seems that this beautiful story is but a legend which must be renounced. True history makes Memling a simple *bourgeois* of Bruges, who painted as did so many others, had learned painting at Brussels, practised it in 1472, lived in the Rue St. George, and not at St. John's Hospital, as a landlord in easy circumstances, and died in 1495. Of his travels in Italy, his sojourn in Spain, his death and burial in the convent at Miraflorès, how much is true and how much false? When once the flower of the legend disappears the rest might just as well follow. There subsists, nevertheless, more than one strangeness in the education, habits, and career of this man, there remains a rather remarkable thing, the very quality of his genius, so surprising at such a time and in such an environment.

Moreover, in spite of the contradictions of the historians, it is still at St. John's Hospital, which has preserved his works, that we like to imagine Memling when he painted them. And when we find them in the depths of this hospice, always the same, within these fort-like walls, in this damp, narrow, grassy square, two paces from the old Church of Our Lady, it is still there and not elsewhere, in spite of ourselves, that we have seen them come into being.

I shall say nothing of the 'Shrine of St. Ursula', which is indeed the most celebrated of Memling's works and which wrongly passes for his best. It is a miniature in oils, ingenious, exquisite in certain details, childish in many others, a charming

inspiration, but, to speak truly, a work far too minute. And the art of painting, far from taking a step forward, would have gone back from the time of Van Eyck and even from Van der Weyden (look at his two triptychs and especially at his 'Weeping Woman' at Brussels[1]) if Memling had stopped there.

The 'Marriage of St. Catherine' (Pls. 12–14), on the other hand, is a decisive piece of work. I don't know whether it marks any noticeable progress on Van Eyck: that remains to be inquired into; but at least it marks, in the manner of feeling and in the ideal, an altogether personal impulse which did not exist in Van Eyck, and which no art, whatever it may be, shows forth so delightfully. The Virgin is in the centre of the piece, on a platform, seated and enthroned. On her right she has St. John the Forerunner and St. Catherine with her emblematic wheel, on her left St. Barbara, and above the donor, John Floreins, in the ordinary dress of a brother of St. John's Hospital. In the middle distance are St. John the Evangelist and two angels in priest's dress. I leave out the Virgin— far superior in choice of type to the Virgins of Van Eyck—but far inferior to the portraits of the two female saints.

St. Catherine is in a long, tight-fitting, trailing robe, of dark ground figured with gold, with sleeves of crimson velvet, low-cut and tight-fitting bodice; a little diadem of gold and precious stones encloses her rounded head. A veil, transparent as water, adds to the whiteness of the complexion the paleness of an impalpable fabric. Nothing could be more exquisite than this childish and feminine face, so delicately set in its head-dress of jewellery and gauze, and never did painter, enamoured of a woman's hand, paint anything more perfect in gesture, drawing, and graceful line than this full and long, tapering and pearly white hand holding out one of its fingers, to receive the betrothal ring.

St. Barbara is seated. With her pretty, upright head, her straight neck, the nape of her neck high, smooth, and well set, her closed and mystic lips, her beautiful pure eyelids

[1] See p. 355.

lowered with a look one may divine, she is reading attentively
in a Book of Hours, at the back of which we can see a bit
of its covering of blue silk. Her figure is outlined under the
close-fitting bodice of a green dress. A garnet-coloured cloak
gives her dress a little more body and clothes her a little
more amply with its large, picturesque, and very skilful folds.

Had Memling painted but these two figures—and the
donor with the St. John is also of the first order, equal in
interest as regards spirit—we might almost say that he would
have done enough to ensure his fame in the first place and,
above all, to cause astonishment in those who are pre-occupied
with certain problems and delight at seeing them solved.
Considering only the form, the perfect drawing, the natural
gesture without pose, the clearness of the complexions, the
satin-like softness of the skin, its smoothness and suppleness;
considering the garments in their rich colours, in their very
right and physiognomic cut, we might well say that it was
nature itself, observed by an admirably sensitive and sincere
eye. The backgrounds, the architecture, and accessories have
all the sumptuousness of the scenic arrangements of Van Eyck.
A throne with black columns, a marble doorway, a marble
floor; under the feet of the Virgin, a Persian carpet; lastly, for
prospect, a fair countryside and the Gothic silhouette of a
town with church towers bathed in the tranquil effulgence
of an elysian light; the same chiaroscuro as in Van Eyck, with
a new softness; a few better marked distinctions between the
half-lights and the high-lights; in every way a less energetic
but more tender work—such is, at a glance, the first aspect of
the 'Mystic Marriage of St. Catherine'.

I shall not speak of the little pictures so reverently preserved
in this same ancient room of St. John's Hospital nor of the
'St. Christopher' of the Bruges Museum, just as I did not speak
of Van Eyck's portrait of a 'Woman' and his famous 'Christ's
Head' in the same museum. These are beautiful or curious
pieces of work, which confirm the idea one should have of
Van Eyck's manner of seeing and Memling's manner of feel-
ing; but the two painters, the two characters, the two geniuses

are revealed more strongly than anywhere else in their pictures
of 'St. Donatian' and 'St. Catherine'. It is on the same spot
and in the same circumstances that we can compare them,
contrast them, and make the one show up the other.

How were their talents formed? What superior education
could have given them so much experience? Who taught
them to see with that strong simplicity, that tender attention,
that energetic patience, that feeling, ever equable, in work so
exacting and slow? So soon were they formed, both of them,
so quickly and perfectly! The first Italian Renaissance had
nothing that may be compared to it. And in the particular
order of feelings expressed and subjects presented it is agreed
that no school of Lombardy, Tuscany, or Venice produced
anything resembling this first outburst of the Bruges school.
The craftsmanship itself is perfect. The language afterwards
became enriched, suppler, developed; of course, before it
became corrupt. It never recovered that expressive concise-
ness, nor that suitability of means, nor that splendour.

Consider Van Eyck and Memling in the externals of their
art; it is the same art that, applied to august things, renders
them in all their richness. Rich fabrics, pearls and gold, velvets
and silks, marbles and graven metals: the hand is employed
only in making manifest the luxury and beauty of the materials
by the luxury and beauty of the work. In this, painting is again
very near its original source, for it means to compete in
resource with the art of the goldsmith, the engraver, and the
enameller. We see, on the other hand, how far it is away from
it already. With regard to process, there are not very percep-
tible differences between Memling and Jan van Eyck, who
preceded him by forty years. One might ask oneself which
of them progressed the quicker and the farther. And, if the
dates did not tell us which was the discoverer and which the
disciple, one might easily imagine, from certain results, that
it was rather Van Eyck who learned lessons from Memling.
One would think they were contemporaries, so alike are their
compositions, so identical their method, their archaisms so
entirely of the same date.

The first differences that appear in their craftsmanship are differences of blood, and are due to fine shades of temperament.

With Van Eyck there is more framework, muscle, and flow of blood; thence the striking virility of his faces and the style of his pictures. In everything he is a portrait-painter of the family of Holbein, precise, keen, impressing even to violence. He sees people with exactness, sees them big and short. The sensations that come to him from the aspects of things are more robust, those that come from their colouring more intense. His palette has a fullness, an abundance, and hardnesses that Memling's has not. His range of colours is more uniformly strong, better kept to as a whole, more skilfully composed as to its values. His whites are more oily, his purple richer, and his indigo blue—the glorious blue of ancient Japanese enamel which is natural to him—richer in colouring principle and thicker in substance. He is more strongly attracted by the luxury and rare value of the precious objects which abounded in those gorgeous days. Never did Indian Rajah set so much gold or so many precious stones in his dress than Van Eyck put in his pictures. When a Van Eyck picture is beautiful— and the one at Bruges is the best example—it looks like a piece of jewellery of enamelled gold, or one of those many-coloured materials having a woof of gold. Gold is suggested everywhere, above and beneath. When it does not play on the surface it appears under the tissue. It is the bond, the basis, the visible or latent primitive element of this pigment rich above all others. Van Eyck is also more adroit, because his copyist's hand obeys certain well-marked preferences. He is more precise, more affirmative; he imitates excellently. When he paints a carpet he weaves it with a better choice of colouring. When he paints marble he comes nearer to the polish of marble, and when he makes the opal-tinted panes of his stained glass windows glisten in the shadow of his chapels he is perfect at still-life deception.

With Memling there is the same power of tone, the same brilliancy, with less ardour and real truth. I would not be

bold enough to say that, in that marvellous triptych of 'St. Catherine' (Pls. 12–14), in spite of the extreme depths of the colouring, his scheme is as well sustained as that of his great predecessor. In compensation, he has gradations, soft and blended half-lights, that Van Eyck never knew. The figures of St. John and of the Donor show—in the way of sacrifice, in the relation of the principal light to secondary lights, and in the relation of things to the plane they occupy—an advance upon the 'St. Donatian', and especially a decided step past the triptych of St.-Bavon. The very colour of the garments, one of a dark garnet colour, the other of a red with rather much body, reveals a new art of composing the tone as seen in the shade, and of already very subtle combinations of colour. The handicraft is not very dissimilar. Yet it differs, and this is how: wherever the sentiment sustains, animates, and moves him, Memling is as firm as Van Eyck. Wherever the interest of the object is less—and whenever, above all, the value he lovingly attaches to it is less—we may say that, compared with Van Eyck, he grows weaker. Gold is no longer, in his eyes, anything but an accessory, and living nature is more studied than still-life. The heads, the hands, the necks, the pearly softness of a rosy skin—to these he applies himself, and in these he excels, for in truth, as soon as they are compared from the point of view of sentiment, there is no longer anything in common between them. A whole world separates them. At a distance of forty years, which is very little, there has taken place, in the manner of seeing and feeling, of believing and of inspiring belief, a strange phenomenon, which bursts out here like a light.

Van Eyck saw with his eyes; Memling was beginning to see with his mind. The one thought well, thought aright; the other does not seem to think so much, but his heart beats quite otherwise. The one copied and imitated; the other copied likewise, imitated, and transfigured. The former reproduced— without troubling about the ideal—human types, especially the manly types, which passed before his eyes in all grades of the society of his time. The latter dreamed while looking at

nature, imagined while he imaged it forth, chose what was most lovable and most delicate in its human forms, and created, above all in feminine type, a choice being till then unknown, and not seen since. They are women, but women seen as he loved them, and according to the tender predilections of a mind with a natural bias towards grace, nobleness, and beauty. This new image of woman was made by him a real person, and an emblem too. He did not embellish it, but he perceived in it what no one had seen in it before. It seems as if he painted it thus only because he discovered in it a charm, attractions, and a self-consciousness no one had hitherto suspected. He adorned it both physically and morally. In painting the beautiful face of a woman, he paints a delightful mind. His diligence, talent, his carefulness of hand, are only a form of the tender regard and respect he had for woman.

There can be no uncertainty as to the time, race, or rank to which these women—fragile, fair, pure, yet of this world— belonged. They are princesses, and of the best blood. They have their delicate muscles, their white and unused hands, their paleness contracted in a sheltered life. They have that natural fashion of wearing their clothes and their diadems, of holding their missals and of reading them, which is neither borrowed nor invented by a man who is a stranger to the world and to that world.

But if Nature were thus, how comes it that Van Eyck did not see it thus—he who knew the same world and who probably occupied higher positions, who lived in it as painter and *valet de chambre* to John of Bavaria, and then to Philip the Good, in the heart of a society more than royal? If the little princesses of the court were like this, how does it come about that Van Eyck has not given us the least delicate, attractive, and beautiful idea of it? Why was it that he observed only men well? Why the coarse, the squat, the strong, or else the ugly, when he had to pass from masculine attributes to feminine ones? Why did he not perceptibly improve the *Eve* of his brother Hubert? Why do we see so little decency above the 'Myth of the Lamb', yet, in Memling all the adorable

delicacy of chastity and modesty; beautiful women with the look of saints, good beautiful foreheads, clear temples, lips without a crease; all innocency in its flower, all the charms enveloping the purity of the angels; a beatitude, a tranquil sweetness, an ecstasy within, which is not seen elsewhere? What grace from heaven had come down upon this young soldier or rich citizen to soften his heart, purify his eye, cultivate his taste, and open up to him such a new prospect, at one and the same time, of the physical and moral worlds?

Less divinely inspired than the women, the men painted by Memling are not less unlike those of Van Eyck. They are gentle and sad personages, rather long in the body, of copper complexion, with straight noses, thin light beards, and thoughtful gaze. They have less passion, but the same ardour. Their muscular action is less ready and less virile, but there is in them an indescribable air of gravity and of trial undergone that makes them look as if they had gone through life suffering and were meditating upon it now. St. John, whose fine evangelical head, bathed in the half-light, is so velvety in execution, personifies once for all the type of the masculine figure, such as Memling conceived it. It is the same with the donor, with his Christ-like face and pointed beard. Note—I insist on this point—that the saints of both sexes are clearly. portraits.

All this lives with a deep, serene, and collected life. In this art, so human nevertheless, there is no trace of the foulness or the atrocities of the time. Look at the work of this painter, who, however he may have lived, must have had a good knowledge of his century: you will not find in him one of those tragic scenes people have been pleased to represent of it since. No tearings in pieces or boiling pitch, except incident-ally, by way of anecdote or medallion; no hands cut off, no naked·bodies being flayed, no ferocious arrests, no murderous judges or executioners. The 'Martyrdom of St. Hippolytus', in the cathedral at Bruges, which is attributed to him, is by Bouts or Gerard David (Pls. 7–9). Old and touching legends, such as St. Ursula or St. Christopher, virgins, saints

affianced to Christ, believing priests, saints who make them-
selves believed in, a passing pilgrim under whose traits we
recognize the artist—these are the people in Memling. In
everything a good faith, an honesty, an ingenuity which have
something stupendous about them, a mysticism of feeling
which is disclosed rather than shown, which we are made
aware of by its perfume, for it gives rise to no affectation in
form—a Christian art, if there ever was one, exempt from any
mixture of pagan ideas. If Memling escapes his own century,
he forgets the others. His ideal is his own. Perhaps he was the
forerunner of the Bellinis, the Botticellis, the Peruginis, but
neither of Leonardo da Vinci, nor of Luini, nor of the Tuscans,
nor of the Romans of the true Renaissance. Here you will find
no St. John that might be mistaken for a Bacchus, no Virgin
or St. Elizabeth with the strangely pagan smile of a Gioconda,
no prophets resembling ancient gods and philosophically
confused with sibyls. No myths nor deep symbols. There is
no necessity for a learned exegesis to explain this sincere art
of pure good faith, ignorance, and belief. He says what he has
to say with the candour of the simple-souled and simple-
hearted, with the naturalness of a child. He paints what is
venerated, what is believed, as it is believed. He takes himself
away to his own world, shuts himself up in it and there,
exalted, he overflows. Nothing of the external world pene-
trates into this sanctuary of souls in full repose, neither what
is done, nor what is thought, nor what is said, nor in any
degree what is seen in it.

Imagine, in the midst of the horrors of the century, a
privileged spot, a sort of angelical retreat ideally silent and
enclosed, where passions are quieted and troubles cease, where
people pray and adore, where everything is transfigured,
physical ugliness and moral ugliness, where new feelings arise,
where simplicity, gentleness, and supernatural mildness grow,
like lilies—and you will have an idea of the unique soul of
Memling, and the miracle he works in his pictures.

A strange thing it is that, in order to speak worthily of such
a mind, out of regard for him and for ourselves, we have to use

special terms, and restore to our language a sort of virginity for the occasion. It is thus alone that one can make him understood; but words have been put to such a use since Memling's time that it is very hard to find suitable ones for him.

PLATES

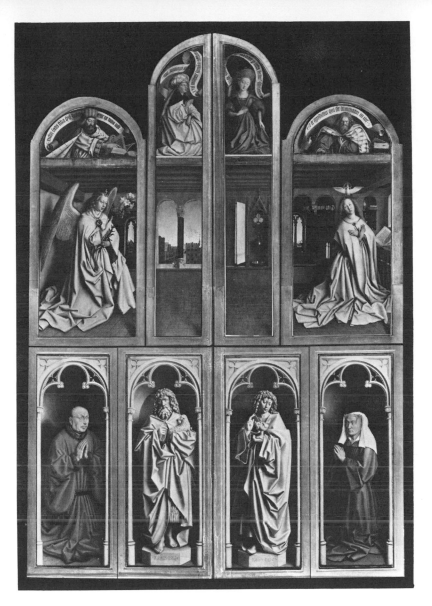

I. HUBERT AND JAN VAN EYCK: THE ALTAR OF THE HOLY LAMB
(Closed.) 1432. Ghent, S. Bavon

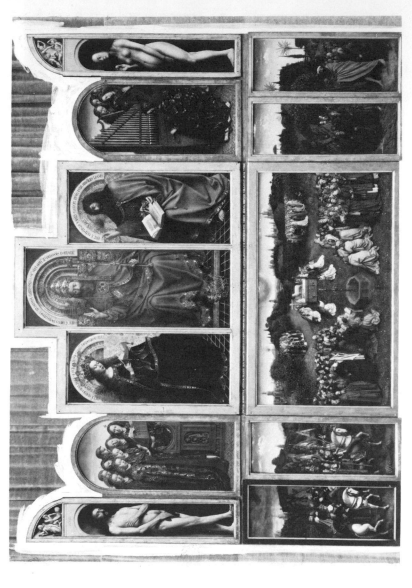

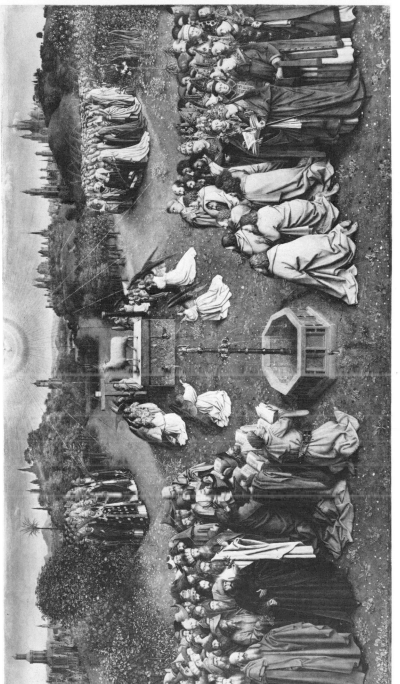

3. Detail from Plate 2

4. Detail from Plate 2

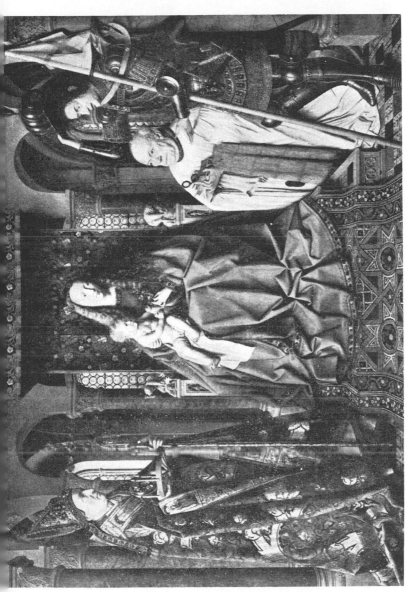

5. JAN VAN EYCK MADONNA AND CHILD WITH ST. DONATIAN, ST. GEORGE, AND CANON

GEORGE VAN DER PAELE

1436. Bruges, Museum

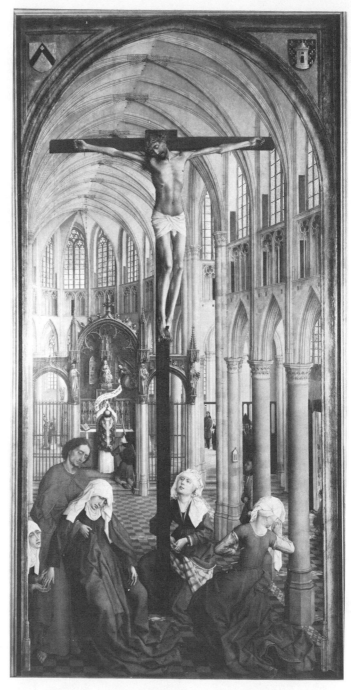

6. ROGIER VAN DER WEYDEN: ALTAR OF
THE HOLY SACRAMENT
Antwerp, Museum

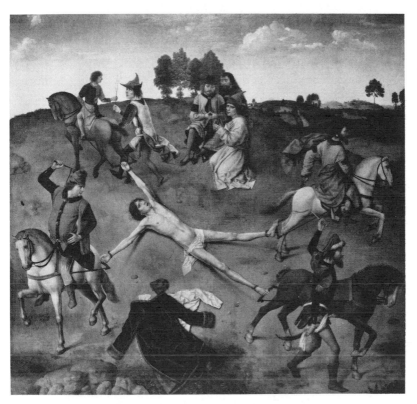

7. DIRK BOUTS: THE ALTAR OF ST. HIPPOLYTUS

Centre. Bruges, Cathedral S. Sauveur

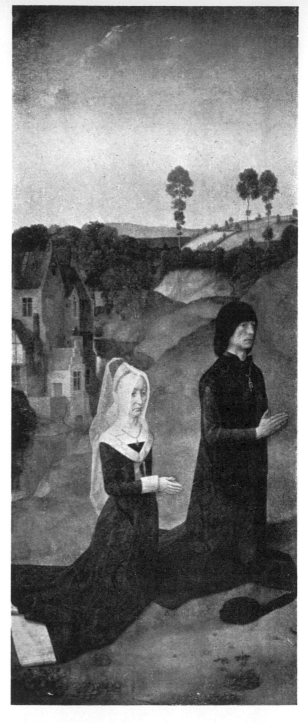

8. DIRK BOUTS: THE ALTAR OF ST. HIPPOLYTUS
Left part. Bruges, Cathedral S. Sauveur

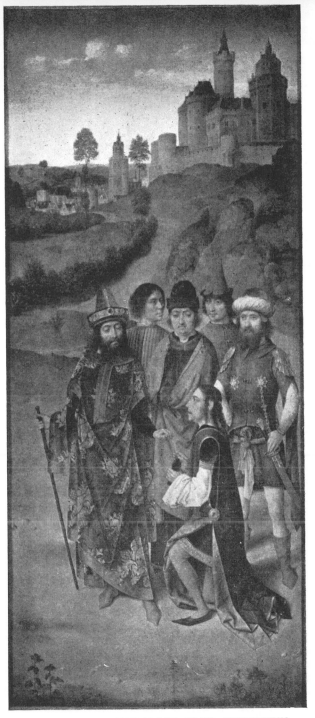

9. DIRK BOUTS: THE ALTAR OF ST. HIPPOLYTUS
Right part. Bruges, Cathedral S. Sauveur

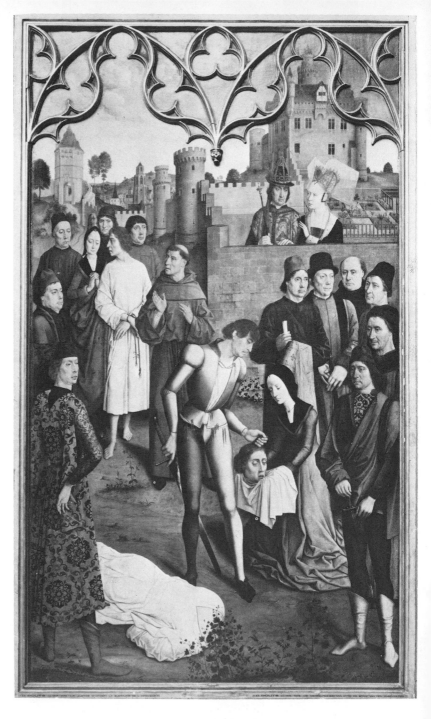

10. DIRK BOUTS: THE JUSTICE OF EMPEROR OTTO
1468. Brussels, Museum

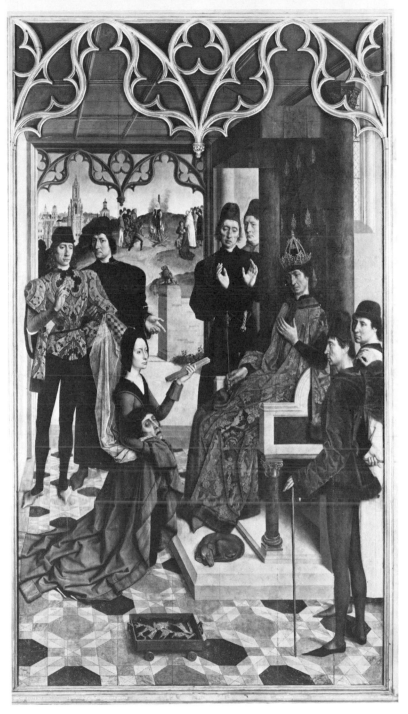

II. DIRK BOUTS: THE JUSTICE OF EMPEROR OTTO
1468. Brussels, Museum

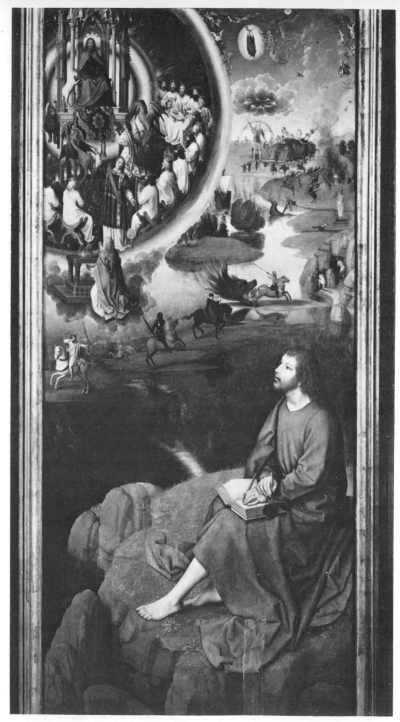

12. HANS MEMLING: ST. JOHN BEHOLDING THE APOCALYPTIC VISION
Right inside shutter of the triptych. 1479. Bruges, St. John's Hospital

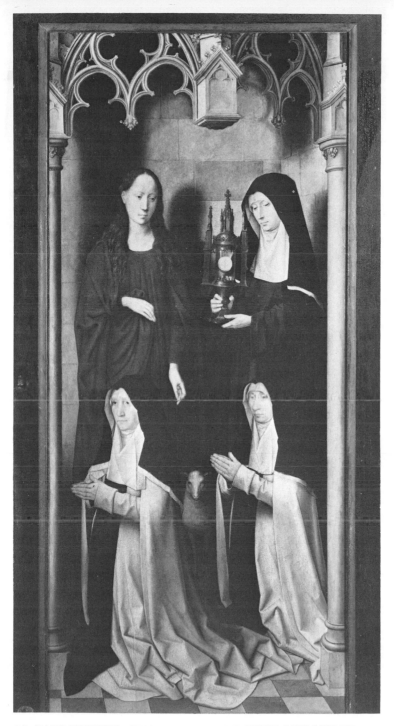

13. HANS MEMLING: TWO DONORS WITH THEIR PATRONESSES
Right outside shutter of the triptych. 1479. Bruges, St. John's Hospital

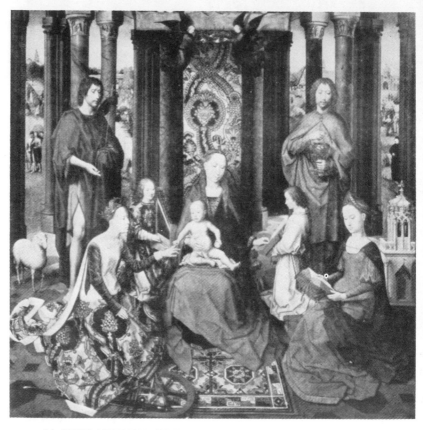

14. HANS MEMLING: THE MYSTIC MARRIAGE OF ST. CATHERINE
Centre panel of the triptych. 1479. Bruges, St. John's Hospital

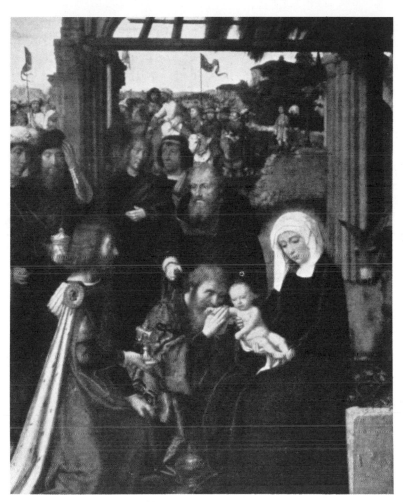

15. GERARD DAVID: THE ADORATION OF THE KINGS
Brussels, Museum

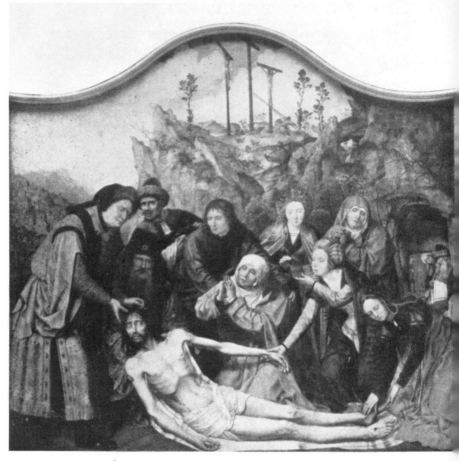

16. QUENTIN MATSYS: THE BURIAL OF CHRIST
1508–9. Antwerp, Museum

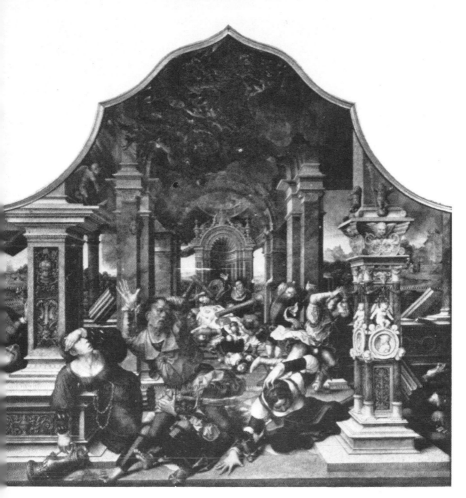

17. BAREND VAN ORLEY: THE TRIALS OF JOB
1521. Brussels, Museum

18. FLEMISH MASTER, SIXTEENTH CENTURY:
THE TEMPTATION OF ST. ANTHONY
Brussels, Museum

19. OTTO VAN VEEN: THE MYSTIC MARRIAGE OF ST. CATHERINE
1589. Brussels, Museum

20. ADAM VAN NOORT: CHRIST AND THE CHILDREN
Brussels, Museum

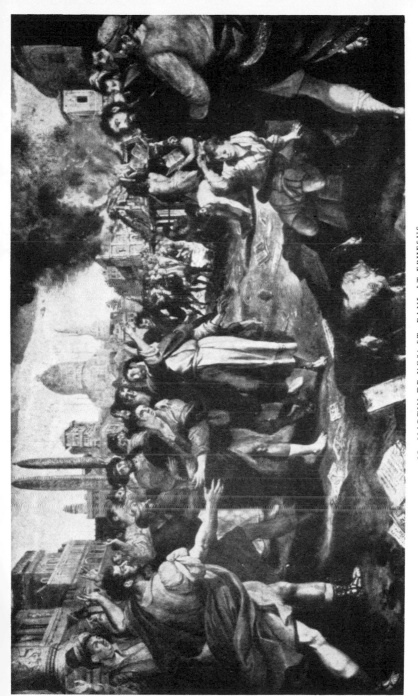

21. MARTIN DE VOS: ST. PAUL AT EPHESUS
=568. Brussels, Museum

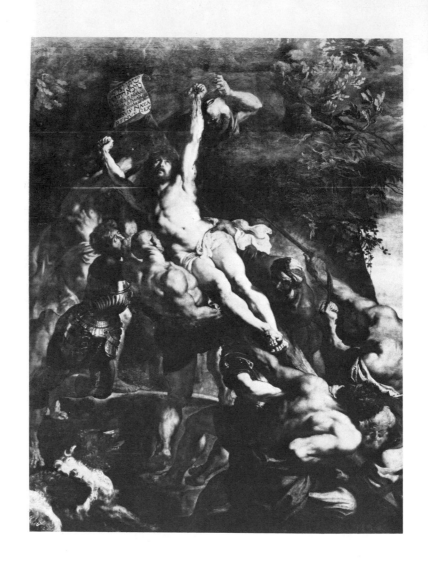

22. PETER PAUL RUBENS: THE RAISING OF THE CROSS
1610–11. Antwerp, Cathedral

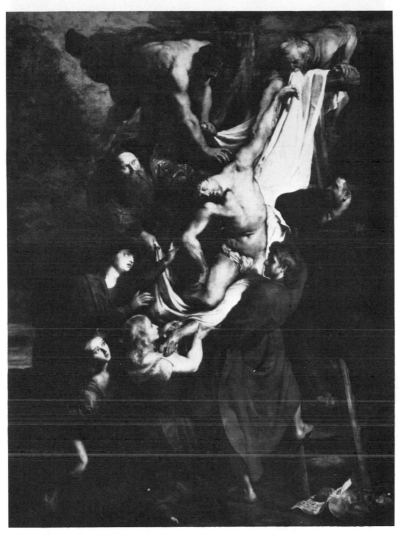

23. PETER PAUL RUBENS: THE DESCENT FROM THE CROSS
1611–14. Antwerp, Cathedral

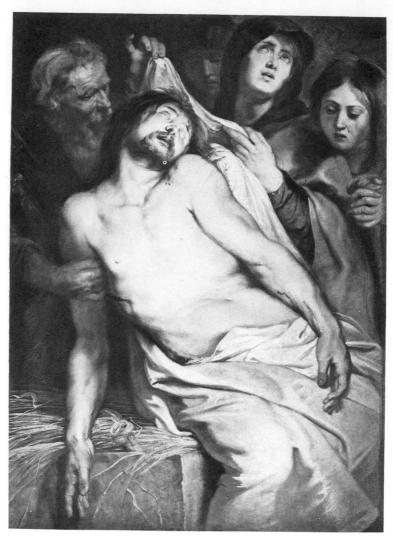

24. PETER PAUL RUBENS: 'CHRIST À LA PAILLE'
1617–18. Antwerp, Museum

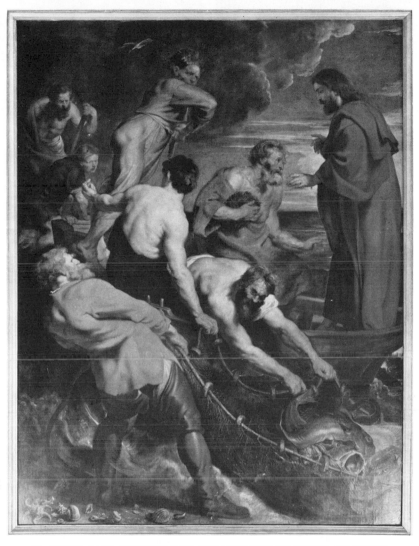

25. PETER PAUL RUBENS: THE MIRACULOUS DRAUGHT OF FISHES
1618–19. Malines, Notre-Dame au delà de la Dyle

26. WINGS OF THE MALINES ALTARPIECE (Pl. 25): ST. PETER AND ST. ANDRE

27. WINGS OF THE MALINES ALTARPIECE (Pl. 25): TOBIT AND THE FISH—
FIVE APOSTLES WITH THE FISH

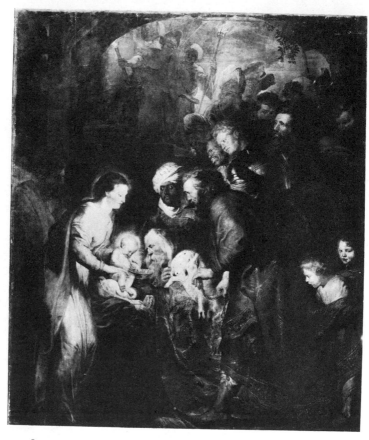

28. PETER PAUL RUBENS: THE ADORATION OF THE KINGS
1617–19. Malines, S. Jean

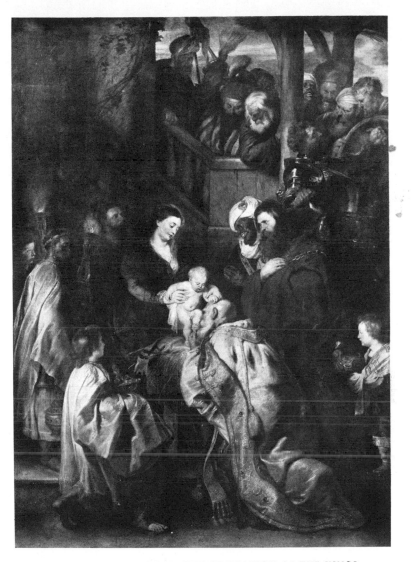

29. PETER PAUL RUBENS: THE ADORATION OF THE KINGS
1618–20. Brussels, Museum

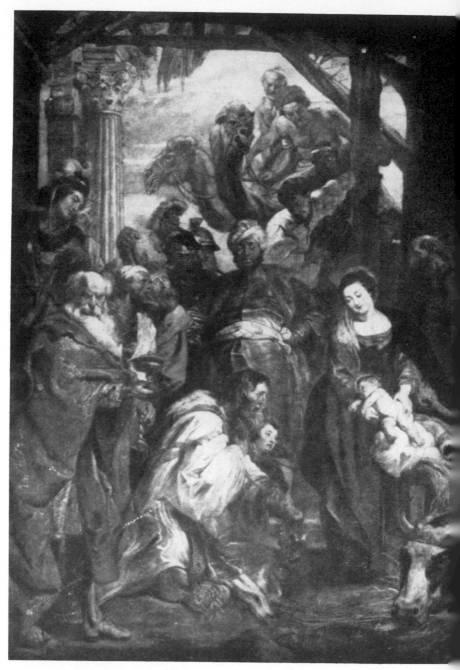

30. PETER PAUL RUBENS: THE ADORATION OF THE KINGS
1624. Antwerp, Museum

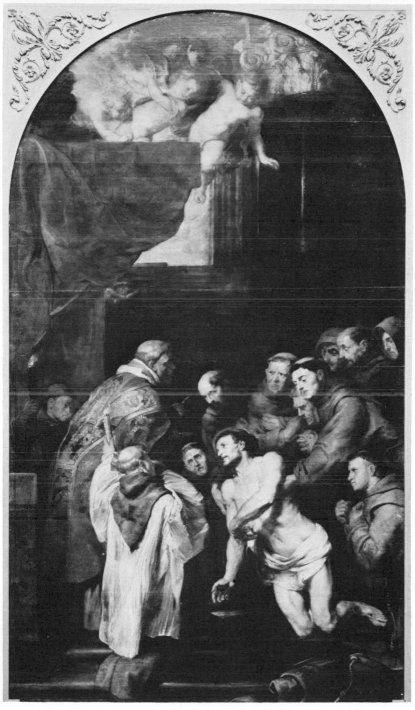

31. PETER PAUL RUBENS: THE SACRAMENT OF ST. FRANCIS OF ASSISI
1619. Antwerp, Museum

32. Detail from Plate 30

33. Detail from Plate 31

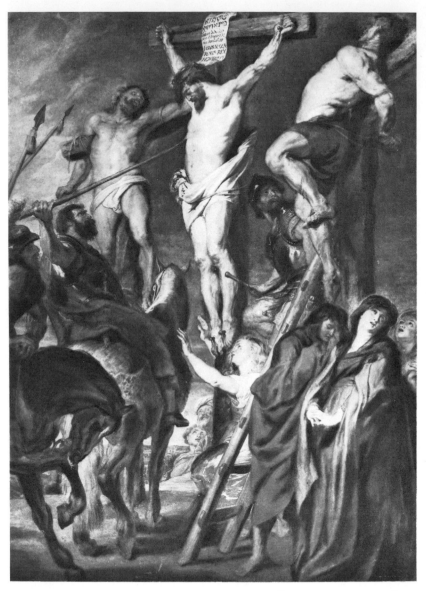

34. **PETER PAUL RUBENS**: **CHRIST** ON THE CROSS ('LE COUP DE LANCE')
1620. Antwerp, Museum

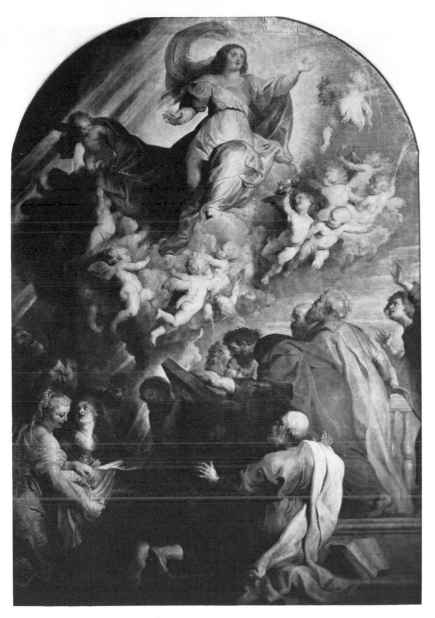

35. PETER PAUL RUBENS: THE ASSUMPTION OF THE VIRGIN
1616–20. Brussels, Museum

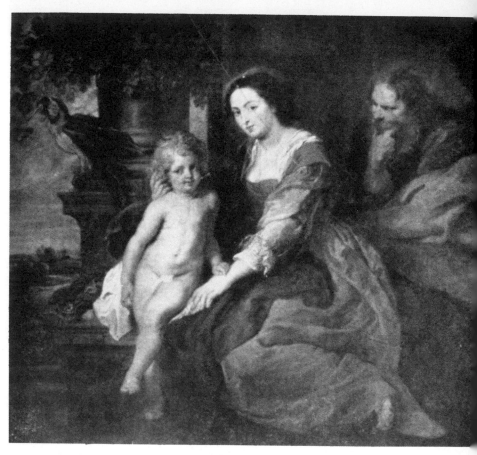

36. PETER PAUL RUBENS: THE HOLY FAMILY
Antwerp, Museum

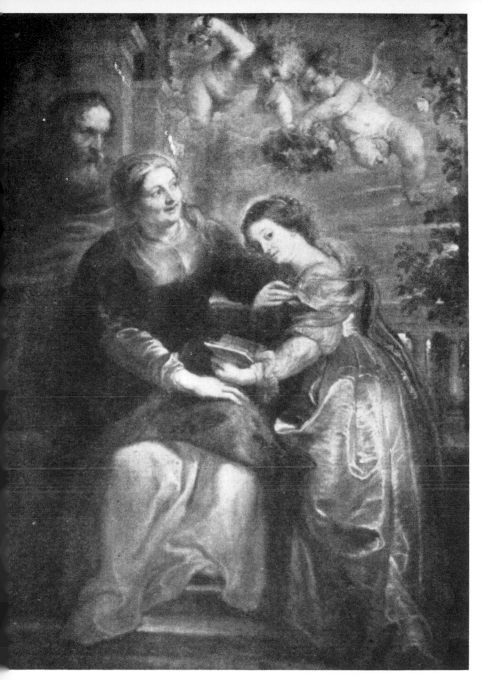

37 PETER PAUL RUBENS: THE EDUCATION OF THE VIRGIN
About 1630. Antwerp, Museum

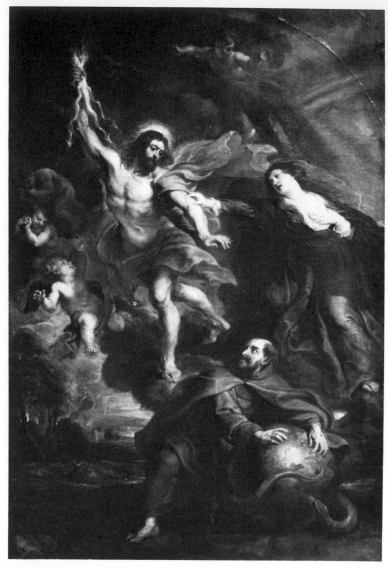

38. PETER PAUL RUBENS: CHRIST WISHING TO DESTROY THE WORLD
About 1633. Brussels, Museum

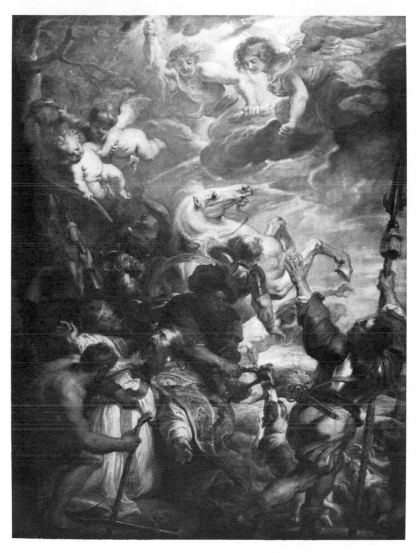

39. PETER PAUL RUBENS: THE MARTYRDOM OF ST. LIEVIN
About 1635. Brussels, Museum

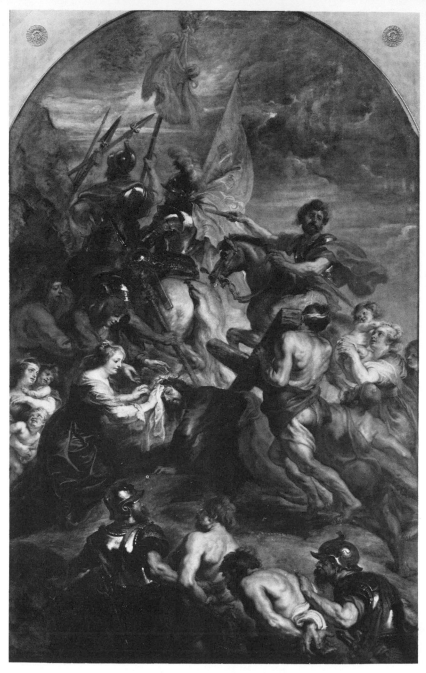

40. PETER PAUL RUBENS: THE BEARING OF THE CROSS
About 1636–7. Brussels, Museum

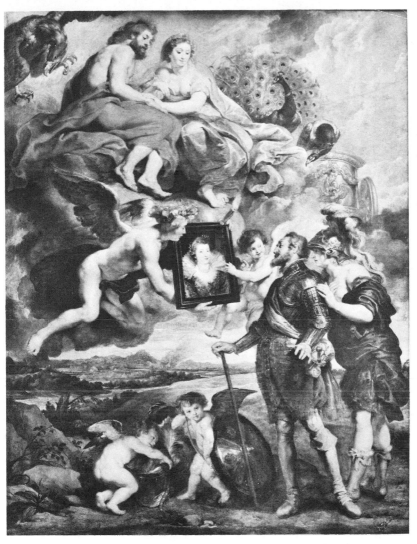

41. PETER PAUL RUBENS: HENRI IV RECEIVING THE
PORTRAIT OF MARIE DE MEDICIS
1622–4. Paris, Louvre

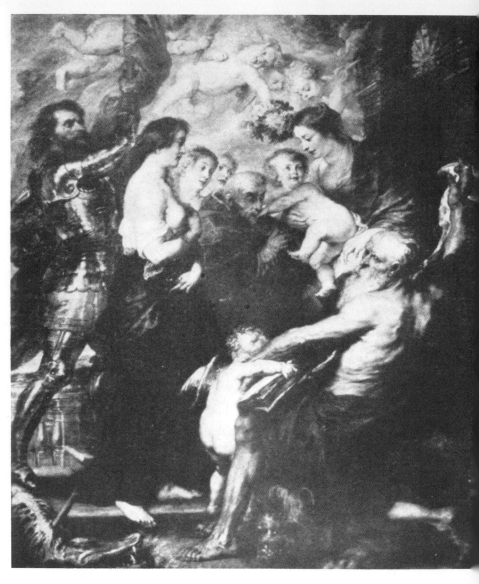

42. PETER PAUL RUBENS: MADONNA AND SAINTS
About 1636–40. Antwerp, S. Jacques

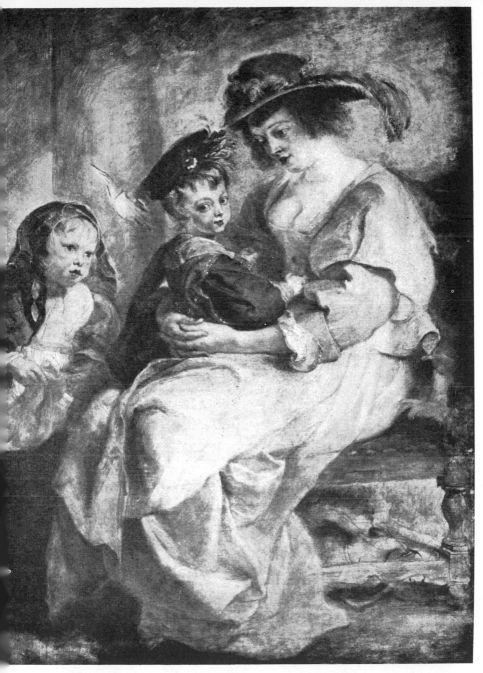

43. PETER PAUL RUBENS: HÉLÈNE FOURMENT WITH TWO CHILDREN
About 1636. Paris, Louvre

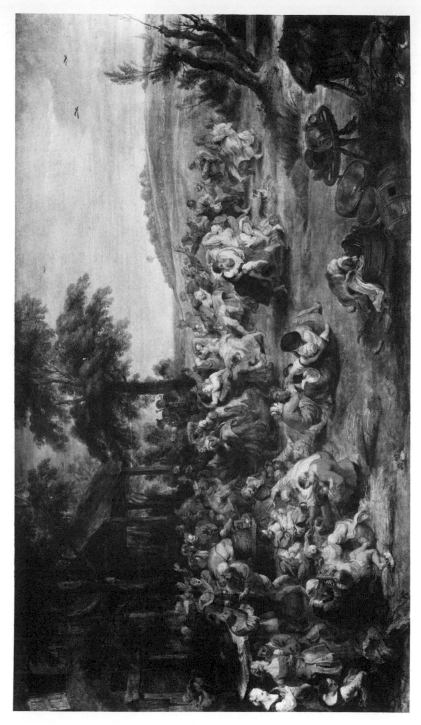

44. PETER PAUL RUBENS: 'LA KERMESSE FLAMANDE'
About 1635–8, Paris, Louvre

45. Detail from Plate 44

46. ANTHONY VAN DIJCK: SELF-PORTRAIT (Detail)
About 1620. New York, Metropolitan Museum (Bache Collection)

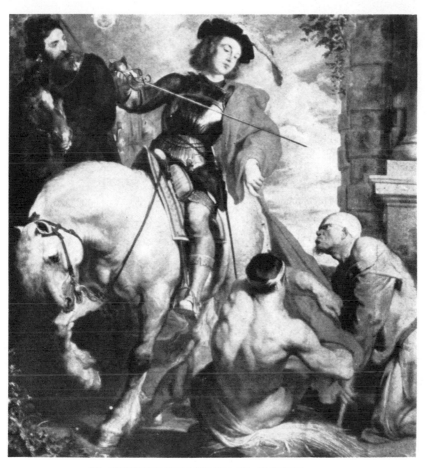

47. ANTHONY VAN DIJCK: ST. MARTIN
About 1617. Saventhem, Church

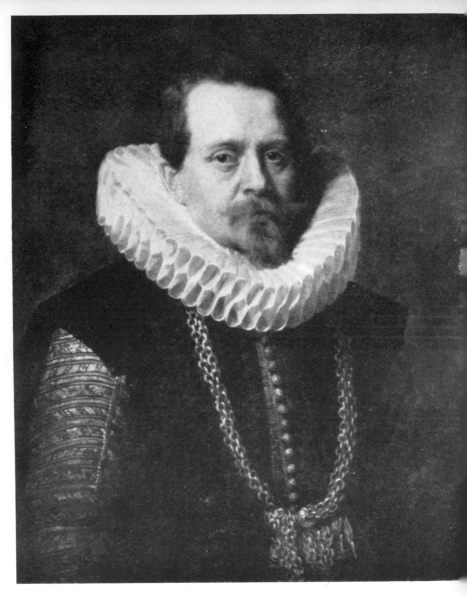

48. ANTHONY VAN DIJCK: PORTRAIT OF JEAN CHARLES DE CORDES
1617–18. Brussels, Museum

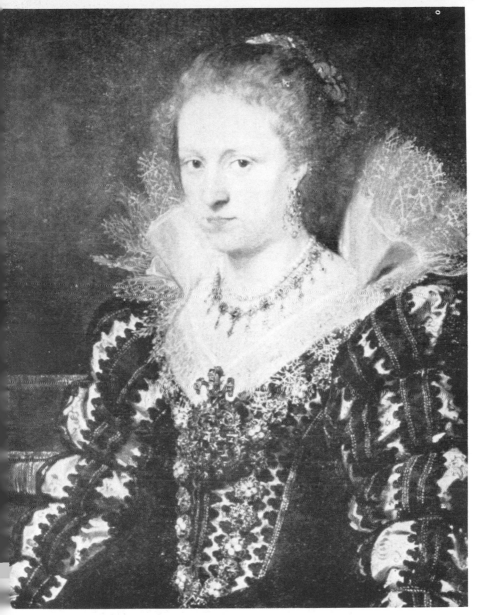

49. ANTHONY VAN DIJCK: PORTRAIT OF JACQUELINE DE CAESTRE
1617–18. Brussels, Museum

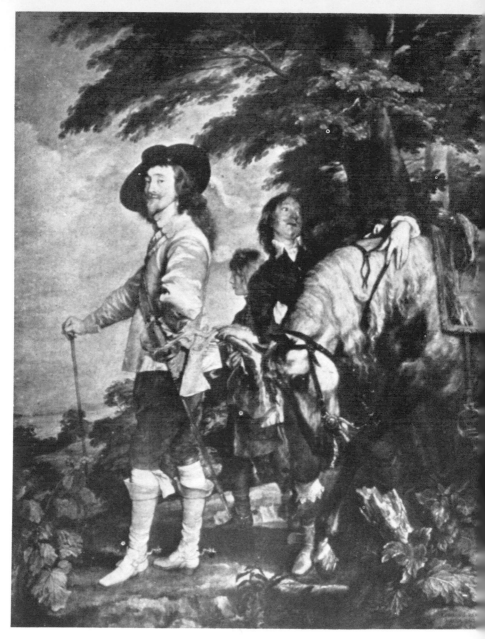

50. ANTHONY VAN DIJCK: CHARLES I
About 1635. Paris, Louvre

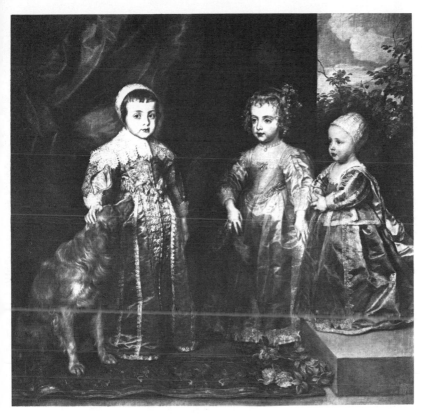

51. ANTHONY VAN DIJCK: THE CHILDREN OF CHARLES I
About 1635. Turin, Pinacoteca

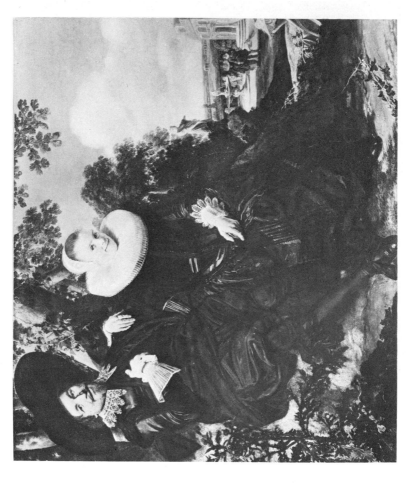

52. FRANS HALS: PORTRAIT OF A MAN AND HIS WIFE

About 1623, Amsterdam, Rijksmuseum

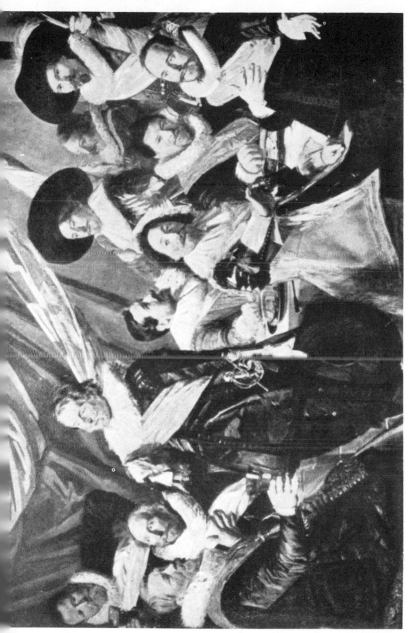

53. FRANS HALS: BANQUET OF THE OFFICERS OF THE ST. JORISDOELEN IN HAARLEM
1627. Haarlem, Museum

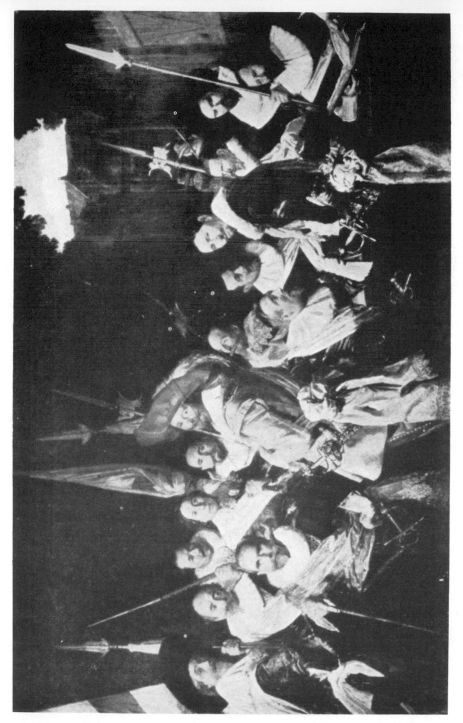

54. FRANS HALS: MEETING OF THE OFFICERS OF THE CLUVENIERSDOELEN
1633. Haarlem, Museum

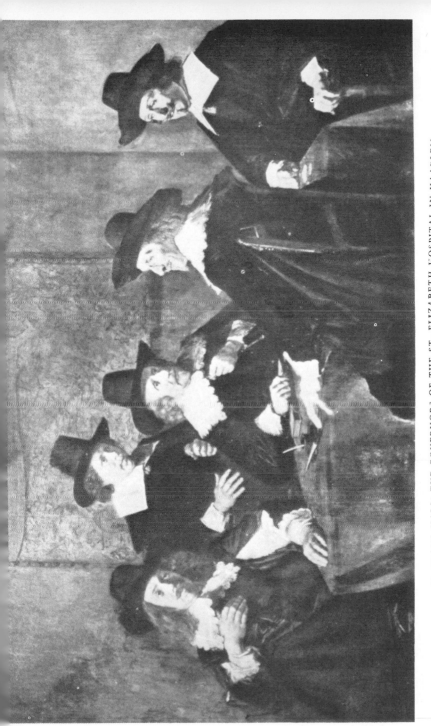

55. FRANS HALS: THE GOVERNORS OF THE ST. ELIZABETH HOSPITAL IN HAARLEM
1641. Haarlem, Museum

56. FRANS HALS: THE GOVERNORS OF THE HAARLEM ALMSHOUSE
1664. Haarlem, Museum

57. FRANS HALS: THE WOMEN GOVERNORS OF THE HAARLEM ALMSHOUSE
1664. Haarlem, Museum

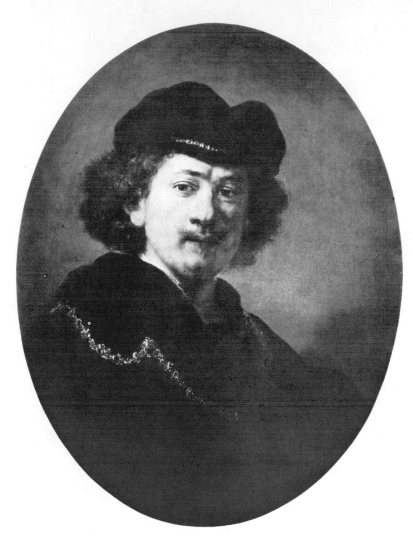

58. REMBRANDT: SELF-PORTRAIT
1634. Paris, Louvre

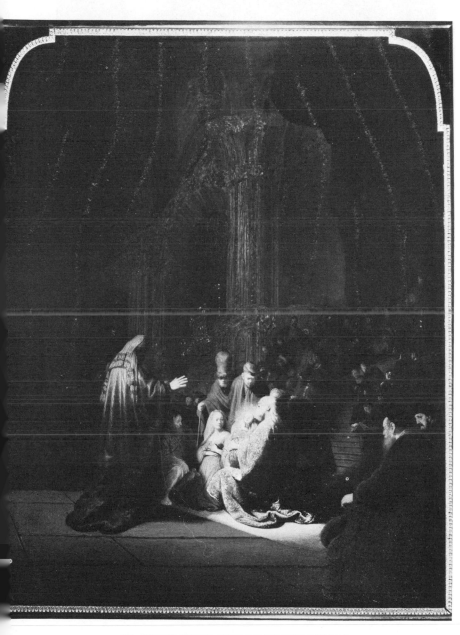

59. REMBRANDT: SIMEON IN THE TEMPLE
1631. The Hague, Mauritshuis

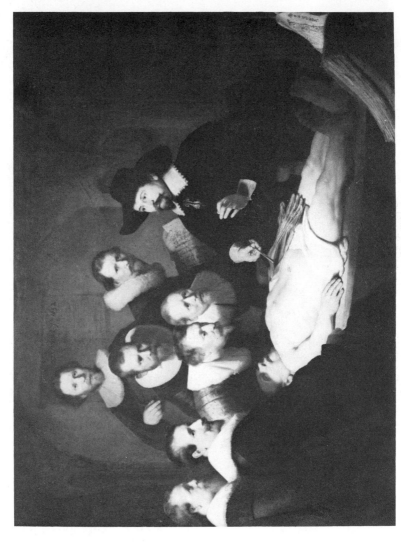

60. REMBRANDT: THE ANATOMY LESSON OF PROFESSOR TULP
1632. The Hague, Mauritshuis

61. REMBRANDT: THE PHILOSOPHER

1633. Paris, Louvre

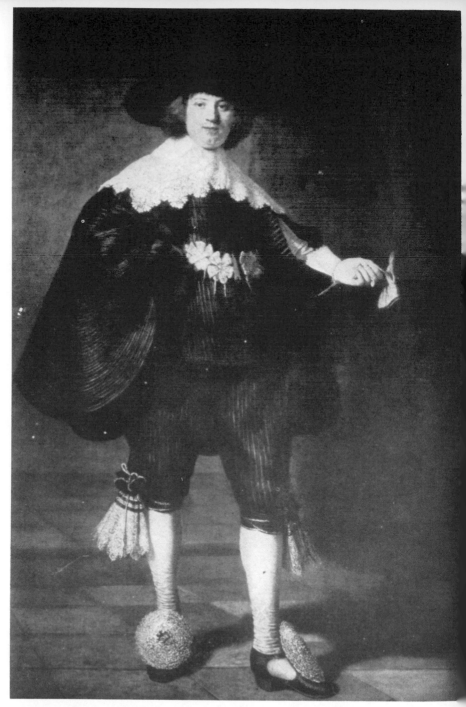

62. REMBRANDT: PORTRAIT OF MAERTEN DAY
1634. Paris, Coll. Rothschild

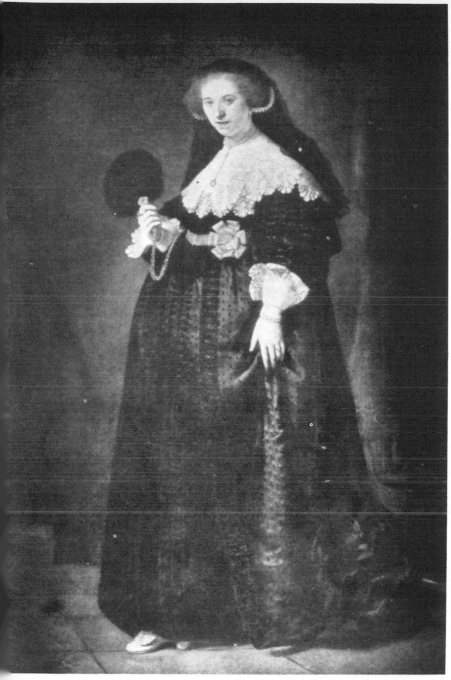

63. REMBRANDT: PORTRAIT OF JOHANNA MACHTELD VAN DOORN
1634. Paris, Coll. Rothschild

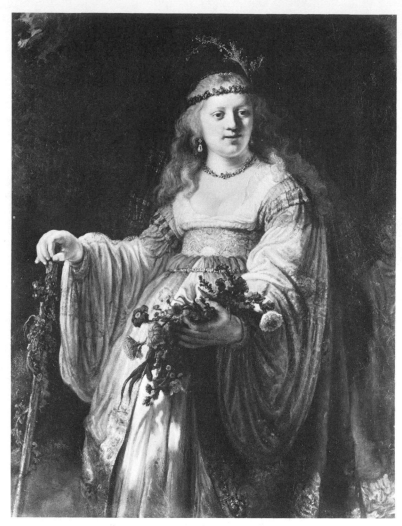

64. REMBRANDT: SASKIA AS FLORA
1635. London, National Gallery

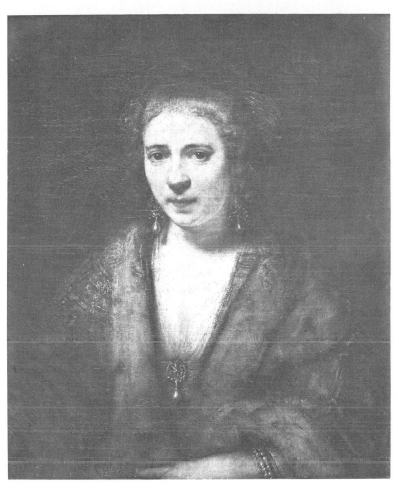

65. REMBRANDT: HENDRICKJE STOFFELS
About 1652. Paris, Louvre

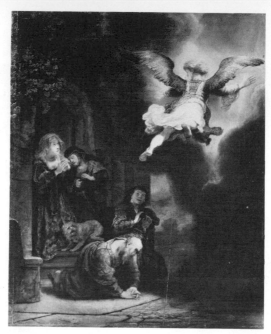

66. REMBRANDT: THE ANGEL LEAVING TOBIAS AND HIS FAMILY
1637. Paris, Louvre

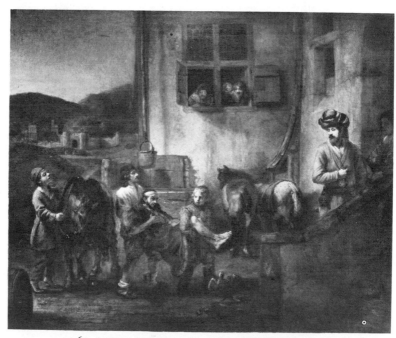

67. REMBRANDT: THE GOOD SAMARITAN
1648. Paris, Louvre

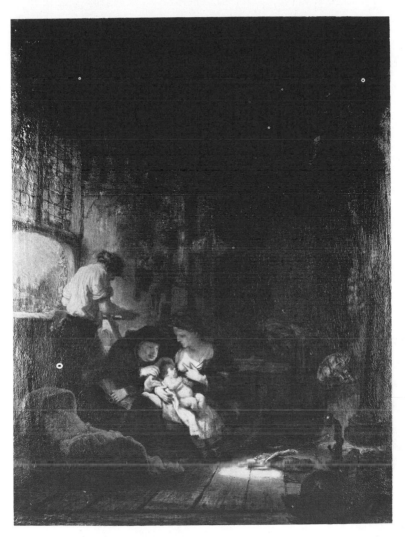

68. REMBRANDT: THE HOLY FAMILY
1640. Paris, Louvre

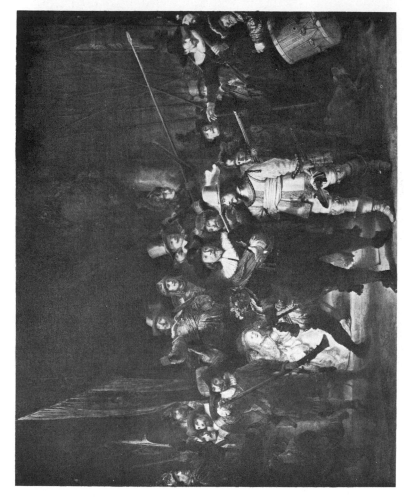

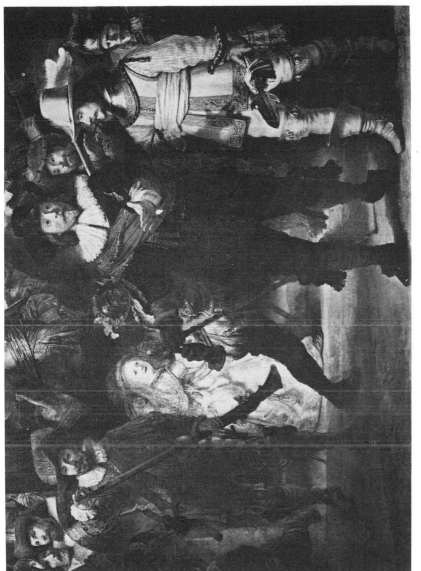

70. Detail from Plate 69

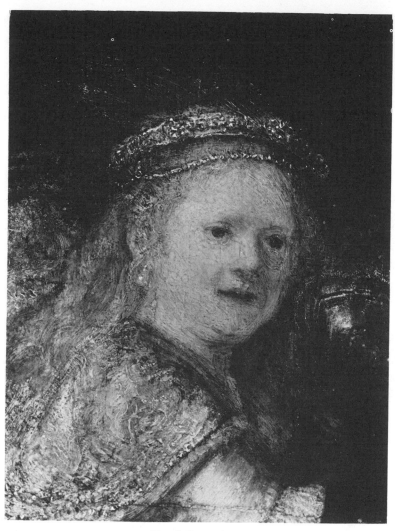

71. Detail from Plate 69

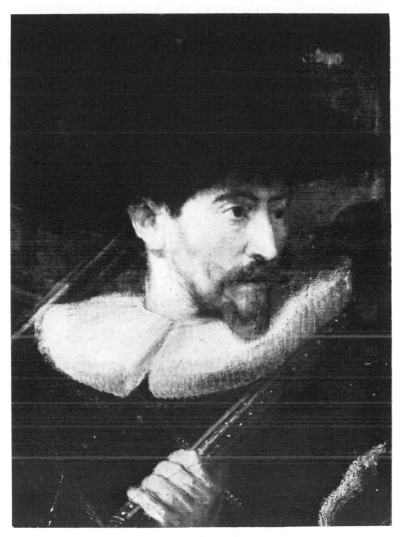

72. Detail from Plate 69

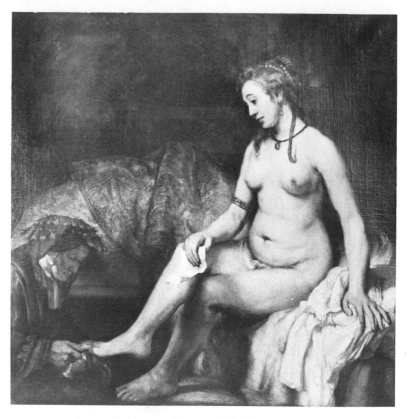

73. REMBRANDT: BATHSHEBA AT HER TOILET
1654. Paris, Louvre

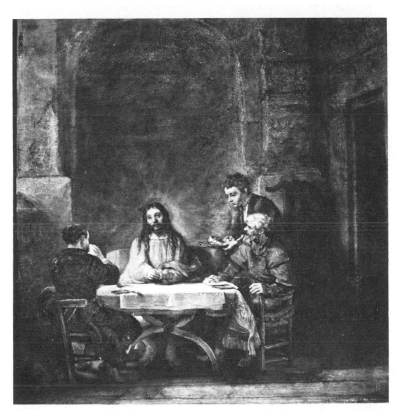

74. REMBRANDT: CHRIST AT EMMAUS
1648. Paris, Louvre

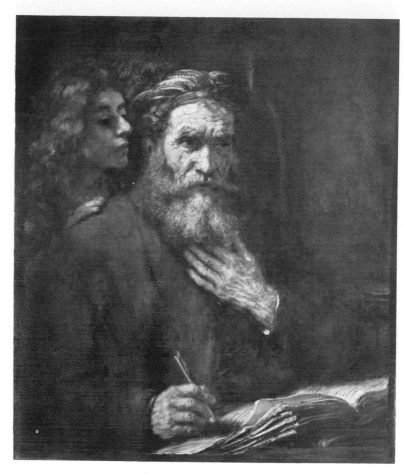

75. REMBRANDT: ST. MATTHEW
1661. Paris, Louvre

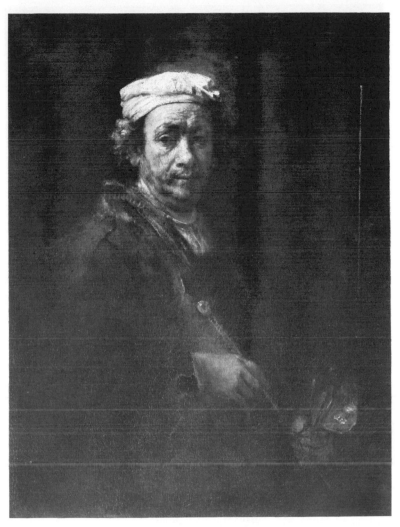

76. REMBRANDT: SELF-PORTRAIT
1660. Paris, Louvre

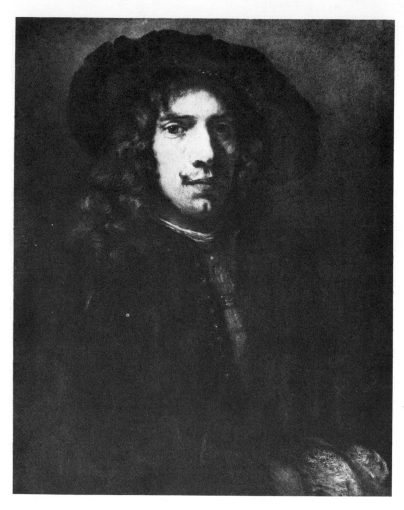

77. REMBRANDT: PORTRAIT OF A YOUNG MAN
1658. Paris, Louvre

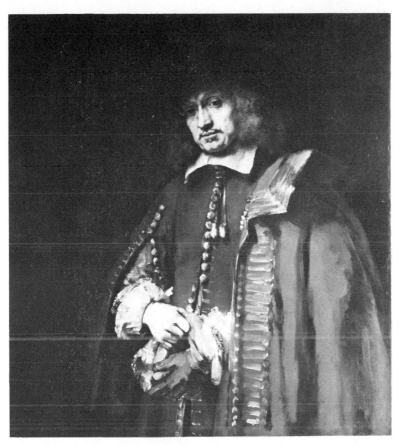

78. REMBRANDT: JAN SIX
1654. Amsterdam, Six Collection

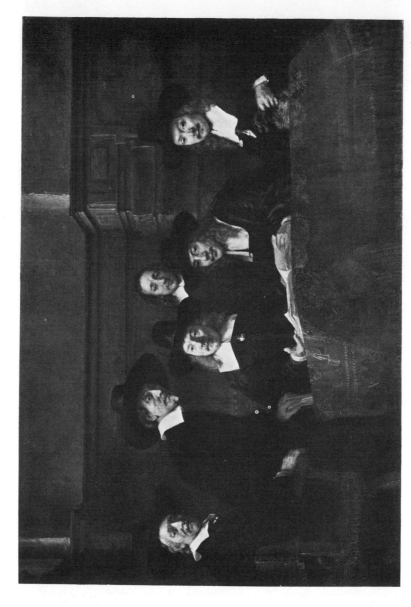

79. REMBRANDT: THE SYNDICS ('DE STAALMEESTERS')

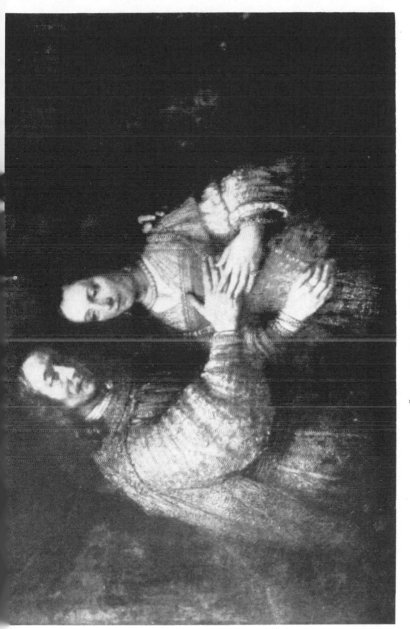

80. REMBRANDT: THE JEWISH BRIDE

About 1665. Amsterdam, Rijksmuseum

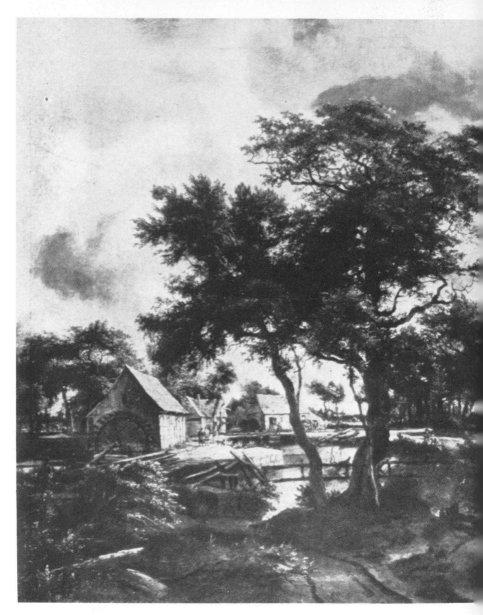

81. MEINDERT HOBBEMA: THE WATER MILL

Paris, Louvre

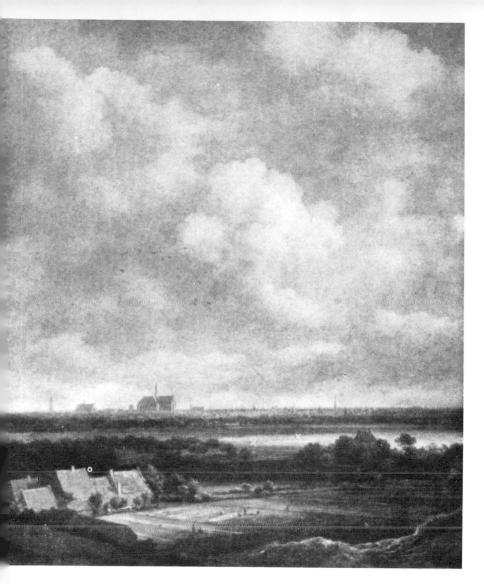

82. JACOB VAN RUISDAEL: VIEW OF HAARLEM
The Hague, Mauritshuis

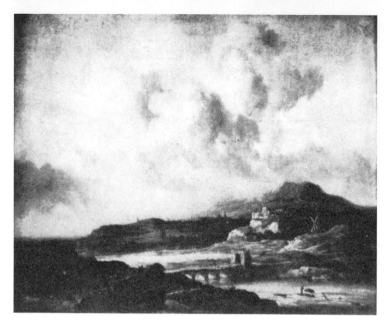

83. JACOB VAN RUISDAEL: 'LE COUP DE SOLEIL'
Paris, Louvre

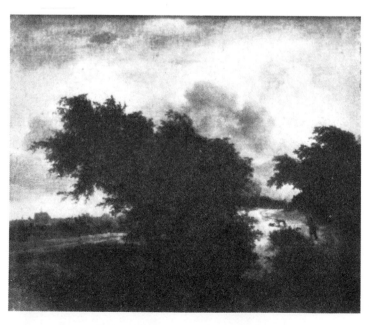

84. JACOB VAN RUISDAEL: THE BUSH
About 1647. Paris, Louvre

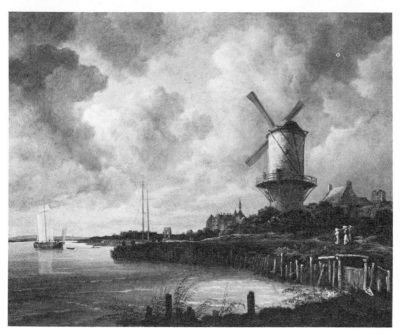

85. JACOB VAN RUISDAEL: THE MILL NEAR WIJK-BY-DUURSTEDE
Amsterdam, Rijksmuseum

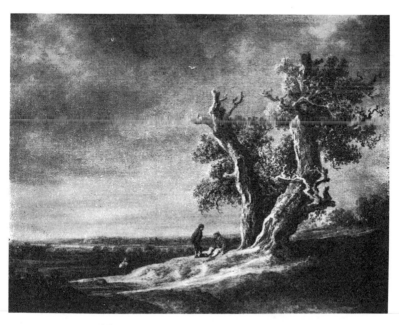

86. JAN VAN GOYEN: THE TWO OAKS
1641. Amsterdam, Rijksmuseum

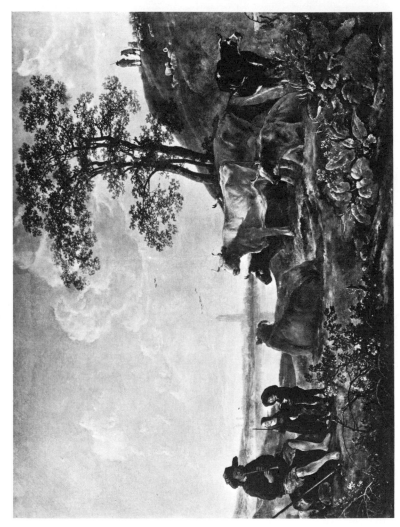

87. AELBERT CUYP: LANDSCAPE WITH CATTLE AND HERDSMAN

Paris Louvre

88. PAULUS POTTER: THE BULL

1647. The Hague, Mauritshuis

89. Detail from Plate 88

90. PAULUS POTTER: THE COW LOOKING AT ITSELF
1648. The Hague, Mauritshuis

91. AELBERT CUYP: EVENING LANDSCAPE AFTER THE RAIN
The Hague, Bredius Museum

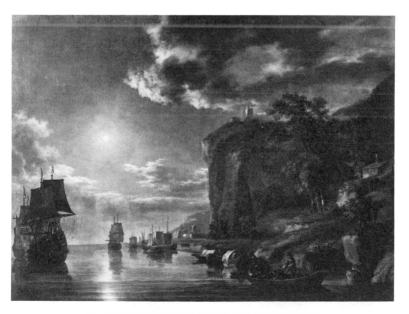

92. AELBERT CUYP: RIVER BY MOONLIGHT
Amsterdam, Six Collection

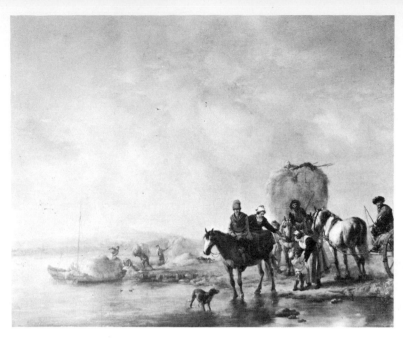

93. PHILIPS WOUWERMAN: THE CHARIOT
The Hague, Mauritshuis

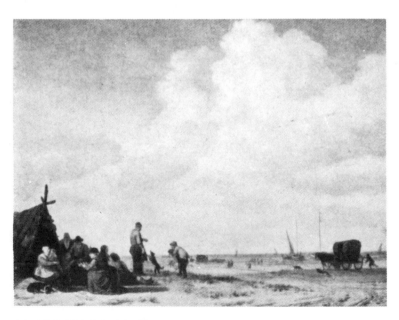

94. ADRIAEN VAN DE VELDE: THE SHORE AT SCHEVENINGEN
The Hague, Mauritshuis

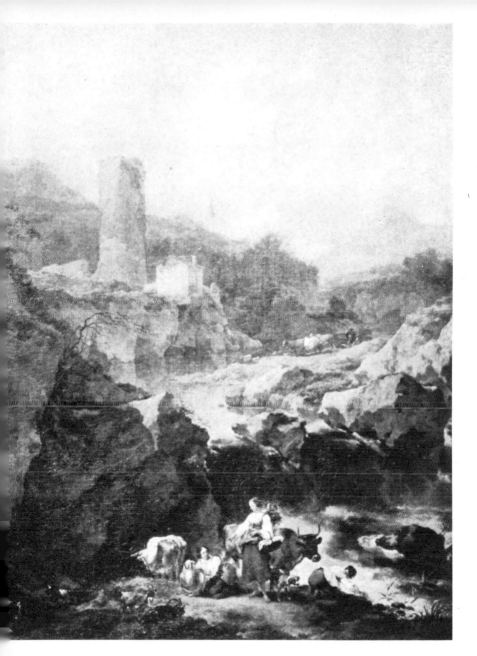

95. NICOLAES BERCHEM: ITALIAN LANDSCAPE
1656. Amsterdam, Rijksmuseum

97. JAN VAN DER HEYDEN: THE HEEREN-GRACHT IN AMSTERDAM

Paris, Louvre

98. ADRIAEN VAN OSTADE: FAMILY GROUP
1654, Paris, Louvre

99. PIETER DE HOOCH: DUTCH INTERIOR

Paris, Louvre

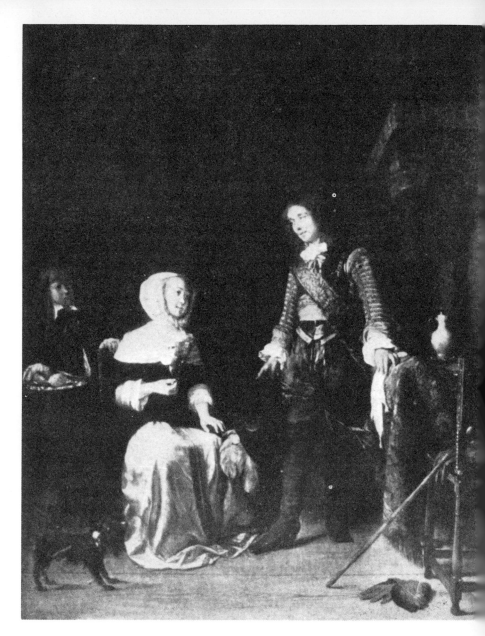

100. GABRIEL METSU: THE VISIT
Paris, Louvre

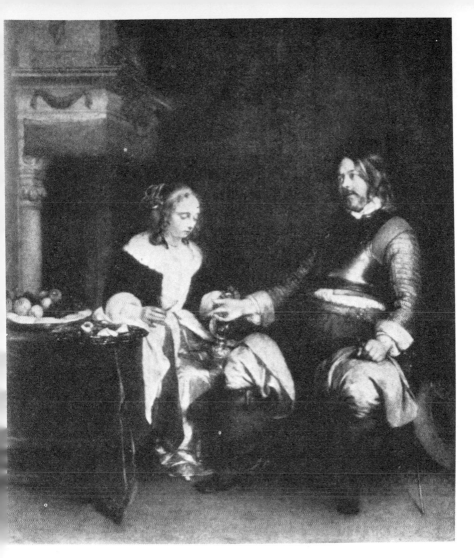

101. GERARD TERBORCH: THE LANSQUENET
Paris, Louvre

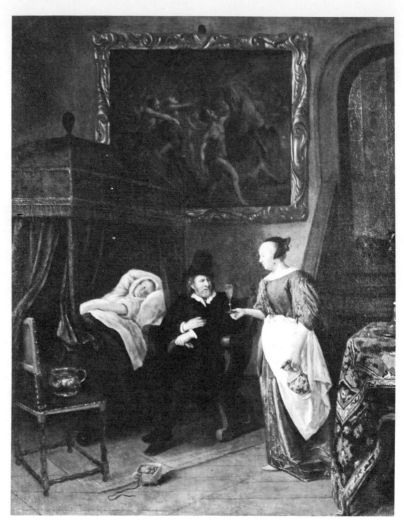

102. JAN STEEN: THE DOCTOR'S VISIT
The Hague, Mauritshuis

NOTES ON THE PLATES

FLEMISH PAINTERS OF THE FIFTEENTH AND SIXTEENTH CENTURIES

FROMENTIN'S warning 'to expect no method of any sort or continuity in these pages' applies mainly to the first and last chapters of the book, which describe his impressions of old-Netherlandish painting. Modern research had scarcely begun in his time and had as yet received little attention, whereas its results have since been accumulated in many popularizing books and are within everybody's reach. Hence we know more and have gained a closer insight as well as a wider survey. But it would not be fair to employ the results or methods of modern science in order to criticize Fromentin, and we confine ourselves therefore to some necessary remarks and corrections. Although it was inevitable to change some attributions we have generally abstained from adducing arguments and quoting recent art literature, in order not to overshadow Fromentin's spirited writing by a heavy scientific apparatus of notes and commentaries.

Page 3.

The fragment of 'triumphant mythology' by Paolo Veronese was ceded in 1920 to the Italian government, which in return gave a portrait by Rogier van der Weyden to the Brussels Museum.

PORTRAITS OF PHILIP THE FAIR AND JEANNE LA FOLLE. Brussels, Museum, No. 557. See page 8.

Painted on the insides of two altar wings. The centre painting was not acquired by the Brussels museum until 1920. According to Friedländer (*Die altniederländische Malerei*, IV, No. 82) the portraits are 'in the manner of the Master of the Story of Joseph', who is identical with the 'Brussels Master of the Abbey of Afflighem', and it is this artist to whom they are given in the museum catalogue.

JAN MOSTAERT: EPISODES FROM THE LIFE OF ST. BENEDICT. Brussels, Museum, No. 584 a–b. See page 8.

These paintings were originally given to Jan (or Pieter) van Coninxloo, and modern opinion has reverted to that attribution.

JAN VAN EYCK
Maaseyck 1385(?)–Bruges 1441

Jan van Eyck and Memling are the only ones of the early Flemish artists whom Fromentin discusses at length. Yet he sighs: 'van Eyck

is not alone: works swarm around him, works rather than names. We cannot make distinctions between them.'

THE ALTAR OF THE HOLY LAMB. Completed in 1432. Ghent, Saint-Bavon. PLATES 1–4. See pages 236–9.

At the time of Fromentin's visit to Ghent, only the centre panel and some of the wings were in the church; the other parts had been sold and had found their way into the museums of Brussels and Berlin. Today the altar is once again complete and in its original form, except for the bottom left-hand wing, representing the 'Iusti Iudices', which was stolen some years ago. A Latin inscription on the frame of the centre panel says that the great work was begun by Hubert van Eyck and completed by Jan. What share of the work should be attributed to each brother is a question that has been discussed by many scholars since (and before) Fromentin touched upon it; but the mystery has remained unsolved. These are some of the more recent opinions: some deny Hubert's existence altogether (Renders) and consequently attribute the entire altar to Jan; Friedländer also recognizes but one artist in the work, namely Jan. Beencken thinks that Jan took over parts of an uncompleted altar-piece from Hubert and rearranged them. The conclusion reached independently by both Leo van Puyvelde and F. J. Mather is that Hubert is responsible not only for the composition as a whole, but also for the execution of many panels; but they do not agree as to the share of each brother. A recent cleaning (1950–1) may upset some of these theories; a final conclusion will probably not be reached from the results of the cleaning alone.

THE VIRGIN AND SAINT DONATIAN. 1436. Bruges, Museum. PLATE 5. See page 240.

This work, the greatest achievement of Jan van Eyck, was cleaned a few years ago and the colours, particularly the blue in the robe of the Saint, have regained their original brilliancy.

ROGIER VAN DER WEYDEN
Tournai 1399–Brussels 1464

Fromentin had little notion of this master's art, and indeed the paintings given to Rogier in the museum catalogue of those years were hardly calculated to convey an adequate impression of his art. It was only towards the end of the nineteenth century that the importance of Rogier and of his teacher Robert Campin was recognized.

Fromentin's praise of Rogier is confined to the words: 'He left among his works a unique masterpiece—I mean a pupil who was called Memling.'

THE WEEPING WOMAN. Brussels, Museum, No. 517. See page 243.
A copy after the Mary Magdalen of the Descent from the Cross in the Escorial.

TWO TRIPTYCHS. See page 243.
One of them (Brussels, Museum, No. 577) is by a so-called Antwerp mannerist of about 1500, and hence is much later than Rogier. The other is probably the so-called Sforza triptych (No. 515), a work of Rogier's atelier, on which the Italian Zanetto Bugatto may have collaborated. Some parts of the wings were probably painted by Hans Memling.

<p style="text-align:center">★</p>

ALTAR OF THE HOLY SACRAMENT. Antwerp, Museum, No. 393.
PLATE 6.
Our illustration shows only the centre panel with the Sacraments of the Holy Eucharist. The two wings show the other six sacraments and the right-hand wing includes a portrait of the Bishop Jean Chevrot, who commissioned the work; his coat-of-arms appears also on the centre panel. It is the most important altar-piece by Rogier van der Weyden preserved in his country, but curiously enough was not touched upon by Fromentin.

DIRK BOUTS
Haarlem, c. 1420–Louvain 1475

ALTAR OF SAINT HIPPOLYTUS. Bruges, S. Sauveur Cathedral.
PLATES 7 9. See page 249.
'Was attributed to Memling, is by Bouts or Gerard David', is Fromentin's comment. Dirk Bouts is also one of the artists 'rediscovered' by modern scholarship. He is thought to have painted this altar in Louvain towards the end of his life; the portraits of the donors, Hippolyte de Berthoz and his wife, were, it is believed, added in Ghent by Hugo van der Goes.

THE JUSTICE OF EMPEROR OTTO. 1468. Brussels, Museum, Nos. 65–6. PLATES 10–11. See page 8.
Commissioned by the town council of Louvain for the town hall. The paintings were intended to exhort the judges, in the medieval manner, to be fair and incorruptible. The first picture shows the

innocent Count being executed upon the denunciation of the wicked Empress; in the second, the Countess proves her husband's innocence by passing through the fire-ordeal, while in the background the Empress is burnt at the stake.

HANS MEMLING
Seligenstadt/Main, c. 1433–Bruges 1494

Memling's fame has never faded. He was the favourite of the romantics and the story of his life was embroidered with legends of all kinds. Many of his works were always to be seen in St. John's Hospital at Bruges. He was one of the few masters of his time to sign his paintings, which were thus never lost in the mass of anonymous works.

THE MYSTIC MARRIAGE OF ST. CATHERINE. 1479. Bruges, St. John's Hospital. PLATES 12–14. See page 243.

On the frame a reliable inscription: *Opus Johannis Memling anno 1479.* The donors appearing in the work are the matrons and nurses of St. John's Hospital.

GERARD DAVID
Oudewater (Holland), c. 1460–Bruges 1523

THE ADORATION OF THE KINGS. Brussels, Museum, No. 191. PLATE 15. See pages 4, 240.

This magnificent work is indeed worthy of a Van Eyck, under whose name it then appeared in the Museum catalogue and to whom it was therefore given by Fromentin. But the supple, compact composition, the lucid arrangement and the advanced technique reveal the artist of a later generation. The work dates from shortly before 1500 and is still free from Italian Renaissance motifs, which soon afterwards spread throughout the Netherlands.

QUENTIN MATSYS
Louvain 1465/6–Antwerp 1530

THE BURIAL OF CHRIST. 1508–9. Antwerp, Museum, No. 245. PLATE 16. See page 7.

BAREND VAN ORLEY
Brussels, c. 1492—Brussels 1542

THE TRIALS OF JOB. 1521. Brussels, Museum, No. 345. PLATE 17. See page 7.

Both are works of a 'new age', when artists relied upon large forms and turbulent movement to surpass the paintings of the previous

generation with their painstaking and almost reverent execution. Fromentin is quite right in remarking that Matsys is much closer to the native tradition, whereas Orley derives strength and inspiration from Italian sources.

FLEMISH MASTER
Sixteenth century

THE TEMPTATION OF ST. ANTHONY. Brussels, Museum, No. 603. PLATE 18. See page 11.

This interesting little work combines elements of Bosch and Patinir. The attribution to Herri met de Bles is certainly wrong. Fromentin rightly sees in its style the prelude to the landscape art of Brueghel and Rubens.

OTTO VAN VEEN (also called VAENIUS)
Leiden 1556–Brussels 1629

THE MYSTIC MARRIAGE OF ST. CATHERINE. 1589. Brussels, Museum, No. 479. PLATE 19. See page 15.

ADAM VAN NOORT
Antwerp 1562–Antwerp 1641

CHRIST AND THE CHILDREN. Brussels, Museum, No. 612. PLATE 20. See page 17.

Fromentin dwells emphatically on the art of these two teachers of Rubens, who together 'represented excellently the two elements, natural and foreign, which for one hundred years had divided Flemish genius between them'. Van Veen's style is well characterized: Fromentin had before him the picture at Brussels and knew the family group of 1584 in the Louvre (No. 2191). With Adam van Noort the case is quite different. After Fromentin has built up the antithesis between Van Veen, who had an Italian training, and Van Noort, who remained rooted in the native tradition, he says somewhat hesitatingly of the latter artist: 'if these traits are accurate, and I think they are, for they were seen in one of his most characteristic works.' To build such a hypothesis on a single picture is rather risky, and the work that kindled Fromentin's enthusiasm for Van Noort, the 'Calling of St. Peter' in S. Jacques at Antwerp, is, in fact, by Jacob Jordaens, as modern art historians (H. Hymans, F. M. Haberditzl, R. Oldenbourg and L. Burchard) have shown. Hippolyte

Taine (*Philosophie de l'art*, p. 131), Fromentin's guide on several occasions, made the same mistake of attributing this work to Adam van Noort. The enthusiasm for this picture is not surprising: it is one of Jordaens's early works, which today also command general admiration. Van Noort, on the other hand, was a rather weak and backward painter, who is not likely to have contributed anything to the development of Rubens. He was and remained throughout his life a 'Romanist', and his later works show a superficial influence of his great pupil.

MARTIN DE VOS
Antwerp 1531–Antwerp 1603

ST. PAUL AT EPHESUS. 1568. Brussels, Museum, No. 862. PLATE 21. See page 7.

An example of the art of the late Romanists—or mannerists as they are called today—who were influenced by Italian art and thus became 'skilful artists, with ease of manner, great experience, true knowledge' and hence forerunners of Rubens. In Martin de Vos's work the influence of Tintoretto is specially noticeable.

PETER PAUL RUBENS
Siegen 1577–Antwerp 1640

'The gallery of Brussels has at least seven important pictures by him', Fromentin wrote in 1875. Since then it has acquired many more. If Fromentin had already known the beautiful late sketches for the decoration of the Torre de la Parada (the large pictures themselves were executed by pupils) he would certainly have given them his full attention, and they would probably have drawn his attention to the other large decorations by Rubens, such as the ceiling of the Jesuit church at Antwerp (only the sketches have survived), the decorations of Whitehall, and others. We must not forget that our knowledge of Rubens's work has increased enormously during the last fifty years. Another field of Rubens's activity which is nowadays highly admired —the landscapes—is not even hinted at by Fromentin, while his judgement of the portraits strikes our modern mind as too negative. But we can hardly blame Fromentin, as the examples that he saw of Rubens's art as a portrait painter were partly poor ones (see below). On the other hand we cannot but admire Fromentin's feeling for style and quality. To mention only one curious example: Fromentin cannot understand (p. 21) that the so-called late works by Rubens,

which were painted in conjunction with his friend Jan Brueghel, should be of the same period as the large altar-piece in S. Jacques, which certainly is late. Fromentin was absolutely right in making this point: as Jan Brueghel died in 1625 (a fact obviously unknown to Fromentin) all paintings to which Brueghel added landscapes or flowers must be fairly early works by Rubens.

The quotations on pages 77 and 78 are taken from H. Taine, *Philosophie de l'art dans les Pays-Bas*, 1869, pages 139, 135.

We add some notes on pictures not reproduced in our edition.

PIETÀ WITH ST. FRANCIS. Brussels, Museum, No. 380. Page 22 f.

Painted already in 1620 for the Capucin Church in Brussels. The execution is to a great extent by assistants and it is not surprising that Fromentin does not deal with this work at length.

THE ASSUMPTION OF THE VIRGIN. Brussels, Museum. Page 27.

In the Brussels Museum there is only one representation of this subject, which Fromentin has discussed already (page 21, Plate 35). Perhaps a confusion with the 'Enthronement of the Virgin' (No. 379), a painting by pupils, gone over by the master. It is hardly surprising that Fromentin shows little enthusiasm for this work or for VENUS IN VULCAN'S SMITHY (No. 382. Page 27). The last-named work is mutilated: it was cut up, and the left-hand part with Vulcan is a later addition, while the original left half with the old woman holding a coal-scuttle is now in the Museum at Dresden. As Fromentin rightly observes, this picture calls Jordaens's works strongly to mind.

THE TRINITY. Antwerp, Museum, No. 314. Page 55.

Not as early as Fromentin believed. Painted not before 1620; to a great extent overpainted.

THE INCREDULITY OF ST. THOMAS. Antwerp, Museum, No. 307. Page 56.

I think the mistake is Fromentin's. The triptych of the Burgomaster Rockox was destined for the Rockox tomb and was executed between 1613 and 1615. It is in the classic, somewhat cold style found in many mythological and Biblical pictures of the period.

ST. CATHERINE. Antwerp, Museum. Page 57.

Probably a mistake of Fromentin's, as there is no such subject in the Museum. He means perhaps 'St. Theresa interceding for the souls in purgatory'.

CHRIST ON THE CROSS and THE DESCENT FROM THE CROSS. Antwerp, Museum, Nos. 313 and 315. Page 57.

Repetitions of other works and as such justifiably passed over without comment.

ARCHDUKE ALBERT AND INFANTA ISABELLA. Brussels, Museum, Nos. 384–5. Page 67.

Two of the four portraits which—rather unfortunately—served Fromentin to illustrate 'the strong and mediocre parts of Rubens's talent as a portrait-painter'. None of these four is by Rubens. (See also Plates 48–9.) The Archduke Albert and the Infanta Isabella are, according to G. Glück, most probably the work of Cornelis de Vos as the two pictures belong to the so-called Arch of Philip, one of the many erected in 1635 on the occasion of Cardinal-Infante Ferdinand's entry into Antwerp. Although the design of the whole festive decorations was due to Rubens, the execution of this arch was entrusted to Jacob Jordaens and Cornelis de Vos, who were paid a considerable sum.

PORTRAIT OF BARON HENRI DE VICQ. Paris, Louvre. No. 2111. Page 70.

De Vicq was Belgian minister to the Court of Paris. Rubens painted his portrait in 1625 to thank him for his assistance in negotiating about the work of the Medici Gallery.

PORTRAIT OF ELIZABETH OF FRANCE. Paris, Louvre, No. 2112. Page 70.

Now regarded as a portrait of Anne of Austria, Queen of France (1601–66), painted about 1623.

A LADY OF THE BOONEN FAMILY. Paris, Louvre, No. 2114. Page 70.

In fact a portrait of Suzanne Fourment, the sister of the artist's second wife. Originally in the Boonen collection.

THE CRUCIFIXION OF ST. PETER. c. 1638. Cologne, St. Peter. Page 80.

The picture was commissioned by the well-known Cologne and Paris banker and collector, Eberhard Jabach, who died before it was finished. Rubens himself had chosen the martyrdom of St. Peter 'with the feet upright' for the subject of this picture.

<p style="text-align:center">★</p>

THE RAISING OF THE CROSS. 1610–11. Antwerp, Cathedral. PLATE 22. See pages 42–53.

Painted between summer 1610 and summer 1611 for the high-altar of the St. Walpurgis Church at Antwerp. Since 1815 in the Cathedral.

THE DESCENT FROM THE CROSS. 1611–14. Antwerp, Cathedral. PLATE 23. See pages 42–53.

Commissioned by the Archers' Guild on 7 July 1611 and completed on 6 March 1614.

'CHRIST À LA PAILLE.' 1617–18. Antwerp, Museum, No. 300. PLATE 24. See page 56.

Painted to adorn the tomb of Jan Michielsen, an Antwerp merchant, who died in 1617. The execution is partly due to Anthony van Dijck.

THE MIRACULOUS DRAUGHT OF FISHES. 1618–19. Malines, Notre-Dame au delà de la Dyle. PLATES 25–7. See pages 32–8.

Commissioned by the Guild of Fishermen in February 1618 and delivered by Rubens in August 1619.

THE ADORATION OF THE KINGS. 1617–19. Malines, S. Jean. PLATE 28. See page 29.

Commissioned in December 1616, delivered in 1619.

THE ADORATION OF THE KINGS. 1618–20. Brussels, Museum, No. 377. PLATE 29. See page 23.

Painted for the Church of the Capucins at Tournai.

THE ADORATION OF THE KINGS. 1624. Antwerp, Museum, No. 298. PLATES 30, 32. See pages 53–5.

Commissioned by Abbot Mattheus Yrsselius for the high-altar of S. Michel at Antwerp. A sketch is in the Wallace Collection, London. Rubens also painted the abbot's portrait; it is now in the museum at Copenhagen.

Modern criticism has established a different chronological order from that given by Fromentin for Rubens's various renderings of the Adoration. It is indeed unlikely that the painting at Brussels (Plate 29) should be earlier than that at Malines (Plate 28), which is known to have been commissioned late in 1616. The version in Paris (see page 23), which is not reproduced here, dates from 1626–7 and is thus one of the latest renderings of the subject.

THE SACRAMENT OF ST. FRANCIS OF ASSISI. 1619. Antwerp, Museum, No. 305. PLATES 31, 33. See pages 57–9.

Commissioned by Jaspar Charles for the Church of the Recollects. The receipt for the payment, signed by Rubens and dated 17 May 1619, is still in existence.

CHRIST ON THE CROSS ('LE COUP DE LANCE'). 1620. Antwerp, Museum, No. 297. PLATE 34. See pages 55–9.

Commissioned by the Burgomaster Nicolaes Rockox for the high-altar of the Church of the Recollects at Antwerp. The execution is partly due to Anthony van Dijck.

THE ASSUMPTION OF THE VIRGIN. c. 1616–20. Brussels, Museum, No. 378. PLATE 35. See pages 21–2.

Painted for the Church of the Carmelites at Brussels. Probably the earliest version of a subject that was treated by Rubens several times. The picture is now cleaned and the overpaintings mentioned by Fromentin have disappeared.

It is strange that Fromentin has not a word to say of the magnificent Assumption in the Antwerp Cathedral, a painting that must have been on view in his time since other travellers were loud in their praise of it.

THE HOLY FAMILY ('LA VIERGE AU PARROQUET'). Antwerp, Museum, No. 312. PLATE 36. See page 56.

The Madonna and the Child were painted first. About 1625 the artist enlarged the picture at both sides, adding the St. Joseph at the right and the landscape at the left.

THE EDUCATION OF THE VIRGIN. c. 1630. Antwerp, Museum No. 306. PLATE 37. See page 56.

Painted for the Chapel of S. Anne in the Church of the Carmelites at Antwerp.

CHRIST WISHING TO DESTROY THE WORLD. c. 1633. Brussels, Museum, No. 376. PLATE 38. See page 26.

Painted for the Convent of the Recollects at Ghent, with the aid of pupils.

THE MARTYRDOM OF ST. LIEVIN. c. 1635. Brussels, Museum, No. 375. PLATE 39. See page 24.

Painted for the Church of the Jesuits at Ghent. A sketch is in the Van Beuningen Collection at Vierhouten, Holland.

THE BEARING OF THE CROSS. c. 1636–7. Brussels, Museum, No. 374. PLATE 40. See page 23.

Painted for the Abbey of Afflighem. There are several sketches, at Amsterdam, Vienna, and Warsaw.

HENRI IV RECEIVING THE PORTRAIT OF MARIA DE' MEDICI. 1622–5. Paris, Louvre, No. 2688. PLATE 41. See page 62.

Belongs to the large cycle of the 'Life of Maria de' Medici', which Rubens painted between 1622 and 1625.

MADONNA AND SAINTS. *c.* 1636–40. Antwerp, S. Jacques. PLATE 42. See pages 60, 71.
As Fromentin points out, a late work, destined by Rubens for his own tomb.

HÉLÈNE FOURMENT WITH TWO CHILDREN. *c.* 1636. Paris, Louvre, No. 2113. PLATE 43. See page 70.
At the left, Rubens's daughter Clara Johanna, about four years old, and the boy Frans at the age of three; at the right, only the hands of the approaching little daughter, Isabella Helen, are to be seen.

'KERMESSE FLAMANDE'. *c.* 1635–8. Paris, Louvre, No. 2115. PLATES 44–5. See page 79.
Only briefly mentioned by Fromentin. Certainly not commissioned by a patron and hence very significant for the master's imagination and artistic power.

ANTHONY VAN DIJCK
1599–1641

Fromentin's appreciation of Van Dijck is based on general, traditional impressions rather than on the works he saw during his sojourn in Belgium. For most art-lovers of the nineteenth century, Van Dijck is completely overshadowed by the art of Rubens: hence Fromentin's attempt to define the younger artist's personality is the more remarkable. However, it was only recent research that succeeded in identifying Van Dijck's work. Many of his earlier works, which had either passed under the name of Rubens or had been lost sight of altogether, have come to light, and it has become possible to distinguish the phases of the painter's development.

Page 83.

The two pictures in the Museum at Brussels, which Fromentin mentions briefly, the SILENUS (No. 163) and the MARTYRDOM OF ST. PETER (No. 164), are early works of about 1616–17.

SELF-PORTRAIT. *c.* 1620. New York, Metropolitan Museum (Bache Collection). PLATE 46.
The artist at the age of about twenty-one years, shortly before his Italian journey.

ST. MARTIN. *c.* 1617. Saventhem, Church. PLATE 47.

An early work. Tradition has it that the picture was painted when Van Dijck stopped at Saventhem before setting out for Italy.

PORTRAITS OF JEAN-CHARLES DE CORDES AND OF HIS WIFE JACQUELINE VAN CAESTRE. 1617–18. Brussels, Museum, Nos. 386–7 (as by Rubens). PLATES 48–9. See page 69.

These two works, then (and in the official catalogue of the museum still) ascribed to Rubens, were acquired by the museum shortly before Fromentin's journey. 'A great value is set on them,' Fromentin reports without sharing this admiration. 'A hurried and brilliant painting, a pleasant likeness, an ephemeral piece of work,' is his final verdict. And, indeed, is it not Van Dijck's style that is much better characterized by such a judgement? The portraits were probably painted on the occasion of the marriage in 1617, or at any rate shortly afterwards, as Jacqueline died in 1618. See also note on page 360.

CHARLES I. *c.* 1635. Paris, Louvre, No. 1967. PLATE 50. See page 85. Van Dijck was for many years court painter to Charles I and this is one of the most famous portraits of the king.

THE CHILDREN OF CHARLES I. *c.* 1635. Turin, Pinacoteca. PLATE 51. See page 85.

The group consists of Charles, born 1630, the later Charles II; Mary, born 1631, later married to William II of Orange; and James, born 1633, the later James II. The picture was given to the Queen's sister, the Duchess of Savoy, who resided at Turin.

HOLLAND

As we have pointed out in the introduction, Dutch painting is the central theme of Fromentin's book. Again and again he returns to the problem of the importance of Dutch art for the French painters of his time. A separate chapter is devoted to Dutch influence on French landscape painting. His opposition to impressionism emerges clearly from what he has to say about Frans Hals and about the interpretation that modern painters were wont to put—quite wrongly, in his opinion—upon the work of that master. Discussion of the Dutch genre paintings in the Louvre prompts him to express his concern about the poor training of the young French artists. These problems are no longer of any interest: historical developments take their course without regard to criticisms of this kind. Then, as now, the

artistic conceptions of the young generation are moulded by stronger impulses. Some of Fromentin's allusions require a note of explanation:

Page 97.

The 'writer of our time, very enlightened in these matters', is again H. Taine (*Philosophie de l'art dans les Pays-Bas*, 1869, page 157). This section is very significant for the way in which Fromentin takes up Taine's philosophy of art. He derives the tendency towards portraiture, which is so strong in Dutch art, from the sociological structure of the Dutch people: Taine himself goes much farther, deriving as he does the character of a people from its race, climate, and past experiences; Fromentin, for his part, pays no attention to such historical premisses and avoids carefully any attempt to 'explain' all phenomena of Dutch art as the result of external conditions.

Page 115 f.

The 'very original painter of our day' is, of course, J. F. Millet.

Page 155.

The 'ingenious painter, brilliant, multiform, who has touched on many things', is very probably Narcisse-Virgile Diaz de la Peña.

Page 161 f.

Who is the painter praised by Fromentin as 'uniting to the true love of the country the no less evident love of ancient painting and of the best masters'? M. Allemand suggests Camille Pissarro; I am inclined to think rather of G. Courbet. H. van de Waal comes to the conclusion that the only artist uniting all the characteristics quoted by Fromentin is Ch. F. Daubigny. We may well be puzzled when we are told that it is doubtful whether his style is more strongly influenced by Vermeer or by Ruisdael.

Pages 93, 96, 119.

When we come to Dutch painting proper, we must again beware of measuring Fromentin's errors by modern knowledge. The discovery and study of old documents has thrown light on the life of many an artist whose career was either unknown in Fromentin's time or had been distorted by tradition. In this respect some of the dates Fromentin takes for granted must be rectified—nowadays Van de Velde and Van Goyen are no more considered to be of one generation than are Ruisdael and Hobbema.

If we were to draw up a chronological sequence of painter generations by decades, we should arrive at the following groups:

Born 1570–80 M. J. Mierevelt, P. Moreelse, J. A. Ravesteyn.

1581–90 Frans Hals, P. Lastman, J. Pijnas, C. Poelenburgh, J. van Schooten, A. van der Venne, G. Honthorst, E. van de Velde.

1591–1600 J. G. Cuyp, Th. de Keyser, J. van Goyen.

1601–10 A. van der Neer, A. Brouwer, Rembrandt, A. Both, A. van Ostade.

1611–20 G. Dou, B. van der Helst, F. Bol, G. Terborch, J. Both, Ph. Wouwerman, A. Cuyp, N. Berchem.

1621–30 A. van Everdingen, A. Pynacker, P. Potter, J. Ruisdael, J. Steen, P. de Hooch, G. Metsu.

1631–40 J. Vermeer van Delft, J. Wynants, A. van de Velde, J. van der Heyden, M. Hobbema.

FRANS HALS
Antwerp, c. 1580–Haarlem 1666

PORTRAIT OF A MAN AND HIS WIFE. Amsterdam, Rijksmuseum, No. 108. PLATE 52. See page 167.

Dates from the early twenties. Probably not a self-portrait, as used to be generally believed.

BANQUET OF THE OFFICERS OF THE ST. JORISDOELEN IN HAARLEM. 1627. Haarlem, Museum, No. 124. PLATE 53. See page 169.

Fromentin, too, regards the treatment of the 'Jorisdoelen' as 'freer and more skilful' than that of the Cluveniersdoelen (No. 125). Is it not therefore likely that the 'Cluveniersdoelen' was painted a few years earlier, about 1624, which would also agree better with the fact that that picture commemorates the departure of the Company for Bergen and Hasselt on 18 October 1622? Fromentin complains here, as in some other cases, about the 'dark and dull' background. A careful cleaning, twenty-five years ago, has not only lightened the background, but has also restored the original freshness of the other parts.

MEETING OF THE OFFICERS OF THE CLUVENIERSDOELEN. 1633. Haarlem, Museum, No. 126. PLATE 54. See page 170.

Here again a remark on the dark background, a complaint for which there is no longer any cause.

THE GOVERNORS OF THE ST. ELISABETH HOSPITAL IN HAARLEM. 1641. Haarlem, Museum, No. 128. PLATE 55. See page 172.

THE GOVERNORS OF THE OLD MEN'S ALMSHOUSE IN HAARLEM. 1664. Haarlem, Museum, No. 129. PLATE 56. See page 173.

THE WOMEN GOVERNORS OF THE OLD MEN'S ALMSHOUSE IN HAARLEM. 1664. Haarlem, Museum, No. 130. PLATE 57. See page 173. In 1908, thirty-three years after Fromentin's visit, the Old Men's Hospital was converted into a Frans Hals Museum, and now the master's last works are hung once more in the building for which they were painted.

REMBRANDT
Leiden 1606–Amsterdam 1669

As in the case of Rubens, many readers will here, too, miss some works that we nowadays believe to be indispensable for a complete survey of the master's work: portraits of his family, landscapes, some early paintings and some late ones. We have not corrected this 'shortcoming', because we regard it as less important to round off the picture than to illustrate Fromentin's remarks by numerous reproductions.

Pages 96, 224, 226.
Since Vosmaer's book appeared in 1869, Dutch research has added continuously to the knowledge of Rembrandt's life. The principal dates are as follows: born at Leiden, 15 July 1606 (not in 1608, as Fromentin has it on page 96); moved to Amsterdam during 1632, and there married Saskia van Uylenburgh in 1642 (that he was married three times is a legend); in 1639 he had bought a large house in the Breestraat (today called 'Rembrandthuis'). Saskia died in 1642. Their only surviving child, Titus, was born in 1641. In that same year, Hendrickje Stoffels entered Rembrandt's household. During 1656–7 he is forced to put up his art treasures for auction and to leave the large house, which he had never been able to pay off. He moves to the Rozengracht, where Hendrickje and Titus look after him. Hendrickje dies in 1662, Titus in 1668, and Rembrandt himself on 4 October 1669. Titus was painted by Rembrandt several times, but not as a 'pleasant and smiling' boy.

SELF-PORTRAIT. 1634. Paris, Louvre, No. 2553. PLATE 58. See page 215.

The picture corresponds closely to Fromentin's description of Rembrandt's appearance on page 223. A self-portrait from the same period is in the Mauritshuis (see page 163).

SIMEON IN THE TEMPLE. 1631. The Hague, Mauritshuis, No. 145. PLATE 59. See page 163.

Probably the most important and most perfect painting of the master's Leiden years.

THE ANATOMY LESSON OF PROFESSOR NICOLAES TULP. 1632. The Hague, Mauritshuis, No. 146. PLATE 60. See pages 162–6.

Professor Nicolaes Tulp (1593–1674) was a well-known Amsterdam surgeon. The names of the spectators are recorded on a sheet of paper held by one of them, with corresponding numbers against the heads.

THE PHILOSOPHER. 1633. Paris, Louvre, No. 2540. PLATE 61. See page 216.

There are two paintings of this subject in the Louvre, but the attribution of the other does not seem to be certain.

PORTRAITS OF MAERTEN DAY AND HIS WIFE JOHANNA MACHTELD VAN DOORN. 1634. Paris, Baron R. de Rothschild. PLATES 62–3. See page 209.

'They have the appearance of having been conceived at the same time,' Fromentin observes quite rightly. The tradition that the female portrait was dated 1643 must be based on an error.

SASKIA AS FLORA. 1635. London, National Gallery, No. 4930. PLATE 64. See page 226.

Fromentin does not mention this particular picture, which he can hardly have known. It is, however, a very characteristic example of 'Saskia dressed up in magnificent disguise'. Pictures of Saskia 'as she really was' do in fact exist, but they had not yet been recognized in Fromentin's time.

HENDRICKJE STOFFELS. c. 1652. Paris, Louvre, No. 2547. PLATE 65. See page 215.

This is not a portrait of Saskia, as was still believed in Fromentin's time. Rembrandt painted Hendrickje several times; the present portrait is one of the earliest of the series.

THE ANGEL LEAVING TOBIAS AND HIS FAMILY. 1637. Paris, Louvre, No. 2536. PLATE 66. See page 214.

THE GOOD SAMARITAN. 1648. Paris, Louvre, No. 2537. PLATE 67. See page 211.

Note how in the works of this year, the Samaritan and Christ at Emmaus (Plate 74), though differently in each case, the architectural

background accompanies the clear composition and the movement of the figures.

THE HOLY FAMILY. 1640. Paris, Louvre, No. 2542. PLATE 68. See page 215.

When we see the 'Holy Family' side by side with the 'Tobias' (Plate 66) we can realize how much calmer and purer Rembrandt's style has become within these few years. The baroque-jagged curves and dazzling contrasts of light and shade have given way to pleasingly rounded forms in the warm glow of a peaceful interior.

THE NIGHT WATCH. 1642. Amsterdam, Rijksmuseum, No. 2016. PLATES 69–72. See pages 177–204, 219–21.

'Le souci de mon voyage,' Fromentin admits. He explains these 'concerns' in detailed discussions, and gives his own solution of this difficult case. He adds that an understanding of the work has been made more difficult by 'several causes which are not altogether the fault of the picture'. At the time of Fromentin's visit, the 'Night Watch' was still hung in the Trippenhuis, and he was not the only one who complained about the bad lighting in a small room. Moreover, the picture has a dark frame, which 'makes it look still more smoky than it really is'. Things have improved: in the Rijksmuseum the picture has all the light it needs, we can look at it from the distance, and finally, the authorities ventured, in 1946–7, to clean the work. The yellow, red, blue and above all the violet tones have reappeared. Today it would no longer be fair to talk of a 'violent and colourless canvas' and Fromentin would be the first to admit it. In the old Trippenhuis the 'Night Watch' faced the 'Banquet of the Musqueteers' by Van der Helst. 'The infallible Van der Helst, a fine painter, of whom I shall not speak today, nor probably any day,' is Fromentin's short comment. But throughout the eighteenth century, Van der Helst was greatly overrated: French artists, and those of the French school, such as N. Cochin, Mme Vigée Lebrun and Liotard, were so blinded by the splendours of Van der Helst that they took hardly any notice of Rembrandt's 'Night Watch' in the same room. Even as late as 1869, E. Montégut described Helst as 'much superior to Frans Hals'. Two hundred years earlier, Frans Banning Cocq may have been of a similar opinion; for when he commissioned a second portrait of himself with three of his colleagues, he entrusted the task not again to Rembrandt, but to Van der Helst (pictures of 1653 in the Louvre and in the Rijksmuseum).

BATHSHEBA AT HER TOILET. 1654. Paris, Louvre, No. 2549. PLATE 73. See page 208.

Fromentin's brief remark 'une étude sur le vif assez bizarre' does not do justice to this work of great solemnity and restrained tension. Or is it the headgear of the maidservant that prompted Fromentin's remark?

CHRIST AT EMMAUS. 1648. Paris, Louvre, No. 2539. PLATE 74. See page 214.

ST. MATTHEW. 1661. Paris, Louvre, No. 2538. PLATE 75. See pages 202, 217.

The angel dictates the gospel to him. A late work executed with great care and affection. Two painted studies for the head have been preserved.

SELF-PORTRAIT. 1660. Paris, Louvre, No. 2555. PLATE 76. See page 224.

Rembrandt at the age of fifty-four, in front of the easel.

PORTRAIT OF A YOUNG MAN. 1658. Paris, Louvre, No. 2545. PLATE 77. See page 215.

PORTRAIT OF JAN SIX. 1654. Amsterdam, Six family. PLATE 78. See page 207.

The picture is dated 1654 (not 1656) as appears from the concealed date in the inscription composed by Six himself.

THE SYNDICS ('DE STAALMEESTERS'). 1662. Amsterdam, Rijksmuseum. PLATE 79. See pages 217–19.

The picture is inscribed twice, first with the date 1661 and again with the date 1662. Fromentin praises it as the perfection of Rembrandt's late style.

PORTRAIT OF A MARRIED COUPLE ('THE JEWISH BRIDE'). c. 1665. Amsterdam, Rijksmuseum. PLATE 80. See page 202.

One of the most splendid works from the master's late period. Only briefly mentioned by Fromentin.

MEINDERT HOBBEMA
Amsterdam 1638–Amsterdam 1709

THE WATER MILL. Paris, Louvre, No. 2404. PLATE 81. See page 137.

Hobbema was Ruisdael's pupil, and not his contemporary as Fromentin calls him in one passage. His works were, and still are, rather rare on the Continent, because English collectors in the eighteenth

century bought up all the master's important works. Fromentin's taste and good understanding of Dutch seventeenth-century painting are shown by the fact that he does not overrate Hobbema, as most critics did, at the expense of Ruisdael.

JACOB VAN RUISDAEL
Haarlem 1628/9–Haarlem 1682

We know now a little more of this painter's life, for instance, that he always signed his name Ruisdael, not Ruysdael. Salomon was not his brother, but his uncle, and possibly one of his teachers. From 1655 to 1681 he lived at Amsterdam. In 1676, nearly 50 years old, he graduated as Doctor of Medicine at the University of Caen. Whether he lived in France for some time is not certain. He died in the Haarlem hospital, which does not however prove that he was quite poor.

Page 139.
His friendship with Berchem is evident from their co-operation in several works. THE FOREST (Paris, Louvre, No. 2557), rather severely criticized by Fromentin, is only one example. Other painters, too, such as Adriaen van de Velde and Philips Wouwerman, added small figures and cattle to Ruisdael's landscapes.

Page 139.
Ruisdael's masterpiece at the Paris Exhibition, which made such an impression on Fromentin, was THE BEACH, now at the Musée Condé at Chantilly.

VIEW OF HAARLEM FROM THE DUNES NEAR OVERVEEN. The Hague, Mauritshuis, No. 155. PLATE 82. See page 142.
Ruisdael painted this view several times. From the dunes one sees the bleaching grounds in the foreground. The vast sky arches over the plain.

'LE COUP DE SOLEIL'. Paris, Louvre, No. 2560. PLATE 83. See page 139.
The 'romantic Ruisdael' is fond of secluded castles and ruins, of windmills and dilapidated bridges. Here an unreal mountain landscape with a waterfall takes shape, under his eyes and hands, as a forceful picture, which is not less complete in itself than his views of the Haarlem dunes.

THE BUSH. *c.* 1647. Paris, Louvre, No. 2559. PLATE 84. See page 137. An early work, showing a motif from the neighbourhood of Haarlem; the church of that town is seen in the background at the left.

THE MILL NEAR WIJK-BY-DUURSTEDE. Amsterdam, Rijksmuseum, No. 2047. PLATE 85. See page 143.

JAN VAN GOYEN
Leiden 1596–The Hague 1656

THE TWO OAKS. 1641. Amsterdam, Rijksmuseum, No. 990. PLATE 86. See page 140.

It was only the art historians (and the art-dealers) of impressionism who rediscovered the beauty peculiar to the works of Van Goyen: the open view upon the Dutch landscape, the lively, almost nervous brushstroke, and the light, blond colouring. In Fromentin's opinion Van Goyen is 'far too uncertain, volatile and evaporated'. In one respect, moreover, he was certainly mistaken when he says that Van Goyen did not make sufficient preparatory studies; in fact, we know of no other seventeenth-century artist who has left more drawings than this master.

PAULUS POTTER
Enkhuizen 1625–Amsterdam 1654

Paul's father, Pieter Potter, was also his teacher. Paul Potter's early works show obvious affinities to the father's style as well as to that of the Amsterdam historical painters P. Lastman and N. Moeyaert. The comparative dates given by Fromentin on page 119 are nearly all wrong. Adriaen van Ostade was, indeed, considerably older: he was thirty-seven years old when Potter painted 'The Bull'; but Albert Cuyp, Terborch, Metsu, Wouwerman and Berchem had not yet reached their thirtieth year, and Wijnants was only fifteen years old. See also pages 365–6.

I append short notes on works mentioned by Fromentin which could not be reproduced:

Page 117.

THE BEAR HUNT (Amsterdam, Rijksmuseum, No. 1910) is in a poor condition and now exhibited in the town hall of Enkhuizen; it is signed and dated 1649.

Page 119.

The signed 'charming engraving made at the age of fourteen' is

probably a drawing in the Staedelsches Kunstinstitut at Frankfurt with the curious inscription: *Paulus Potter f. out 14 jaer. A° 1641 (sic)*.

Page 121.

THE MEADOW (Paris, Louvre, No. 2527) is dated 1652: THE MEADOW in The Hague (Mauritshuis, No. 138) is from the same year.

Page 121.

The two pictures at Amsterdam, THE SHEPHERDS WITH THEIR FLOCKS (No. 1914) and the curious little ORPHEUS (No. 1912), are a little earlier, from 1651 and 1650 respectively.

Page 123.

HORSES AT THE DOOR OF A COTTAGE (Paris, Louvre, No. 2526, signed and dated 1649) must have been painted in the neighbourhood of Delft as the towers of this town are visible in the distance.

Page 123.

The wonderful masterpiece of the Arenberg collection, THE LANDSCAPE WITH A SHEPHERD FAMILY, is known to us only from a poor reproduction. The treasures of this gallery have been lost sight of for many years.

<div align="center">★</div>

THE BULL. 1647. The Hague, Mauritshuis, No. 163. PLATES 88–9. See pages 117–18.

Note the delicately painted background, of which we show a detail reproduction.

THE COW LOOKING AT ITSELF. 1648. The Hague, Mauritshuis, No. 137. PLATE 90. See page 122.

Our modern taste prefers evidently Potter's small pictures, of which this is an example.

AELBERT CUYP
Dordrecht 1620–Dordrecht 1691

This 'very fine painter' was born in 1620, not in 1605 as Fromentin has it. Nowadays his best works, like those of Hobbema, are found in England.

Page 148.

His SETTING OUT FOR A WALK and his WALK (Paris, Louvre, Nos. 2342–3) are not reproduced here because they are, to quote Fromentin, 'not his last word'.

Page 149.

It is for the same reason that we omit a reproduction of the PORTRAIT OF PIETER DE ROVERE (The Hague, Mauritshuis, No. 25).

Page 149.

THE ARRIVAL OF MAURICE OF NASSAU—a misleading title, by the way—is now in an English collection.

Page 150.

DORDRECHT AND ITS SURROUNDINGS is probably the picture in the former Van der Hoop collection; now recognized as a copy. Passed over by Fromentin, whereas other travellers speak of it at great length.

★

LANDSCAPE. Paris, Louvre, No. 2341. PLATE 87. See page 147.

EVENING LANDSCAPE AFTER THE RAIN. The Hague, Bredius Museum. PLATE 91. See page 148.

A particularly moving picture, originally in a French collection. A painting such as this may have been in Fromentin's mind when he praised the merits of this master.

RIVER BY MOONLIGHT. Amsterdam, Six collection. PLATE 92. See pages 149–50.

Cuyp's figures are often somewhat obtrusive, and their unusual proportions mar the harmony of his compositions. Therefore we prefer, as Fromentin did, his landscapes without prominent figures, of which the 'Moonlight' in the Six collection is a happy example.

PHILIPS WOUWERMAN
Haarlem 1619–Haarlem 1668

THE CHARIOT. The Hague, Mauritshuis, No. 218. PLATE 93. See page 114.

'A famous picture.' Fromentin devotes no special paragraph to this painter, whose name, indeed, is mentioned merely as one of those who are lacking in 'subject' in their historical pictures such as battles or cavalry fights. Wouwerman is one of those who 'devoted most of their time to the actual world'. He does however look at it in another way than Cuyp, Potter, or Adriaen van de Velde.

ADRIAEN VAN DE VELDE
Amsterdam 1636–Amsterdam 1672

THE SHORE AT SCHEVENINGEN. The Hague, Mauritshuis, No. 198.
PLATE 94. See pages 100, 140.

The name Van de Velde is mentioned by Fromentin on several
occasions. Sometimes he refers to the sea pictures of Willem van de
Velde. Adriaen, his brother, who painted sunny landscapes, in
Holland and in Italy, is however a much greater artist. How well
does Fromentin's description of his visit to Scheveningen correspond
to the impression made by the picture here reproduced! And how
different is its atmosphere from the dark and stormy landscapes of
Jacob van Ruisdael!

NICOLAES BERGHEM
Haarlem 1620–Amsterdam 1683

ITALIAN LANDSCAPE. 1656. Amsterdam, Rijksmuseum, No. 468.
PLATE 95. See page 114.

'The tradition of travels in Italy', Fromentin states, 'is perhaps the
only one that is common to all schools.' Berchem was the most
elegant representative of that group in Holland, and as such he was
highly admired by the French rococo painters. Fromentin and the
realists of Barbizon preferred the manly art of Ruisdael. Berchem
also painted battle scenes, which have no historical significance.

Page 110.

Speaking of Northern artists who visited Italy, Fromentin mentions
a certain 'Karel', who is said to have died South of the Alps. If he
means Karel Dujardin, that statement is incorrect; he may have had
in mind Andries Both, who was drowned in Venice.

JAN VERMEER VAN DELFT
Delft 1632–Delft 1675

VIEW OF DELFT. The Hague, Mauritshuis, No. 92. PLATE 96. See
page 126.

Even in the briefest survey of Dutch painting in the seventeenth
century, this work cannot be omitted. It is hard to understand how
Fromentin could escape the spell of Vermeer's art. In Amsterdam, he

visited the Six and Van Hoop galleries, he admired Cuyp, Metsu and Ruisdael, but Vermeer's 'Cook' and 'Little Street' made no lasting impression on him. And in the Mauritshuis he missed the 'View of Delft'! Was it not classical enough? 'Van der Meer has some points of view which are rather strange, even in his own country,' is his brief comment upon 'this peculiarity' of Dutch art. Some years before Fromentin's death the Louvre acquired the 'Lacemaker', a gem of a picture though very small. This work also remained outside Fromentin's horizon.

JAN VAN DER HEYDEN
Gorcum 1637–Amsterdam 1712

THE HEERENGRACHT IN AMSTERDAM. Paris, Louvre, Cat. of 1920: page 190. PLATE 97. See page 175.

'Amsterdam is just what we imagine when one thinks of Van der Heyden.' Just as Adriaen van de Velde is for us the painter of the cultivated Dutch landscape, so Jan van der Heyden is the painter of Dutch town life. The works of both evoke the semblance of being faithful renderings of nature, yet neither did in fact copy nature. Van der Heyden, moreover, often juggles with motifs from different places and combines them into one pleasing whole.

ADRIAEN VAN OSTADE
Haarlem 1610–Haarlem 1685

FAMILY GROUP. 1654. Paris, Louvre, No. 2495. PLATE 98. See pages 126, 138.

Fromentin's attention was devoted above all to Rembrandt and the Dutch landscape school. For him even Frans Hals, 'the marvellous craftsman', belonged chiefly to 'what are called painters of exterior'. Hence it is not surprising that the genre painters in the style of Hals are scarcely discussed at all. But we cannot round off a survey of Dutch painting without including 'this humorous painter' who has moreover, in his large œuvre, left a lifelike record of persons of all ranks.

PIETER DE HOOCH
Rotterdam 1629–Amsterdam 1683

DUTCH INTERIOR. Paris, Louvre, No. 2414. PLATE 99. See page 128.

GABRIEL METSU
Leiden 1629–Amsterdam 1667

THE VISIT. Paris, Louvre, No. 2459. PLATE 100. See page 128.

GERARD TERBORCH
Zwolle 1617–Deventer 1681

THE LANSQUENET. Paris, Louvre, No. 2587. PLATE 101. See page 127

Three selected examples of Dutch genre painting in the second half of the seventeenth century. They are taken by Fromentin as his starting point for a discussion of the clair-obscur technique and of the 'valeurs' in Old Master paintings. These observations lead him to complain once more of the defects in the training of modern artists.

JAN STEEN
Leiden 1626–Leiden 1679

THE DOCTOR'S VISIT. The Hague, Mauritshuis, No. 168. PLATE 102. See pages 125–6.

Fromentin is right in saying that Jan Steen is 'a very unequal painter and one has to look outside France to learn what he is worth'. To our mind, Jan Steen is much more than just one of the humorous Dutch artists: he is a really good painter of refined taste, who knows how to build up a composition and how to paint with 'valeurs'.

NOTE ON SOME OF THE COLLECTIONS

From 1815–85 the RIJKSMUSEUM of Amsterdam was housed in the so-called TRIPPENHUIS (House of the Brothers Trip). It was there that Fromentin saw the 'Night Watch' (see page 369). The VAN DER HOOP collection was bequeathed in 1854 to the city of Amsterdam. The pictures were then shown in the 'Oumanshuis-poort'; now they are also in the Rijksmuseum. The Rembrandts of the VAN LOON collection were sold in 1877 to Gustave de Rothschild in Paris. Only a few pictures and family portraits remain in the SIX collection in Amsterdam: a part of the collection was sold in 1928, one Vermeer and some other pictures having been acquired by the Rijksmuseum as early as 1908. Monsieur Louis LA CAZE bequeathed his collection in 1870 to the LOUVRE.

The collection of the Duke of Arenberg was formerly in Brussels; its present location is not known.

SELECTED BIBLIOGRAPHY
AND INDEX

SELECTED BIBLIOGRAPHY

Fromentin's own writings:

LE SALON DE 1845. In *Revue organique des départements de l'Ouest (la Rochelle)*, 1845.
See L. Rosenthal in *La Revue de l'art*, 28, 1910, pp. 367–80.

UN ÉTÉ DANS LE SAHARA. Paris, 1857.
First published in *Revue de Paris*, 21–3, 1854.

UNE ANNÉE DANS LE SAHEL. Paris, 1859.
First published in *Revue des deux Mondes;* II, 18, 1858.

DOMINIQUE. Paris, 1863.
First published in *Revue des deux Mondes*, II, 38–9, 1862.
The 1912 edition with several letters by Fromentin, published by Pierre Blanchon (pseudonym for Jacques-André Mérys).

LES MAÎTRES D'AUTREFOIS. Paris, 1876.
First published in *Revue des deux Mondes*, III, 13, 1876.

LETTRES DE JEUNESSE. Biographie et notes par Pierre Blanchon. Paris, 1909.
Already partly published in *Revue des deux Mondes*, V, 29, 1905, pp. 578–618.

CARNETS DE VOYAGE. Published by Pierre Blanchon in *Revue de Paris* 18, 1911 (4), pp. 5 and 301; 19, 1912 (1), pp. 225 and 623.

CORRESPONDANCE ET FRAGMENTS ·INÉDITS. Biographie et notes par Pierre Blanchon. Paris, 1912. (With bibliography.)
Already partly published in *Revue des deux Mondes*, V, 46, 1908, pp. 241–83, and VI, 7, 1912, pp. 581–612.

Books and articles on Fromentin as a painter and as a writer:

Sainte-Beuve, Nouveaux lundis 7, 1867, pp. 120–50 (reviewing Fromentin's books UN ÉTÉ DANS LE SAHARA and UNE ANNÉE DANS LE SAHEL).

Charles Blanc, LETTRE À PAUL DE SAINT-VICTOR. In *Le Moniteur universel*, 5 Septembre 1876.
Reprinted in *L'Artiste*, Novembre 1876, pp. 287–94.

Charles Blanc, LETTRES DE HOLLANDE. In *Le Temps*, 5 et 11 Octobre 1876.

Catalogue de la vente Eug. Fromentin, Paris, 30–1 Jan. to 2–3 Feb., 1877.

L. Gonse, (introduction to the) Catalogue exposition Eugène Fromentin. Paris, 1877.

Philippe Burtin, 25 DESSINS D'EUGÈNE FROMENTIN REPRODUIT À L'EAU-FORTE PAR E. L. MONTEFIORE. Paris-London, 1877.

J. Rousseau, EUGÈNE FROMENTIN. In *L'Art*, 8, 1877, pp. 11 and 25.

Emile Montégut, FROMENTIN ÉCRIVAIN. In *Revue des deux Mondes*, III, 24, 1877, pp. 674–709.
Reprinted in *Nos morts contemporains*, Paris, 1884, II, pp. 77–111.

Louis Gonse, EUGÈNE FROMENTIN PEINTRE ET ÉCRIVAIN, OUVRAGE AUGMENTÉ D'UN VOYAGE EN ÉGYPTE ET D'AUTRES NOTES ET MORCEAUX INÉDITS DE FROMENTIN. Paris, 1881.

JOURNAL des Goncourt. Paris, 1887–95 (especially II, pp. 110, 275; V, pp. 191, 247, 293).

Ferdinand Brunetière, EUGÈNE FROMENTIN ET LA CRITIQUE D'ART. In *Le Correspondent*, 10 Octobre 1903.
Reprinted in *Variétés littéraires*, Paris, 1904, pp. 243–76.

Louis Gillet, EUGÈNE FROMENTIN ET 'DOMINIQUE'. In *Revue de Paris*, XII, 4, 1905, pp. 526–58.

E. Faguet, LA JEUNESSE D'EUGÈNE FROMENTIN. In *Revue des deux Mondes*, V, 50, 1909, pp. 599–614.

Pierre Martino, FROMENTIN. ESSAI DE BIBLIOGRAPHIE CRITIQUE. In *Revue africaine*, 58, 1914, pp. 153–82.

L. Rosenthal, DU ROMANTISME AU RÉALISME. Paris, 1914.

L. V(ollmer), FROMENTIN. In *Allgemeines Lexikon der bildenden Künste*, 12, 1916, pp. 523–4 (with bibliography).

Mary Pittaluga, EUGÈNE FROMENTIN E LE ORIGINI DE LA MODERNA CRITICA D'ARTE. III, Eugène Fromentin. In *L'Arte*, 21, 1918, pp. 145–89.

Edmund Pilon, LE PÈLERINAGE DE 'DOMINIQUE'. In *Revue des deux Mondes*, VI, 59, 1920, pp. 839–62.

Albert Thibaudet, LE CENTENAIRE DE FROMENTIN. In *Revue de Paris*, XXVII, 5, 1920, pp. 760–89; XXVII, 6, 1920, pp. 149–84.

EUGÈNE FROMENTIN. In *Le Pays d'Ouest*, 10, 1920, Octobre. With contributions by P. Blanchon, A. Chevrillon, J. Tharand, L. Hourticq and L. Souvlet.

Le Figaro, 28 Août 1926, Supplément littéraire (with articles by several writers).

Prosper Dorbec, EUGÈNE FROMENTIN. Paris, 1926.

Paul Jamot, LA PEINTURE AU MUSÉE DU LOUVRE. ÉCOLE FRANÇAISE, XIXᵉ SIÈCLE, III (1928), pp. 114–16.

Paul Jamot, POURQUOI FROMENTIN A-T-IL VOULU ÊTRE PEINTRE? In *Revue universelle*, 32, 1928, pp. 113–20.

Hubert Pierquin, EUGÈNE FROMENTIN. In *Art et les Artistes*, n.s. 20, 1930, pp. 217–21.

M. Revon, FROMENTIN. Les meilleurs textes, Paris, 1936.

Maurice Allemand, (introduction and notes to) Eugène Fromentin, LES MAÎTRES D'AUTREFOIS, Paris (1939).

V. Giraud, FROMENTIN: L'HOMME, L'ŒUVRE. In *Revue des deux Mondes*, 51, 1939, pp. 406–31; 653–67.

Hela Zimmermans, EUGÈNE FROMENTIN, LEBEN, KUNST UND KUNSTAUFFASSUNG. Heidelberg, 1943. (Typewritten dissertation.)

Meyer Schapiro, FROMENTIN AS A CRITIC. In *Partisan Review*, 16, 1949, pp. 25–51.

H. van de Waal, EUGÈNE FROMENTIN, DE MEESTERS VAN WELEER. Rotterdam, 1952. (Published in 1951; Dutch edition of *Les Maîtres d'autrefois* with introduction and extensive notes.)

INDEX OF NAMES

INDEX OF COLLECTIONS